HANG-UPS

Essays on Painting (Mostly)

Simon Schama is University Professor of Art History at Columbia University in New York. His award-winning books include *Patriots and Liberators, Revolution in the Netherlands 1780–1813*; *The Embarrassment of Riches*; *Citizens: A Chronicle of the French Revolution*; *Dead Certainties (Unwarranted Speculations)*; *Landscape and Memory*; *Rembrandt's Eyes* and the *History of Britain* trilogy. Since 1990 he has been writer and presenter of many television programmes on art and history for BBC2, including the fifteen-part *A History of Britain*. His work has been translated into thirteen languages.

ALSO BY SIMON SCHAMA

Patriots and Liberators: Revolution in the Netherlands 1780–1813
Two Rothschilds and the Land of Israel
The Embarrassment of Riches: An Interpretation of Dutch Culture
in the Golden Age
Citizens: A Chronicle of the French Revolution
Dead Certainties (Unwarranted Speculations)
Landscape and Memory
Rembrandt's Eyes
A History of Britain, vol. I: At the Edge of the World? 3000 BC–AD 1603
A History of Britain, vol. II: The British Wars 1603–1776
A History of Britain, vol. III: The Fate of Empire 1776–2001

SIMON SCHAMA

HANG-UPS

Essays on Painting (Mostly)

Published by BBC Books, BBC Worldwide Ltd,
Woodlands, 80 Wood Lane, London W12 0TT

First published in hardback 2004
This paperback edition first published 2005
Text copyright © Simon Schama 2004
The moral right of the author has been asserted.

ISBN 0 563 52289 5

Commissioning Editor: Sally Potter. Project Editor: Belinda Wilkinson
Designer: Linda Blakemore. Production Controller: Peter Hunt

Printed and bound in Great Britain by CPI Bath
Colour separations by Radstock Reproductions Ltd, Midsomer Norton

For more information about this and other BBC books, please visit
www.bbcshop.com

CONTENTS

for Chaya,

to life

INTRODUCTION

Lunches at the Courtauld

ART BEGINS WITH RESISTANCE TO LOSS; or so the ancients supposed. In a chapter on sculpture in his *Natural History*, Pliny the Elder relates the legend of the 'Corinthian Maid' Diboutade who, when faced with the departure of her beloved, sat him down in candlelight and traced his profile from the shadow cast against the wall. Her father, the potter Boutades, pressed clay on the outline to make a portrait relief, thereby inaugurating the genre (and wrecking, one imagines, the delicate shadow-play of his daughter's love-souvenir).

For art, like memory, is never truly solid (even when made from stone or wood or metal) and seldom free of melancholy ambiguity, for it presupposes the elusiveness, if not the outright disappearance, of its subject. Its deepest urge is to trap fugitive vision and passing sensation – elation, horror, meditative calm, desire, pathos – the feelings we have when we experience life most intensely, before routine, time and distance dull the shock, and veil the memory. This craving to nail down transient experience is an unassuageable craving, as basic to us as the self-pitying

9

sorrow for our own mortality, and just as invariably doomed to disappointment. But art draws its wistful power from this heroically futile struggle against disappearance, and what it leaves behind are the visual traces of its defiance. We infer from the awkward turn of the head of Vermeer's turbaned girl that she must soon turn again from us and dissolve back into the void. For a moment, the immense globes of her eyes are convex mirrors in which we might, were this not a picture, witness our own gaze. Pollock's serpents of dripped and whipped pigment forever writhe on the canvas at the precise moment before they settle back into dense encrustation. Constable's onrushing clouds will exit from his pictures as swiftly as they enter but for the instant the cloudcatcher has bagged them.

Art replaces seen reality rather than reproduces it. And the strongest art is the work that is frankest about its artifice, its failure, finally, to duplicate the world, or even to arrest its mutability; the art that, when faced with the commonplace boast, *ars longa vita brevis,* humbly begs to differ.

Eighteenth-century anecdotalists, in their spirit of cheerful utility, and much taken with Pliny's story of the Corinthian Maid, took the story as an account of art's ambition to copy physical reality rather than a parable of wistful passion. Joseph Wright of Derby's painfully literal rendering of the scene thus turned poetry into a demonstration of early graphic technique. But the paintings that most haunt us are most often those that hint at their own instability; the unbridgeable distance between technical bravura and the world it ostensibly doubles, even when the illusion is more compelling than the material reality. It is precisely the unattainable serenity of Vermeer's Delft, fictitiously repaired as a civic paradise from the blackened ruins of its gunpowder explosion, which makes it lodge in our imagination. That Delft is forever barred to us, not just by a breadth of water and an array of towers, gates and walls, but by the distance between a shimmering vision projected on a back wall by a camera obscura, and the mundane reality of a small provincial Dutch town past its prime. The image cast by the lens on the wall is sharp but trapped in the unforgiving brilliance of a dream. It is also upside down. Caravaggio's *Basket of Fruit* (in the Pinacoteca Ambrosiana in Milan)

bathes in a light strong enough to register with uncanny precision the misty bloom on the skin of its black and green grapes. And there is an apt apple, for this is, among other things, a vision of the fall, the most arresting detail of the fruit, the blackened wormhole, marring its rosiness. A pear shows the early freckles of its own decay. But the tip-off that this is a vision, not of substantial, but precarious, naturalism is the artist's refusal to let us see, comfortably, how the basket is set in space. Its bottom edge rests on a slight support that is scarcely thicker than the picture edge itself (and could easily be altogether hidden by a frame). That support might be readable as a ledge or a shelf, but the dead flat, shadowless paint behind it refuses to let us know whether this ledge is connected with anything, nor give us any clue on the breadth of the support. The cumulative effect is to turn a still life into a visual thriller, precariously perched on the lip of collapse, a fatalism signalled, in case we'd missed it, by a vine (or possibly a fig) leaf, folded and faded about the stem.

This tantalizing, built-in unreachability is all the more ironic, since an element of art's allure is the alternative version of existence with which it teases us: a fictitious world in which the sprawling tangle of existence has been tidied, its chaos drilled into shape; its patches of raw ugliness edited; its hang-ups well and truly hung-up. Art is life under New Management – the management of picturing's resident conventions: coherence, harmony, tonal balance. Never mind the rough and tumble enjoyment of a wild ride with de Kooning or Rauschenberg at their most raucous; no one who cares for paintings is entirely immune from the pleasure-trance induced by contemplating strenuous exercises in engineered satisfaction. Poussin's classical architecture, distributed about his landscapes and histories at musical intervals, a projection here, a recession there; a glittering van Dyck portrait where perfectly judged passages of adjacent colour silkily interlock; or a Mondrian grid calibrated so finely that to imagine the black armature moved a millimetre up dooms the whole to immediate disintegration – all correspond to another ideal of Greek aesthetics: that of transcending the physical for the metaphysical.

But art is at least as powerful when it shows up in the opposite guise: as saboteur and thug; the wrecking crew of exquisiteness; the mugger of our reveries; the ghetto blaster in Arcadia. Beauty? 'What beauty?' it roars. 'I'll show you *beauty*.' And it pulls us into the dangerous shadows where mischief, shame, sorrow and occasional moments of glee all happen.

Take, for instance, Honoré Daumier's *On a Bridge at Night* (1) in the Phillips Collection in Washington, in which a woman, presumably a mother, leads a small child by the hand across a nameless span, the river-side buildings summarily described, strong moonlight at their back casting long shadows before the figures as if obstructing their progress. The narrative information is sketchy, no more than tentatively suggested: the woman's bulging sack, the burden perhaps of another of Daumier's wanderers in the years of insurrection in Paris; the child's bent knees rubbery and sagging as if dragged in sleepy reluctance. All this might be projection. But the play of nocturnal brilliance and deep obscurity – the woman's cap picked out by moonbeams, the child's right shoulder angled in the darkness as if holding fast to some object tucked under her arm – cannot help but draw from us pulse waves of pathos and anxiety. The shadows of woman and child lie heavily athwart our own fears and night-mares and the two become translated, in the empty, indifferent place, from the local to the monumental. They are nobodies and thus become everybody.

Once the unnaturalness of naturalism (the impossibility of art's dou-bling of the world, its shadow-play relationship with its subject matter) is acknowledged, its real vocation – making the invisible visible (light itself, for instance) – can be registered and enjoyed. It's in the neigh-bourhood of imperfectly described things or even in the shifting spaces between them, in the half-tones and grace-notes, in the slightly unstable location of the subject in pictorial space, that the strongest charge of art often resides. And it is when the description of objects hints at some-thing other than their mere material constitution, much less their func-tion, that the sorcery of painting begins. A Campbell's soup can is not a soup can, Magritte's pipe is emphatically not a pipe. An ox carcass by Rembrandt seems so utterly butchered as to be agonisingly still alive. A

tiny mirror image of the king and queen at the back of Velázquez's *Las Meninas* suddenly makes them the fulcrum on which the entire meaning of the scene must turn. Manet's life-size but literally faceless vision of the Emperor Maximilian, executed by firing squad in nineteenth-century Mexico, testifies not to our capacity to imagine The News but to its inaccessibility. We see these things and pick up an unsettling, barely perceptible tremor in the assumed relationships between seeing and believing; the tiniest shifting of subterranean tectonic plates, which nonetheless betokens something disconcertingly off kilter. Art, when it works most powerfully, is a prescription for unease; a touch of giddy disorientation; a buzzing in the brain.

I first picked up this disturbance in the aesthetic airwaves while munching in solitude on cheese and tomato sandwiches in the Courtauld Galleries. In 1961, the spectacular collections of Samuel Courtauld and Viscount Lee of Fareham (from Cranach to Picasso) were housed, not in the grandeur of Somerset House, but in a decidedly functional University of London office building at the drabber end of Bloomsbury. But this was just a few minutes' walk (and a universe away) from my place of relatively gainful summer employment: the Royal Institute of Chemistry. Needless to say, I had not been hired for any hitherto unsuspected promise in the natural sciences. All the Institute wanted was someone who could proofread their Year Book. Nothing of any scientific significance was to be checked by the lowly adolescent hired help, only the names and addresses of the Fellowship, many, many thousands of them. Even by the time I had got to the 'Bs' [Bunsen-Burner, Nigel Alistair, MA (Cantab), DSc (Lond), FRIC; 4 Holly Mews, Sydenham, Kent], it seemed to me, as the galleys lay curling on the desk, that anyone who had ever been given a chemistry set for their birthday was entitled to a Fellowship. When I got to the 'Cs' [Cadmium, Magnus, MSc (Glas), PhD (Aberystwyth), DSc (JohHpkns); 2162 Buena Vista, Calif, USA], I was desperate. Happily, the merciless stress of doing this kind of thing without either falling asleep or going mad seemed to affect those to whom I reported, such that the lunch hour was liberally interpreted to mean, usually, two.

Walking north from Russell Square looking for a bench to park myself, my Raymond Chandler and my sandwiches, I noticed the unassuming sign indicating the Courtauld Institute Galleries. That same summer I had chosen – as my school History Prize book, *Cézanne. Fifty Plates in Full Colour*. (I had also, predictably, selected *Ulysses*, which through some error in the presentation ceremony had been bestowed on a startled Divinity Prize winner, while Schama, Simon (Lower Sixth) got his *Observer's Book of British Birds' Eggs*.) I had developed a sophomoric obsession with what I already took to be Cézanne's inspired perversity: the wife painted as though she were made of wood; the pine-woods painted as though they respired; the odd pulsing inner life of things belied by their commonplace surfaces. I had even attempted – with unfortunate results – to paint arrangements of apples and oranges on the kitchen table with the same imminent loss of equilibrium that the master stage-managed. I could do the modelling; I could do the linseed oil; I could even imitate Cézanne's blocky stabbing motion with the square-ended hog-bristle brush. I just couldn't paint. Being sixteen and literal-minded, I somehow imagined that my chances of emulation would be better if I could myself contrive an unstable arrangement of table, cloth, fruit. The experiment failed though much time was spent under the kitchen table picking up Bramleys and swearing.

I knew there were famous Cézannes in the Courtauld collection. And besides, the mere name 'Courtauld' evoked, in my memory, dashing displays of colour and form, since my textile-merchant father had done business with the great Lancashire manufacturer and sometimes had taken me along on buying trips. In loom sheds, somewhere between Bury and Burnley, I'd gaped in the clatter as yarn magically resolved itself into sheets of brilliant fabric that furled and flowed off the ends of the machines: Action Weaving.

But nothing about the dim and mournful entrance at the corner of Woburn Square gave any hint of what the building concealed. An arthritic lift groaned its way up to the fifth floor, opened on to a carpeted floor and there, in a space not much wider than a corridor, was Cranach's *Adam and Eve*: hello paradise. He looked winsome, curly and hapless (what

else); she was gem-eyed, snake-hipped, breasts like pippins (more apples): goodbye paradise. More wonders lay within; Rubens's oil sketch for his Antwerp Cathedral, *Descent from the Cross*, a near-conversion experience, such was the bolt of pathos carried in the sagging load of the pallid body, lowered into the receiving embrace of John the Evangelist in his blood-red coat. The finished altarpiece in Antwerp is a grand machine of pain and redemption; every piece of it calculated to instill helpless devotion. But the sketch, while undoubtedly animated by Christian zeal, is something else: the draughtsman's instinct on fire; the hand running free and delirious, barely ahead of the shaping thought; the colours dabbed and dazzling. Suddenly, the burden of Christian sacrifice assumed a form other than the theological masochism I'd found so alien. It became, as Rubens meant it to be, a witness to the weight of the world's redemption.

Moving from the Lee Collection to Samuel Courtauld's haul of Impressionists, anti-climax was unavoidable. With Sisley's busy little suburban train, puffing through its cutting at Cheam, Renoir's creamy pin-up, all velvet ribbons and corseted embonpoint, up there in her Loge, her indifferent male companion checking out the audience through his opera glasses, and a standard-order Riviera confection by Monet in high-calorie pink and lavender, the Sublime seemed suddenly to have called for the carpet slippers. Yes there was Impressionist light: flicker, flicker, flicker; very nice. I heard the cheese and tomato sandwich calling and since there was no guard to say I shouldn't eat it, I did. (Returning almost every day that summer and finding the gallery all to myself again, only the filling changed; crumbs carefully brushed back into the paper bag.)

There was, though, one startling exception to this tepid bath of pleasure and that was Cézanne's *Montagne Sainte-Victoire*. Like all knock-out masterpieces, it made an immediate, visceral hit: carrying the eye on a soaring flight into its deep space, rising on the thermals that seemed to pulse in Cézanne's burning cerulean sky and swooping to the parched plain where a viaduct sat in mid-ground. The picture was at once monumentally still, presided over by its adamant purple mountain, yet

alive with the kinetic energy that vibrated through the pines: the visual equivalent of the chatter of cicadas at dusk. It was this contrapuntal arrangement – the slight shake of the pine needles against the immovable cubes of the little farm houses strewn through the picture space, the painter hatching forceful, narrow, downward strokes for the vegetation, but using staccato, squared-off marks for the masonry – which lent the picture its musical power. I stayed in front of it, mesmerized, truant from the Year Book, working the detail of each and every passage, following where the draughtsman's guiding intelligence led: along the branch of the foreground tree limb, over the contour of the mountain, swept back again right to left through bands of colour made by the houses and the viaduct, across the picture plane and then up again and back and forth from shallow to deep space.

And as the picture gathered cumulative force I began to sense the cognitive wobble that signals an uncoupling between ostensible subject-matter and the act of painting itself, a movement of colour and line across a two-dimensional surface. There are other Cézannes where the painter more aggressively ruptures this match between subject and mark by leaving patches of canvas baldly exposed. And in the most dramatic of his late paintings, of the *Stone Quarry Near L'Estaque*, for example, Cézanne seems to invite analogies between the broken, faceted stone, and the shattered coherence of the depicted image. The view disintegrates, painting happens.

An hour of this total immersion brings on an uncomfortable fullness (and not the kind induced by cheese and tomato sandwiches): an alternation of elation and exhaustion; yes, almost *that* kind of elation and exhaustion. But the next day I was up for it again. A smaller gallery, leading off the Impressionists had four paintings in it, each one of them a revolution: Manet's last masterpiece, *A Bar at the Folies-Bergères*; Seurat's *La Poudreuse (Woman Powdering Herself)*, Gauguin's *Te rerioia (The Dream)* and Van Gogh's *Self-portrait with Bandaged Ear*, painted not long after he had tried to assault Gauguin and then turned the razor on himself. Can there ever have been four hundred or so square feet so packed with marvels, each one of them (but especially the Manet and the Gauguin) so full of

visual teasing that they each needed a lunch to themselves to work through the visual labyrinth?

Both paintings are modern cautionary utterances: a farewell to simple materiality and the art that pretended to represent it; a warning to mistrust the casual gaze; what you see is not what is. As soon as it registers that the mirror reflection of Manet's bar-girl occurs at an impossibly oblique angle (given her frontal address to the moustached customer in whose shoes the viewer stands), visual quicksand opens. Is the apparent reflection of the bar-girl seen from the rear, in fact, a second bar girl identically posed and dressed? Or is this last great work in Manet's bitterly disappointed career a picture that deliberately makes an optical nonsense of art's pretence at doubling and so, prophetically, renounces it? The beer and champagne bottles perched at the barmaid's edge of the counter appear in the mirror image, also at the far, rather than the near, edge where, if this is indeed a reflection, they should be. And where, in relation to the audience is this girl, with her *je m'en fiche* impassivity, standing? Where *is* this bar, which seems to float beneath the gallery but above the stalls in some sort of spatial limbo? The ground shifts, the head swims, the eyes get rubbed. Disbelief dances a tango with disorientation. Legs materialize out of the gloom, standing on a trapeze but the trapeze is not swinging. Vision gives up, its dependability (like those pink legs) suspended until further notice.

The hypnotic Gauguin, painted fifteen years later, in 1897, is no help either. Like Manet's painting, Gauguin's enigmatic *Te rerioia* is set on an uncertain support, for the floor on which his two beautiful Tahitian women, one half-naked, one not, squat, is tilted impossibly steeply towards the rear, in defiance of all the rules of perspective. The back wall is pierced by a view of a man on a horse, seen from the rear, riding away from us towards tropically lush mountains. This landscape might be a view seen through a window (and thus an analogy to perspective itself as defined by Alberti, a 'window' into the illusion of space). But equally it might be a painting laid flush against the wall, in which that illusionistic perspective is embodied. Or the scenery might be a dreamscape since the painter himself warned that *everything* in the picture is a dream.

But who is doing the dreaming? The pensive women who see *themselves* in their semi-conscious vision; the artist who has imagined them in his own languid reverie or his erotic fantasy, or the baby sleeping in the cradle? Perhaps even the creepy white cat sleeping with its yellow eyes open? At any rate, the thresholds between waking and sleeping, looking and dreaming, have been scrambled by the painter who covers everything in the darkly gold and empurpled veil of his mystery. The people seem trapped in this slumberous, claustrophobic mesh, while the creatures in the relief decorating the sides of the room seem, on the other hand, worryingly alive. On one wall, lovers embrace, but even as the man shields his girl with the closeness of his body, he turns, his eyes white with a sense of sudden alarm, towards a nymph-like figure emerging from a monstrous blossom, or perhaps towards the fertility goddess Hina on the farther wall, raising her arms to the gods. Something is leaking out in the borderland between the human and inhuman worlds, something not reassuring. The decorative homunculus at the end of the cradle seems to be pushing in the wrong direction, against, rather than with, the mother-nana, as if eager for a prize. Vision fails again. Unease hangs in the air like the heavy scent of a fleshy plumeria bloom.

Those lunchtime epiphanies at the Courtauld gave me a healthy respect for the creative shiftiness of art. And by the same token they made me permanently allergic to the literal-minded way in which some historians (or their publishers) casually used paintings as if they were snapshots from the past. Narratives of Napoleonic Europe, for example, reproduced Baron Gros's hagiographic images – of the first consul in the Plague House at Jaffa, or of the emperor, seated on his messianic white horse, looking stricken as he viewed the carnage at Eylau and bestowed magnanimous compassion on the bodies of the fallen foe – as if they were reports from the scene rather than the feverish and fantastic recycling of Christian hagiography. Likewise, as I attempted an interpretation of seventeenth-century Dutch culture, I became resistant to the reductionist truism that assumed that Dutch art somehow 'reflected' some presumably more solid form of social experience: the making of

money or the wielding of power. Pondering the density of emblems and images that seemed to point precisely in the opposite direction – that images could hold up the glass of conscience, as much as self-congratulation, to its patrons – it seemed to me at least as feasible to argue that the pictures had made the culture as vice versa.

Now, of course, it is a commonplace to observe that neither social rank nor political power can be imagined without the imagery that invents and sustains them; so that 'real' political actors sometimes seemed imprisoned in some sort of perpetually nocturnal pod while their envisioned versions do their thing in The Matrix of the news. For better or worse the images make and unmake our norms. Think Queen Elizabeth I or Karsh's Bulldog Churchill. But think also Abu Ghraib, an atrocity in which *picturing* was an integral part of the torture, given that the elaborately obscene degradation of the prisoners was consciously reinforced by their being threatened with images of their emasculation being made public.

So if there can be no art without history, neither can there be history without images, and image-making, moreover, understood as a process far more complicated than ceremonial illustration. So when I was asked in the mid-seventies by the editor of *The Times Literary Supplement* (TLS), John Gross, if I would review a show of Dutch genre paintings at the National Gallery in London, I rather gracelessly warned him not to expect 'an historian's view', a communiqué from the canals. The ter Borchs and Steens and Metsus could not help but be a visual document of some sort, of course, and establish, cumulatively some sort of consensus about the taste of patrons. But notwithstanding their surface secularism and domesticity, they were just as likely to tell untruths and fables about the society they inhabited as any more conspicuously Christian culture. Within little canvases, in which apes stopped wall clocks and flowers of utterly different seasons shared the same pot, whoppers were being told, fantasies spun, little sermons and big jokes thrown at the beholder. 'Fine,' he said, smiling that patient and winning Gross smile, doubtless wondering first about the gratuitous vehemence of my protest and secondly whether he'd commissioned the right person for the job.

Improbably, the review got published and even more improbably John commissioned a few more review essays, mostly on British art (two of which, the pieces on Lawrence and Rowlandson, are reprinted here). Throughout, I tried to keep faith with my hostility to historical over-determinism, a prejudice to which I quaintly clung precisely at the moment when the fashion in art history was turning towards historical context. At the Courtauld Institute (rather than the gallery), and else-where, history was now embraced as the antidote to precious connois-seurship and arid formal analysis (the unpacking of pure technique within the picture). The artist was now reconceived as a social actor and his work not the product of some urgent inner muse, but a negotiation between his creative impulse and the demands of patron, market and reigning canons of taste and ideology. Hallowed texts, like Heinrich Wölfflin's *Renaissance and Baroque,* which described the change in painterly style almost entirely in formal terms as the shift from a 'closed' to an 'open' or a 'linear' to a 'painterly' manner – as if these habits had an exis-tence of their own floating free from particular historical cultures – were now stripped of their authority and targeted for derision.

Now why should an historian have any argument with any of this? The turn to history (which had in truth been going on for at least two generations) was a timely correction: the junking of empty grandilo-quence long overdue. We certainly did need to know more about Caravaggio's Cardinals and Michelangelo's account books, the political bickerings of Amsterdam's oligarchs and even perhaps the exigencies of Peggy Guggenheim's sexual appetite. What bothered me, however, in this headlong rush to history (and away from a sense of artists as bonded by the peculiarities of their own discrete tradition, education and cul-ture) was how indiscriminate the appeal to history as an explanatory *deus ex machina* could be. From details of the subject-matter of paintings, or details of the way in which they had been handled, all sorts of inferences were drawn, often by a rule of nothing more than instinctive proximity. Turner's tug belching smoke while pulling the *Fighting Temeraire* was so very black and beastly that it must, surely, have been making a Romantic protest against the death of naval heroism – that kind of thing.

There was no pleasing me, I suppose. Just as I had fretted over historians who used art illustratively, I now became irritated by the indiscriminate use art historians made of history to confirm assumptions they seemed to have coined in prior ideology. But nor was I about to turn into an airy formalist myself, content to gush over the chiaroscuro. But in the essays I wrote in the United States, first for Leon Wieseltier in *The New Republic* and then for Tina Brown and David Remnick in *The New Yorker,* I tried to give a sense of the particular culture in which the art had been created, without ever assuming it would necessarily be obedient to its norms. Sometimes an artist would have precedents, paragons, peers and patrons very much in mind and still end up going his or her way.

One awkwardness never left me, not during the writing of the early pieces for the *TLS,* nor in the many American essays that followed: the problem of translating images into prose. I was (and still am) mildly surprised by how insignificant an anxiety this redundancy seems to be for the vast majority of critics and scholars who seem to feel no embarrassment at all in the face of the inadequacy of our writing to convey even a vivid description of a work of art, much less the nuances of its making and meaning. But perhaps imperviousness is the better way. The alternative is a self-consciousness that has only two ways to go: the laconic, deliberately distancing itself from any suspicion of imitating the art it describes (though a laconic reading of minimalism would immediately get itself into trouble), or the Romantic, in the gloriously over-wrought fashion of John Ruskin, which heroically struggles to invent a language of reading commensurate with what he takes to be Turner's re-invention of painting. So as he looks fondly at the *Slavers Throwing Overboard the Dead and Dying – Typhon Coming on,* Ruskin cannot help but writhe and roll along with the brushstrokes as if he were composing music or poetry or both: a kind of manic chant. (Try reading this out loud.)

Along this fiery path and valley, the tossing waves by which the swell of the sea is restlessly divided, lift themselves in dark, indefinite, fantastic forms, each casting a faint and ghastly shadow

behind it along the illumined foam. They do not rise everywhere but three or four together in wild groups, fitfull and furiously, as the under strength of the swell compels or permits them; leaving between them treacherous spaces of level and whirling water, now lighted with green and lamp-like fire, now flashing back the gold of the declining sun, now fearfully dyed from above with the undistinguishable images of the burning clouds, which fall upon them in flakes of crimson and scarlet and give to the reckless waves the added motion of their own fiery flying.

This sort of performance, I felt sure, was probably not the kind of thing that would sit well between the cartoons and 'The Talk of the Town' in the glossy pages of *The New Yorker*. But neither did I want to fall into the densely theoretical diction favoured by academic art historians, nor the watch-this-space casualness of the occasional writer on art. Not long after Tina Brown hired me in 1995 as art critic, two of her editors took me out to lunch and handed me a list of my august predecessors among whom the name of Harold Rosenberg, an immense and embattled eminence in the New York artworld of the nineteen-fifties and sixties, dauntingly featured. It was at that point I knew there was no point in writing to any imagined template of the ideal or even the imperfect critic, nor for that matter anguishing over the fatal discrepancy between image and prose. A reasonable goal might be to give readers just enough vividness and honesty of response, enough of the background world that had engendered the work, and enough of the issues and conundrums it might raise, for them to go see for themselves and make up their own minds. Ruskinian flooding was entirely to be avoided.

Once again, I was churlishly defensive that my writing about art would be taken somehow as the 'historian's view', for I no longer had any idea what that might be, except an account of the art minus the art and that, too, was a poor way to start this job. So I struck a deal with Tina, who after all was taking one of the wilder flyers of her life on making me an art critic with a regular beat. With an exhaustive big Mondrian retro- spective coming up in Washington and New York, I would write her a

big piece about the quintessential abstract painter for whom the very condition of modern art was its annihilation of subject matter. This would be an assignment where history was no help at all.

Off I went to the National Gallery in Washington, armed just with notebook and wise old saws from wise old friends and critics like Robert Hughes who counselled me never ever to go to press openings. 'Full of people with glasses of Chardonnay, accousti-guides desperately clamped to the ears.' (The only time I had no choice but to go to a press opening, I discovered he was right.) Instead, get to the shows while they are being installed or after the openings along with Joe Public, and feed off their response. Never review a friend. (Though in one case alone, that of the sculptor Andy Goldsworthy, I make no secret of a long admiration, and a long irritability with lazy readings of his work.)

For some years, then, I was in journalist heaven, sitting on the floor of galleries with workmen banging away at the installation, pictures leaning against the walls, one of the best angles, I learned, for appreciative engagement. In that heaven there were all sorts of guardian angels to keep me honest: Tina Brown herself who exercised a shockingly astute ability to see at a glance that paragraph A should actually be paragraph D; and an editor, the poet Deborah Garrison, with whom I had as an ideal a literary relationship as any writer could hope for. Deb's forte was painless surgery or the spiking of adjectival bloat (moi?) without the victim ever noticing the elegance or the precision of the edit. What was left after her work was not just recognizably still me but a colossally improved version of me; the literary me I had meant to be: leaner, punchier, funnier, sharper. When, for some reason, I won a National Magazine Award for my first year of art criticism, I felt the prize ought to have gone to both of us for what was, in truth, a collaboration. Whatever energy these essays might have owes a great deal to the immediate circumstances – and the beckoning deadline – of the assignment. So I have left reference to museums and installations intact, pretty much as published. *Hang-Ups* is a book about art *shows*, as well as art.

What happened to the beat was the BBC. With *A History of Britain* consuming an ever larger chunk of my life, and still wanting to teach art

history and history at Columbia University, something had to give. Since 1999 under the generous and patient editorship of David Remnick and Dorothy Wickenden, I have continued to write essays on culture, and sometimes on art, for *The New Yorker,* often (as in the pieces reprinted on the enigmatic Michael Sweerts and on Andy Goldsworthy's sculpture) at greater length than was possible in the columns. I've been grateful for that collegial generosity, for the pages, for the consistently shrewd and sympathetic editing.

But there was something avid, high-pitched and even slightly drunken (in the most literary way, of course) about the regular art column, which I'm not sure I shall ever quite recapture: the dizzy turn-around from brooding on Rembrandt to walking the racks at the Haute Couture show at the Metropolitan Museum's Costume Institute; from rediscovering Hockney in London to communing with Soutine's blood-soaked carcasses in the Jewish Museum; an endlessly moveable feast with each dish quickening the appetite for the next. And the writing, now that I can bear to look at it again, I see has something of that shamelessly noisy quality that the normally demure and restrained Professor Schama is famously careful to avoid.

Don't worry. It won't happen again.

I
DUTCH GAMES

MICHAEL SWEERTS

Another Dimension

IN CALVINIST AMSTERDAM in the summer of 1661, the Catholic painter Michael Sweerts began to exhibit signs of indiscreet fervour. He fasted, took Communion in hidden chapels, slept on hard floors, and gave away his portraiture fees to the poor. Sweerts was from Brussels, the son of a merchant. He had worked as an artist in Rome, bought paintings and antiquities for a rich Dutch family, and run a drawing academy in Brussels in the late sixteen-fifties. And at some point, according to the travel diary of a French missionary, he underwent a 'miraculous conversion'. While he was in Amsterdam, where he had gone to help prepare a ship for an evangelical mission to China, his devotions were intense. Gazing at the cross, he was vouchsafed 'beautiful secrets'. He appeared to be not only 'one of the greatest painters in the world', the French missionary wrote, but a paragon of piety.

The Counter-Reformation was committed to mobilizing the senses in the work of salvation, and because the natives of Asia were thought to be particularly moved by spectacle, the Société des Missions Étrangères,

which followed the teachings of the austere St. Vincent de Paul, wanted to include an artist among the lay missionaries it was sending to the East. (There would also be a musician to introduce the heathen to the sweet euphony of the faith, a sculptor to fashion images of the Saviour, and a surgeon to minister to the bodies of converts.) Sweerts must have seemed right for the appointment. He spoke seven languages and had seen enough of the world to know its perils and stratagems, although not so much as to compromise his faith.

But it was a long way to China. On the arduous sea voyage in the winter of 1661–62, four members of the small company died. The interminable and dangerous overland journey through Syria and Persia made for an even sterner test of humility and discipline. Somewhere amid the dun tracks of the Persian plateau, Michael Sweerts became obnoxiously counter-suggestible. He was, the missionaries reported, incapable of holding his tongue. Not even Bishop Pallu, the leader of the mission, was spared his bumptious homilies. Though much tried, Pallu was patient. Sweerts had painted his portrait and the Bishop liked it. So his initial reprimand was mild, far too mild for some.

Sweerts would recant and abjectly implore forgiveness after his outbursts, but, as the caravan plodded on, the loud-mouth got louder. One of the missionaries, René Brunel, went to the Bishop and let him know that the mere presence of the obstreperous Sweerts had become more than the rest of them could tolerate, and somewhere between Isfahan and Tabriz in the summer of 1662, there was a parting of the ways. Michael Sweerts journeyed on to golden Goa, the Portuguese colony on the west coast of India. It was another citadel of faith, but one – and this cannot have been a coincidence – dominated by the theological adversaries of St. Vincent de Paul's Lazarists: the Jesuits. Between Tabriz and Goa, between the ascetic Lazarists and the imperious Jesuits, the documentary trail, never very clear in the case of Sweerts, peters out completely. We have no idea how the artist got to India, or whether he preached or painted after he arrived. We know only that he died there in 1664. He was forty-six.

The first article on Michael Sweerts, disentangling him from the many other painters with whom he was confused, was published as long ago as 1907, but it is safe to say that he is still not exactly a household word, even among those few who, on entering a great museum, can't wait until they get to the Flemish Baroque. (Should you need a sit-down, it's a rule of thumb to look for galleries where rubicund boozers by Jacob Jordaens and eviscerated roebucks by Jan Fyt preside over imposing emptiness.) Sweerts has been a well-kept secret among Netherlandish art historians, dealers and curators, surfacing in conferences or in seminar chatter as an unclassifiable, mercurial wonder who seemed to come from nowhere (with all due respect to Brussels) and to want to do everything.

The remarkable thing about this most protean of artists was that, technically, he *could* do almost everything. In the dazzling show of his work at the Wadsworth Atheneum in Hartford (a co-organizer of the exhibition, with the Rijksmuseum in Amsterdam and the Fine Arts Museum of San Francisco), you can find him serving up, with equal aplomb and confidence, a juicy Caravaggio street boy, all sharp blue silk and pouty come-hither lips; big-boned labourers with basketballer feet, chiselled into the same kind of dignified human monuments turned out by Velázquez (who was in Rome when Sweerts was, in the mid-sixteen-hundreds); a glossy little boy, the spitting image of Van Dyck's Stuart princes; and – in a moment of spectacular overreach – a plague scene meant to show Nicolas Poussin (whose *Plague at Ashdod* was famous in Rome) just who could do cheese-coloured corpses with rolled-up eyes and nose-holding citizens crouched in nauseated terror.

Having a go at Poussin was, of course, asking for trouble, and draughtsmanship, Poussin's special genius, was not Sweerts's strong suit. But for aspiring seventeenth-century painters emulation was not merely allowable; it was expected. The rule since the Renaissance had been to learn by imitating the masters before you had the temerity to compete with them or the presumption to fashion your own *maniera*. Sweerts, his head spinning with the choice of available role models, living and dead (for he was plainly also drawn to Lorenzo Lotto and Annibale Carracci), often took emulation right to the edge of impersonation. The most

brazen borrowing of all appears to be the portrait that is, literally, the poster boy for the Sweerts show: a dewy preadolescent youth in a beat-up brown slouch hat, a mane of auburn locks falling on his neck, calf eyes wide, his head swung over his right shoulder, the figure set in indeterminate depth and space to give it radiance and extraordinary immediacy. Goodness, you might say, he could even do Vermeer.

And you would be wrong. The disconcerting truth is that by the time Vermeer painted the *Girl with the Pearl Earring*, sometime in the mid-sixteen-sixties, Michael Sweerts was either well east of Aleppo, lecturing his fellow-missionaries on their duties to Christ and man, or dead. If there is a link between the two paintings, it must have been Vermeer who emulated Sweerts, not the other way around. No evidence of any direct connection exists, but we know that Sweerts's paintings had reached Delft by the sixteen-sixties. And Vermeer's biographer, John Michael Montias, reminded me of one documented, indirect connection between the Delft master and Sweerts. In 1663, Vermeer received a visit from a French gentleman connoisseur, Balthasar de Monconys, whose travelling companion was a painter from Brussels, Louis Cousin. Sweerts and Cousin had been neighbours in Rome and both had worked for the Pamphilj, the family of Pope Innocent X. Cousin might well have discussed Sweerts with Vermeer.

Most of Sweerts's work is undated, frustrating the tidy habits of biographers who like their painters and paintings sorted into early, middle and late periods. The heads that are some of the most poetically realized and singular paintings of the seventeenth century seem to come from late in his career, in the middle or late sixteen-fifties, either toward the end of his sojourn in Rome or after he returned to Brussels. Most of the Flemish and Dutch painters working in Italy at the time made money from servicing the vacation-in-the-Campagna market up north: slumbering cows, hunters and ruins, a good drenching in hot yellow light. But Sweerts was after something more ambitious than atmospherics. He wanted to marry the physical monumentality of great Italian art with the common humanity of the north, and the best paintings in the Hartford show achieve just that.

A maidservant in one gallery, neither especially pretty nor especially plain, turns her head over her left shoulder, away from our gaze (2). The rendering of her skin is a technical marvel on a par with Rembrandt's or Gerard ter Borch's greatest adventures in naturalism: rosy where it should be rosy; blue-shadowed between the bridge of the nose and the eyes. The shallow valley between the ridged tendons of her throat gets precisely the warm carnation tint it needs not just for anatomical naturalism but for expressive tenderness, as if the woman had been caught in some thoracic blush by the self-consciousness of posing. The eyes are, as always with Sweerts, enormous, the irises coloured a strong hazel-green but with the paint thinned enough to describe, exactly, their vitreous transparency. No trick of the trade is neglected; the barely covered canvas weave helps create an illusion of the slightly granular, filmy surface of the cornea. Highlights work tonally rather than logically, the one on the collar at the girl's foreshortened left shoulder making a sharp contrast with the light shadow cast by the left side of her chin.

These calculations of what the seventeenth-century Dutch manuals called *houding* – the interlocking juxtaposition of cool and warm, light and dark passages of paint, to create illusions of three-dimensional modelling in space – are unerringly calibrated. Without the highlight, the progression of the shadow from pale to deep beneath the chin itself would be lost. And without that deep shadow modulated to a more delicate shade along the left side of the face, the movement of the head away from us would be tentative rather than dynamic. Having managed all this art, Sweerts allows himself a little exclamation point of self-congratulation: the glittering pins fastened in the girl's bodice. Perhaps she is a seamstress. Sweerts often uses the conceit of stitching and embroidering as a metaphor for art, which – unlike many of his contemporaries – he does not want differentiated from craft.

Move along the wall and Sweerts does another quick change, but this time into a portrait manner completely unanticipated by any of his cynosures. The old – or perhaps not so old – duck with a bravely watery smile and painstakingly stitched patches depicted in *Head of an Old Woman*, which belongs to the Getty, is neither a Rembrandtesque sympathy

milker nor one of the grotesque hags of the Leonardo tradition nor a standard-issue procuress of the kind painted by Sweerts himself, all receding gums and beady-eyed predation. This woman is not, in fact, a persona – the mask of a type – but a person. Instead of doing what the hacks would do – offer the usual platitude about the loss of beauty – Sweerts actually observes beauty's sweetly lingering ghost. Washed by a light that is cooler and sharper than anything that would be used for portraiture until Ingres, the face was, clearly, not so very long ago, good-looking.

This one gallery in the Wadsworth demonstrates that it would be a gross mistake to write Sweerts off as a facile imitator, when he was capable, on occasion, of peerless inimitability. Another lissome youth, only recently identified as a Sweerts, is painted in precisely the opposite manner from the Getty picture: with free, loose and fluid strokes, as if caught by a little gust of wind – the kind of sketchy plein-air manner that would be the rage a century later for milords ordering by the yard from Gainsborough or Fragonard.

The sense of Sweerts as a larger-than-life personality divided between a classically thoughtful temper and a spirited one is caught perfectly in the two big portraits hung at the beginning of the show. The painting of a classic melancholic – gaunt, pale, and pointing to a skull – has been published as a self-portrait, although the face doesn't much resemble that in other paintings which are more probably likenesses of Sweerts. But painters often featured themselves brooding on their own mortality – sometimes contrasted with the longevity of art, sometimes reinforcing its transience – and there is no doubt that Sweerts put a lot of himself into the study. The second big portrait at the beginning of the show is an even more stunning painting of a young man, this one from the collection of the Hermitage. It is a picture of genuinely solemn contemplation, akin to a metaphysical poem by George Herbert. The young man's head rests on his hand at a full forty-five degrees to his desk. Before him, painted with as exquisite a realization of surface and texture as anything achieved by Vermeer, are the materials of worldly fortune: commercial

papers, a purse, a gleaming inkwell and quill (the translucence of the goose feather perfectly described). But those substantial things surrender to the conventional warning pinned to the tablecloth: '*Ratio quique reddenda*': each man must make a reckoning.

The pose of wistful reflection was sometimes just that, and sighing at the mirror could be dangerously close to narcissism. Sweerts may have painted sadness, sometimes more feelingly than any of his contemporaries, but it is less clear that he suffered from it. The two generally accepted self-portraits we have of him convey a sense of burly self-confidence. The earlier one (which is in the Uffizi and has not been included in this show) probably dates from the late sixteen-forties and is painted with such thickly applied Rembrandtesque coarseness that it reminds us how well known the Dutch master was in Italy. But the big self-portrait from the late sixteen-fifties that dominates the gallery in Hartford is *sui generis*. This is Sweerts, the genial colossus, posed against the distant blue horizon of an Italian landscape, as though the painter's feet were planted on the foothills of Parnassus. He holds a loaded brush in one hand and, in the other, a palette with the paints arranged in standard order, from warm vermillion to sienna and black. Beads of pigment are deposited to represent beads of pigment. (Ceci *est* une pipe.) Painters depicting themselves with the tools of their trade had a long pedigree, especially in the Netherlands, but a landscape setting for such working self-portraits did not. The most obvious precedent was the self-portrait of another artist who worked in Rome when Sweerts did and who had a richly merited reputation for cranky individualism: Salvator Rosa.

Art historians like to correct romantic fantasies about great art issuing from the visions of a few sublimely inspired Prometheans. Masters, along with masterpieces, are now just so many bourgeois fetishes in the moribund temples of decayed capitalism. Quality is ideology. Instead of the breathless hush and the deathless genius, we have image and sign, in no meaningful sense separate from a welter of other images in social circulation – Renaissance helmet decorations, rococo snuffboxes, tobacco-store Indians, movie posters, subway graffiti. The images are said to be the products of the market, the critical zeitgeist, the

patron-painter-public nexus, or – in traditional art-historical literature – just another link in a long chain of predecessors, prototypes, and role models. In the case of figures like Rosa and Sweerts, who seem to stand apart from, or at least to one side of, the herd, the finger-wagging against anachronistic cults of the solitary artist-hero gets frantic.

But we know that Salvator Rosa did indeed think of himself as a maverick hero. The romantic idea of the artist in combat with vulgar patrons and dimwitted critics begins with Rosa, right in the middle of the seventeenth century. (Visitors to the Sweerts show at the Wadsworth Atheneum can find one of Rosa's strongest displays of visual histrionics, *Lucrezia as the Personification of Poetry*, in a downstairs gallery.) Rosa fancied himself a satirical poet and a classical scholar as well as a painter and engraver, and he despised the powerful. One of his best etchings is of Diogenes telling Alexander the Great to get out of his light. To avoid contractual captivity, Rosa sold his pictures at public exhibitions. And his style was of a piece with his uncompromising personality: whiplash lines; hurricane hairdos; cavalry horses caught in spine-bending twists; errant boys lost amid sylvan fronds; mossily crumbled bridges; overhanging precipices; skies with an attitude; cavernous lairs prowled by brigands. His stagy convulsions were the antithesis of what orderly academic classicism demanded.

The fact that Rosa paraded his erudition made his calculated unruliness even more irksome to the guardians of classical decorum. One of his etchings, called, with characteristic self-effacement *The Genius of Salvator Rosa* features the hero in the attitude of a river god, crowned with a wreath of ivy and about to receive the cap of Liberty. For the first time (that I know of), the equation between art and freedom has become a manifesto. Rosa's self-portrait now in the National Gallery in London is surely a prototype for Sweerts. There, too, the genius is stationed colossally in indeterminate space and depth, as if communing with the muses. He holds a philosophical inscription that reads, in Latin, 'Keep silent unless your speech is better than silence.'

Which is not to say that, even though Rosa's fierce star exercised a powerful influence in mid-seventeenth-century Rome, the bright young

merchant's son from Brussels intended to cast himself in a similar role. While Rosa's face glares from his self-portrait, Sweerts paints himself all innocent self-satisfaction. Far from spurning patrons, Sweerts likely courted them. In Rome, he acted as a purchasing agent for the wealthy Deutz brothers, the portraits of two of whom appear at the Wadsworth Atheneum, their elegantly understated patrician uniforms surmounted by pudding heads and wetly glittering bug eyes. And Sweerts worked for the nephew of Pope Innocent X, Prince Camillo Pamphilj. In a city bursting with outsized talent – Bernini, Borromini, Velázquez, Poussin, Claude Lorrain, Gaspar Dughet and the elderly Pietro da Cortona – Sweerts had, by 1652, become an eminence in his own right, enough of one, at any rate, for the famously irascible Pope to have raised him to the rank of *cavaliere,* which Rubens and Van Dyck had also held.

Sweerts was no rebel, but he wasn't much of a joiner, either. Though he lived in the Via Margutta, in the rowdy Santa Maria del Popolo quarter of Rome, where Dutch and Flemish artists congregated, he seems not to have become a regular among the roistering gang of the *Bentvueghels* ('birds of a feather', as the northerners called themselves). Nor was he likely a member of the Accademia di San Luca, an artists' guild. He was not the enemy of the academies, or of their curriculum, which demanded for the highest vocation – history painting – training grounded in *disegno,* or the drawing of antique sculpture, usually in the form of widely available plaster casts. But the internal evidence of his off-kilter paintings depicting artists and apprentices drawing suggests a fascinating ambivalence about those very practices. Why, for example, is the most brilliantly lit young apprentice in the foreground of *The Drawing School* the only figure looking neither at the male model nor at his sketch pad but, rather, at something or someone beyond the frame?

In the seventeenth century, the making of art was argued about intensely. Was painting an art because of its closeness to observed nature or its distance from it? Was it a straightforward report or a refined editorial? Was it to be earthy or erudite, philosophical or social? Was the instrument of its transport colour or the drawn line? By the time Sweerts

showed up in Rome, these debates were hoary, but the status of the painter was still at stake. Was he an artist – and in both Italian and Dutch the word itself, *arte* or *kunst*, meant skilled craft, not aesthetic practice – because of his intellectual grasp or the finesse of his hands?

Sweerts went out of his way to confound the cliché that Flemish painters were amusingly mindless craftsmen. He embraced *disegno* rather than *colore*, and painted artists in the process of drawing. But he had not so much made a choice as refused to make one. All he asks is that we look hard and think as we look. It's easy to miss this sly thoughtfulness in the apparently anecdotal gatherings that populate the busy paintings of wrestlers and bathers as well as those of sketchers and embroiderers. The show in Hartford dumps the pictures into the category of 'genre paint- ing', a slightly tired category for slices of life, street or domestic, comic or serious, that make no strenuous demands on the beholder. And in one nice little number, a painting of a Dutch patrician having his riding boots pulled off by a manservant, Sweerts shows that he is not above this.

Superficially, some of the other work in the show – a painting of an artist sketching Bernini's *Neptune and Triton*, for instance, and one of a well-dressed man and woman slumming with a group of off-duty shep- herds – seems to be no more than visual eavesdropping. Yet neither of these pictures makes the slightest sense as a social document. The first painting is abruptly and unequally divided. On the left side, beneath one of Sweerts's brilliant cerulean skies, Bernini's youthful, breakthrough sculpture (now in the Victoria and Albert Museum in London) stands in an imaginary Roman street. But scowling Neptune, ploughing the sea, could not have been less like the models of classical restraint recom- mended by the academy. The painting's gravitas is embodied in a group of workers standing around in the foreground, oblivious of the artist's efforts. A knife grinder and a cleaver-toting butcher are in deep shadow, the details of the figures not worked up. Some faces are no more than monochrome smears. Thus far, Sweerts's intention is clear. He has put aside the pretensions of the artist as a *pictor doctus*, a learned painter following the rules of drawing, and is aligned with the workers. But – and it turns out to be a big but – the most strongly lit figure in the

painting is a bearded, heavily muscled, half-naked man, recumbent against what seems to be felled logs, fallen columns, or both. He gazes raptly past the seated artist at Bernini's sculpture group. Half submerged amid the debris, he is either Lazarus awakening to the power of art or a reclining river god who belongs with the marble figures glowing in the late-afternoon light. Sweerts, perhaps for the first time, but not the last, is playing Pygmalion.

The painting of the well-heeled couple's encounter with the shepherds is even odder. It is one of the few seventeenth-century paintings where sophisticated patrons for whom the pastoral was a polite game – poetry to be written and recited, cantatas to be sung, dress-up picnics to be taken in the Campagna or the northern meadows – are actually confronted with the physical reality behind the Arcadian fantasy: solid, dirty, hairy men unimpressed by their visitors. A shepherd taking a slug from a flask, his legs parted, feet bare, eyes the couple. The uneasy husband folds his hands together and looks down at a moustached figure whose features are not dissimilar from Sweerts's own, while his wife, her right hand on his shoulder, stares sourly at us, implicating us in the trespass. It is possible that this extraordinary subversion of the usual pastoral-dress paintings of the aristocracy was nonetheless commissioned, and even possible that the patrons failed to notice the ominous collision of social unequals. Yet it is unmistakably there.

This sort of thing was not what Netherlandish artists in Rome were known for. A decade before Sweerts arrived in the city, the Bamboccianti – the followers of Pieter van Laer, nicknamed Il Bamboccio, or the 'crooked doll', because of a deformity that made him resemble a commedia-dell'arte figure – had begun turning out innocuously profane wall candy. In a gallery adjoining the Sweerts show, the Wadsworth Atheneum has helpfully installed a selection from its own collection of mid-seventeenth-century Roman paintings, including a number painted by the Bamboccianti. There is a schlock-horror self-portrait by van Laer of the artist as alchemist. A potion simmers in a skull; a paper on which a drawing of a heart has been rent by a knife lies to one side; and, at the

right of the frame, a wicked set of demonic talons reach for the throat of the alchemist, whose eyes start from their sockets, his mouth frozen in a terrorized O.

Van Laer more often produced picaresque scenes of the street life around the Piazza del Popolo and the Piazza di Spagna. His acolytes, such as Jan Miel, Andries Both and Johannes Lingelbach, extended their repertoire to street singers, carnivals, beggars and *baroni* – the vagabond petty criminals and roughnecks of the back alleys and the countryside. The Bamboccianti were said to have 'opened a window onto the world'. or 'pictured the unadorned truth' – another way of saying that they were concerned with picturesque observation of the lowest kind of subject matter.

Italian patrons and critics had not always seen Netherlandish art this way. In the fifteenth century, no painters were more admired and coveted in Italy than Jan van Eyck and Rogier van der Weyden. Their work, not least because of the brilliance of oil-based pigments, was thought to join miraculous naturalism with tender Christian devotion. The Medici bank in Bruges spread its buying net so widely that by the end of the century more than a third of the entire Medici collection consisted of Netherlandish paintings. Florentines like Botticelli were acutely conscious that their efforts would be measured against the supremacy of the northerners.

But by the middle of the sixteenth century the northerners were sneered at rather than envied. Michelangelo commented that Netherlandish painting was hardly more than an accumulation of details: 'bricks and mortar, the grass of the fields, the shadows of trees...and little figures here and there.' It seemed essentially artisanal: an extension of the brilliant colour trades at which the northerners were still unquestionably dazzling – textiles, tapestry, jewellery. History painting, by contrast, was imbued with poetry and classical philosophy.

Flemish and Dutch artists who crossed the Alps early in the seventeenth century – Rubens, Van Dyck and Rembrandt's teacher, Pieter Lastman – wanted to drink at the well of classicism so that they would qualify as history painters. Some of them, of course, became bewitched

by the electrifying carnality of Caravaggio. Others discovered that sending home landscapes glowing with the apricot light of the countryside would find a ready clientele. And then there were the Bamboccianti, who worked the stereotype of anecdotal low life for all it was worth.

Nothing like a true Bamboccio picture by Sweerts's hand survives. Whenever he turned to street scenes, the action slowed: the figures became weightier and more monumental. Sweerts may have lived with the clowns, but he had his sights set on the grandest patrons, like the Pamphilj, and he ran with the scholars. There must have come a time, though, when the choice between marble and plaster on the one hand and the common clay of humanity on the other was a choice he did not want to make. He may even have thought it a false dichotomy. In any case, he began to muddle the genres. Living flesh – wrestlers and bathers; the reclining Lazarus/river god – took on the quality of heroic statuary, while plaster casts began to come alive. Some of these role reversals are winningly perverse. Rampaging Mars, the unhinged destroyer of the arts, wears what has been thought to be the face of Sweerts, but the body and head on which he tramples – that of the Laocoön, the antique statue that epitomized physical torment – remains a mask of pain. In the ostensibly straightforward painting from the Rijksmuseum of an artist's studio, with apprentices sketching from both live models and plaster casts, the human figures are summarily blocked in, the kneeling nude model painted in almost caricatural two dimensions, as though it had stepped from a Greek vase or a Roman frieze. The plaster cast of a flayed man, by contrast, seems alarmingly alive, as though all that exposed musculature were about to flex. In the foreground, brilliantly lit casts of the faces of an old woman, of Juno, and of a grieving Niobid express intense passions amid a pile of shattered torsos and heads and a single, unidentifiable bone from an arm or a leg.

Sweerts knew exactly what he was doing. Others had invested the commonplace with the dignity of the classical: Caravaggio and Velázquez and, perhaps, the Le Nain brothers in France, although their images of simple artisans and peasants are coated with a kind of docile sweetness that Sweerts avoided. But at some point this exercise became more than

just a smart game for Sweerts and turned into a profession of faith. That point was reached when he painted *The Seven Acts of Mercy*, one per picture, all of which are reunited for the first time since they hung together in the grand Amsterdam canal house of the Deutz family.

The 'miraculous conversion' that the French missionary spoke of could have occurred had Sweerts read *The Contentment of Poverty (La Povertà Contenta)*, published in Rome in 1650 by the Jesuit Daniello Bartoli. It reiterated conventional pieties – for example, that, unlike the rich, who are constantly harrowed by their sinfulness and pride, the poor are content, because owning nothing they risk nothing, and because the temptations and transgressions of the wealthy are beyond them. Bartoli's tract appeared at the same time that Salvator Rosa, the Diogenes of papal Rome, was attacking paintings that showed works of charity, calling them cheap salves for the conscience of the rich.

Rosa undoubtedly had in mind those works-of-mercy pictures that complacently showed the rich and the righteous clothing the naked, feeding the famished, and performing other obligations listed in Chapter 25 of the Gospel According to St. Matthew. But Sweerts's vision is shockingly different. In *The Seven Acts of Mercy*, those who give and those who receive are socially indistinguishable. Authority is present, but stands heartlessly – pharisaically, one thinks – apart from the Christian drama (and typically is sketched in unfinished dead-colour monochrome). A physician delivers cold comfort to the stricken by pointing to Heaven as the only remaining source of salvation, while a child, his face distorted by tears, exposes his pain to the beholder. A stove-hatted lawyer, dehumanized by being seen from the back, gestures self-importantly at unfortunates squatting on a prison floor. True mercy is delivered by the poor to the poorer. In the prison scene – perhaps the most elementally pathetic of the series – a half-clothed, dramatically lit man of great beauty and sanctity, his own feet chained, ministers to an old man, also in shackles, wearing heavily patched breeches and a shabby coat. The succouring figure lowers his head to the old man and rests one hand on his shoulder. But the old man does not respond. He stares dead ahead, his jaw set.

He is either blind or indifferent. This moment of compassion blunted by hopelessness is unlike any other passage I know in Baroque painting.

In *Harbouring the Stranger,* a homely figure with a string around his coat directs a pilgrim toward the courtyard of an inn. It has been suggested that the pilgrim is the risen Christ, arriving at Emmaus. This may or may not be right, but it is certainly unimportant, compared with the startling insertion of a third figure or, rather, a third face (for the half-hidden body is strangely unreadable and appears to have no legs at all), lurking between the pilgrim and his kindly guide. That face belongs to the young Michael Sweerts. The principals of the grave little drama pay him no heed whatsoever. Sweerts's paintings are full of figures – clothed men among the naked, allegorical seamstresses amid urchins – who seem to have strayed onto the scene from another dimension. Here the painter himself is invisible to his creations because he is the phantom of our conscience. His business, as the direction of his gaze makes clear, is with us. Sweerts has already become a missionary.

REMBRANDT

Did He Do It?

IS REMBRANDT/NOT REMBRANDT (at the Metropolitan Museum) the first interactive Old Master exhibition? The Met, usually busy instructing visitors on what to see and how to admire, has paid the public the shocking compliment of asking it to exercise its own judgment. We supply the art and the information, you bring your common sense, is the spirit of the show – which is nothing short of heresy in matters generally reserved to the priesthood of experts ordained to determine what is, and what is not, a Rembrandt.

Unlike the coolly exquisite Raphael or the sumptuous, esoteric Rubens, Rembrandt has long been Everyman's Old Master: emotionally direct, universally accessible. It's this proprietorial relationship the public has with Rembrandt that has made a series of verdicts handed down by a remote and august body in Amsterdam so unsettling. It is decreed, for example, that long-cherished icons like the *Young Woman at an Open Half-Door*, in Chicago, and the Frick's *Polish Rider* are now to be considered the work of Rembrandt clones like Samuel van Hoogstraten and Willem

Drost. But with this exhibition's honest effort to present both the evidence on which such judgments are made and the process by which they are arrived at, the public has been promoted from a passive receiver of bad news to an active participant in the argument. What makes this show such an unmistakably American event is the cheerful faith that, given the material evidence and a crash course in close attentiveness, it should be possible to create a democracy of connoisseurs.

The insistence on unveiling these mysteries is all the more welcome because, from the outset, connoisseurship has presented itself as an arcane craft. Its forensic mode of operation was first established in the eighteen-seventies, by the Italian physician Giovanni Morelli. Morelli's corrections of Renaissance misattributions were illustrated with detailed anatomical drawings that made them resemble pathology manuals. For Morelli, innovations in criminology, such as fingerprinting, photographic archives, and handwriting analysis, were of the utmost relevance in the reconstruction of authorship. Nothing stirred him more than the illumination provided by clues – the inadvertent eloquence of apparently trivial detail. Precisely because it would be habitually rather than studiously rendered, the curve of an earlobe or the moon of a cuticle would, in his view, betray authenticity or fraud more decisively than the self-consciously crafted manner in which a painter executed a smile.

Not surprisingly, Morelli and the connoisseurs who followed his example have often been compared to Sherlock Holmes. Their tracking skills, like the great detective's, depended on a divining 'eye' – a gift of superior vision denied to the amateur. The etymology of 'connoisseur' (in Dutch the word is *kenner*) implies higher knowledge. In the late nineteenth and early twentieth century, Rembrandt-*kenners* like Abraham Bredius and Cornelis Hofstede de Groot found that not only was the laity in awe of this knowledge but dealers and museum curators were prepared to pay for its practical exercise.

The great nineteenth-century French critic Théophile Thoré was thinking of Rembrandt when he declared that 'to be a master means not to be similar to anybody'. Precisely because of this obsession with singularity, the certification of Rembrandts became the litmus test of modern

connoisseurship. Furthermore, in the early decades of this century, sup-plying 'real' Rembrandts satisfied a growing appetite in the museums of Europe and America. Earlier, the Romantics had adopted Rembrandt as their own true godfather: the scruffy bohemian who had poked the polite burgher in Amsterdam in the eye with his cosy paintings of the common people and who had been punished for his temerity. But by the turn of the century the mythology of the artist-rebel had itself become a bour-geois fashion – particularly if the rebel was safely dead. The same cura-tors who would never have had a van Gogh or a Manet cross their threshold rushed to acquire one of Rembrandt's glinting caverns of darkness or one of his canvases covered in clotted ropes of impasto.

So for about three-quarters of a century it rained Rembrandts. Wrinkled matriarchs, street-corner apostles, and doughy girls done up in silks and flowers appeared with amazing regularity in the salesrooms and galleries. In 1868, Carel Vosmaer, one of the first serious Rembrandt-counters, listed three hundred and forty-two works; by 1915, Hofstede de Groot, famed for his fastidiousness, had certified nine hundred and eighty-eight. By the thirties, a third of the bloated corpus had fallen away, but the former Met curator W. R. Valentiner, in his astonishing *Rembrandt Paintings in America* (1931), nevertheless managed to include virtually anything that looked brownish-goldish and dashing-oldish, especially if it came with thickly loaded brushwork or signs of a heavily applied palette knife.

By the three-hundredth anniversary of Rembrandt's death, in 1969, the mood had turned sharply deflationary. Archive documentation, which had been frustrated by a Master who had left only seven known letters, began to yield a wealth of fresh information on Rembrandt's patrons, his in-laws, his court cases, and his students. The isolated virtuoso now sprouted connections with the urban culture of the Dutch Republic, with the traditions he drew on, and with his pupils, to whom he liberally passed his techniques. The singular Rembrandt had turned plural.

Scholars had long known the identity of many of Rembrandt's most conspicuous students, including Gerard Dou, Govert Flinck, and Samuel van Hoogstraten. But as researchers turned up less familiar names –

Constantijn van Renesse, Jan Victors, and Willem Drost – the composition of an entire Rembrandt school became a major preoccupation of scholars. Paradoxically, the rapid growth of the look-alike industry was what provided the Rembrandt Research Project with its mission of sifting, once and for all, the wheat from the chaff. And while the Amsterdam-based project was established, in 1968, essentially as a committee of *kenners*, its experts were no longer willing to put their faith solely in the sharpness of their collective 'eye'. Instead, a new generation of techno-toys was marshalled to probe beneath the skin of the paintings and to deliver final, irrefutable verdicts. No self-respecting Rembrandt exhibition catalogue these days is complete without X-radiographs, infrared spectroscopy, autoradiographs, canvas-warp-and-woof counts, dendrochronological (tree-ring) analysis of panels, and microscopically differentiated strata of grounds, glazes, and pigments. But the techno-*kenners* had hardly donned their lab coats before it became apparent that scientific investigation was a lot stronger on promise than on delivery. For while dating wood or cloth samples could distinguish paintings made in Rembrandt's lifetime from later imitations, the vast bulk of questionable work originated from Rembrandt's own period – and, in more than one instance, from the Master's own studio. Technology, it seems, is good for exposing fakes but no good for winnowing out Rembrandt wannabes.

Rembrandt/Not Rembrandt is of two minds about the oracular powers of technology: the exhibition presents its scientific evidence in the form of photographs and other graphic displays, but also supplies ample reason not to put much faith in such evidence. This is not surprising, since the show is actually the product of two minds: it was organized by Hubert von Sonnenburg, the head of the Met's conservation department, and Walter Liedtke, the museum's curator of Northern European paintings. Given the obvious differences between their approaches – guess which one is more enamored of the power of science – the self-conscious gesture of publishing the exhibition catalogue in two separate volumes probably wasn't necessary. As it is, *Rembrandt/Not Rembrandt*, although admirable in many ways, suffers from creative schizophrenia. Even the

definition of connoisseurship offered in Liedtke's excellent catalogue essay differs tellingly from the wall caption that greets visitors at the start of the show. Liedtke defines connoisseurship traditionally, as 'the determination of which paintings are by Rembrandt and which are not', and, indeed, the promise of mysteries solved is the promotional lure the show offers. But in the introductory text on the museum wall a postmodernist Fifth Column (until now incredibly well hidden at the Met) has defined connoisseurship as 'an ongoing process, a form of criticism and self-criticism' – a formulation that would have had an old *kenner* like Bredius reaching for his smelling salts.

I once had a student who, after a lecture, complained, 'You know, Professor Schama, my parents aren't paying all this money for me to become more confused.' Since what may strike specialists as refreshing candour risks leaving the public anxious, graduates of 'Rembrandt/Not Rembrandt' can be forgiven for feeling the same way. In addition to accustoming themselves to twin captions in disputed cases (so that spotting the initials W. L. or H. v. S. becomes as important as looking for *Rembandt fecit*), visitors have to negotiate their way through a bewildering and inconsistently applied set of terms that are used to classify the Not Rembrandts. One encounters 'Follower of', 'Imitator of', 'Copy after', 'Style of', and 'School of', among others.

There are other ways, too, in which the posture of transparency actually serves to make matters more, rather than less, obscure. The interests of total disclosure seem to have required von Sonnenburg, in his essay, to catalogue technical details more exhaustively than any layman could possibly want him to. It's good to know, I suppose, that to fill 'cradle voids' (don't ask) he is using 'Elvacite 2046' rather than, say, Tru-Value superglue, but it doesn't do much to edify the perplexed. Moreover, the efficacy of using X-rays to distinguish between Rembrandt and his imitators seems to depend on prior, subjective assumptions about exactly which kind of brushwork exemplified the true techniques of the Master. It's disconcerting to be told by von Sonnenburg to look for 'nervous, feathery, interwoven strokes as the sign of the real thing in portraits of the sixteen-thirties, or to have a dab-and-inspect buildup of impasto

rejected as prohibitively Rembrandtesque, a little later. On the other hand, the innocent display of seventeenth-century artists' materials including the lampblack and chimney soot that Rembrandt used in his undersketches, and the ground glass he added to pigment to lend it greater luminosity, brings a magical touch of immediacy to a show that sometimes threatens to turn into a seminar.

It's not all hard work. The modern scale of the Metropolitan's exhibition, drawn entirely from its own collection, allows for thoughtful and unforced comparisons. (There are fifty-five paintings including twenty or so certified Rembrandts, and sixty-two drawings and prints.) This is far less taxing than the 1991–92 travelling show 'Rembrandt: The Master and His Workshop', which was conceived principally as a showcase for the findings of the Rembrandt Research Project. Where that earlier show segregated the officially accepted Rembrandts from paintings said to have been produced in a 'workshop' (a business enterprise whose existence, Walter Liedtke argues, is unsupported by any persuasive historical evidence), the Met presents indisputable, documented masterpieces like the *Herman Doomer* and *Aristotle with a Bust of Homer* interspersed with works of uneven quality suggesting more than one hand; with works tentatively (or not so tentatively) reassigned; and with paintings by artists who simply came under Rembrandt's influence. Some of the offerings in this last category, including the ingratiating genre pieces of Nicolaes Maes and the prosaically bright paintings of Jan Victors, display characteristics fundamentally irreconcilable with Rembrandt's hallmark work. As for Drost, a little display of his dreamily tenebrous Italianate portraits, all smoke and velvet, doesn't do much to promote his candidacy for the Best Not Rembrandt award – especially when his *Sybil* invidiously shares exhibition space with the stupendously beautiful late Rembrandt *Woman with a Pink*.

Names and IDs of alternative artists are not really essential in order to recognize that some paintings done in a Rembrandtesque manner are merely laborious exercises in emulation. Comparing the respective sleeves of the *Aristotle* and the so-called *Auctioneer* reveals one hand miraculously confident of conveying illuminated texture through the

freest but most precisely delivered brushwork and another that has to settle for a perspiring approximation, an optimistically loose *impression*. But solid-gold masterpieces can themselves be misleading indices of Rembrandtness. Like most great painters, Rembrandt was perfectly capable, at virtually all stages of his career, of producing work of distinctly sub-masterpiece calibre. He was also given to restless reinventions of his own chosen idiom, sometimes within the same year, or even within the same commission, if, for example, it was a pendant pair of marriage portraits. The twisted angle of the pose in *Woman with a Fan*, the brilliant shaft of light slanting across her right wrist, and the whisper of a smile held in her right eye's catchlight make clear the identity of the painter. The much less inventive treatment of the female half of the so-called Berestyn portraits, executed at about the same time, doesn't necessarily announce the work of someone else, however. For although the Berestyn woman's head seems to have been awkwardly hoisted onto its millstone collar, the impression of discontinuity with the body may be as much an effect of the archaic costume as of some perceived fault of composition. No one argues with the brilliant rendering of her husband's eyes and collar, or, for that matter, with the gold brocade or the shadow cast by the wife's powder-puff hair, which announce Rembrandt at his silky best. Occasionally, it can seem as though multiple Rembrandts were occupying a single canvas, as in the *Herman Doomer* portrait, where the bold manipulator of impasto in the virtuoso rendering of the collar exists alongside the miniaturist of the eyelid.

In the end, the virtue of this interesting and courageous exhibition may not lie in its pretense of enlisting the public in a curatorial version of 'You, the Jury' or in its offering the opportunity to mull over the vicissitudes of connoisseurship (though a spacious mulling room adorned with photographs of generations of *kenners* has been thoughtfully provided). While it's pleasant to browse among the works of Backer and van den Eeckhout and Maes, some of them very nice, it would be a pity if it took time away from noticing, say, the perfect bead of light glancing off Aristotle's ring – a detail added by Rembrandt to direct our attention to his subject's thoughtful fondling of the heavy chain of honour; or the

animating highlight at the base of Doomer's cornea, where it meets the edge of the lower eyelid; or the rhyming arabesque gathers of the turban and the filament-shot scarf of the *Noble Slav;* or the savage sabre-slash of flesh pink applied at the side of the syphilitic snout of Gerard de Lairesse; or the single pearl drop depending from a headband that soaks up the light on the broad-boned forehead of the *Woman with a Pink*, above the great pile of crimson fabric cascading down into darkness. Whatever the lessons of this show, it doesn't take a connoisseur to know that these miracles are not Not Rembrandt.

HENDRICK GOLTZIUS

WHAT IS A VIRTUOSO? The answer is provided by a disfigured hand, one of the many spellbinding images that appear in the sleeper show of the summer, the Hendrick Goltzius exhibition at the Met. Who was Goltzius? He was, it's been said, this hand: tendons fused, index finger permanently bent, nail bed of the middle finger caved in – a decided handicap, you would suppose, for an artist whose forte was drawing. When Hendrick was around a year old, his friend and biographer Karel van Mander tells us, he fell face forward into a fire, and clutched at the hot coals. The result was the clawlike right hand, incapable of fully unclenching its fingers, but the result was also this pen-and-ink drawing, which, in its exacting precision, demonstrates the fine motor skills the deformity might have precluded. Beneath the drawing is an autographic inscription: 'HGoltzius fecit.' And indeed he did.

The Goltzius exhibition, and an equally surprising show, at the Frick, of the bronze sculptures of a forgotten Dutch master, Willem van Tetrode, capture a moment in the history of Western art – after

Michelangelo and Dürer but before Rubens and Caravaggio – which has all too often been written off as a hiatus between the classical monumentalism of the High Renaissance and the feverish theatricality of the Baroque. That anachronism is belied by these two exhibitions, charged with whipsaw violence and erotic play.

At the Frick, the normally demure garden court has been invaded by a small army of Tetrode's gesticulating titans, arms thrown out, heads wrenched back, the backs of horses arched and bucking. Multiple Herculeses go about their business, poised to pulverize the giants and centaurs. When not about to deliver the coup de grace, our hero (modelled on classical statues discovered in Renaissance Rome) rests moodily on a club approximately the size of Mt. Olympus, one hand behind his back toying testily with his golden apples; or he gets into slugging position, brows knitted, expression homicidally cross. In the well of the court, a flayed man exposing his improbably perfect musculature falls backward (and who could blame him), his now empty right hand held aloft, the better to display the drapery of his own skin. In a manner typical of Tetrode's restive reinventions, Christ, flagellated against a column, is anything but resigned to his martyrdom, writhing in an agony of thwarted escape.

None of these bronzes are more than twenty-five inches high – compact masterpieces made for Italian patrons who wanted their own editions of classical statuary. It was the genius of Tetrode to appreciate that, far from depleting energy, the compression of his bronzes magnified it. At a time when cultural elephantiasis seems to be the norm in contemporary art, with ever vaster installations demanding ever more acreage of exhibition – and getting it – it's good to be reminded that high aesthetic voltage can be generated from miniature power packs.

Taking a conventional genre and transforming it into something unexpected was, ultimately, what Hendrick Goltzius also aimed for. Paradoxically, the artist's reputation may have suffered from van Mander's overeagerness to make him the epitome of everything noble about Netherlandish art: the perfect union of northern naturalism and Italianate classicism; the thinker as well as the craftsman. Much of this

eulogy was true, but the central place in the Dutch pantheon allotted to Goltzius, analogous to Michelangelo's in Vasari's *Lives*, may have obscured the Netherlander's power to shock.

Even the rather workmanlike engravings that begin the show mislead, for they glide smoothly over the surface of a rocky early history. Goltzius was born in 1558, in the middle of a war zone, as Spanish armies arrived to crush the rebel Flemish and Dutch. His struggling artist father and his frail mother were living just on the German side of the south-eastern frontier of the Netherlands. Hendrick's first teacher, the engraver, poet, and philosopher Dirck Volckertsz Coornhert, was a relic of an older, learned, relatively tolerant Catholicism about to be smashed between the grindstones of Calvinist iconoclasm and Counter-Reformation image veneration. In search of asylum, Coornhert and Goltzius moved north to Haarlem, a city ravaged by a Spanish siege and occupation. No wonder, then, that when Goltzius came to engrave a *Massacre of the Innocents*, in 1585–86, as the war was going badly, he produced a coiled knot of terrorized figures – distraught mothers, old men pathetically trying to take stabbing blows aimed at infants – with a heroically modelled nude captain calmly surveying the butchery from the foreground.

To make the heroic demonic was unusual, if not unprecedented, but Goltzius had already shown evidence of creative mischief-making. Engraving variations on a workaday series of prints by Maerten van Heemskerck devoted to the *Rewards of Labour, Industry, Practice and Art*, he undercut the homily by making the personifications nude and having them flirt their way through the sequence. Labour and Industry, caught in a sensual embrace, seem to be more committed to producing the fruit of their union than the allegory strictly required. Haarlem, with its memories of summary executions by the Spanish, generated a demand for patriotic prints – images of local worthies and national heroes like the Prince of Orange. But in Goltzius's hands *The Standard Bearer*, ostensibly a depiction of an ensign in the Dutch army, becomes an extravagant spectacle, the lissome young officer tripping along on the balls of his feet

like a dancer while the immense flag billows through the picture space and out into our own, enfolding us in its jubilation. At the same time, he was producing some of the most exquisite portrait drawings in northern-European art since Dürer and Holbein. A metalpoint drawing of a young boy, perhaps his stepson and student Jacob Matham, unfinished yet miraculously rich with detail, is a perfect marriage of a meticulous and a free hand. The velvety cropped hair and the delicate shadows beneath the eyes are caught with the finesse of a miniaturist, while the lad's forthright gesture with his left arm, rendered much more sketchily, is the exact match for his adolescent bravura.

Prints like *The Standard Bearer* advertised that Goltzius, still in his twenties, was a master of what came to be called Mannerism, that most peculiar of aesthetic fashions, born of an indifference to both classicism and naturalism. Its practitioners made paintings that were self-consciously visionary, histories crowded with loops of ethereally elongated figures, whose tiny heads, aloft giraffe necks, sprout from sinuously elastic torsos clad in strangely shredded garments that resemble a second flaking skin. The bodies turn, twist, bob and drift along a serpentine line, disrupting the expectations of the beholder and keeping the travelling gaze in thrall. All the prescriptions of classical art, sternly laid down by Renaissance writers since Alberti, were exuberantly junked: fixed-point perspective, hard-line contour, the integrity of narrative coherence within a contained picture space. Art now belonged to the mind, and the mind belonged to the metaphysical Signor Plato.

Not, all things considered, the sort of thing to be expected from the stolid, earthbound Netherlanders, except that they took to it like ducks to a Dutch canal. The effect of Goltzius's prints of the late fifteen-eighties, the works that established his international reputation, was calculatedly sensational. His *Great Hercules*, the barely credible hulk of the show, is like no Hercules before it: a superannuated hero, grizzled from his Labours, his club warty with overuse, his stocky body so overstuffed with muscles that they threaten to pop from his skin. The figure provokes both awe and mirth, which just about defines the comic-book hero whose paternity starts here. Likewise, the *Disgracers*, wanna-be heroes

whose insolence is punished by precipitous descent, are both terrifying and ridiculous in their tumble through space, all foreshortened limbs, jaws and noses.

Though he was sought after by princely collectors, Goltzius was not content to rest on his laurels. At thirty-two, he made the predictable pilgrimage to Rome. Van Mander says that he went, in part, to be cured of a mysterious wasting disease that triggered fits of bloody vomiting. But at least as important was Goltzius's desire to take instruction from the classics. Travelling incognito, he sketched with students at the feet of the *Dioscuri* on the Quirinal Hill, and produced a lovely drawing of Michelangelo's *Moses*. Returning home a year later, Goltzius, without renouncing the drama that had infused his best work, abandoned the posturing perversity of Mannerism for the more serene harmonies of religious prints that, in their human completeness (beggars and Africans) and the painstaking construction of their space, look back to Dürer and Raphael. At their best – an all too perfectly detailed *Circumcision* – the prints are marvels of evangelical tenderness. But Goltzius is plainly also struggling to find a graphic language that is, paradoxically, painterly. And it is just when he comes closest to 'painting' with his burin, the candlelight reflected in the faces of the *Adoring Shepherds*, that he abruptly leaves off the work, as if defeated by the futility of the translation.

So in 1600 he throws away his burin and takes up history painting, never to make engravings again. These paintings, grandiose and brilliantly colourful, have sometimes been seen as an anticlimax. But the stylish group in the Met's show – a lubricious, avaricious *Danaë; a Fall of Man* engineered by the weirdest serpent in European art, her Barbie-doll face a snickering study in toxic cuteness; an apple-cheeked, pippin-breasted Pomona seduced by the gardener Vertumnus, disguised as a hag – all demolish the assumption that Goltzius as a painter was half the artist he had been as printmaker. Hailed as the Proteus of Netherlandish art, the man who could do anything in any medium, Goltzius finally delivers a characteristically droll rebuttal to those who assumed that draughtsmen and painters belonged in different creative worlds.

Two paintings, both around the erotic theme taken from the Roman dramatist Terence, *Without Bacchus and Ceres* (wine and food) *Venus Will Grow Cold*, are 'pen works': monochrome compositions carefully drawn on tinted canvas that pretend to be giant prints in much the same game-playing style as Chuck Close's painted faux photographs. In the bigger version, from the Hermitage, Goltzius himself appears in the background, ever the manipulating magus, standing beside the fire of Cupid's altar and holding in both hands pairs of engravers' burins. The right hand, the famous Goltzius talon, is held in the fire itself, but the master smiles directly at us, unconcerned, knowing that, this time, it's the love of art which is heating up.

JOHANNES VERMEER

Through a Glass Brightly

NEVER CONFUSE LIFE WITH ART, especially in Holland, where the temptation is strong. Visitors to the National Gallery's heart-stopping Vermeer show might suppose themselves transported to a bourgeois elysium: a brick-walled paradise of quotidian blessings, mantled in moist sunlight where gracefully costumed burghers perform delicate flirtation rituals beside heavy furniture and where the coarsest sound is the scratching of a goose quill: *luxe: calme, et volupté.* But Johannes Vermeer did not spend his days in a cube of light. For much of his life he occupied the back rooms of an inn on the market square of Delft, together with his wife, Catharina Bolnes, her mother Maria Thins and (at least) eleven children, struggling to complete his annual quota of two paintings that would keep his many creditors at bay a little longer. When the art enthusiast Balthasar de Monconys visited Vermeer in 1563, hoping to see some of his work, he was sent to the local baker, to whom the artist had consigned work in exchange for bread. Having seen the picture, Monconys's only comment was that in his view the painting had been overpriced.

And though Vermeer succeeded in banishing those eleven children, every one of them, from his painting, it's unlikely that their presence in his house made for an atmosphere of unruffled tranquility. The inventory of his possessions drawn up at his death in 1675 mentions chairs, cots and beds scattered randomly through the house—a picture by Jan Steen, not Johannes Vermeer.

If the atmosphere of gentle conviviality that drapes Vermeer's genre paintings was drawn from life, it was just as well, since the archives also speak of impoliteness. Vermeer's father, Reynier, originally a silk worker, had been arrested for knifing a soldier in a tavern brawl, but he went on to make enough money from art dealing to be able to buy the scene of the crime, the inn called 'Mechelen'. But Vermeer's in-laws, despite a substantial fortune made in brickworks and real estate, had their own share of aggravation. His mother-in-law, Maria, had suffered repeated violent assaults from her brutally abusive husband that led in the end to formal legal separation, an especially shocking trauma for a pious Catholic. And after Vermeer himself had converted to Catholicism and married Maria's daughter Catharina, their household was plagued by unwanted visits from her equally crazed and vicious brother Willem, whose idea of fun was to pull a knife on his pregnant sister.

None of this is to say we should now imagine Vermeer as a destitute bohemian. His wife's fortune and his own small art dealing business ensured that he could afford his studious pace of production, painting on commission rather than building an inventory for the market. And he was sufficiently well thought of, at least locally, to be elected headman of the artist's guild of St. Luke four times. Still, as Michael Montias, on whose pioneering archival research our historical understanding of Vermeer is based, points out, he owed this office less to any recognition of his pre-eminence than the dearth of alternative candidates. By the mid-sixteen-sixties, when Vermeer was at the height of his powers, most painters with ambition and talent – Gerard Houckgeest, Pieter de Hooch, Christiaen van Couwenbergh and Emmanuel de Witte – had either already left town or would soon depart. Only Vermeer's old mentor, Leonaert Bramer, hung on, surviving his protégé by three years.

Compared with the courtly elegance of the Hague, the roaring dynamism of Amsterdam or the precocious maritime hustle of Rotterdam, Delft was a half-ruined, snoozy backwater, forever trading on its associations with William the Silent, who had been shot at the Prinsenhof and buried in the Nieuwe Kerk. In 1654 the powder magazine of the arsenal of the States of Holland exploded, devastating much of the centre and northeast of the town (which is one reason why Vermeer's *View of Delft* is painted from the south), killing, among scores of citizens, the painter generally recognized as Delft's best claim to genius, Carel Fabritius. Only partially recovered from the calamity, Delft was turning into a one-business town (pots, of course) with small-time remnants of its old industries, brewing and tapestry; a place with no theatre, little music, a stuffy Calvinist patriciate that still obliged Catholics such as Vermeer and his family to worship in hidden chapels shoe-horned into the cramped 'Papists' Corner'.

But we don't go to Vermeer for illustrated social history. And though, thanks to Montias, we know a great deal more about his milieu, the personality of the artist remains in deep shadow. Much of the documentation concerns debts, marriage contracts and notarized acts of witness; and in his essay for the exhibition catalogue Ben Broos must perform miracles of syllogism to make decisive connections between Vermeer and important cultural contemporaries such as Constantijn Huygens (involving, for example, a virginal-maker they may have had in common). A single fascinating document survives in which the artist ventures an expert judgement in a dispute between the dealer Gerrit van Uylenburgh and his customer the Elector of Brunswick as to the quality of a consignment of paintings. Vermeer wrote them off as rubbish, doubtless helping to sink Uylenburgh's already foundering fortunes.

For the most part, though, Vermeer is unavailable for comment; missing from the scene, not least in his own paintings. Countless other Dutch masters – including some whom Vermeer knew, such as Gerard ter Borch, Carel Fabritius, not to mention Fabritius's teacher, Rembrandt, Gerard Dou, Jan Steen and the 'fine painter' Frans van Mieris the Elder, who got himself up in garishly loud gold satin to eyeball

the impressed viewer – were eager to offer self-portraits, often in the act of painting. Vermeer, by contrast, was almost perversely self-effacing.

In two of the most sophisticated statements about their practice, Rembrandt (in his deceptively unpretentious little panel of 1629 in the Boston Museum of Fine Acts) and Velázquez (in *Las Meninas*) are both at pains to display the mediating countenance of the creative artist while turning the back of the work to the beholder. In the great *Art of Painting* (sadly missing from this show, though with so many masterpieces complaints seem churlish), Vermeer reverses these visual priorities. His subject – the Fame of Netherlandish painting, allegorically personified in the figure of Clio with a trumpet and book and reinforced by Nicholas Visscher's map of the seventeen provinces of the old united Netherlands – is unequivocally proclaimed, while the painter himself gives us only his back. In one of the show's most elaborate stunners, *The Music Lesson* from Buckingham Palace, Vermeer gives the coyest possible indication of his controlling presence in the scene by a mirror reflection of the legs of his easel. Tucked into the tiny patch of canvas behind the much more prominent reflection of the head of the keyboard player, the gesture is eloquently furtive.

This obstinate refusal of self-presentation, so rare in Dutch painting, is one of Vermeer's greatest gifts to his devotees, for it forces us back to the act of painting itself. It also inconveniently sets obstacles in the way of almost any and every approach conventionally offered by art history. It's hard to think of another master whose poetic self-containment makes virtually any commentary prosaically superfluous. Context? Who needs it. Formal analysis? Oh, the orthogonals go that away. I see. Iconography? The snake means Heresy? You don't say! X-radiography? The blue skirt was originally a tad bigger at the back. Wow.

Not that Vermeer's calculated obliqueness has deterred a long line of interpreters from offering their respective versions of his uniqueness, often presented as a decoding of visual crypt, whether in mechanical-optical mode (arcane disquisitions on the camera obscura) or the transcendentally enigmatic mode (arcane disquisitions on the Jesuits). Perhaps it's symptomatic that much of the most persuasive writing on

Vermeer has been done either by painters relatively unencumbered by the obligations of interpretations, such as Lawrence Gowing, or by technical analysts such as Arthur Wheelock Jr, one of the two curators of this exhibition, whose *Vermeer and the Art of Painting* is incomparably the best account of the artist's working practices, in particular the elaborate layering of pigments and glazes that gives Vermeer's 'colour drawing' its distinctive lustre and freshness.

Anyone sharing my own allergy to flat-footed prose-renderings of Vermeer will be grateful for the simplicity and the economy of the National Gallery's installation. Wall-caption overkill designed to turn the beholder with curatorial erudition is mercifully absent here, though anyone wanting complete information on Vermeer's career and reputation, as well as thoughtfully presented technical and scientific information, will find it all in a separate room halfway through the show. Given all the things that could go wrong, the design and the lighting of the galleries by Mark Leithauser and Galliard Ravenel is a model of restraint, the only jarring note being the noisily worked late-seventeenth-century frame in which the Louvre has imprisoned *The Lacemaker*, so that one has to fight one's way through the floral marquetry to get inside Vermeer's tightly organized little space. But given the curatorial wonders wrought by Frederik Duparc, the Director of the Mauritshuis, and Arthur Wheelock Jr. in coaxing fragile, precious masterpieces out of understandably apprehensive lending institutions, it's probably too much to ask them to rip it from its frame.

Everything else is perfection, fitting enough for a painter for whom nothing less would do. We are so accustomed to seeing Vermeer's little jewels emitting their pulses of intense light from a corner of a museum gallery crowded with works deemed related – De Hooch, Metsu, Netscher, ter Borch – that the experience of encountering nothing but Vermeers induces a kind of kinetic power surge in our optical equipment. And it reinforces the impression that, while any number of Dutch masters excelled in creating painterly light on the canvas, only Rembrandt and Vermeer managed to reproduce the precise sensation of drenching illumination. But Rembrandt offers illuminated action, while Vermeer's

illumination is the action. Delft's one remaining distinctive cultural speciality was optical and Vermeer's light is the closest thing we have to a transcription of seventeenth-century optical theory that imagined light not as a passive property but an active force travelling to rays from luminous surfaces toward the organizing intelligence of the eye.

What is it, though, that traps us all in a state of dumb rapture before the greatest of Vermeer's works? The bath of light, now lustrously blue, now intensely gold, that washes over his figures? Yes and no. Although the freshness and the truth of that light ought to make everything within Vermeer's pictures exquisitely lucid, the cunning of his art is that it does not. The brilliant scintilla glittering from the edge of the great black boat moored on the river Schie below the walls of Delft ought to correspond to the diffused highlights said to be seen in a camera obscura image of the scene. Naturalistically, though, the boat is in shadow precluding those granular highlights, and Vermeer, whose own intelligence never condescends to the beholder, means us to notice this, just as he means us to notice that the ultramarine woman reading her letter in the pouring light, like a witch, casts no shadow at all. As the gallery guard with whom I stood in front of *The Music Lesson* observed, the mirror on the wall above the virginals casts an unfaithful reflection of its player's head, displaying more of her features than should be possible given its angle of inclination, straight down toward the keyboard.

It's a commonplace now to insist that Vermeer was a self-conscious magician, a lightshow specialist, who, however knowledgeable and respectful of the laws of optics, was perfectly prepared to bend its rays for his aesthetic and psychological manipulations. This paradoxical achievement was to make some of his most luminous light-effects melt the linear edges of the material world into an atmospheric vision entirely of his own creation. In this sense, what casually appears to us as a super real brightness serves to veil, rather than to expose, the empirical measure of people and things. All those maps are not the key to Vermeer's conception of visualizing the material world; they are the flat, diagrammatic challenge to his powers of invention. So we look at a string of pearls, a

ceramic water-pitcher, a bead of moisture lingering on the inside of a
rosy lip, and we see these things through a glass brightly, but they are all
no less unattainable for their apparent clarity. Vermeer teases us, some-
times mercilessly, with the unbridgeable distance between vision and
possession; with the fugitive, disobedient quality of visual memory;
things caught in a burst of dazzling illumination and then lost again to
the heedless impatience of time. That's why he caught Proust's eye and
why he cuts us to the quick.

Vermeer's pronounced aversion to crisp linearity was there, virtually
from the beginning. His beautiful *Diana and Her Companions*, from around
1655, already violated most of the conventions expected of aspiring
history painters. Stylistically and thematically, the painting is willfully
indeterminate in a genre where precise contouring and intelligible clas-
sical allusion and narrative were conditions of success. Vermeer's peachy
maiden, robed in Correggio gold, the sleeves of her chemise rolled up, is
only formulaically identifiable as Diana by the halfmoon tiara. But the
composition is imprecisely located; no peeping Actaeon; no presumptu-
ously pregnant Callisto. Instead Vermeer seems to have imported the
detail of a servant washing Diana's feet directly from Rembrandt's
Bathsheba of 1654, smoothly and expediently transferring the theme of
illicit voyeurism from one story to another.

Jacob van Loo's equally imprecise scene of Diana and attendant
nymphs is usually cited as a precedent, but Vermeer's mood-music has
absolutely nothing in common with van Loo's hard, pert creature staring
directly at us. Van Loo lights his coquette (perhaps a 'historiated portrait'
of a sitter) to flatter her face and the conventionally exposed huntress-
breast. Vermeer characteristically has light fall over her neck, shoulder
and creamy half-moon breasts, while leaving her face illegibly shrouded
in shadow. Allegorical details, such as the dog and thistle (faithfulness
and sorrow), are treated even more sketchily, while the golden water
basin is presented at an impossible angle to allow Vermeer a passage of
bravura still-life illusionism. As a showcase for a young classicist the
painting is wonderfully wrong, invoking Titian's manner at its smokiest,
gathering its graces, one of them African, about a pinwheel of delicate

movement that suggests the wistful Italianate love ballads popular in Amsterdam (but not in Delft), the truisms of proper history painting surrendering to lyric refrain.

A few years later Vermeer seems to have given up on history painting altogether, but with *The Little Street* (6) he was not exactly doing a routine townscape either. It's that diminutive *straatje*, the relatively modest format and what was, for the most part, an accurate rendering of the houses along the Voldersgracht that Vermeer would have seen from his window, that has led to this tour de force being treated as an unassuming prelude to the more rhetorically spectacular *View of Delft*. Certainly the ostensible subject is the kind of thing done more simply and repeatedly by Pieter de Hooch and the mysterious Jacobus Vrel. In the guise of a slice of street-life, however, Vermeer has launched into an experiment in spatial ordering that is proto-abstract in its daring.

His starting point is the longitudinal division of the picture space at a little less than a third of its depth. The line marked by the façade of the house with its architecturally eccentric central arched mullion window and irregularly whitewashed walls continuing to the blue-shuttered house abruptly cropped at the left constitutes, in effect, a second picture plane, parallel to the original. And it is this second plane, screening off deep space, which Vermeer then pierces with recessions and apertures of irregular depth, or to which he attaches shallow projections like the benches, or, most sweetly, the broad, yellow-skirted rear end of a girl playing knuckle bones on the checkered street. The astonishing, contrapuntal rhythm of all these openings and shuttings, enriched with precisely calibrated colour alternations on the shutters, are what give the picture (as distinct from the scene) its chattering energy.

For what this painting is *not* is 'quiet'. It hopscotches its way back and forth along the aggressively marked line of perspective, the busy movement kept in order by the strong, solid diagonals of the gabled roofline at the left. Working in visually neat rhyming couplets, the painting pairs windows, doors, children, the two maids standing and sitting: the latter's face somehow conveying concentration on needlework despite being scarcely more than a casual dab of pink paint. But the most elaborately

paradoxical of these twinned images matches the black arched door at left centre with the next door view through to a servant at a water barrel. For the ostensibly shut black arch is carefully painted to imply an opening, while the view into the little passage seems oddly flat, discontinuous with the foreground and even opaquely mirrored. In other words, this seems a lot more like Mondrian's territory than Pieter de Hooch's. Like the explicitly abstract master, Vermeer was aiming for timelessness – all the more urgent since this entire row of houses was scheduled for demolition and did indeed fall to the wreckers after the explosion in 1654.

Likewise the *View of Delft* that won the awestruck admiration of such nineteenth-century critics as Théophile Thoré for its presentation of a civic world apparently impervious to upheaval, swaddled in serenity, is better understood as a response to the reverberations of Delft's famous calamity: the dull blast, the shattering of glass and splintering of timber repaired more effectively on this canvas than in the rubble-strewn streets. Vermeer's answer to smoke and ruin (painted in a documentary spirit by Egbert van der Poel and Daniel Vosmaer) was a resurrection piece, an act of faith that sprang naturally from his Catholic piety. The time is morning; the moment of another day's redemption. Sunlight streams from the east to part clouds formed like the wings of a dark angel, or rhetorically drawn back (as in other Vermeer paintings) like a heavy curtain, to reveal the inner sanctum of the town, the spire of the Nieuwe Kerk, the resting place of the martyred William, concentrating the most intense radiance. Dirck van Bleyswijck's eulogy to the city that included a poem by Arnout Bon lamenting the death of Fabritius but praising Vermeer as his true successor was published a few years after this painting; but the image of the Phoenix arisen, like other holy miracles, from the pyre, was already a commonplace.

Deceptively uncluttered, Vermeer's painting is in fact dense with allusion and quotation, not least to the epitome of topographical paintings of stoutly walled and simply rendered Dutch cities, Esaias van de Velde's wonderful *View of Zierikzee*, done in 1617, from which Vermeer surely took the *repoussoir* of the sandy riverbank. But there were also examples closer to home – Hendrik Vroom's early view of a simpler

Delft, the site of princely martyrdom and many more sophisticated versions of citadels of liberty seen across bodies of projecting water like the Valkhof at Nijmegen painted many times by Jan van Goyen and Aelbert Cuyp. Vermeer's aim must have been to invoke and to surpass all these precedents by a virtuoso display of every imaginable painterly skill.

The texture of the red-tiled roofs at left, for example, was made more dense by mixing sand into the pigment, almost as if Vermeer was as much rebuilder as image-maker. The same perspectival drive at work in *The Little Street* is deployed here to more theatrical effect, pulling the sightline through the apertures of the Schiedam and Rotterdam gates, over the bridge into the sunlit heart of the inner town, its detail shielded by the protecting walls. And although it seems likely that Vermeer did set up a camera obscura in a house across the Schie, his selective transfer of its image does not suggest, as Daniel Arasse has argued in *Vermeer: Faith in Painting* (Princeton University Press), the most compelling of recent Vermeer studies, an artist slavishly obedient to device. Just the reverse, in fact. While the lens-focused image projected onto a wall of a darkened room from a small hole was greeted by painters such as Samuel van Hoogstraten as the objective transference of natural truth, Vermeer's willfully inappropriate rendering of its highlights suggests an unrepentant retort to all those who believed the magic image would make the painter's craft redundant.

Producing an illusion of the shining surfaces of things, after all, was barely half of Vermeer's work. Invariably, his most astonishing paintings report the negotiation between visible and invisible worlds: between the immediacy of sensations and their contemplative, interior echo. It is in this sense that our understanding of the word 'reflection' as simultaneously an effect of light and an effect of thought seems an apt characterization for Vermeer's deepest preoccupations. Oddly enough, the one genuinely gifted painter who arrived in Delft after most others had left, the still-life artist Abraham van Beyeren, was himself interested in reflection-play, and on occasions would offer fugitive images of himself, or the cross-pattern of a window frame reflected in a wine glass or silver bowl.

The conventional pieties of *vanitas* symbolism were too hackneyed to

be of much interest to Vermeer. Even his Jesuitically theatrical *Allegory of Faith* is saved from being a mere inventory of devotional emblems by the typically oblique gesture of replacing the standard reflection of a cross in the crystal orb with an impression of the interior working space of his own studio, lit as always from the left: icons of painting and religion neatly dissolved into each other. For the works which most directly engage with Vermeer's great issue of the mystical marriage of the material and spiritual – the Berlin *Woman with a Pearl Necklace* and the National Gallery's own *A Woman Holding a Balance* – Vermeer employs purely painterly indicators of the fluctuating relationship between seen and unseen matters. In the Berlin painting, Vermeer painted out a map that he had originally meant to place between the profile of a girl, dressed in ermine-trimmed, primrose-dyed satin, toying with her pearls like a rosary, and the twinned glasses of mirror and window, and instead allowed a broad expanse of whitewashed wall to hold the balance between vanity and innocence. That airy emptiness, bloated with golden light, is proclaimed to be the core of the painting through the dramatic contrast with its chromatic opposite: the heaped mass of black cloth threatening to overrun the entire lower half of the painting were it not for a little aperture of light opened at the base that reassuringly silhouettes a table leg.

That dark zone functions as a formidable barrier between the beholder and the ostensible subject of the painting, and many of the most powerful works in the show cast their spell by appearing to proffer something irresistible (a jewel, a tune, a face, the heart of a city) only to put it out of reach, insisting on confinement within the realm of painting. *The Music Lesson* virtually barricades its protagonists behind a succession of impediments – the great baroque sweep of the Turkish table rug, made to appear even more grandiose by Vermeer's eccentrically low point of view: the chair with its studs picked out with pimples of brilliant reflection; the bass viol and the gleaming ceramic water jug – all interposing themselves between us and the figures, connected along their musical axis. It's as though we have to cup our hand to our ear to hear the *Musica laetitia comes medicina dolorum*, the 'companion of love and

balm for pain' inscribed on the instrument's lid. But the orchestration of patterned rectangles playing through the composition in time with the virginals establishes, in addition to the two spaces of foreground and background figures, the additional notational space of the painter's invention, revealed in the mirror, and thus, in actual terms, *in front* of the scene we are witnessing.

In the most tantalizing of all his works, the one still called *Girl with a Pearl Earring* even though cleaning has revealed an underside reflection of a tear-shaped ornament too massive and silvery to have been grown in any known oyster, Vermeer mobilizes all his skills to probe the relationship between innocence and desire. Be advised that the result bears no relationship to any impression gleaned from printed reproductions, however seductive, and is likely to make strong persons buckle at the knees and reach for a glass of water.

Bought for the princely sum of two guilders in the nineteenth century, the painting predictably became known as 'the Dutch Mona Lisa'. Both heads achieve a timelessness that the term 'portrait' inadequately describes, but a better comparison would be with Rembrandt's portrait of Jan Six, which is to say, the greatest portrait in the history of Western painting. Both use a black ground, especially uncharacteristic for Vermeer, densely worked so that the brilliant colours required to advance from an indeterminate, suggestively infinite space can be precisely calibrated for maximum vitality and projection. In Rembrandt's figure, it is the dazzling scarlet cape that does the work of 'introduction' between artist and beholder. Vermeer opts for the stunning headdress in blue and gold, wrapped and gathered like no known Dutch costume but which soaks up gentle, sumptuous light. In both cases, the precisely established relationship between brilliantly lit figure and obscure ground succeed in giving their subject stillness *and* animation.

In Vermeer's miraculous confection, the light, originating who knows where, fills the opal face, itself an enlarged echo of the jewel, and shines from reflections standing at the edge of the hazel iris, executed by Vermeer with a single stroke of lead white continuing from the surface

of the cornea to the edge of the dilated pupils. Exactly modelled through the gentlest shadowing on the right side of the forehead, nose and jaw, this face manages to keep a perfect proportion while somehow conveying the distinct possibility that at any minute it might retreat and dissolve once more into black invisibility. Paradoxically, the craquelure that now covers its surface like the most delicate porcelain only intensifies the strange urgency with which the image asks to be registered. Only Vermeer could have managed to paint moistly parted lips that suggest at the same time greeting, expectation, consummation and valediction.

For all his unparalleled skill in registering the sharp poignancy of things lit, seen and then relinquished back to the darkness, Vermeer's art, unlike Rembrandt's, is not, in essence, tragic. In its way, though, it is heroic in its triumphant celebration of small pleasures intensely felt. Through the moments of lovelorn letter-writing and dreamy gazes caught in the whisper of a smile there runs a note of controlled exhilaration that Vermeer allows to blaze away in the sheer intensity of his colour: the shimmering lead-tin yellow, the precious ultramarine usually reserved for saints and deities.

Standing in one of the exhibition rooms, between two such intense points of radiance as *Woman with a Pearl Necklace* and *Woman in Blue Reading a Letter* uncannily reproduces the sensation of being caught in one of Vermeer's magic light boxes, with mirror images and paired paintings softly addressing each other across a lit space. It's hard to think of any exhibition of twenty-one paintings more potent in its capacity to pull the beholder inside their world, to flood us with a trance-like elation at the illuminated fabric of our lives.

2
BRITISH EYES

THOMAS LAWRENCE

Flashes of the Peacock's Tail

VISITING THE NATIONAL PORTRAIT GALLERY'S Thomas Lawrence exhibition is rather like shopping at Harrods. Its rooms are seductively well-appointed and crowded with images of famous and glamorous faces, exquisitely turned chins and impeccably manicured hands. Carefully disarrayed (but expensively clothed) children romp around while well-groomed members of the gentry and overfed, glossy-coated hounds show signs of mounting impatience. One can almost inhale the perfume and stroke the fur.

There are also, of course, the troops of daunting dowagers. One such formidable matron (three not two-dimensional), swathed in black velvet and glittering dangerously at neck and wrist, sits glaring at a portrait of Lady Robert Manners, likewise encased in fetching bonnet and dark satin. Peering at the picture's label she seems to be scrutinizing Lady Manners's suitability for a Belgravia At Home. Exclaiming, 'I've got another engagement with Miranda's godmother this afternoon,' she sweeps majestically to the door but not before delivering a withering

glance in the direction of the male portrait opposite. 'Johnny Nash is it? I might have guessed,' she announces as though testifying to a life-long acquaintance with the disreputable genius.

This feeling of fashionable gregariousness, of the informal companionability of Regency England, is just one of the pleasures of this impressive show.

Michael Levey, who is largely responsible for mounting the exhibition, is surely correct in pointing to the portraits of doughty old ladies as exemplary correctives to the casual view of Lawrence as a mere virtuoso of feathers and fluff, parlour coquettes, scarlet-tunic captains and apple-cheeked Fauntleroys. In their stiff bodices and piercing gaze – in the ovoid self-containment of Mrs. May or the tight-lipped resolution of Nurse Isabel Smith, Lawrence conveyed an authority and expressiveness which he ironed out from his more toothsome society beauties. Even Queen Charlotte, painted, as her chamberlain waspishly remarked, 'when the bloom of her ugliness was fading', is so contrived as to suggest, if not animation, then at least a kind of milky benevolence. Her unbonneted shock of grey hair which so upset George III (no oil painting himself) echoes the dove-grey gentleness of her costume and endows her with an approachability quite distinct from the more formal version by Gainsborough.

Ominously, Michael Levey instructs us that exhibitions should not merely show off a painter, but should demonstrate something significant about his art. In this case the wide range of paintings and drawings is intended to correct the condescension to which Lawrence has been subjected, and to raise him above the ranks of the merely accomplished – a Romney or a Hoppner – to the altogether more elevated pedestal of the Enduring. If comparisons with Goya push the promotion a bit far, it is true that Lawrence's reputation has suffered from worldly success. His rapid climb to the top – royal commission at twenty, Academician at twenty-five, heir to the honours and status of Reynolds – all militated against serious evaluation in later ages, critical of easy advancement and suspicious of painters alleged to pander to social vanity.

It is also timely for this exhibition to draw attention to the immense

pains taken by Lawrence to sketch, model, pose and dress his subject before embarking on the final stages of the work. He was capable of minute agonizing if a single detail of dress struck him as aesthetically jarring. Informed that he was going to have the stripes on his sash painted out, the Duke of Wellington good-humouredly responded, 'Never mind. They only constitute me Generalissimo of the Armies of Spain.' This obsessive perfectionism was, however, matched by such exuberance of brushwork, dynamism of style and relish for brilliance of colour that the prodigious labours involved in painting a portrait were disguised by apparent spontaneity in execution. These extraordinary techniques – the marriage of high craft to intuitive flair, together with his unrestrained representation of texture – perhaps constitute his most challenging claims to re-evaluation. And in all these respects this exhibition does Lawrence proud.

Paradoxically, it is in official portraiture – not the most promising genre for deploying expressive gifts – that Lawrence's work most spectacularly transcends the formal demands of the commission. In the most striking picture in the exhibition, Pope Pius VII is seated uncomfortably – both literally as well as figuratively – on the pontifical throne, as if expecting to be evicted from it at any moment. One velvet slipper slides off the cushion and his expression is frozen on the nervous borderline between pathos and ingratiation, exactly apt for a man subjected to brutal intimidation by Napoleon. The coils of the Laocoön in the background in this case do more than serve as a visual calling-card; they reflect ironically on the poignant disparity between the office of the Papacy, and Pius's own wretched history. At the opposite pole of mood and temperament, the Duke of Wellington painted after Waterloo, at the zenith of his prestige, stares out with indomitable fortitude and bluntness from a portrait much less saturnine and Byronic than Goya's (7). Arms crossed, he confronts the viewer like some muscled rugger captain, possessed of alarming reserves of controlled brutality.

Other war-lords are more obliquely viewed. The Archduke Charles's Habsburg pedigree is unfortunately advertised in the exophthalmic smirk and blubbery lips, doubtless rendered as sympathetically as

possible, but gently parodying his reputation as the Promethean People's Hero of Wagram. Best of all is Alexander I, dressed in knife-sharp bottle-green uniform, his face bleached pink with self-admiration and his fidgety hands clasped tightly in front of him (a pose, said Lawrence, to which he kept returning): the perfect visual equivalent of Tolstoy's literary portrait of capricious and feckless autocracy.

These portraits from the Waterloo Chamber at Windsor are a salutary reminder that Regency England was about power as well as style; and, as Lord Thurlow's beetling brows recall, about hanging Luddites as well as hanging paintings. Its other qualities — buccaneering imperialism and commercial aggression — are also represented, respectively, by the affable Earl Grey posing while some hapless Maharajah's fort is razed to the ground behind him; and by the Barings dramatized (after the manner of Rembrandt's *Staalmeesters*) as Men of Action in the counting-house.

It would be absurd, however, to characterize Lawrence as a trenchant social observer. Nor is there any need to wax apologetic about his addiction to the sensuous. To suggest that his marvellous orchestration of colour and texture, physical surface and facial expression, movement of body and decoration of dress, all anticipate the finest fashion photography might offend his most solemn advocates, but probably won't upset Richard Avedon. For these qualities are notoriously difficult to harmonize in a single composition, and in the best of Lawrence's pictures they all come together with apparently effortless grace.

His passion for the theatrical must have helped. In a culture (like Edwardian England) where the stage was the ante-room to an aristocratic boudoir, the theatre was a direct route to opulence and fame. In the same year that Lawrence painted Queen Charlotte he depicted the actress Miss Farren (later Countess of Derby), posed with deliberate coyness, dressed in brilliant satin and fur like a matinée empress, and with her lips shining and eyes sparkling in a well-rehearsed come-hither smile. Another actress, Mrs. Maguire, who became the Earl of Aberdeen's mistress, is painted with radiant infant and slavering dog, but staring enticingly at the viewer as if to tease the stuffy into submission. Other public heroes and heroines — Emma Hamilton and the actor John

Kemble – are posed against theatrical backdrops: crashing waterfalls and antique ruins, as if parading their lives as bravura episodes, the one more extravagant than the next in a desperate attempt to stave off encroaching ennui.

There were darker sides to the histrionic nature of Regency culture which Lawrence accommodated: the *accoucheur* father of his friend Miss Croft was pilloried for the alleged incompetence which killed Princess Charlotte in her childbed. When a later incident reminded him of the affair he took his life, and Lawrence has a moving drawing – less a deathmask than the closing scene in a tragedy – where Croft's permanent repose has taken on the aspect of Romantic oblivion. In another drawing, made as a study for the 1822 portrait of George IV, the king, no longer strutting in his finery, is seen instead as a moribund playboy; obese and clumsy, crammed into his corsets like so much bulging sausage-meat.

Lawrence died in 1830 laden with honours and renown. With his passing went a world in which the unbuttoning of formal manners, easy disclosure of personality, the exuberant affability of family life had been taken further than at any time in the country's history. Already, however, the sombre power of evangelism was cranking up a kind of piety that would repudiate the Regency as a Babylonish exile – an idolatrous and repugnant past. The buttons would be done up again; the children exiled to the nursery; lechery secreted in the back-streets and servants' stairs. Lawrence's art was a last gorgeous flash of the peacock's tail; a happy and candid vision of a time when beauty and companionability could go hand in hand, and the pleasures of this world indulged without fear of punishment to be inflicted in the next.

THOMAS ROWLANDSON

Rowlandson in the Round

THERE IS A MOMENT IN THE HANDSOME and entertaining exhibition of Thomas Rowlandson's drawings from the Paul Mellon Collection (at the Royal Academy) when the viewer is made party to involuntary self-caricature. In a corner of the Royal Academy one stoops and bends to see what turns out to be a picture of spectators at the Royal Academy stooping and bending and peering. It is a rich drollery which Rowlandson would surely have enjoyed, given as he was to dwelling on the ironies of vicarious experience. In a drawing of the 1780s, now in a Vancouver collection, he has a young man sitting behind his lady friend and staring intently at her absorption in a book. In the great spectacle scenes, it is generally the audience, sprawling and careening in the foreground, thrashing about in the throes of the *comédie humaine*, which arrests the view, while the ostensible objects of their attention – singers at Vauxhall Gardens; prize-fighters on Newmarket Heath; or soldiers in review – either recede into middle distance or are immobilized into the fulcrum on which the hectic shamble turns.

Eighteenth-century writers like Fielding were fond of comparing public life to theatre, and Rowlandson plainly enjoyed witnessing it as a series of social performances, complete with unintended pratfalls, miscued lines, preposterous casting, and gangs of irrepressibly rowdy spectators. It is not accidental that figures who pretended to be nothing *other* than actors, like his friend John Bannister, or the comely actresses sketched in their Drury Lane dressing-room, are treated with admiring benevolence by his pen and brush. Those who paraded in the human pantomime as though the world was really their stage are more laconically dispatched. Few artists before Daumier were more adept at stripping away the cosmetic; at disrobing ceremony, exposing the laborious pains of social disguise, and contrasting the naturally graceful with the artificially got up. Wigs are torn off to reveal the naked pates of male and female; globulous folds of flesh are crammed into stays; and in *Dr Graham's Earth Bathing Establishment* helpless human puddings cook slowly in their 'beautifications'. At Bath, where entire service industries dedicated themselves to gratifying these fancies, Rowlandson found an ideal milieu for his withering irony. In *Private Practice Previous to the Ball,* a figure of massive ungainliness lurches around in cumbersome rehearsal, and in *Gouty Gourmands at Dinner,* the cripples of greed lie semi-paralysed amidst the debris of their gluttony, only their twitching maws mobile and eager for further stuffing. There could hardly be a more grisly image of vanity guyed by time and decay than the *Old Coquette Outstood Her Market*, where a girlish dress hangs on the cadaverous frame of the crone, outlining her rib-cage.

Rowlandson was the virtuoso of the inspired accident, the divinely positioned banana-skin. Pomp tumbles into broad farce at his bidding; riders are thrown from horses skidding to a halt, or are seen stricken with fright at the moment of impending collision. But the intended effect is more often roguish than savage. He was, after all, genial 'Rolly', the student with the pea-shooter in the Life Class, sworn enemy of gravitas and decorum. Rage, spleen and bile – the full repertoire of Hogarthian satire – were left to the more caustic temperament of Gillray.

Excessive academic solemnity, however, does seem out of place when

enumerating Rowlandson's several virtues as a graphic artist. It may now seem extraordinary that the Victorians dismissed him for wanting adequate sensitivity to pain and suffering when the famous shipwreck drawing *Distress* seems to supply exactly the quality of agonized melodrama they admired. More likely he fell from favour through his choice of picaresque topics, and his relish of sexual innuendo. It has been the commendable task of recent writers on Rowlandson to rescue him from the fickle adjudication of social propriety, so that his reputation rests on more solid grounds than mere anecdotalism. His gifts as a draughtsman of prodigious genius, and as a master of the flowing line, are splendidly celebrated in the Mellon Collection. Is it too much to wish that he had not been subjected to the professional habits of analytic evisceration, that the components of his technique had not been dissected, laid out, and pickled in academic formaldehyde as though they might be genuinely separable from the trunk of his thematic content? Dividing the exhibition into chronological periods is of biographic rather than aesthetic interest since Rowlandson is one artist who obstinately resists attempts to force him into a developmental theory of style. It is true that he abandoned his emulation of Mortimer's 'Hatching and Stippling' in favour of expressive penwork and shaded areas, and that there were some periods when his taste for the pastoral prevailed over the burlesque. But as John Hayes insists in his admirable book (now available as a paperback from Phaidon Press), 'the Rowlandson of the 1790s or of 1805, or 1820 was fundamentally the same as the Rowlandson of 1785'.

There are, however, three major components of Rowlandson's technique that are felicitously emphasized in the exhibition. The first is the famous freedom of line, now obligatorily described as rococo, sometimes taut and wiry, but more memorably arabesque and serpentine, dipping and curving, climbing and swooping, so fluid that when the motion is abruptly interrupted (a favourite Rowlandson idiosyncrasy), the effect is all the more arresting. The second element is the exquisite colour tinting of many of the drawings: areas of fragile and transparent pastels laid on in delicate wash. If the Mellon *Vauxhall Gardens* has faded a little to an evanescent dappling; the vivid greens and reds of *A Merchant's Office* (8),

the rich browns of the 1790 *Stable of an Inn*, and the decorative blobs of *The Review of the Light Horse Volunteers at Wimbledon* are all fully suggestive of the subtlety and elegance of Rowlandson's watercolour palette.

Third and last, there is his powerful command of balance and composition. Not all of the drawings on show at the Royal Academy display this mastery at its best, and in some of the sporting scenes it is conspicuous by its absence. But the very best crowd scenes go far beyond a piling-up of individual comic episodes and detail to a magnificent orchestration of shape and mass. In the superlative 1787 *Prize Fight*, cascades of men, beasts and objects tumble over the composition right and left, but the tumultuous upheavals of figures is pinned together not only by the fixed lozenge of the ring and fighters, but by the absolutely still backs of spectators in the front centre. No other English artist, not even Hogarth, could have better expressed the surge and ebb of crowd adrenalin; the dynamics of tension and release; the great ocean waves of simultaneously collapsing humanity. Would that the Kop or the Stretford End had found its Rowlandson.

The exhibition also has a number of topographic scenes and landscapes less conventionally associated with Rowlandson. A number of these, drawn in the seventeen-nineties when he seems to have travelled a good deal in Europe, are bread and butter stuff: elegantly contrived, urbanely ordered views of Jülich, Antwerp, Amsterdam, but emptied of much of the dynamism and motion which expressed his vitality. Occasionally figures are reduced to not much more than architectural adornments, filling the crannies of windows or promenading around a square. Even some of these more sedate studies, however, show off another aspect of Rowlandson's skills, and one which was the opposite to his love of tumbling shapes: the marshalling of lines of figures horizontally or vertically to complement architectural detail. In this respect, the *Quakers' Meeting* of 1810 stands at the opposite pole to the *Prize Fight*, the difference of style exactly matching the difference of mood and content.

In the end, though, it is Rowlandson's human bestiary which remains most powerfully imprinted on the imagination. His comic distortions derived, like those of other contemporaries, from the *Caricatura* first

popularized in England by Pier Leone Ghezzi. Rowlandson, however, went a stage further in reducing physiognomy and anatomy to functions of animal appetites. Eventually the types become repetitive and predictable: the pig men with their button eyes and snouts raised peering up into the muslin skirts of the *Female Dancer with Tambourine*, her own face pink with self-admiring excitement; or the ferret men bony-cheeked, spindle-shanked, leering through spectacles and poking a horny finger at some fresh and voluptuous girl; or the massive hippo women exemplified in *The Register Office* ogling young bachelors. In some of his last pieces like *The Tub Thumper* Rowlandson continued the process of reduction so that human physiognomy became so many piles of Jerusalem artichokes in which nothing at all was left but the warts. In many of these scenes the sounds of snuffling and grunting, of heavy breathing and eruptions of air are produced fortissimo. Rowlandson's world turns into a kind of human zoo in which the seraphic and the abhorrent, the sublime and the monstrous, the Houyhnhnms and the Yahoo are imprisoned within the same cage. In *A Maiden Aunt Smelling Fire* the shapely déshabillé of the erring niece adds to the mockery of the spinster grotesquely displaying a pair of shrivelled dugs.

It is not a gentle vision, and in one of his last series, *The English Dance of Death* where Death briefly hoists the debauchee to a terminal copulation with his young mistress, the effect is mordantly cynical. But until Ackermann encouraged him, it seems Rowlandson had taken little or no interest in what was anyway a popular genre. At bottom he was not a committed spine-chiller, and there was something forced about his depiction of grand guignol. In the eighteen-twenties he continued to draw caricatures dressed in the costume of the seventeen-eighties as if emphasizing the anachronism of the mode. None of the filth and verminous stench of the eighteenth century overflowed into his art as it did into that of Hogarth and into some of the more acidulous work of Gillray. His was a more quizzical sardonic view of the curiosities of human behaviour, and the inevitability of human decay. Perhaps its ambiguity is best reflected in the elegiac gaze of the portly gentleman, rattling his way backwards across Bodmin Moor in a cart pulled by a

mule and an ample farm girl, reluctant to turn from the pleasurable view of an open winding track, and in the happy cavorting of the single small dog running alongside.

WILLIAM HOGARTH

Mad Cows and Englishmen

HAD IT UP TO HERE WITH THE RISOTTO OF THE DAY? Sick of goat cheese and sun-dried-tomato pizza? Well, then, how about Albion's answer to fugu fish: Baked Buttock of British Beef, courtesy of a manuscript recipe of 1765, reproduced in Elisabeth Ayrton's *The Cookery of England*? 'Take a thick piece of buttock beef,' the recipe instructs, 'lay it to soake in a pint of claret wine and a pint of wine vinegar, the beef being first seasoned with peper nutmegg and salt and soe let it lye two days, then take the beef and put it in a pasty well seasoned with nutmeg and salt.' Easy as pie, yet the recipe is now a poignant relic of the heroic days of English cattle, when carnivorous gusto was virtually a condition of patriotism. One of England's earliest historians, the Tudor chronicler Holinshed, boasted that 'the English cookes, in comparison with other Nations, are most commended for roast meates'. Before the invention of stove cooking, in the nineteenth century – an innovation that produced the brownish-greyish overdone joints that were sneered at in American travel guides – an English baron of beef, spit roasted, scorched with 'the taste of fire',

and 'frothed' with a basting of floury juices, was the envy of Europe. Certainly the quantity of the meat, if not the quality, made an impression. A bill of fare from a mid-seventeenth-century Twelfth Night feast in Essex reveals that *each* of the guests was expected to guzzle his or her way through anywhere from seven to eight pounds of beef, mutton, veal and other meats.

In the ebullient infancy of the British Empire, beef was not just the dinner (and also, to serious gourmands like the Prince Regent, the breakfast) of choice; it was an entire gastronomic constitution, the marrow of political freedom. The motto of a dining club named the Sublime Society of Beefsteaks was 'Beef and Liberty', and in Hanoverian London a commonplace had it that consuming sirloin supplied freeborn Englishmen with their daily requirement of bloody-minded patriotic virtue. Even the foes of the British Empire believed that it was what it ate: in 1749, the French philosopher La Metrie attributed the contempt that Englishmen displayed for other nations to an excessive fondness for rare steaks.

Given this ancient assumption that Britannia ruled the waves just as long as her belly was full of beef, no wonder the current plight of the British livestock industry has turned into yet another trauma of national identity. The monarchy may have become soap opera, and the national cricket team a bad joke, but the extinction of the Sunday lunch of Roast Beef and Yorkshire Pudding has tabloid soothsayers prophesying the death knell of British culture – or, at least, of the Tory Government, which has been accused of procrastination in the face of the impending 'beef crisis'. The spectre of 'mad-cow disease' – an illness that may be contracted by humans, afflicting them with a degenerative brain disorder – has led the European Union to prohibit the import of British beef, and has produced a near-hysteria in England. To those who assume that national passions are artificially manufactured by cynical politicians, all the rage and anguish stirred up in Britain over the European ban will seem overwrought. But the modern British national identity was shaped, in the eighteenth century, around such emotional national icons as the oak and the bull, and defined, invariably, against the French. To have the

four-legged symbol of essential Britishness repudiated by the European Union precisely at the moment when discussions are underway on Britain's federal future is to be reminded in the most painful way of the awkwardness of the fit between British insularity and Continental federalism.

What particularly sticks in the patriotic craw is the mortifying spectacle of *le rosbif* being forbidden entry to Continental Europe, for in its glory days the quality of British meat was deeply envied abroad. Advocates of the ungarnished simplicity of the English table – among them Queen Anne's chef, the wonderfully named Patrick Lamb – liked to argue that the reason French cuisine gussied up its fare with complicated sauces was to disguise the dreadful quality of the meat – if, that is, any meat was available. In 1759, a composer named Theodosius Forrest offered a musical-culinary contribution to the war with France by publishing a cantata entitled *The Roast Beef of Old England*; in his libretto he waxed indignant that fashionable chefs in England 'have been taught to dress our meat by nations that have no meat to dress'.

Forrest's cantata was inspired by a William Hogarth engraving; the engraving, in turn, was the printed version of *The Gate of Calais, or the Roast Beef of Old England* (9), a painting that Hogarth had completed in 1748. (It is now in the Tate Gallery.) As befits a member of the Sublime Society of Beefsteaks, Hogarth has documented more enthusiastically than anyone before or after him the foreign-policy implications of sirloin exports.

The peace of Aix-la-Chapelle, in October, 1748, had made it possible for Hogarth and a group of friends to undertake a sketching expedition to France. The return route from Paris took Hogarth through Calais, and while he was waiting for the packet boat he decided to sketch the ancient fortifications of the port, which were built during the two centuries of the city's submission to English rule, and still were emblazoned with the English arms. In the left middle ground of the subsequent painting, the artist is about to be interrupted by an ominous halberd poised above his head, and an apprehending hand has already landed on his right shoulder. To his chagrin, Hogarth was arrested for

spying, was interrogated and was released only when he could prove that he was a mere painter – something he established, the story goes, by making lightning-fast caricatures of his guards. The story also asserted that the unconvinced guards continued their watch even after he had boarded the ferry, and 'spun him round like a top on the deck' before finally allowing him to proceed.

The painting and the print were Hogarth's revenge for these humiliations. The scene at the Calais Gate is a tableau of the misfortune of being French: 'A farcical pomp of war, parade of riligion and Bustle with very little bussiness,' as Hogarth wrote shortly after he returned to England. 'In short poverty, slavery and Insolence with an affectation of politeness.' And at the centre of the scoffing satire is their most pathetic predicament: a salivating greed and desperate hunger that only the all-conquering British sirloin can assuage. Hogarth's side of beef is so mighty that it crooks the knee of a scowling French cook who is carrying it to the Lion d'Argent, the hostelry for English travellers. The entire composition is Hogarth's version of the old genre of Fat and Thin Kitchens, reworked as Gallo-phobic propaganda. Sweaty relish can be seen shining from the slavering chops of a fat friar. In the left 'wing' of what Hogarth seems to have anticipated would be staged performance lurk leather-faced fishwives cackling over their skate, and on the right there is a miserable Highlander: no Aberdeen Angus, no Braveheart, but, rather, a fugitive from the failed Jacobite rebellion of 1745, reduced to sitting on his bagpipes and contemplating a kettle of *soupe maigre* passing by. The other stock target of English scorn – an Irish mercenary, denoted by his scrawny frame and tattered hose – is spilling his bowl at the sight of the meat. And through the portcullis, beneath the sign of a dove (the Holy Ghost converted into an inn sign), craven subjects of the beefless Bourbon monarch can be glimpsed kneeling before the Host – the only victuals they could expect from the largesse of the Catholic Church and the throne.

The Gate, then, is the threshold of two realms: one officiously policed, servile, superstitious and starving; the other uninhibited, satirical and indomitably beefy. Prints of O *the Roast Beef of Old England*, as the

engraving was called, became a popular source of anti-French propaganda for generations, and the paunchy friar and the starveling sentry were the epitome of the evil from which the bully-beef-fed Royal Navy had spared Britain.

Autres temps, autres mœurs. If Hogarth were around today, would he have to relocate the scene of his satire to a container dock somewhere on the south coast of England, where eleven-year-old kids, desperate for a Big Mac, forlornly await the arrival of Argentine beef, while on a far-off wharf – at, say, Calais – uniformed customs officials mount a round-the-clock vigil against nocturnal landings of unhinged bovines? Perish the thought.

STANLEY SPENCER

The Church of Me

SATURDAY, MAY 29, 1937. Maidenhead Registry Office, Berkshire. The wedding photograph: the groom is Stanley Spencer, a compact but explosive force of nature who has already produced some of the most memorably strange paintings in twentieth-century art and will go on to paint many more. He is wearing his favourite shapeless felt hat, which instantly transforms him into a toadstool pixie, twinkling and eager. Four days earlier, he divorced his wife of twelve years, Hilda Carline, also a painter. The new bride, her attention caught elsewhere, left hand carefully avoiding contact with the new husband, is Patricia Preece, aspirant artist, fashion plate and lesbian. To her right is her live-in friend of many years, Dorothy Hepworth, tight-lipped, hands grimly clasped on her bag as she struggles to celebrate.

Patricia and Dorothy had appeared in Stanley's native village of Cookham at a time when Hilda was preoccupied with their small children and a sick brother in London. Patricia, exuding silky glamour (by Berkshire standards, anyway), seemed as alluring as Hilda was

homely. 'Her high heels and straight walk used to give me a sexual itch,' Stanley later wrote to Hilda. For Patricia Preece, ensnaring the famous Stanley Spencer offered a chance for the financial security her wardrobe demanded and the possibility of slipstreaming her own work (or, more likely, Dorothy's paintings signed as hers) behind his renown. She put everything she had into the effort. Hilda wrote to Stanley's dealer, Dudley Tooth, that Patricia 'vamped him to a degree unbelievable, except in cinemas. If he went to her house she always received him half or quarter dressed.' The strategy paid off quickly and handsomely. Made to feel cruelly redundant, Hilda spent more time with her family in London. In 1935, Stanley agreed to transfer Lindworth, his Cookham house, to Patricia. A year later, Hilda declaring to Stanley that 'my desire for you is for your happiness in the way you want it', consented to a divorce.

The new marriage collapsed immediately into tragic farce. For Patricia, it was a necessary chore, rather like a long interview with an especially squalid bank manager; for Stanley, it was a nightmare of ungratified longing. Patricia and Dorothy spent the honeymoon together in a cottage in Cornwall, banishing Stanley to separate accommodation. He had hoped to keep Hilda as a creativity concubine, on demand whenever his brushwork flagged, and now he turned to her for consolation. Instead of smacking him, she stayed the night, but his suggestion that they should return to the Suffolk village where they had spent *their* honeymoon was not warmly received. Having been evicted from her house and her marriage, Hilda was not about to trade the position of wife for that of mistress, even with Patricia's permission.

In 1938, Patricia, who had graciously allowed Stanley to use studio space in the Cookham house, announced to him that her needs were such that she was obliged to let it. Friends and supporters of the now home-less painter found him lodgings in Swiss Cottage, ten minutes' walk from Hilda's family. Chastened and desolate, Stanley roamed the wilderness of his walkup flat. Instead of having both wives, he had neither. He decided to paint forty pictures, one for each day of Lent, representing Christ in the Wilderness. Eight were completed, the least elaborate and most affecting things he had ever done. A stocky, lumbering Saviour tenderly

scrutinizes a scorpion in the palm of his hand, or rises from a surprisingly fertile crater (this is, after all, an English wilderness) like a lily, white-shrouded, his outstretched arms seeking the sun. Looking back on the wilderness series, Stanley wrote, 'I loved it all because it was God and me, all the time.'

When Stanley Spencer showed up in October, 1938, at the house of the new director of the Tate Gallery, the maid opened the door to a dishev-elled wreck, his coat fastened with a safety pin, and she reasonably assumed he was a tramp. Just two years before, in December, 1936, on the strength of a rare one-man show at his dealer's, Spencer had been hailed as a genius – an abnormal genius, one reviewer was careful to say, but a genius all the same. Despite the reservations about his eccentricity, there was a consensus that Spencer was an astounding original, who had some-how managed to reinvent native British painting, liberating it from the thrall of Picasso and European modernism. It was the raw energy of his work, its dismissal of abstract formalism, and its ravenous appetite for poetry, history, flesh and blood, place and prayer that so cheered the critics of Stanley Baldwin's little England.

All this changed during Spencer's time of troubles. His fusion of the sexual with the spiritual, the odour of sanctity with a whiff of the bed-sheets, disconcerted a national culture that generally liked such things kept apart, thank you very much. After the Second World War, he was taken seriously again, but as an inimitable oddity rather than as a hero of twentieth-century British art. Only in the body works of Lucian Freud and Francis Bacon did he have any real progeny. And beyond Britain, especially in the United States, he disappeared from view, unknown and almost unexhibited.

Two events are about to make good this absurd neglect. A major survey of sixty of his works will open at the Hirshhorn Museum, in Washington, in the autumn. And on February 20 Pam Gems's fiercely moving play *Stanley* opens at the Circle in the Square. For nearly three hours, audiences can sit right in the middle of Spencer's hopelessly tangled life and see one of the most astonishing acting performances of

the last several decades – Antony Sher's incarnation as the painter. Impassioned, visionary, compulsive, lyrical, he is randy as a goat and pathetic as a child; incontinently garrulous; impossibly selfish.

At one point in the play, Stanley whines, 'What I want to know is, why must a man have only one woman?...I suppose I must be polygamous if I want more than one wife but I don't see why that should be derogatory. I think it's a sign of intelligence.' Earlier, he upbraids Hilda for failing as his muse by being preoccupied with the children: 'The trouble is, there's nothing left for Stan!' Patricia, played with feline dangerousness by the brilliant Anna Chancellor, whispers into Stanley's ear precisely what he wants to hear: 'You are an artist. Why not? You must have whatever you need. If what you need for happiness is women, women, women, Stanley, I'll get them for you.'

Have we heard this before? Erotic egotism, once treated as an incidental (if deplorable) aspect of the creative temper, now threatens to become the organizing principle of art biography, to the point where an entire exhibition, *Picasso and Portraiture*, could be conceived as an odyssey through the human wreckage of the painter's sex drive. Saturn, the god of melancholy, whose aura was once thought to govern the artistic muse, seems to have been replaced by the Satyr. It's true, of course, that the pantheon of painting is loaded with libidinous monsters, outrageously disingenuous in their pretence of engaging with their models as art objects, and thus exempting themselves from bourgeois norms of conscience. Two of the painters most admired by Stanley Spencer, Gauguin and Rossetti, both self-consciously at war with middle-class morality, were conspicuously carnivorous in their relationships with their models. Gauguin set up the pubescent Anna la Javanaise as his mistress in Paris; Rossetti drove Lizzie Siddall to laudanum and suicide, then took his friend William Morris's wife, Janie, as model, muse and lover.

The Hilda-Stanley-Patricia triangle is so powerfully caught in Pam Gems's play that it runs the risk of being taken for yet another formulaic contribution to the flourishing genre of painter-as-prick. But Gems is at pains to present Spencer's waywardness less as the calculation of a cynic

than as the greediness of a perpetual child, sucking on nothing much naughtier than his own thumb. Spencer was unapologetic about this childishness, cultivating what he took to be its redeeming innocence; he wore schoolboy bangs his whole adult life. While he features himself in his erotic art almost as compulsively as Picasso, he appears not as the horny Minotaur but as little Stan, the prodigy as shorty, gawping, cradled, nuzzled, cuddled, or suckled by a parade of colossally enveloping Earth Mothers.

Paradoxically, while the nudes of Patricia, so disconcerting to his contemporaries, were unprecedentally graphic in their anatomical precision (no crease, dimple, hair, or vein left unsurveyed), they startle because of the *distance* they interpose between perception and gratification. 'He's drawn me all crooked,' snaps the play's Patricia, and so, in a manner of speaking, he has. The erotic effect of one of the more alluring of the paintings, *Nude, Patricia Preece* (1935), is sabotaged by the artist's cramming her body into a brutally confined space, so that it resembles a cartilaginous reptile flattened against an aquarium tank, the head elastically dislocated from the torso. Twice in this series, Spencer inserts himself into the composition, but hardly as the bête noire of feminist art history, the lord of the penetrating gaze. In the most decisively alienated of the paintings, *Self-portrait with Patricia Preece* (1936–37), Spencer is seen in rear profile, shoulder blades chalk-white but cheeks and neck ruddy with unassuaged passion, staring off past the supremely uninterested face of the beloved, the two of them trapped in precoital *tristesse* (10). In the notorious *Double Nude Portrait: The Artist and His Second Wife*, Spencer has assembled heaps of what he described as 'male, female and animal flesh', including a phallic shank end of raw mutton that is in livid contrast to Stanley's own penis, dangling pallidly, more in hope than in expectation, beside Patricia's midriff. Behind him an oil stove burns, the only note of warmth in a tundra of human bleakness. Stanley had written to Hilda (with his usual sensitivity), 'The more severe and austere [Patricia is], the bigger the thrill. Every inch I gain with Patricia is real achievement – it is so extraordinary to get near *at all*.' But the closer he got the more remote she became. These paintings proclaim the defeat of intimacy by

proximity, the frustration of love by unsparing clarity of focus. Stan is the consumed, not the consumer, here, his mutton doomed to go forever uncooked.

When the *Leg of Mutton Nude* was included as the sole British representative in a 1981 Pompidou Centre exhibition devoted to figurative painting between the wars, it was shown alongside work by Otto Dix and other artists of the German New Objectivity, as though they were Spencer's closest artistic companions. But, as the artist himself was at pains to point out, it was precisely the dispassionate quality of the nudes that made them an anomaly in a career otherwise devoted to the painterly expression of passion, much of it fervently religious. Referring to the *Leg of Mutton*, he wrote, 'There is none of my usual imagination in this thing. It is direct from nature and my imagination never works faced with objects and things.'

Perhaps the reason Spencer has suffered from neglect, at least outside Britain, is that in almost every important respect his work truculently resisted the received wisdom of modernism. While the patriarchs of twentieth-century painting were committed to essentialism, stripping away conventional outward forms to disclose an inner reality, for Spencer reality *was* surface, texture, skin. Where they were prophets of disembodiment, his art was copiously embodied. Where their art was based on compositional economy, his canvases revelled in figural glut, feverishly congested like the paintings of Bosch and Bruegel that so bewitched him. Where modernism hungered for the purity of science, Spencer thirsted for the purity of faith. The modernists cleansed their work of anecdote, incident, and textual allusion; Spencer couldn't get enough of them. Abstraction demanded meditation; Spencer's work is an invitation to the carnival. Most decisively of all, he rejected as barren narcissism modernism's insistence that art should be dedicated to investigating the constituents of its own autonomy. His technical gift he thought worthless, except as a means to a higher end. 'My capacity to draw and paint has got *nothing* to do with my vision; it's just a meaningless, stupid habit,' he wrote. Conversely, his own declared goal for art would have made the modern masters shake with mirth had they been paying him any mind.

Art, Spencer affirmed, over and over, was the visual translation of epiphany, the proclamation of love on earth: 'Love is the essential power in the creation of art. And love is not a talent.'

A further condition of Spencer's art that has obviously worked against international recognition is his insularity. His most important teachers were all adamantly, even chauvinistically, English. From the rowdy titans of the English graphic tradition – Hogarth, Rowlandson, and Gillray – he learned the seriousness of comedy, an affection for the grotesque, an appetite for narrative richness, and the skill to contain its elaboration through daring but rigorous draughtsmanship. From Ruskin (who, had he but seen Spencer's educationally detailed nudes, might have saved his own marriage) he took the conviction that true 'modern painters' could do no better than emulate the intricacy and integrity of late-medieval stonemasons and sculptors. Blake reinforced his intuition that bodily and spiritual rapture were one and the same. And from Samuel Palmer, the early-nineteenth-century bucolic visionary, and William Holman Hunt, the most blessedly weird of the Pre-Raphaelites, Spencer grasped the illumination that the acts of the Gospels still worked their sublime mysteries through the lanes and hedgerows of the English countryside.

Any fool knew that paradise on earth was to be found in an English village. Spencer knew, still better, that Eden's coordinates situated it thirty miles up the Thames from Westminster, at Cookham. Lying in the belly of an S bend in the river, between Maidenhead and Marlow, Cookham was surrounded by water meadows, so that a small boy born in 1891 might still see the village as an island, moated off from the grinding highways of the wider world. It was a place of buttered scones and boat-yards, smelling of river weed and breweries. For Stanley, it was peace but not quiet, since there were nine children at home. William Spencer – Pa, a paterfamilias beyond the dreams of Dickens – presided over the enormous brood. He had titled himself Professor of Music but his only academy was Cookham, where he played the church organ and gave piano lessons. Edward Marsh, one of Stanley's first patrons, who visited

the 'pullulating bosom' of the Spencer home, described Pa as 'a tremendous talker, and frightfully pleased with himself, his paternity, his bicycling, his opinions, his knowledge, his ignorance'.

All the children Did Something, often at the same time, one playing cello, another violin, Stanley pounding out Bach on the ivories. Since Pa had no faith in the public-school system, Stanley was educated by his sisters in a corrugated-iron hut next door. A lending library was run from their home, and Stanley, who rapidly developed into an unstoppable talker, read everything and anything.

One doesn't have to be Freud to see that the snug fit of the Spencers into their village hearth and home was not altogether cost-free for Stanley's progress to manhood. He spent a good part of that adulthood searching for a place as secure as his childhood bed. In one of the most intense of his early works, *The Centurion's Servant*, Spencer makes a double appearance – as an agitated child-man, stretched out on the bed as if he were striding through the sheets, and as one of three figures gathered at the bedside in attitudes of prayer, impassively regarding his contorted alter ego.

The Centurion's Servant was both Gospel and autobiography. The ostensible subject was the episode related in Luke 7, when the centurion, thoughtfully aware of Christ's tight schedule, asks him not to trouble himself with a bedside visit to his sick servant, but, if it isn't too much of an inconvenience, might he perhaps manage a long-distance miracle? Originally, Spencer intended to paint two separate moments from the story, but later he reverted to the Old Master convention of collapsing separate episodes into a single frame. The figure on the bed, then, can be read as both in motion (the centurion's messenger approaching Jesus) and at rest (the ailing servant); or, alternatively, as the invalid prostrate with sickness *and* restored to health and vitality. But it also drew on the painter's memory of the family gathered by the bedside of a sick brother or sister, praying for recovery. Notwithstanding the nightmares that his brother Gilbert said regularly afflicted Stanley, the bed, with its pink, flounced, maternal skirt, was his ultimate refuge, his 'just me happy' place.

For many of Spencer's contemporaries in Edwardian Britain and

beyond, art was embraced as a liberating alternative to religion. It was the new church. For Spencer, on the other hand, it was the old church; and his unshakable belief in salvation through painting marked him out from the very beginning as a naïf. Yet when he got to the Slade School of Art, in 1908, his ingenuous zeal fitted right in with the avant-garde's interest in primitive religion. At Roger Fry's first Post-Impressionist show, at the Grafton Gallery, Spencer would have seen forty Gauguins, many of them the great Pont-Aven religious paintings. A number of his earliest efforts, in particular *Apple Gatherers* and *The Nativity*, borrowed numinous colours and loaded, shimmering brushwork directly from Gauguin's Breton icons; statuesque figures in mysteriously erotic communication made an improbable migration from the tropics of Tahiti to the orchards of Cookham. On the strength of these enigmatic, symbolically charged works, Spencer was classified as belonging to the British neo-primitives, and a number of his paintings were included in Fry's 1912 follow-up show, along with works by Duncan Grant and Vanessa Bell, where they hung opposite the likes of Cézanne and Picasso.

In reality, there was nothing 'neo' about the simplicity of Spencer's pantheist vision. To the amusement of such criticis as Fry and Paul Nash, he turned out to be the tribesman, not the anthropologist. He later complained, 'What is so disconcerting to me is to find that people are not in the least moved by the sort of religious "urges" I get.' But when his Slade friends condescendingly gave Stanley the nickname Cookham they were shrewder than they knew, for, as he put it himself, 'a person is a place's fulfilment as a place is a person's'. To sustain the intensity and the peculiarity of his vision, Spencer needed to plant his easel not in Chelsea or Bloomsbury but back in his riverside idyll, in studio space rented for one shilling and sixpence a week. As Kenneth Pople's thorough biography points out, the more parochial Stanley's address the more fantastically his imagination flowered. 'In a way all the things that happened at Cookham happened in the Bible'. Stanley declared with utter sincerity, so it was natural, rather than allegorical, that Joachim should join the shepherds on Strand Meadow, and Christ be betrayed in the garden behind Fernlea schoolroom.

Cookham's malthouses, in particular, inspired some of Spencer's most original compositions, their tall white cowls transformed into the conical excrescences of an esoteric temple. The interior of a malthouse – strictly forbidden to the Spencer children, and therefore a place of irresistible magic – served Stanley as the setting for his *Last Supper* (sketched in 1915 but completed after the First World War). Christ, seated in front of a red brick wall that, cutting through the picture space, forces the figures to the extreme front of the painting, as if in a shallow relief, breaks the bread, flanked by the feminine figure of John, who is said by the Gospel to be resting against Jesus's breast, and whom Spencer, typically, paints with his eyes wide open, and by the neurotic Judas, a defensive hand clapped against his mouth. In the rhythmically orchestrated lines of apostles' heads on the left, their arms on the right, and, above all, the extraordinary congregation of feet that dominate the foreground, Spencer has begun to discover the elements of a completely original manner: modest in its homage to Giotto and the fresco painters of the early Renaissance, and audacious in its confident reinterpretation of sacred narrative. With visions like these crowding in on him, no wonder Spencer declared, 'I never want to leave Cookham.'

Leave he did, though, going off to war for King and Country in a Thames Valley downpour that turned his straw boater into a soggy ruin. Spencer signed up with the Royal Army Medical Corps, serving initially in a Bristol hospital that treated casualties from the Front, and from 1916 to 1918 in the highlands of Macedonia, where British and French troops were fitfully attempting to push back the Bulgarian and Austro-Hungarian occupiers. As a hospital orderly in Bristol, he pared dead skin away from mutilated survivors of the slaughter pits of Flanders, and kept the tea urns filled. In Macedonia, he wandered around hilltops strewn with tortoise shells bleached white by mortar fire and with letters dropped by Bulgarian soldiers in panicky retreat. He was a long way from Cookham. But his response to the apparently pointless savagery was not, like that of most of the 'generation of 1914', fury born of reflection. He made sure to nurse his composure by omnivorous reading –

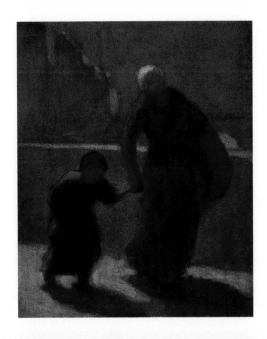

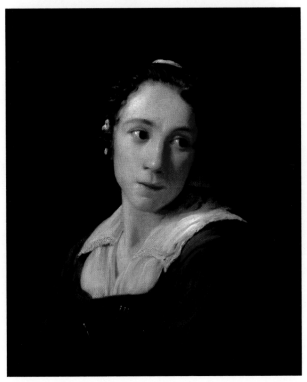

TOP 1 Honoré Daumier, *On a Bridge at Night, c.* 1845–48, oil on wood panel (The Phillips Collection, Washington, DC, USA).

ABOVE 2 Michael Sweerts, *A Young Maidservant, c.* 1660, oil on canvas (Fondation Aetas Aurea).

TOP LEFT 3 Style of Rembrandt, *The Sibyl, c.* 1654–56, oil on canvas (The Metropolitan Museum of Art, Theodore M. Davis Collection, Bequest of Theodore M. Davis, 1915 [30.95.268]). Photo © 1995 The Metropolitan Museum of Art, New York, USA.

TOP RIGHT 4 Rembrandt, *Woman with a Pink,* early 1660s (The Metropolitan Museum of Art, Bequest of Benjamin Altman, 1913 [14.40.622]). Photo © 1991 The Metropolitan Museum of Art, New York, USA.

ABOVE 5 Hendrick Goltzius, *Study of a Right Hand,* 1588, pen and brown ink (Teylers Museum, Haarlem, The Netherlands). Photo © Teylers Museum. All Rights Reserved. 2004.

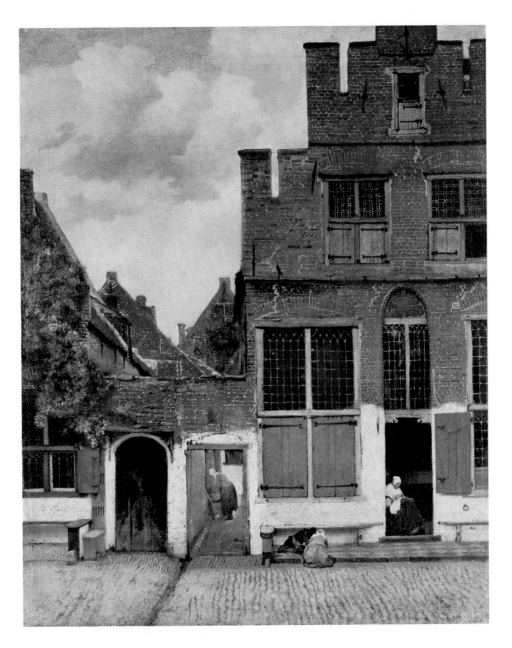

ABOVE 6 Johannes Vermeer, *The Little Street* (or *A Street in Delft*), 1658–60, oil on canvas (Rijksmuseum, Amsterdam, The Netherlands).

TOP 7 Sir Thomas Lawrence, *Portrait of Arthur Wellesley, 1st duke of Wellington*, 1814, oil on canvas (Apsley House, The Wellington Museum, London, UK).

ABOVE 8 Thomas Rowlandson, *A Merchant's Office*, 1789, pen and ink and watercolour over graphite on paper (Yale Center for British Art, Paul Mellon Collection, USA).

TOP 9 William Hogarth, *The Gate of Calais*, 1748, oil on canvas (Tate Gallery, London, UK). Photo © Tate London 2004.

ABOVE 10 Stanley Spencer, *Self-portrait with Patricia Preece*, 1936–37, oil on canvas (Fitzwilliam Museum, University of Cambridge, UK). © Estate of Stanley Spencer 2004. All Rights Reserved, DACS.

TOP 11 Winslow Homer, *Summer Night*, 1890, oil on canvas (Musée d'Orsay, Paris, France).

ABOVE 12 Victor Dubreuil, *The Eye of the Artist, c.* 1898, oil on canvas (Butler Institute of American Art, Youngstown, Ohio, USA).

OPPOSITE, TOP 13 Maxime Du Camp, *Abu Simbel, Egypt,* 1849–50, paper print (Musée d'Orsay, Paris, France).

OPPOSITE, BELOW 14 Paul Cézanne, *The Bridge at Maincy, c.* 1879, oil on canvas (Musée d'Orsay, Paris, France).

TOP 15 Egon Schiele, *Reclining Nude in Black Stockings*, 1914, oil on canvas (Private Collection).

ABOVE 16 Chaim Soutine, *Beef*, 1925, oil on canvas (Stedelijk Museum, Amsterdam, The Netherlands). © ADAGP, Paris and DACS, London 2004.

Shakespeare, Milton, Blake, Keats – and, when he could, heated debates on painting and music. Mainly, though, he kept sane by keeping busy, plunging energetically into the routine work of the Medical Corps – swabbing floors, hauling the wounded to dressing stations on mule stretchers, decorating the sign for the sergeants' latrine with painted flowers. It was a vision of God revealed in Augustine's *Confessions* that most comforted and inspired Spencer, not the deity who, to so many outraged minds, had gone conspicuously AWOL from the trenches but God as eager beaver. 'Ever busy, yet ever at rest. Gathering yet never needing; bearing, filling, guarding, creating, nourishing, perfecting; seeking, though thou hast no lack.'

It was this image of the Almighty as both non-stop busybody and tent of repose that Spencer eventually transferred to his war paintings, to my mind the most powerful art to emerge from the carnage of the Great War. *Travoys with Wounded Soldiers Arriving at a Dressing Station at Smol, Macedonia* was commissioned for the British Ministry of Information but has nothing to do with propaganda. Its closest kinship is with an Adoration of the Magi, albeit with four stretcher cases lined up at right angles to the picture plane and converging along the line of perspective toward a brilliantly lit interior space, no manger but holy nonetheless, where white-coated angelic figures minister to a childlike figure. Even the animal detail – four sturdy mules, seen from the rear and stylized like the horses in another of Spencer's favourite paintings, Uccello's *Battle of San Romano* – recalls the creatures present at the Nativity, their ears attentively pricked and sharply outlined against a window bathed in supernal light.

Completed in 1919, *Travoys* brought Spencer a little fame and a little fortune: two hundred pounds. As a result of its success, he was asked, four years later, by the sister of an officer who died of an illness contracted in Macedonia to compose a series of works commemorating that campaign. 'What ho, Giotto!' was his famous response as he conceived a cycle of paintings that, like the Arena Chapel frescoes in Padua, could be read programmatically but whose several parts would resolve into a coherent whole, building to a climactic work at the visual centre,

The Resurrection of Soldiers. In one respect, Spencer was even more fortunate than Giotto: his patrons were so impressed with the preliminary sketches that they had a chapel built to house the series.

'It is as though a Pre-Raphaelite had shaken hands with a Cubist' was one verdict on the Burghclere Chapel murals. But, while Spencer's organization of narrative detail within a strongly decorative arrangement (wildflowers everywhere) was somewhat reminiscent of Millais or Ford Madox Brown, the analogy sells him short. A more accurate description would be a marriage of the stylized forms and manipulated perspective of the fresco with an arsenal of twentieth-century idioms. Though Spencer hotly denied any debt to contemporary art, the cylindrical rhythms of *Filling Tea Urns* are kin to Léger; the ghostly figures in *Scrubbing the Floor* trapped between a dark corridor and a glossy yellow wall, echo Chirico's surrealist dream world. The borrowings, though, are trivial compared with the profound originality of the cycle, packed with touches of inspired Spencerian mischief: the obscured feet of a foreground figure in *Washing Lockers* displaced to the bootlike iron feet supporting a blazing-scarlet bathtub; Stanley as Saviour, his arms outstretched, holding the corners of the sheet as he makes a bed, amid soldiers who are neatly tucked up, as if the barracks had been transformed into the Cookham nursery.

For the great altarpiece of *The Resurrection of Soldiers,* Spencer turned to Bruegel's apocalyptic *Crucifixion*. Like Bruegel, he shrank the ostensible protagonist of the painting – Christ bundling up crosses – into the background, while maintaining his narrative centrality by keeping him close to the vanishing point. The centre of the painting is dominated by two white mules rising from the tomb, twinned like heraldic supporters, their necks craned to observe the Saviour tidying up behind them. 'They awake to the loads of hay waiting for them,' Spencer wrote. 'I am sure this would convince them that the Resurrection had taken place!' At their right, Christ appears again, ensnared in the barbed wire that serves as his crown of thorns. In front of the mules, an avalanche of crosses descends through the foreground and, by a brilliant optical illusion, out beyond the picture space into the interior of the chapel itself – an

invasion of the beholder's convenient privacy by the irreversible force of historical tragedy. It is as though a sacred earthquake had shaken the battlefield and from the fissures soldiers had emerged, not jubilant but wearing the same expressions of astonishment, ruefulness and resignation they wore at the moment of being cut down on the field of battle.

Stanley himself had been reborn in 1925, when (after proposing seven times and breaking off the engagement six) he finally managed to marry Hilda Carline and experience his 'union with you...my union with the world'. Since he was Stanley Spencer, it wasn't quite enough to celebrate this sexual epiphany with, say, a private portrait. Only the vast *Resurrection, Cookham*, nine feet by eighteen, set in the kind of churchyard that Spencer's hero of holy erotics, John Donne, had called 'the holy suburb of heaven', would do. As an anthem of rapture, the painting goes on and on and on, rather like a deflowered virgin compulsively inserting the name of the beloved into casual conversation with a third party. Before a friezelike line of 'prophets', including Moses, who emerge from their tombs rather lazily, as if getting out of up-ended bathtubs, Hilda and Stanley appear in manifold guises: Stanley laid out on a folded tomb that resembles a half-open book; Renaissance Stanley, nude and virile; Stanley's head strangely surmounting Hilda's body, as though marriage had grafted the two together; Hilda in bridal white; Hilda half submerged in grass, her face pressed to a spousal sunflower; and, most peculiar, Hilda as Christ, enthroned beneath an immense arbour of white roses, with a homuncular baby Stan, naked and cradled in the crook of her left arm. 'Eat me, darling,' he had written on the back of a drawing of Hilda. 'Let me become you. In the midst of your belly I cry out my love for you.'

The London *Times* called *The Resurrection, Cookham* 'the most important picture painted by an English artist in the present century', and it was bought by the Tate for a thousand pounds. But seventy years later it seems nowhere near as successful as the Burghclere murals in marrying the epic with the domestic, or in pulling together a mass of symbolically laden detail into a compositionally satisfying whole. Spencer could be

briskly critical of artists who lacked narrative discipline – Michelangelo, for one – but his own effort at heroic allegory suffers from precisely the additive quality he faulted in others, never managing to transcend an inventory of his obsessions. When Hilda gently implied that self-importance was what led him to work on this scale, he turned on her with 'choking rage'.

Reigning supreme among his *idées fixes* was the conviction, relentlessly exhibited, that sexual experience was the gateway to salvation, and that fleshly and spiritual ecstasy were not just closely connected but the same thing. 'God speaks eloquently through the flesh,' he wrote. 'That's why he made it.' This idea was not exactly new, but Spencer felt the need to announce his erotic pantheism to the world, as if it were the religious equivalent of the Theory of Relativity. In this respect, as in many others, he was simply reiterating – more endearingly, perhaps – the proclamations of D. H. Lawrence and Eric Gill. Like them, Spencer, despite the best efforts of Christian missionaries, believed that non-European cultures had managed to retain their instinctive sense of the holiness of copulation; and the Hindu temple sculpture at Khajuraho, with its populous and versatile performances, only reinforced his faith that the road to Nirvana was strewn with innocent promiscuity.

Hence the Patricia fiasco; but also two large canvases, *Love on the Moor* and *Love Among the Nations*, in which an elaborate chain of figures do their best to strengthen the bonds of multicultural intercourse. *Love Among the Nations* is particularly embarrassing, not because of the epidemic of foreplay that has broken out among its cast of characters but because of the childishly racist quality of its fantasies: heavily muscled black men or naked Negresses doing their laborious best to drive the washed-out but titillated Occidentals into states of carnal rejuvenation. It is as if the official Peoples of the World style obligatory in the lobbies of international peace organizations had been redesigned by Lady Chatterley.

Even paintings on this scale were not quite big enough to match the grandeur of Spencer's ruling passion. Nothing short of an entire building, bigger than the Burghclere Chapel, would do to house his manifesto on the union of body and soul. In the late twenties and the thirties, he began

planning what he called his Church-House: a hybrid of a domestic and an ecclesiastical structure that would have at its centre a formal nave and crossing but would also incorporate side chapels, clinically characterized as 'cubicles', in which the worshipper could contemplate the many stages of Stanley Spencer's quest for the orgasmic grail. 'A man raises a woman's dress with the same passionate admiration and love for the woman as the priest raises the host on the altar,' he wrote. Accordingly, there would be a Patricia Chapel, a Hilda Chapel and even an Elsie Chapel, devoted to the maid at Lindworth, whose legs, seen as she pegged out the washing, became cheerfully fetishized by her tirelessly lubricious employer. A passageway connecting the central church space with the cozy domestic rooms would be adorned with the six Patricia nudes, along with a series of *Beatitudes* and *Domestic Scenes*.

Though the *Beatitudes*, with their grotesque and even deformed figures displayed in poses of amorous connection, were perhaps the most universally criticized of Spencer's works, they are actually among his most bizarre and original paintings. Each represents a moment of amorous stimulus – *Contemplation*, *Desire* and so on – but pairs a spectacularly incongruous couple. In *Contemplation*, for example, a rubber-limbed Stanley leans, hypnotized, on the shoulder of a burly inamorata whose monstrously elongated arms end in overgrown chicken claws. *Desire* features Stanley reduced to a pathetic mannikin caressing the arm of a colossally bulbous woman, whose breasts descend like slowly deflating balloons inside her lurid floral-print dress.

Comparisons with Renaissance grotesques or the most aggressive nightmare creations of George Grosz are beside the point. For Spencer, the series was a hymn to the truism that beauty lies in the eye of the beholder, and that the passion stirred by the ordinary and the ugly was just as moving as that stirred by the perfectly chiselled. As a result, he could never comprehend why the *Beatitudes* affronted even his admirers, let alone the wider view that these paintings were the product of a mind unhinged by indiscriminate lust. Nor, for that matter, could he understand the failure of a patron to come forward and sponsor the Church-House, as had happened with Burghclere. After all, since 'I like my own

life so much that I would like to cover every empty space on a wall with it,' it stood to reason that someone, somewhere, must share this unlimited enthusiasm for the Gospel According to Stanley.

No one did, except Hilda, who had become a devout Christian Scientist. Though she refused to return to Spencer's bed or board, she remained devoted to him in every other way. Through all the Patricia years and beyond, when Spencer had fallen seriously out of fashion and was forced to churn out landscapes to make ends meet, she anointed his ego with admiration. They wrote to each other frequently, frantically, and at incredible length, some of the letters running well over a hundred pages. In 1942, Spencer worked up an old drawing of her into a painting that (in sharp contrast to the Patricia nudes) is one of the tenderest things he ever achieved. Though he had brutally wounded her, throughout the forties he continued to insist that she was his true communion, his sacrament, his altar, his Holy Grail. (The Cult of Hilda did not, of course, rule out periodic sojourns in the alternative shrines of a Daphne and a Charlotte.) In any case, as Hilda pointed out sadly, all this mutual adoration came too late. In the forties, while Spencer was working as a war artist, doing scenes of shipyard life at Port Glasgow and flirting with the wife of a local art teacher, Hilda wrote, 'There seems to have been tragedy throughout our marriage. When there should have been complete happiness, it was never quite so,' and, in a blacker mood, 'Physically and mentally I am going under. There are so many degrees of dying. What you are doing is nevertheless a degree of murder.' In 1950, she died, of cancer.

In 1958, Spencer painted his last *Crucifixion*, a piece of shrieking savagery, with Pa Spencer in a swimsuit standing in for the tortured Christ, and two leering executioners, nails between their teeth, witnessed by a youthful Stanley. At the foot of the Cross, the prostrate Mary Magdalene seems to have Hilda's features and wears a skirt with the same checked pattern as the executioner's trousers.

But by 1958 there was no longer any reason for Spencer to see himself as either martyr or murderer. Attempts to prosecute him under

Britain's obscenity laws had been abandoned, and instead of being cruci-
fied he had been dignified as a CBE and a Knight of the Realm. Though
he claimed to hate the work, he continued to turn out landscapes and
portraits of the Great and the Good: Oxbridge dons, boardroom indus-
trialists and justices of the peace. His work hung in the Tate Gallery and
in the Fitzwilliam Museum in Cambridge. He had become, in spite of a
lifetime of un-British self-advertisement, an institution.

That year, my father took me to Cookham. It was, he told me, an
obligatory stop on the Thames-side tour of Great British Culture. We
had already done Hogarth at Chiswick, Pope at Twickenham; and had
taken our leave of Turner at Maidenhead. Cookham still smelled
comfortingly of cups of tea and pints of bitter, and along the riverbank
children were busy emptying bagfuls of bread crumbs down the throats
of mallards. The Wesleyan chapel, where the nine Spencer children had
raised their voices and Stanley had felt a kind of pious clamminess that
made him believe that somewhere there was a warmer, friendlier Jesus,
was now filled with his paintings. 'Hello, the village fête seems to have
got out of control,' my father volunteered as I stared hard at the assort-
ment of bodies curled about the tombstones. 'It's a little much, isn't it?'
I said, unsure whether I meant the piety or the profanity. 'Oh, it's just
Stan,' my father said, as if he had been a lifelong chum of the painter.
'Just Stan having a bit of fun.'

There's no doubt that Spencer deserves to be much better known,
and both Pam Gems's play and the Hirshhorn exhibition will bring him
long-overdue recognition. But to rank him among the movers and shak-
ers of twentieth-century painting seems a pointless exercise, for his
enduring virtue was his unforgettable peculiarity. 'It isn't that he is con-
sciously or intentionally good or bad, or intentionally anything,' the wise
Hilda wrote, 'for he *is* the thing that so many strive for and he only has to
be and a sermon is preached....Stanley's home seems to be the whole
world.' So let's not talk Picasso here. For when someone at the Slade
asked him what he thought of Picasso his answer was, 'I don't know.
I've not got beyond Piero della Francesca.'

3
MODERN MOVES

WINSLOW HOMER

Homer's Odyssey

TWO BODIES, FASTENED TOGETHER, swing through space between a dirty sky and a boiling sea. A young woman, her figure tightly modelled by the saturated dress, face upturned in a half-drowned swoon, lies heavily between her rescuer's supporting thighs. His hands lock beneath her right breast, and his left boot projects through the picture space while his right foot drops like a rudder into the slapping grey-green water. Incongruously delicate droplets stream from the woman's hands into the marine trough that divides a monstrous oncoming wave from the churning breakers. Across the length of the painting is strung the cable from which the bodies are suspended, between a wreck and a bluff – death and life. A little left of centre, a block and tackle, sharply defined against an exploding column of spray, holds the composition stable and secures the destiny of its protagonists.

End of story? Not in a Winslow Homer masterpiece. For although in a preliminary drawing he sketched in the rugged features of the coast guard, the finished version of *The Life Line* shrouds them behind a

windblown blood-red muffler. That calculated invisibility, set in the dead centre of the painting, suppresses any possibility of melodrama, while the visibility of a half inch of knee between sodden stocking and skirt promotes the union of sensuality and pathos. A predictable drama turns enigmatic, hauntingly unresolved.

No matter how many times one has seen *The Life Line*, or the many other canonical works in the great Winslow Homer exhibition now at the Metropolitan Museum, it's impossible not to be struck all over again by their epic power. The forcefulness of Homer's work makes itself felt not so much through its ostensible subject matter, which can be either humdrum or heroic, as through the quirky originality of his composition. The greatest of the pictures break free of narrative description and pull the viewer into a universe of raw animal action, of creatures caught in unsparing nature. Exhibited in 1884, *The Life Line* was acclaimed a tour de force, and was sold for the substantial sum of twenty-five hundred dollars. But many of Homer's other marine paintings, executed with the same dark intensity – *The Fog Warning*, for example – failed to find buyers. Samuel Isham, who, shortly before Homer's death, in 1910, published the first comprehensive history of American art, understood that the rejection of decorative anecdote was what often made Homer's paintings difficult to sell. Unlike Innes's or Whistler's paintings, he explained, 'they will always be windows opened in a wall rather than squares of brocade stretched upon it; they have none of the amenities of the drawing room, and you might almost as well let the sea itself into your house as one of Homer's transcripts of it.'

On Cape Cod, Thoreau had called the seacoast a 'wild rank place... [with] no flattery in it'. Homer, in his later years, consciously cultivated a briny persona that matched this roughness. When he was not communing with the roaring sea from his studio, on Prout's Neck, Maine, he was off in the Adirondacks with his brother Charles, angling for trout. During his lifetime and after, his reputation was that of an inspired brute – an artist whose testiness was legendary and who preferred the company of his dogs and the wheeling gulls to the din of city life. The portrait of the artist as a storm-wracked hero (it's hard to believe he

wasn't pleased by the many puns on his name) answered the post-Civil War need for an assertively and distinctively American painting. But the truth about Homer is more complicated. This was a salt-caked genius who seldom sailed and never swam; who on being faced with the necessity of killing a live duck for a stew preferred to make it a family pet; and who gloried in a huge wardrobe, designed after the manner of an English squire – underwear purchased by the gross, 'trousers of the month' delivered from his tailor. Though many of his arresting images of the Maine coast, pounded by north-easters, are set in bleak winter, he spent some of those winter months in Florida or the Caribbean, producing magically deliquescent watercolours. And, while it's usual to consider Homer the polar opposite of Whistler – confrontationally blunt rather than atmospherically ingratiating – one of the current exhibition's most beautiful rooms displays work from the eighteen-seventies, when Homer painted girls posed ornamentally in window bowers and summer gardens and also the curvy blonde in *The Dinner Horn*, who is lit so that her hips echo the trunk of a springtime tree.

Even in this 'aesthetic' phase, though, Homer was a stubborn oddity. *Blackboard* (1877), which in lesser hands would be a sentimental genre piece, is a psychologically charged study of schoolgirl moodiness. The girl, given physical immediacy by a touch of pink on the outer rim of her ear, turns, like so many of Homer's young women, in pensive profile from the mechanical drawings on the board. With typical slyness, Homer has indicated the smarting confinement of geometry not just by the chalk figures but by austere solid rectangles – flesh pink, slate grey and black (floor, wall, and blackboard) – that partition the picture within its claustrophobically shallow space.

Many of Winslow Homer's best paintings manage to personify American – or even universal – themes in isolated figures or small groups. When, early in his career as an illustrator-journalist, he was commissioned by *Harper's Weekly* to provide images of the Civil War, he painted *The Sharpshooter on Picket Duty*, which eschewed cast-of-thousands battlefield bombast in favour of a single soldier, wedged in the notch of

a tree and peering through his telescopic sights at an unseen target. Instead of opening up the space to indicate some distant quarry, Homer brings the beholder disconcertingly close, as if he were perched in a neighbouring tree. A dab of strategically placed scarlet on the soldier's cap paradoxically puts him in *our* gun sights, as if the sense of vision itself had been made to go soldiering.

Given Homer's resolutely unromantic view of the war, it's perhaps surprising that his Civil War paintings made his reputation. Even when he deepens the picture space, as in *A Rainy Day in Camp (Camp near Yorktown)*, he uses the orthogonal lines of perspective to marshal endless trains of mules, horses, tents and wagons, stretching away to the vanishing point, and suggesting the melancholy infinity of the conflict. In 1867, two of his best-known paintings – *The Prisoners from the Front* and *The Bright Side*, which depicts a group of emphatically undeferential black sutlers resting by their tent – were shown at the Exposition Universelle in Paris. It's often said that Homer brought nothing home with him from this trip by way of painterly inspiration. His profoundest work of these years, *The Veteran in a New Field*, where waves of grain stand in for the numberless war dead, might seem to owe a debt to Millet's monumental peasants but was in fact completed before the French stay. Yet Homer's turn toward social scenery – croquet greens and bathing resorts – does seem to respond to calls, both in France and in America, to replace unpopulated sublimity with 'the painting of contemporary life'.

The exhibition catalogue for the Met show, which includes excellent essays by Nicolai Cikovsky, Jr., and Franklin Kelly, makes much of Homer's 'modernity', seeing in his mallet-swinging or mule-riding ladies exemplars of the Strong American Women that he is said to have admired. At various points in the catalogue, Homer is likewise recruited as environmentally sensitive, racially broad-minded, conscientiously pacifist, child- and deer-friendly, and, for the straw-hat-and-whiskers generation, just a terrific specimen of the New Man.

But Homer, it seems to me, was interested less in modernity than in eternity. *The Two Guides*, one of the freshest and most exhilarating of all Homer's works, unites a grizzled patriarch and his younger partner with

the Adirondack scenery by burying their boots in the windblown waves of fern and bracken. Wisps of early-morning clouds, painted with confident freedom, hang on the hillsides and hover about the men. A sharp point of sunlight catches the wooden handle of the younger man's axe, which is perpendicular to a sliced-away branch. Yet somehow the whetted steel and the wood are made partners rather than adversaries. The entire painting proclaims a natural bond between the antiquity of America's geography and the youthfulness of its history.

Homer's instinct for seeing classical, and even antique, figures reincarnated as contemporary types was allowed full expression during 1881 and 1882, while he was staying in the fishing village of Cullercoats, on the Northumbrian coast of England. Cullercoats had already been adopted as a painter's and photographer's resort, so that the fisherwomen whom Homer translated into mackerel-whiffing Penelopes, scanning the horizon or standing in the shallows while their skirts billow, sail-like, in the wind, would probably have had some experience in posing as objets d'art. But the transformation of simple into grand matter occurred in Homer's medium as well as in his subjects. The Cullercoats paintings are almost all watercolours, which, though a cumulative process of drawing, washing, rewetting, scraping, lifting, blotting, and wiping, invested a medium that was still thought of as delicately picturesque with rugged power. Whether Homer was calculating the precise effect of a wet-in-wet wash to create a great bloom of smoke from a distant ship in *Fisherman's Family (The Lookout)* or building dense layers of grey-black to create the evil sky beneath which the lifeboat in *The Wreck of the Iron Crown* labours, he liberated watercolours from their deference to oils, exploiting their varying degrees of transparency to maximum dramatic effect.

As Homer's watercolours achieved unprecedented clarity, his oils went in the opposite direction, becoming a vehicle for testing the limits of sight. The veiled face of the coast guard in *The Life Line* has been associated with Homer's urges toward simultaneous display and concealment – the boldness of his shyness, as it were – and many of the most profound of the paintings of the eighties make obscurity and visual isolation their subject. The solitary fisherman in *The Fog Warning* – from his frail

dory, weighed down with a pallid catch of halibut – looks desperately toward a mother vessel that appears to be sailing away as the shrouding fog rolls grimly toward him. And the closest to self-portraiture that Homer ever approached was the eerie image of his own studio in Prout's Neck mantled in thick Maine fog.

The Boston *Herald*, in 1884, described Prout's Neck as a 'strange hermitage' and Homer's existence in Maine as one of 'profound and guarded solitude'. He had chosen to live there so as to be next door to his brother Charles, whose retreat was known as the Ark, but during the twenty-five years Homer spent there, up until his death, he became inhospitable to any other kind of human company, deterring enthusiasts and would-be biographers and claiming to paint strictly for the money. Behind this curmudgeonly guise, however, a profound alteration in his sensibility was taking place, as it shifted from a descriptive to an imaginative, even mystical, temper. Humanity, once a leading player in his portrayal of nature's epic performances, now played only a bit part. Throughout his career, Homer was strangely evasive about physiognomy, repeatedly summarizing facial appearance, turning heads to the rear or to quarter profile, or hanging lengths of hair over the face. And by the mid-nineties the only face that interested him was the countenance of the ocean. Where the brawny pair of Adirondack guides seem to draw strength from their habitat, the hunter in *The Winter Coast*, his features virtually invisible, is artificially miniaturized in relation to the granite slabs and the clouds of sea foam that confront him. Instead of commanding the scenery, Homer's creatures become its prisoners.

When Homer concentrated on his essential subject, his painting abandoned realistic description for an expressive sensationalism unprecedented in American art. The formal organization of the late marine paintings is aggressive in its compressions of depth and space. A square format, as in *On a Lee Shore* and *Cannon Rock*, reinforces the sense of entrapment by perpetually returning the beholder's gaze to the centre of the painting, like flotsam driven by the tide. While Homer undoubtedly wanted these paintings to represent the creative and destructive moods

of the sea, the truth of these representations is less literal than virtual. The rolling, heaving forms establish their own hypnotic rhythm, working on the surface of the canvas yet retaining their identity as forces of nature. Giddily, we sense as much as, or more than, we see.

On the rare occasions when figures are set against the ocean they are almost always women, and at such moments Homer, the lifelong bachelor, seems to suggest a natural sympathy between the tidal flow of human and marine life: the sea as the great matrix of the world. The same passion for sea-mothering turns up throughout nineteenth-century culture – most movingly in Jules Michelet, Victor Hugo, Whitman and Conrad. But none of them come close to Homer's *Summer Night* (11), where, bathed in milky moonlight, a group of women sit watching the reflections bob and lift while two others dance in syn-chronization with the lilting ocean. The dress of one of the women seems itself a surfy cascade, on which her partner, with closed eyes and dreamy expression, rests her cheek. For the last time, Homer's bodies touch, and their hands, held out over the ocean, fold gently against each other, like the waves that are rolling – serenely, for once – to the shore.

American Illusions

The Rubin Lecture on American Art, the Metropolitan Museum of Art, New York, December 1998

IN THE SPRING OF 1993 Secret Service agents working for the Department of the Treasury confiscated the work of the artist J.S.G. Boggs. Their interest in Boggs's art lay in the fact that the artist's speciality was painstakingly copied, actual-size images of banknotes. Specifically, Boggs was charged with violating the 1909 statute which prohibited the reproduction of non-official copies of what are officially described as 'monetary tokens', except those either made or sanctioned by the Treasury. Now, as it happens, my family were in a Washington DC souvenir store just the other week where photographically exact copies of, say, Grover Cleveland thousand-dollar bills or Jefferson two-notes are available as message pads, dishcloths, or, if that's your kind of thing, as items of underwear. So I have to say that Mr. Boggs's suspicion that the statutory ban is honoured more in the breach than the observance seems to have a point. In any event, he sued the Treasury for the restoration of his work. In December 1993 Judge Royce C. Lamberth of the District Court of Columbia ruled in favour of the Treasury and the

114

Department of Justice on the grounds that Boggs's 'art bills' could in fact be taken as genuine currency, adding the pithy comment that 'it is often said that a picture is worth a thousand words. Unfortunately, Mr. Boggs's works are often worth a thousand dollars'.

This was not the first time J.S.G. Boggs and his art pieces had got themselves in trouble with the law. Indeed, he seemed to have the knack of actually attracting its attention. In 1986, when he was working in London, he was briefly jailed on a warrant from the Bank of England for offences against the integrity of the pound sterling (in those days in need of all the integrity it could get). Who knows what he has in mind for the Euro? Of course, as I'm implying, I hope not too uncharitably, the kind of stunt-art, which in the nineteen-eighties was cropping up like mushrooms after a downpour, actually presupposed intervention by the indignant authorities in order to complete the art-performance. Otherwise the gadfly would go unnoticed and, in this case, the rather jejune little commentary on the relationship between art and value, go unheeded. By the late nineteen-eighties, in any case, the joke had already worn a bit thin. Andy Warhol had already done his versions of dollar bills; Joseph Beuys had scored through a Deutschmark with the inscription *Capital = Kunst* (brilliant, no?) and Boggs himself merely repeated an old trick perpetrated by both Duchamp and Picasso when he offered to pay a restaurant bill with a work of art, the slightly lame joke in this case being that the art in question was a copy of the dollar bills with which he would have otherwise have settled the cheque. One of the sadder images in the sad history of aggressively self-promotional art is the photograph taken by Boggs as part of his subsequent installation, drolly called *Dinner for Eight*, of the waiter looking nervous as to whether he had done the right thing in accepting the spurious joke money on the grounds that, as it was valuable 'art', he and their management would surely come out ahead on the transaction. One can imagine the scene: the firing; the telephone call; the 'Awfully sorry about your job, Antonio. Why not write it off as a sacrifice for post-modernist performance?'

Of course, Boggs could always claim himself to be part of a particular American tradition – and in an article in *Art and Antiques* he did

exactly that, noting the fact that his arrest in London occurred exactly a century after the trompe l'oeil painter William Michael Harnett had his work impounded by Treasury agents on suspicion of being counterfeit currency. But the historical circumstances could hardly have been more different. Boggs was (and I guess still is) working in a culture in which anything goes, in which the old boundaries – between 'high' museum art and commercially reproduced artifacts (that Soup Can); between the studio creation and the ready-made (that wine-rack); between the one-off original and the knock-off multiple (that Elvis); between the thing as social icon and the thing as formal arrangement of colour and line (that flag) – have long, *long* gone.

Harnett on the other hand (who had been doing his dollar paintings since 1877 when he first sent one to the Philadelphia Institute of Art show), was operating at a time when the nature of money, and in particular paper money, was a major cultural and indeed political obsession. In *The Rise of Silas Lapham* William Dean Howells put into the mouth of one of his characters: 'there's no doubt but money is to the fore now. It is the romance, the poetry of our age'. But in the midst of the dizzy uncertainties of the gilded age, there was a good deal of uncertainty as to what *real* money was? Was the real thing clinking, bite-tested metal specie; was it paper backed by the real thing – gold – or was it paper that could be backed by the silver being dug up by the cartload in the West? How *real* were the free silver certificates? Could you pay your rent with them? And what good were those bills issued by thousands of different private banks – as quick to come and go – as those mysterious entities operating out of Delaware offering us credit cards every week? This was also the golden age, as it were of *real* counterfeiting. The Treasury agents who raided Harnett's studio were actually hot on the trail of New York's most notorious forger, known to the police as 'Jim the Penman', and who, when finally caught, turned out to be a former sign-painter and German immigrant named Emmanuel Ninger. Living and working in New Jersey Ninger actually took as much pains over real fakes as Harnett did with his fake fakes, pressing banknotes on to damp, coffee-stained, silk-fibre paper and then tracing the lines and colours. Needless to say, many of

Ninger's thousand-dollar bills remained in circulation and actually appreciated well over their face value for anyone lucky enough to have one and not get prosecuted.

William Harnett had only become suspect when his actual-size bills had been brazenly displayed in a place of public resort and recreation (rather than in a museum show); in particular at Theodore Stewart's saloon, imprudently close to City Hall, and a regular haunt of the police as well as city officers. It was the same establishment where his most famous illusionist painting, *After the Hunt*, was on permanent show, and both that painting and the dollar pictures were evidently major attractions, drawing wagers and bets as to whether the objects were painted depictions or their material selves. In his defence Harnett insisted that 'I do not paint from nature' and that since he had deliberately painted the banknotes in a crumpled or tattered state, it was obvious that he meant them to be picturesque objects, akin to the well-smoked pipes or battered books that he and his friend, John Frederick Peto, favoured as objects rich in social associations, things that had been much used. 'I explained to the [police] chief how I had happened to do the work and showed him the harmless nature of it. Harmless though it was, it was clearly against the law and I was let go with a warning not to paint any more life-like representations of the national currency – a warning it is almost needless to say that was conscientiously heeded.' But not all Harnett's colleagues were quite so easily chastened. John Haberle, an assistant at the Yale Paleontological Museum, and an expert preparer of fossil specimens, had a quite different response when he too was threatened with the rigour of the law for taking the 'national currency' in vain. Instead of doing what he was told, Haberle made the clumsy intrusion of the law an element of the art itself: inserting his own picture into the compositions, as if to help the dunderheaded police identify him, giving them titles like *Imitation*. In 1888, barely two years after Harnett's run-in with the law, Haberle – the true ancestor of American pop-art conceits – literally made a spectacle of himself when he produced the punning *Can You Break a Five?* that included a faux-newspaper review admiring his earlier *Imitation*, and the back of a single dollar, with its

solemn warning against imitations clearly visible. 'Counterfeiting or altering this note...or having in possession any false or counterfeit plate or impression of it or any paper made in imitation of the paper on which it is printed is punishable by a five thousand dollar fine or fifteen years' hard labour or both.' Just in case anyone missed the point, Haberle also included a pair of broken eye-glasses beside his bills as if challenging the evidence of the spectator's eyes: 'Can *you* break a five?'

Harnett and Haberle offended twice over – against the codes of financial and of cultural authority, both struggling to assert their dignity amidst the speculative excesses of the gilded age. On the first count, they seemed knowingly to subvert official endeavours to persuade ordinary Americans that decisions regarding basic economic security could indeed be entrusted to the money-arbiters of Washington and New York. Both of these artists were, in their mischievous ways, offering a reading of American history through the relationship between presidential power (the icons on the bills) and economic power (the authority of the banks). Hence the conspicuous presence of an earlier warrior for the people versus the banks, Andrew Jackson, on the face of Haberle's five, even though, I believe the face ought to have been then, as it is now, that of Lincoln. The disparity between the myth of enduring money and its evident ephemerality – in the so-called 'shinplaster' currency issued during the Civil War and repudiated just two years before Harnett produced his first paintings – was also inscribed into the bruised, worn and ragged notes they favoured. Some other illusionist painters, in particular the historically fascinating (though artistically inferior) Victor Dubreuil, used their skills almost entirely to campaign on what was thought to be the side of the people (that is the bimetallists who campaigned for currency based on silver to have the same value-status as currency backed by gold), against the eastern conservative-gold establishment. Dubreuil's *Cross of Gold* was, of course, the precise visual equivalent to William Jennings Bryan's famous speech to the Democratic Convention of 1896 (and in a later age would have made a stunning piece of political advertisement), with thumb tacks standing in for the crucifying nails.

For the guardians of cultural authority in the eastern establishment,

the offences of Harnett, Peto and Haberle were even more grievous than their critical scrutiny of fiduciary orthodoxy. Indeed, of course, very often the pillars of the financial and the museum-patronage world were one and the same. But they were often guided in their axioms of taste by artists gathered in institutions like the National Academy of Design, who saw themselves in the high-minded role as cleansing the American temple of its most sordid preoccupations with filthy lucre (notwithstanding that, or maybe because, so many of the lucre-loaded were their patrons). This was the age when American art felt itself appointed to a redemptive vocation: the rescue of the republic from the dross and gim-crackery of its relentless commercialism. Crucial to this sense of art as saviour was its sharp distinction from photography: the medium of pseudo-art; of journalism; of advertisement; of cheap tourism and other sorts of naughtiness. Now here, in the creations of Harnett and Haberle, was something that purported to be art, but which actually seemed to rejoice in its kinship with these other varieties of vulgar imagery: the images of the marketplace; a pseudo-art that was based on the most debased standards of mimcry and cheap, photographic verisimilitude; a Barnum-and-Bailey art; a painter's freak show that smelled of fairground candies and saloon tobacco. The mere idea that the *saloon* had usurped the place of the *salon*, was bitterly mortifying to the first generation of the museum elite. It was akin to the shock registered (by Frederick Law Olmsted among others) when it was suggested that the unwashed hoi-polloi might actually be allowed to picnic in Central Park and that it might be provided with pedestrian paths as well as carriage roads.

The art establishment of the academies, institutes and museums, for the most part, held Harnett, Haberle and Peto in contempt as an aesthetically lower life-form, as a bottom-feeder off the regrettable public taste for sensation, even perhaps as crooks. A Chicago art critic played right into Haberle's hands by alleging that his painting sent to the Institute was 'a fraud of which it is not pleasant to speak. It is that alleged still-life by Haberle supposed by some to be a painting of money. A one-dollar bill and the fragments of a ten have been painted on canvas cov-ered by a thin scumble of paint and further manipulated to give a painty

appearance. That the management of the Art Institute should hang this kind of "art" even though it were genuine is to be regretted; to lend itself to such a fraud whether unwittingly or not is shameful.' The word 'art' invariably appears in this kind of comment in quotation marks for, as the critic of *The New York Tribune* explained in connection with a Harnett painting (*Social Club*):

> ...the real fact is that the charge of inferiority is justified by the consideration that this imitative work is not really so difficult as it seems to the layman...when we come close to works like this of Mr. Harnett it is evident that only time and industry are necessary to the indefinite multiplication of them. There are sign painters in plenty in this city of ours – and in all great cities today – who have only to be sufficiently discontented with their present calling to aim at the name of artist to rival Mr. Harnett...

Harnett and his ilk were, queer birds, ugly ducklings, then rude mechanicals. No wonder that they failed to understand that by reducing art to the contrivance of deception, they robbed it of its moral vocation. The 'aha' aspect of illusionist art, it was commonly said, was devised solely to persuade the spectator to admire the cunning of the visual magician, much as they might admire a conjurer or an escapologist, and that was to confuse art with artfulness. The painter George Inness, very much at the top of the professional tree went even further by identifying the meretriciousness of this art, its deep falsehood, as its essential characteristic.

> [paintings]...of a barn door with hinges on it and a keyhole painted so well you would swear the hinges were real and you could put your finger in it; but it is not real. It is not what it represents. It is a lie. Clever, but it gives no sensation of truth because before you look at it you are told that it is a lie. The only charm is that the picture is deceiving you... Now in art we are not seeking to deceive. We do not pretend that this is a real tree, a real river but we use the tree or the river as a means to give you

the feeling or the impression that under certain conditions a certain effect is produced upon us...

The incoherence of Inness's defence of Impressionism (compared to the polemical clarity of his criticism of trompe l'oeil) suggests what was at stake for his generation: precisely the implication that illusionist painting was a paradigm for *all* art; that it was only an extreme version of the deceptions on which every kind of art based its practice. This was a horrifying thought, especially for a generation itself engaged in a struggle over the nature of realism, over the nature of truth and falsehood in painting. Remember that the last quarter of the nineteenth century was the heyday of positivism: the philosophical doctrine that the world was constituted from a bedrock of scientifically discernible matter, and that it might be possible for art, imitating the systematically cultivated objectivity of science, to reveal the core reality of the material world. To the untutored eye, of course, the representations of that reality would appear drastically different from traditional assumptions of verisimilitude that merely reflected the surface or skin of things. Instead, Impressionist technique or later Pointillist technique would offer optically and kinetically 'true' visions. So, for these advocates of a newer, truer reality, it was unutterable agony to watch and listen to the crowds at the Chicago Art Institute or the National Academy of Design praise Harnett or Peto's letter-racks or bookshelves as 'astonishingly lifelike'.

William Merritt Chase, the epitome of high-art production, always made a point of reminding his students of the story 'of the picture of the fruit which was so natural that the birds flew down to peck at it'. 'I do not need to see that canvas,' he admonished them, 'to know that it was a terrible thing.' Though, when humorously challenged by one of those students to see if the despised imitative skills did actually require any skill, Chase obliged with a faux coat-peg at the precise place where one of his colleagues was accustomed to hang his hat – with the predictable result: hat drops to floor, Professor scratches head, hat drops to floor again, class convulsed with tee-hees.

It's interesting, though, that in his own account Chase carefully

avoids mentioning that the story of the birds and the grapes is not just some random anecdote, but the account given by Pliny in his biographies of ancient Greek artists, of the skills of one of the greatest of them all, Zeuxis. For the young students of the academy were still supposed to admire classical precedent and it would embarrass the claims of nineteenth-century art to concede that its founders in antiquity were unapologetic about defining it in essentially imitative terms. Art was born, the ancients liked to say, when Narcissus saw his own beauteous reflection in the water: the creation of the first perfect copy, the mirror of nature. Statues of Narcissus were, then, prized in so far as they, too, could claim the status of the exact copy. Callistrates' *Descriptiones*, for example, described one such statue, which was 'so delicate and which imitated the mantle so closely that the colours of the body shone through the whiteness of the drapery, permitting the gleam of the limbs to come through'. The *work* of art – that is, its task – according to ancient writers was to give figures and objects a second life, virtually indistinguishable from the original, or as Philostratus concisely put it: 'painting *is* imitation through the use of colour'.

The candid confession that art was indeed about imitative illusions was most famously exemplified in another story related by Pliny in which Zeuxis's rival Parrhasius displayed:

> ...a picture of a linen curtain so realistic that Zeuxis, elated by the verdict of the birds, cried out that now at last his rival must draw the curtain and show his picture. On discovering his mistake he surrendered the prize to Parrhasius, admitting that he, Zeuxis had deceived only the birds while Parrhasius had deceived himself, a painter.

From that moment on, the trompe-l'oeil curtain became the equivalent of a rhetorical exclamation (especially exploited by the Dutch who used actual curtains to protect their pictures from dust), simultaneously advertising the magical skills of the artist, but also frankly celebrating, rather than apologizing for, the essentially artificial nature of the craft.

Some of the first moveable paintings we know of were themselves illu-
sionistic curtains, created by a Greek artist called Agatharos for plays by
Aeschylus performed before the emperor Augustus. So, from the very
beginning, painting was invested with a decidedly theatrical, you might
say, showy character.

But this spectacular quality took two very different forms,
each of which could be adopted by claimants to the classical tradition as
representing its authentic legacy. On the one hand, there was 'mega-
lography' – let's call it 'grand illusionism' – that took its cue from the
myth of Vulcan who was said to have represented the entirety of the
heavens and the earth and all the doings of gods and men, all this on the
shield of Achilles, a feat that might conceivably be beyond even Julian
Schnabel. On the other hand, there was 'rhopography', from the Greek
word *rhopos,* for the trivial or picayune – let's call this 'little illusions' –
the representation of commonplace things often in a state that advertises
their ephemerality, like the startling mosaic of an unswept floor (itself a
second-century AD copy of an original said to have been by Sosos of
Pergamon), where life-size mice and insects root around the left-overs
(peapods, nutshells, chicken claws) strewn about from a Roman feast.

The descendants of the two genres were, by the eighteenth century
classified as history painting and *nature morte*, still life painting, respec-
tively the most, and the least, noble forms of art according to the so-
called hierarchy of genres. But to stay for a moment in an older past, once
pagan Europe had become Christian, *both* manners of illusion posed
problems for the custodians of religious orthodoxy like St Augustine who
damned all images as seductions of the eye, expressly designed by satan
to seduce believers away from the Gospel truth that was accessible
through prayer and faith, not through the senses. As long as such illu-
sions were confined to sacred manuscript illuminations, it was thought
they would, in some sense, be guarded by the text but, until the twelfth
and thirteenth centuries, the Church still remained suspicious of painted
images as sacrilegious 'second creations': copies of things to which the
Creator had already given perfect form. This wariness was relaxed by
Aristotle, or more exactly by his medieval interpreters like Thomas

Aquinas who inherited the Aristotelian division of the universe into 'Essence' (things spiritual and inaccessible to reason and the senses) and 'Existence' (things observable, including the natural world). Once this dualistic division was acknowledged, the world of men and nature might indeed be freely explored without any danger of trespass on the realm spiritual.

And so it might also be painted. Two inventions – one made in southern Europe, the other in the north – transformed the possibilities of illusionistic painting. The southern invention was, of course, perspective, which opened up illusory space behind the picture plane in which the great Christian and mythical narratives could epically unfold. The northern invention, in the Low Countries, was free-standing oil painting, which created hitherto undreamt-of possibilities for the life-like representation of solid objects and landscapes.

It was not accidental that this second innovation, the loving, almost fetishistic description of objects, was most brilliantly achieved in the Burgundian Netherlands. For that was the culture in which the line between the decorative arts and what we now call the fine arts, was most porous: where tapestry-weaving, the cutting and polishing of gems, the gilding of plaster and leather, the carving of wood, the dying and embroidering of textiles, the engraving and staining of glass, were all seen, not in opposition to, but as a necessary enrichment of, sacred histories. Hence the glossy radiance achieved in the details of the paintings of the brothers van Eyck or Hans Memling or Petrus Christus are rightly called brilliant, the same adjective applied to work in gemstones. Hence, too, the unembarrassed elaboration of the draperies and robes in which Flemish art costumes its Madonnas and saints. Of course, to the apostles of the grand illusion, like Michelangelo and his biographer Giorgio Vasari, this was trinkets and trumpery, the kind of thing the Netherlanders were good for; the sort of thing Michelangelo told Francesco da Olanda was admired by women. In fact there were occasional Italian illusionists like Angelo Moro who, in an astonishing anticipation of Magritte's sleights of hand, painted a canvas peeling away from its backing which itself displays an identical scene. But it's safe to say that

Michelangelo would not have had much time for this kind of thing either, except as low diversion. And for generations, at least until Italian opinion acknowledged Rubens as a true peer, Netherlandish artists had to live with the backhanded compliments of being classified as masters of the commonplace.

For that matter, the life-like representation of objects also had its critics north of the Alps. It was precisely the skill at conveying the surfaces and textures of things that most offended the antagonists of Church imagery during the years that led to the Protestant reformation in the sixteenth century. Salvation (when not pre-ordained) would be promoted by attention to the spoken and written word of scripture, not by dallying among idolatrous images. The pictorial tradition was so strongly rooted in the Netherlands that all the Calvinist sermons could not manage to strangle growth of new painterly creativity. But it did leave its mark on still-life painting, the genre that was most open to the criticism that it was a form of worship of dead objects. So one of the very earliest Dutch still life paintings, Jacquyes de Gheyn II's *Vanitas,* is a paradoxical statement of contempt for the very things that are so precisely represented and that – from the tulip to the bubble, to wisps of smoke, the medals and coins – all had strong associations of transience, vanity and death. Right at the beginning we have life-like technique mobilized to argue that earthly life is itself an illusion.

Of course *vanitas* paintings did not encompass the whole of still-life painting in the Netherlands, but they did make up an exceptionally important part of the genre. When taken together with the ostentatiously simple subjects of half-eaten meals (the *banketjestukken*) or breakfast pieces, they were bound to exercise a strong appeal to later generations of American artists who had their own reasons for immortalizing the mortality of the world; for insisting on the artificiality and ephemerality of fame and fortune, and doing so by representing their objects as unnervingly *real*. But the crucial point is that for a few generations, at any rate, Dutch still life painters managed a kind of adroit moral insurance policy by which they built into their arrangements a profound sense of the impermanence, let's call it the *illusory* nature of the material

world. This often mandated references to smoking, a conventional emblem of idleness and time-wasting, to music, another form of sorcery for the unserious; and it also sometimes even included art itself among the repertoire of vanities. For the Dutch, at least, *all* fame was, if you were fortunate, just fifteen minutes long.

Then, around the middle years of the seventeenth century, a noticeable relaxation occurred. Perhaps it was the end of the eighty years' war for their freedom from Spain with the peace signed at Munster in 1648. Perhaps it was their unparalleled prosperity, the sudden and dizzying acquisition of a spectacular colonial empire in the East Indies. Perhaps it was just the natural evolution of the ruling patriciate from a business and trading class to the second generation who became rentiers, bankers and real estate moguls and who developed correspondingly more sophisticated tastes. Increasingly, these tastes were classicizing and self-consciously cosmopolitan and refined. The compelling description of humble, patched and worn things (like the astonishing detail of plaster peeling away from a wall to expose the brick in a corner of one of Rembrandt's earliest paintings) suddenly seemed embarrassingly homely, as did still life paintings that had as their subject half-eaten pies and fish.

Instead, the most skilled artists now took to exhibiting their talent, not just in arrangements of precious objects that themselves embodied more glittering plutocratic pretentions (like Willem Kalf's), but also in promoting themselves as virtuosi of visual illusions. The most telling example of this change was Samuel van Hoogstraten who started his career as one of Rembrandt's most talented pupils, but who, by the sixteen-fifties had set his sights on something much grander than the rewards available in his provincial home town of Dordrecht (where he had already become a master of the local mint). He won fame in Vienna in the court of the Holy Roman Emperor, Ferdinand III, and a place in the archives of the successors of Zeuxis and Parrhasius by fooling the emperor himself with one of his *oogbedriegetjes* (optical deceits), and was, as the story goes, 'punished' for his temerity by the enchanted prince keeping Hoogstraten's work for himself. This optical manipulation was the making of Hoogstraten's reputation, not just as a virtuoso artist, but

as an *honnête homme,* which means the opposite of what it should – not someone of transparent artlessness, but someone who had cultivated the art of witty and gracious pleasing, the sine qua non of a successful courtly life. It should come as no surprise, then, to discover Hoogstraten celebrating his success by painting a succession of trompe l'oeil pieces all of which gathered together the trophies of his social success: the chain and medallion, with the emperor's likeness upon it, and the toilet items that signified his gentility, his graduation from the ranks of the merely middle-class.

Hoogstraten was not the only painter who achieved success with this kind of illusionism. Wallerand Vaillant inaugurated the letter-rack tradition, a device expressly calculated to intrigue the beholder with snippets of autobiographical information, half-revealed, half-concealed, and which fabricated a kind of personal agenda for the artist through items of correspondence with the rich and famous like the princes of Orange-Nassau. Cornelis Brizé, otherwise rather a nobody, could likewise advertise both his skills and his connections by painting this illusion of official documents of the Treasury of Amsterdam; and the most technically accomplished of them all, Cornelis Gijsbrechts, the inventor of the Quodlibet or 'What have you?' got the Parrhasius memorial prize by producing a painting in the likeness of the back of a stretched canvas. The work was deliberately designed to be stood against the base of a wall as if it were a piece that was still incomplete or awaiting hanging, luring the unwary to turn it about and be duly thunderstruck by the discovery that what he had supposed to be the back of the picture was in fact its front.

Laughs all round, a pat on the head by an amused prince or patrician, gales of appreciative titters from the courtiers. But it's possible to read these visual performances – the painter as court jester – in both a flattering and unflattering fashion. You might say that Hoogstraten and company were indeed merely following the cue of antiquity in their candid profession of art's mimetic power. For they were not at all mindless but almost dauntingly mindful of what they were up to. Hoogstraten published the most influential Dutch theoretical treatise on painting in 1678 and pointed out that one of the generic terms used for life-like

paintings was *contrefeitsel*, which to the modern ear sounds suspiciously like counterfeit, but to the seventeenth-century painter was morally neutral. 'A perfect painting,' Hoogstraten wrote, 'is like a mirror of nature that makes things that do not exist appear to exist and deceives in a pleasurable, permissible and praiseworthy manner.' On the other hand, of course, there were those who protested against that truism, who argued that art's higher vocation was a pursuit of an unliteral truth, something not to be confused with the rendering of surface reality.

At which point we need to return to the USA. Now you might suppose that with the proclamation (on the dollar bill of course) of the masonic *Novus Ordo Saeclorum*, the new order of centuries, that is to say, the *American* order of centuries, all these debates would become obsolete; that intuitive American can-do practicality of a Franklin-Jeffersonian kind would prevail to make all such distinctions between noble and ignoble art forms redundant. But, as we've already seen from the response to Harnett and company, this was emphatically not the case. Almost from the outset, American painting was seen as a redemptive and ennobling art; whether in the neo-classical idiom of history and portrait painting, or the Romantic idiom of landscape. What was freshly American about it was less any kind of redefinition of art itself (akin, say, to the genuine redefinitions that occurred in Holland in the sixteen-twenties, in Paris in the eighteen-sixties, or in New York in the nineteen-forties), than an application of the existing hierarchy of genres to American subject matter. Thus it was possible for Benjamin West (admittedly someone of less than burning American zeal) to move freely from stately American subjects, like Penn signing a Treaty with the Indians to Agrippina with the Ashes of Germanicus, which made his name with King George III. Whether in architecture or history painting, the language of classicism, indeed of Old World *European* classicism, was adopted for the Jeffersonian project of civic virtue.

The young American republic, you might then say, was proud of being low-born but high-minded, and its cultural citadels like Boston and Philadelphia were thus not especially promising terrain for an art of the commonplace to prosper. Even its decorative arts, as any connoisseur

of Paul Revere's austerely elegant silverware, or the best American furniture, would agree, had loftily grand pretensions. So it was hard luck on the relentlessly enterprising Charles Willson Peale, the founding father of Philadelphia painting, that of all his sons it was Rafaelle who *ought*, by virtue of nomenclature, to have exhibited the qualities of high discipline and measured self-containment, but who was the scapegrace of the family: drunk, spendthrift and dissipated. But we should always beware of projecting too directly from biography to style, for what work Rafaelle completed, does in fact have the exacting linear clarity that lives up to his monniker, though it falls far short of the Renaissance master's elevated subject matter. Perhaps it was just because Rafaelle Peale personally was such a disgrace to the republic of virtue that he felt free to incorporate into his work the quotidian fabric of American life and also had the temerity to do so with a bemused even slightly satirical eye. *A Patch for Dr Physic* continues the letter rack tradition started by Vaillant and much in vogue in France, but takes the history of public health, from Dr Hunter of Edinburgh to the great local hero of medicine, Benjamin Rush, and sticks them pell-mell into the same epistolary collection. More seriously (or more whimsically), Rafaelle's most famous painting, *After the Bath*, has attached to it a Plinyesque apocrypha of visual deceit, namely that the artist's wife seeing a pretty pair of arms and feet exposed from behind a sheet, assumed her husband to be concealing a mistress and was, as the story goes, only *slightly* mollified to discover her error. But the fun that Rafaelle was having here was actually less at the expense of his wife than his father, or rather the entire classical tradition that had become an iron orthodoxy in America, not least in the academic figure – the necessary condition of an artistic career in Philadelphia as it was in London, Paris or Rome.

Two generations later, when William Harnett (who had been born in Ireland during the famine year of 1848) entered the Philadelphia Academy, it was still, according to Edward Austin Abbey,

...a fusty fudgy place...the trail of Rembrandt Peale and of Benjamin West and all the dismal persons who thought

themselves 'Old Masters' was all over the place and the worthy young men who caught colds in that dank basement with me and who slumbered peacefully by my side during long anatomical lectures all thought the only thing worth doing was the grand business, the 'high Art' that Haydon was always raving about.

It was in sharp reaction to that academicism, as well as to the grisly sentimental genre paintings that were churned out to please popular taste that the greatest figures of the post-Civil War generation – Winslow Homer and Thomas Eakins (who had returned to teach at the Philadelphia Academy when Harnett enrolled in the eighteen-seventies), embarked on their heroically experimental careers. But the dominant tone was set, not by their scoured-down crisply focused realism, but by its opposite, the luminist panoramas and late Hudson Valley school vistas, washed in the light of America's historic and spiritual destiny, the kind of thing that the deans of the National Academy of Design in New York – the men whose bottoms filled the armchairs at the Century Club – had baptized as definitively native. Ever since Thomas Cole had sketched out the basic principles of light-drenched and allegorically-loaded landscapes, the transcendentally spiritual quality of the American landscape had been visually expressed by exposing the beholder to the vastness of its continental space. So the techniques of our megalographers, the grand illusionists – powerfully deep recession, what we might now tend to see as cinematically colossal deceptions of scale and height, a revelation of the illimitable – all these in the work of the most grandstanding practitioners, like Thomas Moran and Albert Bierstadt, defined an American triumph by converting history painting into geography painting and with no loss of epic stature.

This is what William Harnett and John Frederick Peto would have seen dominating the galleries of the Philadelphia Bicentennial Exhibition of 1876. And it is what makes their own drastically different choice of subject matter and technical manner so astonishing. Instead of infinite recession, we have virtually none at all (rather, a claustrophobic proximity). Instead of the great outdoors, we have the worn familiarity

of the indoors and the shop doors. Instead of an expansive view of America the Beautiful, we have a minutely sectioned slice of America the Homely. Instead of the picture plane being treated, as all theorists from Leon Battista Alberti onwards had instructed – as a window behind which, thanks to perspective, an infinity of space stretches – we have here a shallow space that actually projects in *front* of the picture plane. And – and this seems to me the most breathtaking of all the qualities embodied in these wonderful and intellectually subtle paintings – instead of the devices of pictorial illusion being taken for granted, taken as read, you might say, and laid out in the service of the subject matter, those devices are *themselves* the unavoidable subjects of the paintings: their reason for being. Assumed to be the most anachronistic of all kinds of paintings, they ought actually to be seen as the most radically innovative, for they are the first American paintings to confront the beholder with the intrinsically synthetic nature of painting, *mirabile dictu,* with flatness: the flatness of the letter rack, of the office board, of the five-dollar bill; the paradigm, not just of still life, but of all art.

Have we heard this sharp riff on flats before? Yes we have. It was Clement Greenberg, who, in arguably his most important essay, defined modernism as the turning away from traditional painting's long struggle to overcome the inherent confinement of its two dimensions, its flatness. Instead, Greenberg argued, artists beginning with Manet embraced flatness as the peculiar province of painting and created an art that would guarantee that the beholder would never forget it. For Greenberg, this aggressive self-consciousness about art's reduction to its intrinsic characteristics was its liberating condition. Once released from the reality-assumption, painting could be free to present itself as pure arrangements of colour and line, which might be pleasing, disturbing or, if the artist were, say, Mondrian, occasionally profound.

Now the epistolary grids of Harnett and Peto have sometimes been compared with those of Mondrian (not to mention, of course, of Braque and Magritte), though I must say that such comparisons, for the most part, seem over-stretched. But even if you're doubtful whether or not they represent the ancestry of Rauschenberg and even Warhol's

play between art and its objects, they do, it seems to me, have a strong claim to be included in any exhibition of modernist still life like the ambitious show at MoMA where, in fact, they are conspicuous by their absence.

Suppose you and I were curating that show and wanted to make a case that Peto, Harnett and Haberle ought to be included. How would we make that case? First, perhaps, we would want to refute their contemporary critics' claims that these are the most conceptually empty products of American painting. We would point to their being packed with the very characteristics that the critics assumed was absent: their strong concentration on formal arrangements, on patterns of colour and line (as in the pinwheel spiral of flat planes of colour in Peto's work. Then we would want to argue for the narrative richness of these pieces (against Jean Baudrillard's breathtakingly ignorant claim that all trompe l'oeil paintings are, by definition, bereft of narrative). Not only are there narratives here, but a kind of populist commentary on the nature of American history, no less eloquent than old-style history painting for being tightly compressed into an array of artifacts (never, by the way, as Baudrillard also claims, an arbitrary array). You would suppose that the kind of mischievously disenchanted commentary on the pieties of American culture that turns up in Peto and especially in Haberle might have struck a post-structuralist by its ironic force. Haberle's *Changes of Time*, for example, counterpointed the commercial Currier and Ives mythologies of the American presidential succession with a pecuniary version of history, from the currency of the British colonies, through revolutionary bills all the way to the five-dollar silver certificates bearing the face of Ulysses S. Grant.

On one important point, the nineteenth-century critics of these paintings were absolutely correct. They were notoriously, indeed aggressively, promiscuous in the kind of imagery they thought fit for representation; which is to say anything that washed up in the flotsam of contemporary culture: shinplasters, shop signs, cigar boxes, postage stamps, playing cards, news clippings, old and new photographs, graffiti and chalkboard inscriptions, ticket stubs, food cans, postcards of places and faces and, in some cases, like Haberle's wonderful *Bachelor's Drawer*, of

1889, rather more than faces. All these things were collected and ordered both for their contrasting and intersecting formal qualities (colours, shapes) *and* for their eloquence as signs of the past and the present; their marks of human use and abuse. There is a sense in the best of these pictures of the chaotic quality of social experience, of its arrival pell-mell in our days, and the resistance of so much stuff to careful ordering, which the beleaguered guardians of American civility, like Henry Adams and indeed Henry James, found so upsetting. And lest it pass unnoticed in Haberle's little masterpiece, we even have this sense of pleasurable chaos (in his case about to be succeeded by the modicum of order necessary to his imminent married life), embodied in the *Bachelor's Drawer* being seen simultaneously from above *and* side-on.

Neither Harnett nor Peto essayed this kind of innovative mischief from the beginning. Both of them were from comparatively humble backgrounds, Harnett suffering his father's death when he was just thirteen and being obliged to go on the streets as errand boy and news vendor before getting himself apprenticed to a silver engraver. Peto's father went through a number of trades, beginning as a gilder and framer, then running a restaurant and finally ending up as a vendor of fire-fighting equipment. Both artists, then, from an early age were surrounded by odd miscellanies of objects: the random inventories, one might almost say, of city life. And both confessed that they took to still-life painting after a period at the Pennsylvania Academy of Fine Arts because, unlike Eakins, they couldn't afford live models, clad or otherwise. Of course this would have been no obstacle in the way of their becoming landscapists or even, like others, sketchers of parks and streets had that been to their taste. But it wasn't. Even in the eighteen-seventies, Harnett and Peto (who continued to be in contact after the latter moved to Island Heights, New Jersey, where he had been a cornettist at religious camp meetings), created still lifes that were, for the most part, a far cry from the cult of the prettily sentimental then in vogue. Their chosen objects were, indeed, picturesque, but in the original eighteenth-century sense of the term denoting: a pleasing state of ruin, well-worn like the brass kitchen bucket turned on its end to reveal its pitted and scarred

surface; or a heavily smoked pipe, its inner lining charred and tarred. Peto seemed to take it as a challenge to turn ostensibly hundrum things, like the box of peanuts in Peto's *Fresh Roasted, Well Toasted*, and turn them into objects of playful mystery. Peto's picture could hardly be more self-conscious about the teasing relationship between artist and consumer, multiplying fictive spaces (like Hoogstraten's startling *Man at the Window*), and challenging the beholder to figure out the problematical relationship of the two nuts that seem to have strayed from their assigned pictorial space and were now shown strangely free-floating without any legible anchorage, unless, that is, they were glued to the vertical like some ball-park collage.

Of our three principals it was only Harnett who travelled to Europe in 1876, or rather to London, for in the heyday of Victoria Regina they were not at all the same. Undeterred, Harnett spent some months in Germany, in Frankfurt and Munich, but the academic variety of realism he found there only seems to have spurred him to even stronger experiments on his return to the United States in the eighteen-eighties: paintings that ostensibly shared the German partiality for still lifes of newspaper, tankards and pipes, but which – in their stripped down images of eerily lit arrangements set against sepulchral blackness – became much more reminiscent of Dutch vanities. It's worth noting, too, that even before Harnett and Peto took to their shallow-space illusionist paintings, the motifs that recur obsessively in their still lifes of the eighteen-eighties (smoking, hunting, reading and music-making) were all, par excellence, the pursuits – both rural and urban – of the American gentry: the class that liked to think of itself as the nation's cultural guardians, holding back the unholy alliance of the newly rich and eternally poor, the commercially unscrupulous and the ethnically unwashed. This was the class, for example, that not only used decoy ducks in their water hunts, but which began in this period to collect them as if they were works of art. It was this hunting, shooting, trapping class that was likely to have been made most uncomfortable by visual parodies of trophy paintings like Peto's outrageous *For Sunday Dinner* displayed at the very ungenteel address of a local New Jersey drug store.

These are emphatically *not*, then, paintings that speak of the haunts of civility: the smoking room, the panelled library, the conservatoire or the well-bred stable. Instead, they reek of the stale and musty air of the tavern, the gaming room and the used-book dealer. They are, in the unrepentant titles of the artists, *Job Lots Cheap* or *Old Scraps*. Instead of documenting the strength and order of Western civilization, or the virility and optimistic energy of the American republic, they seem to feed on the standard nightmares of the populist and progressive generation. *The Writer's Table, A Precarious Moment* seems to mock the social pretensions of the literary vocation itself, which presumed to stand against the forces of decay, since a book jacket hangs by a thread; volumes are mistreated, their spines bent backwards, the pages folded under each other; the jumble of books seems at times to hint at a visual analogy of the crowded rookeries and tenements of the city. Which is not to say that there could not also be a strange beauty amidst the shabbiness, both of the books and the metropolis.

I've said that the strongest work of these illusionists displays an extraordinary degree of formal inventiveness and narrative subtlety. And both these qualities were released when Harnett and Peto upended their angle of vision from dead-on to constructions organized entirely parallel to the picture plane, with little or almost no relief. And because these illusions worked best, with the flattest of objects, their deceptions, once over and done with, actually *reinforced*, rather than transcended the two-dimensionality of the paintings.

There are all sorts of American illusions being simultaneously exercised and subverted here, not least art's own pretensions to educate the eye. But among other illusions, more crudely and polemically taken up by camp followers like Ferdinand Danton and Victor Dubreuil, were the perennial Benjamin Franklin piety, freshly adapted for the industrial age that *Time is Money* and Dubreuil's shameless theft of another sacred American icon: the all-seeing eye of the Freemasons, filched as the 'eye' and indeed the 'I' (that is the persona) of the artist himself (12).

As Alfred Frankenstein, the scholar who did more than anyone to rehabilitate the reputation of the American illusionists (and to disentangle Peto's from Harnett's work) recognized (and John

Wilmerding more recently has rightly emphasized), Peto's letter racks
and office boards combined three uniquely American obligations: that of
personal profession of belief (seen at its most numbingly shrivelled in the
tee-shirt and the bumper-sticker); that of autobiographical confession
(the memoir); and finally the commentary on the State of the Union
perceived through both public and private experience. All these things
were ravelled up together in Peto's own family since both his father
Thomas and his father-in-law seem to have served on the Union side at
Gettysburg and one of them (depending on which sources you read) was
said to have picked up the Bowie knife that features in a number of Peto's
late letter racks and in one of which cuts through both the head of the
father of the country, Abraham Lincoln, and the words, 'the head of the
house', namely Peto senior. His son John Frederick is often described as
a rather mournful figure, but it must have been no fun suffering from
Bright's disease, a condition that led to repeated gallstone attacks and
ultimately to his premature death after a botched operation in a physi-
cian's office in Greenwich Village, after which Peto walked all the way
from the Village to 86th Street and Riverside Drive before collapsing
with a violent post-operative fever. His painterly temper should perhaps
better be characterized as poetic or elegiac, the latter still certainly at
odds with the raw energy of, say, Eakins's or Winslow Homer's view of
American nature and culture, and even more sceptical of the gung-ho
muscular imperialism of Teddy Roosevelt's Rough-Rider bully-pulpit
politics. Peto's racks and boards are filled with torn and ragged things; as
many absences as presences; things of phantom value like shinplaster
currency and repudiated silver certificates; cancelled stamps; letters and
people gone astray; communications interrupted; proclamations contra-
dicted; contents emptied; a civilization seen not through its monuments
but its detritus. We're back to that unswept floor in the Roman villa, but
it's been upended as a scarred door; its official slogans reduced to gouge-
marks in peeling paint. All of this detritus is pinned together only by the
presence of a sense of family, the national family whose father had been
murdered, and Peto's own family in which his daughter, Helen, time and
again, carries the full weight of his sorrow-inflected love.

There were, of course, worse things you could do than represent America by torn paper and casual scratchmarks. You could, if you were the wicked John Haberle, do the same thing to Art itself. For although Haberle spent virtually all of his quiet life in pack-rat domesticity (substitute Utopia Parkway, Queens, for New Haven and you have, I think, an earlier incarnation of Joseph Cornell), there was nothing mousy or furtive about his visual wit. He is, as every commentator has recognized, much the most fully-knowing of our three illusionists. Perhaps his routine experience with the paleontologist Dr Othniel Marsh – piecing together ancient histories from bones, constructing, dismantling and reconstructing skeletons – made Haberle sensitive, in a genuinely protomodern way to the contingency of things, not excluding art. Two of his works make his scepticism about art's claims to endurance dramatically clear. One is a painting called *Torn in Transit*, which wickedly makes the ostensible subject of painting – a landscape done in the debased Hudson Valley style still popular with the crowds – play second fiddle to its ripped wrapping paper, thus neatly transferring the status of 'art' from the ostensibly superior to the inferior object. Pathetically peeping from its wrecked container, there is no chance for the illusion of scenery to survive. It's just stuff lost and torn in transit. With this one stroke an entire museum culture, with its vested interest in the grandiose, in the monumental, the sacred value of the original object, and in posterity and permanence, takes it right on the chin and goes down for the count, three quarters of a century before Andy Warhol ever climbed into the ring. And in case it seems to get up off the floor, Haberle's *Leave Your Order Here* delivers the knock-out. Here, an art object, his own art object, the art object called *The Bachelor's Drawer* has been reduced to the most ephemeral of all inscriptions, a faint chalkmark on a tavern slate, usually used to order drinks but on which the artist has written (in paint): 'A Bachelor's Drawer Is for Rent. Inquire of John Haberle.' And on top he has drawn his cartoonish alter ego in the form of a grinning cat, the wickedest cat on the street, at once Felix, Fritz and Cheshire, since sly John Haberle dares to say that art's pretensions to permanence are about as solid as the body of a Cheshire cat or a chalky scribble.

No wonder, then, that Marcel Duchamp seems to have understood that these extraordinary paintings were something more than sub-photographic exercises in mindless mimicry. Or rather that, if they were exercises in mimcry, they turn out to be phenomenally mindful. Which did not, of course, stop Duchamp himself being fooled by one of those dollar bill paintings, which even he insisted had been pasted, rather than painted on to the canvas. And that should really arouse our serious respect. For it was one thing to fool Zeuxis, quite another to get the better of Marcel Duchamp.

Up the Nile with a Camera

NINETEENTH-CENTURY PHOTOGRAPHY

YOU DON'T MAKE PHOTOS; YOU TAKE THEM. From the start, photography's working vocabulary, at least in English, has been invasive. Subjects are framed, captured, shot. It must have been easy in 1850 for Maxime Du Camp to persuade his Nile boatman to stand very, very still on the roof of the Ramesseum (Ramses II's funerary temple) at Thebes. He just made him believe that his camera was a gun. But then Nubians were supposed to make themselves available as human yardsticks for the photographer's conveyance of scale, thus sparing Europeans the indignity of being dwarfed by the pharaohs (13). Look at the pictures in the Metropolitan Museum of Art's lovely little show, *Along the Nile: Early Photographs of Egypt*, and you'll see the shutter and the cartridge paired as naturally as the camel and the sphinx. Eliot Warburton's *The Crescent and the Cross*, published in 1844, had anticipated this: 'A brace of pistols in one's girdle, and...hippopotamus-whip in one's hand, does more in the East towards the promotion of courtesy, good-humour and good fellowship, than all the smiles and eloquence that ever were exerted.'

The Victorian excursionists photographed by Francis Frith at the Ramesseum in 1858 compose themselves in shallow space, as if inhabiting their own frieze before a theatrical backdrop of abraded and shattered stone torsos, knowing that the camera has already trumped the colossi. An intrepid Maud sits sidesaddle on a donkey while an armed dragoman, kitted out in nattily checked pants, awaits, like the dromedary, the party's pleasure. A young man, aquiline nose visible beneath the rakishly tilted headgear, holds his cane lightly between thumb and forefinger and returns Frith's attention with a dead-on stare. He has already learned the power of the pose, and his gaze has the nonchalant authority of imperial possession.

Missing from Frith's and Du Camp's pictures of the Ramesseum is a seven-ton granite head that had been transported to London decades before by Giovanni Belzoni, ex-circus strongman, self-taught Egyptophile, and the greatest of the schleppers of the Nile. It was after viewing some of Belzoni's loot in 1817 that Shelley wrote *Ozymandias*, the name the Greek historian Diodorus Siculus used when discussing the largest of the statues at Thebes, which lay in broken pieces before the temple compound.

When Belzoni found the bust lying in the sand, he imagined it was 'smiling on me at the thought of being taken to England'. This is not how Frith felt about the plunder of antiquities. In one of his famous books of photographs, he raged against the 'hordes of careless people who throng the British Museum' and 'smile thoughtlessly' at the 'incongruous quaintness' of the Egyptian antiquities 'and, in England, their unintelligible grandeur'. Frith was enough of a cultural entrepreneur to know that the spectacular display of rifled Egyptiana had been the making of the public museum in Europe. He would not have pretended to offer his books as either reparation or apology. But he did hope that they would encourage the export of tourists to the Nile rather than the importing of masonry from it.

The crocodile of cultural guilt seldom breaks the placid surface of either *Along the Nile* or a companion exhibition of startlingly beautiful pictures,

The Pharaoh's Photographer: Harry Burton, Tutankhamun, and the Metropolitan's Egyptian Expedition. The shows document one of the West's most ingrained cultural obsessions, inherited from the Enlightenment: the itch for lucidity and exposure, and the recoil from obscurity and concealment embodied in, for example, the veiled costume of Islamic women or the impassivity of ancient Egyptian masks. The smile of Ramses II at Thebes or of the Sphinx at Giza was not the same as the smile of Voltaire, who, predictably, wrote off classical Egypt as institutionalized cruelty protected by infantile superstition. The optimistic materialists of the Enlightenment had little patience with enigmas. Freemasonry, intensely popular in the eighteenth century, had inherited from earlier pseudo Egyptology a fascination with pyramids and hieroglyphs, but it defanged the occult into something harmless enough to go on the back of the great seal of the sunny-side-up American republic. Very few of the early Egyptomanes understood or sympathized with the place of deep shadow in Egypt. The mission of most of those making the trip to the Nile – from Herodotus to Harry Burton – was, in the habitual phrase of the scholars, to 'throw light' on the impenetrable darkness of the tombs, something the English Burton learned how to do by taking a trip to Hollywood to study floods and spots when he documented the Tutankhamun dig in the nineteen-twenties. The very idea of so much sublime skill, intensive labour and untold wealth being lavished on art expressly designed to be invisible affronted the deepest assumptions of Western aesthetes, presupposing, as they did, the pleasure of display. Rising to the challenge, European Egyptologists became crypt-breakers, in the double sense of tomb penetration and the decoding of glyphs.

They were not the first to break and enter. When the archaeologists and draughtsmen shipped in along with Napoleon's army got into the tombs at Thebes, they found that most of them had long since been emptied of treasures by generations of raiders, going back to the time of the pharaohs. The scholars and artists who, once a steam passage was open to Alexandria, arrived in increasing numbers from the eighteen-thirties to the eighteen-fifties, saw themselves as the protectors of antiquities from local pashas with no scruples about hauling off ancient

stones to build sugar refineries. The real 'Egypt', deemed a common property of mankind, needed rescuing from the natives. It was no accident, then, that the most photogenic temples – at Dendera and Philae – were Ptolemaic, dating from only two or three centuries before Christ: the product of a Hellenic-Egyptian cultural fusion. In 1799, pursuing the Mamluk army of Mirad Bey all the way to the first cataract of the Nile, General Desaix carved into the face of Trajan's kiosk at Philae an inscription celebrating the victories of the army of the republic. Half a century later, as another Napoleonic empire was being created, Félix Teynard, in one of the most dazzling of the photographs in *Along the Nile*, took care to illuminate – and thus glorify – the French graffiti in a blaze of raking sunlight, while other walls remain masked by a shadow.

Patriotic grandstanding aside, Teynard set great store by the camera's resistance to romance. In the spirit of Fox Talbot's manifesto for photography, *The Pencil of Nature*, the photographers of the mid-century saw themselves as technicians of truth, light-years ahead of the draughtsmen who had created the classic, multi-volume *Description de l'Egypte*, which was published between 1809 and 1828. Egyptologists sent from Paris, Berlin and London had begun using a camera lucida – a prismatic lens reflecting an image – to make more accurate tracings. Shortly after Louis Daguerre succeeded in fixing an image on a silver-coated copper plate, the *Excursions Daguérriennes* project was launched to document 'vues et monuments les plus remarquables du globe'. But daguerreotypes were unreproducible images that, set in elaborate frames, in no time at all acquired the status of the art objects they were supposed to replace.

Fox Talbot's invention of calotypes – prints made from paper negatives – changed all this and made it possible, for the first time, to imagine educating a broad public in the unsentimental 'truth' of remote geography and archaeology. When Maxine Du Camp was commissioned by the French Ministry of Education in 1849 to compile a photographic record of the canonical Egyptian monuments, his camera was described as a 'new companion – resourceful, quick and always scrupulously faithful'. Du Camp, along with his other travelling companion, Gustave Flaubert,

wanted his work to stand as a corrective to the steamy fantasies of Romantic painting. No more writhing Nubians; no more rosy dawns over the pyramids. But the calotype turned out to be the enemy of hard-edged realism. The grainy softness of the paper negative conspired against crispness. In Du Camp's pictures in the Met show, the sky over Thebes sweats with sultry drama and Flaubert waddles about in his Cairo hotel garden draped in a white Nubian robe. Face to face with the Sphinx, the two anti-Romantics turned to jelly. 'Maxime went quite pale,' Flaubert wrote, 'and I was terrified that the head would turn and I struggled to control my emotion.'

Friends at the outset, Flaubert and Du Camp turned out to be horribly ill-matched fellow-travellers. Except for the epiphany at the Sphinx and another at Karnak, Flaubert made a great show of his bore-dom with the monuments, preferring to inhale the aromas of the bazaar and envelope himself in the generous folds of the courtesan Kutchuk Hainem. Du Camp, in the meantime, was getting on with the business at hand, hastening (as far as the *cange* sailboats would allow) from site to site, and stockpiling the portfolio of photographs that would make his fame and fortune when it was published in 1852. The book was a portrait of Egypt largely denuded of Egyptians, and his essay on the trip said not a word about Flaubert. But Du Camp's work brought him the Legion of Honour, the admiration of the Parisian *monde*, and enough temporary glamour to steal Prosper Mérimée's mistress.

Egypt and Palestine Photographed and Described by Francis Frith was published by subscription beginning in January, 1858, just six years after Du Camp's book. But the difference between Du Camp's relatively austere images of pitted columns rising from wind-scoured desert and Frith's gorgeous extravaganzas is the difference between chamber music and grand opera. Frith had been prompted to take on Oriental photography by the com-mercial and artistic success of David Roberts, a theatre set designer turned Near Eastern painter. The luminous theatricality of Frith's own pictures was made possible by the brand-new wet-collodion process, which substituted glass plates for paper negatives. Prints made on egg-white-coated paper from glass negatives were capable of incomparably

greater brilliance, sharpness and lustre than the velvety calotypes. Frith's three journeys to Egypt and the Holy Land between 1856 and 1860 yielded four hundred pictures and eight separate photographic books. *Egypt and Palestine*, which was published in an edition of two thousand, included seventy-six of the choicest pictures. Queen Victoria, who had her own darkroom at Windsor Castle, was an admirer.

Frith needed (in the absence of enlarging technology) three separate cameras for his campaigns – one for regular studio-size prints, the second for the jumbo format (sixteen by twenty inches), and a third, dual-lensed apparatus for the new stereoscopic viewers that had become the rage in London. Two men were used just to carry the crate of glass plates, and Frith's chemicals, distilled water, cork packaging, and several baths and vessels used to sensitize the plates in situ weighed more than a hundred and twenty pounds. He had a specially designed wickerwork carriage in which he both slept and worked. Even so, the collodion boiled on the plate in torrid weather, and retreating to the relative coolness of rock tombs seemed like a good idea until the dust clouds that were stirred from the floor – not to mention the droppings of countless bats suspended from the roof – fouled the plates.

Frith, who was a small-town Derbyshire Quaker, became a shameless imperial entertainer. His yarns about wielding both gun and tripod ('Immediately behind the temple I shot my first Egyptian hare; rather small but well-flavoured...'), and dealing smartly with threatening, brandy-soaked Nubian river pilots ('Presently his huge bony face glowed with unmeaning alcoholic energy...') were a part of his popular appeal. The Egyptology of the museum had always had an uneasy relationship with sensationalism. (Even Herodotus lingers lovingly over the clinical details of evisceration and embalming.) Giovanni Belzoni, a six-foot-seven Paduan who had made his living carrying ten men around a stage in a human pyramid, did not hesitate to display at the Egyptian Hall in Piccadilly the antiquities unsold to the British Museum, and to auction them off in 1822. The Tutankhamun phenomenon, a century later, united vulgar Mummymania with serious archaeology. The Met's wall labels for Harry Burton's dramatic photographs of the unsealing of the

boy pharaoh's tomb make much, perhaps too much, of this show-biz connection. There is also irresistibly watchable silent footage of a dig, featuring a cast of hundreds of toiling natives and well-heeled patrons mugging for the camera aboard a millionaire's yacht.

But Burton's photographs – the gems from a huge archive, most of which is solidly documentary – are mercifully free of brash celebration. Images of a sycamore-fig garland, taken perfectly intact from a tomb, and of Tut's childish glove, the filaments stretched but not broken against the unsparing light, seem shrouded in apologetic silence. Read as a series, Burton's photographs re-enact the penetration of the tomb and the unceremonious, if fastidious, unwrapping of its occupant, who is inspected and inventoried right down to his golden toe stalls. The most affecting image is of Queen Merytamun's unfolded linen wrap, dark stains from the ritual resins poured on her body still rhyming its contours, a photographic reproach to the impoliteness of the trespass.

PAUL CEZANNE

Cézanne's Mission

ON OCTOBER 13, 1907, Rainer Maria Rilke reported to his wife on his umpteenth visit to the Salon d'Automne in Paris. The reason he kept going back to the Grand Palais was the two rooms devoted to the paintings of Paul Cézanne, an artist of whom he had known nothing prior to the show. Like so many others before and since, Rilke felt as if the experience had supplied him with a fresh pair of eyes – as if his optic nerve had undergone a pleasant but drastic rewiring. 'Today I went to see his pictures again,' he wrote. 'It is remarkable what an ambience they create. Without looking at any particular one, standing there between the two galleries, you feel their presences joining together into a single colossal reality. As if these colours were stripping you of your indecisiveness once and for all.'

This 'colossal reality' is on show at the Philadelphia Museum of Art's astounding exhibition of Cézanne's work. No one should be nervous, though, that Rilke's poetically tuned receiving equipment is a precondition for pleasure. Cézanne's reputation as the father of modernism may

trip a difficulty alert for those hankering after a summery stroll through Giverny, but nothing short of colour blindness can blunt the overwhelming power of the two hundred works assembled at Philadelphia by Joseph Rishel and his colleagues. Still, it is true that Cézanne's masterpieces ask for, and repay, intense and prolonged attentiveness. Meyer Schapiro, whose essays on the painter remain classics of acute perception, compared the 'long concentrated vision' that Cézanne demands of the viewer to the absorption due to great music. And anyone prepared to surrender to the harmonies and rhythms of these paintings will find one of art's great mysteries taking place before his eyes: the transformation of the quotidian – seven apples, a wall of rock, a pair of card players – into monumental objects of inexhaustible contemplation.

Cézanne himself offered the best explanation of why his art appeals simultaneously to the intellect and the senses when, in a conversation with his admirer Joachim Gasquet, he summarily abolished the ancient distinction between *disegno* and *colore*. 'As one paints,' he explained, 'one draws; the more colours harmonize among themselves, the more precise the drawing becomes...When colour is at its richest, form is at its fullest.' This is why he saw no contradiction in admiring both Poussin and Rubens, who for centuries had exemplified the mutually opposed poles of form and colour. By making colour the architecture of his compositions, building potent structures from carefully laid chromatic blocks, Cézanne freed it from obedient service to Big Ideas; in his hands, colour *was* the Big Idea. It's not surprising, then, that the artists who prided themselves on owning Cézannes included, as it were, people of colour as well as people of form: Matisse as well as Henry Moore.

Until fairly recently, though, Cézanne's role as the godfather of the avant-garde has rested more on his reputation as Cubism's herald than on the inventiveness of his colour composition. Any number of works in this show seem to vindicate this claim: the extraordinary Fogg Art Museum drawing *Corner of a Studio*, which is cropped to suggest a quasi-abstract arrangement of intersecting angles rather than a group of stretched canvases propped against a wall; the blocks and masses

(ostensibly farmhouses and rocky terraces) that punctuate the shimmering landscape in *Houses in Provence – The Riaux Valley Near L'Estaque*. And, because Cézanne's structural compulsiveness became a truism in modernism's Book of Genesis, a personality of the creator has developed to match it. In this orthodox version of Cézanne's evolution, he figures as the outsider: quick to take offence, misogynist, ascetic, as dry as the Provençal earth and as crusty as its bread. Some of the best studies of him have seen the evolution from a passionate to a philosophical temper as the precondition of his true modernity. Guided by this chronology, it's possible to read a pair of self-portraits from *c*. 1875 and 1877 as illustrations of an odyssey of withdrawal. The earlier portrait presents a countenance boiling with suspicion, anxiety, and self-interrogation: the eyebrows arched like the back of an angry cat; the slightly exophthalmic brown irises bituminously dark; the jutting beard of a Mesopotamian despot; skin painted with the self-mortifying stabbing motions of a flattened palette knife and broken with flecks of angry carmine. Two years later, all these passions seem mysteriously spent. The domed head is smooth and illuminated, as if filled with philosophy; the eyes have settled back into their sockets, which have lost their angry shadows; and the ground modulates from a cerebral grey at the back of the head to an effulgent brown at the front of the face. To those who like this reading of the artist's persona, it looks as if Cézanne had begun to turn himself into a still-life, a russet apple: the mercurial bohemian of Aix reconstituted as the Buddha of modernism.

But if anyone goes into the Philadelphia show clinging to the received wisdom that Cézanne's principal claim to authority is his designated role as proto-Cubist, the cliché is unlikely to survive the visit. Near the 1877 self-portrait is another portrait, this one of his earliest collector, the customs official Victor Chocquet. His elongated head is chiselled with sympathetically broad strokes, and his dense mane of grey hair rises from a nobly lit brow; the open collar of his shirt announces candour and humanity. The mood is not that far from Expressionism – an apt reminder that, throughout Cézanne's career, contemplative and emotive tempers worked with, or sometimes against, each other, creating a

dialectical tension that often generated his most powerful art. The solid forces of the great paintings – their geology – is almost always made answerable to, and enlivened by, their biology: clumps and masses of unruly verdure; slender screens of pine or poplar; an arrangement of breasts and thighs. To accomplish this balance between the statuesque and the mobile, and to make the equilibrium seem natural, however, took a serious psychological toll on the painter. So that even though there are no sliced ears or flights to the South Seas in his curriculum vitae, Cézanne was nonetheless possessed by a merciless creative fury – one that was all the more punishing, perhaps, for being directed inward, toward his endlessly complex compositional intelligence. Had he actually been what the proto-Cubist orthodoxy wants him to be – that is, an artist for whom subject matter was a pretext for the manipulation of form – Cézanne's compositional agonies might have been less protracted. But it was precisely because this was *not* true – because he was anything but indifferent to the objective properties of the subject, and sought to liberate, rather than suppress, them by distortions of perspective and startling tonal inventions – that he achieved an illumination both of this world and immeasurably beyond it.

Astonishingly, the Philadelphia show is the first in sixty years to offer a survey of Cézanne's entire career, from the aggressive early works of the eighteen-sixties to the luminous oils and watercolours of his last year, 1906. The exhibition positively invites the visitor to disobey the usual one-way traffic regulations of museum-going and move back and forth between decades and rooms, as motifs appear, disappear and reappear in different moods and manners. The late watercolour of a single skull – seen dead on, sardonically reposing on a bright-coloured drapery, the cranium poignantly identical to Cézanne's own bald dome – is the valedictory bookend to one of his earliest paintings of a skull, in which the impasto is trowelled on with a palette knife in the turbid, ballsy manner (literally the *style couillard*) of the eighteen-sixties.

As the son of a well-to-do Aix banker, the young Cézanne wanted to prove himself Provençal rather than provincial, and throughout his life

he referred to his early, southern friends as *mes compatriotes*. It was Provence that provided the sensual, morbid and darkly religious themes of temptation and suffering that took on a sado-erotic tinge in Cézanne's early work. Painfully shy and repressed, he covered his awkwardness with mangled quotations from Old Masters, and his canvases with scenes of rapes, murders and debauches. The remarkable *Feast*, with its post-coital bodies wound like strings of *boudin blanc* sausages about a long, upturned table, apparently floating in a cerulean void, evidently came to Cézanne from Veronese's *Wedding at Cana*. Similarly, the shrieking victim and her knife-wielding assailants in *The Murder* are earth-weighted bodies from the repertoire of Daumier and Courbet, though the hideous nightmares are all Cézanne's own.

Cézanne, who never thought of himself as a revolutionary, aspired from the outset to find a modern visual language that, paradoxically, would be strong enough to claim its place in the pantheon of past masters. And for that very reason he tormented himself with a sense of the impossibility of the enterprise and the inadequacy of his paltry gifts. (When his childhood friend Emile Zola tactlessly presented him, in 1886, with the novel *L'Oeuvre*, in which he was portrayed precisely in this light, it was the abrupt end of their long and warm relationship.) Cézanne's early insecurities made him especially ambivalent about contemporary innovators who seemed to possess the confident vision he wanted. One of his responses to Manet's supercool *Olympia*, in 1875, for example, was a facetious parody, in the lightning-sketch manner of Fragonard, with himself posed as the Artist, dark and beetling, before a powder-puff model curled in foetal self-defence. *The Eternal Feminine* took this attack on art's fetishes even further, by exhibiting a summarized nude, her genitals displaced from the actual groin (which is incoherently sketched) to the vaginal canopy over her bed; her eyes are reduced to bloody daubs. The miscellaneous idolaters gathered at her divan range from a Provençal troubadour and a bishop to a dark-suited bourgeois holding a sign that reads 'B-A-N', which we are evidently meant to complete as '*banque*' and thus recognize as emblematic of Cézanne's father. And, just as the right side of the painting is dominated by two

men wrestling, the divided self of the artist appears in two separate per-sonifications: the painter whose description of the scene is nothing other than the vaginal canopy and, in the lower foreground, the bald head of the voyeur, scrutinizing the entire, unholy *messe*.

With these misgivings about painterly fashion preying on him, it's not surprising that Cézanne found it hard to settle down in Paris, even after he began living with the model Hortense Fiquet, by whom he had a son in 1872. Throughout the seventies, he kept going back to Aix, always concealing his ménage from his forbidding father, even for a time taking a job in the family bank, lest he be cut off without a sou. If Zola played the role of sympathetic brother, shelling out loan after loan with no illusion of repayment, it's not too much of a platitude to see the protec-tive figure of Camille Pissarro as the surrogate *bon papa*. And it's equally tempting to assume a period of Impressionist therapy for Cézanne, as he was coaxed into relaxation by the mentorship of Pissarro at Auvers. But in fact the result of Pissarro's genuine benevolence was to encourage Cézanne to pursue his own flinty path. Impressionism's essential project – the capture of momentary effects of light – was too insubstantial to fully engage him. Cézanne's sights were set instead on what he described as 'a taste of the eternity of nature'. So although conventional wisdom insists that Cézanne underwent an Impressionist 'transition' en route to his mature landscapes and still lifes, the most powerful paintings belonging to the late seventies are fundamentally anti-Impressionist in concept and execution.

The *Rocks at L'Estaque* for example, contradicts all the Impressionists' rules of thumb. The viewpoint is dramatically low, claustrophobically resisting any possibility of panorama. Within the shallow picture space the ancient rocks rise like granite knuckles, clenched and grim, toward the bay. The seawater that in a Monet would sparkle with multicoloured reflections seems confined and dammed up in Cézanne's work, and is painted a flat marine. In contrast, the entire surface of the foreground parallel to the picture plane has broken out in a rash of short, flicked-on green strokes – the only element of organic liveliness in the choking stillness. And when Cézanne does admit the play of reflection, as in

The Bridge at Maincy (14), he deploys it as another disorientation device in a composition that presents space so chopped and sheared and sliced and sectioned that it defies coherent legibility. This is a bridge not built to carry our visual load, for the two spanning arches are out of alignment; the wooden crosspiece seems attached to neither end; the river flows beyond its crossing in any and every direction; and the entire scene is engulfed in a mass of swaying, arching foliage, arranged to run the gaze ragged, in and out and through the teasing, multiple perspective.

Few of these radically inventive paintings from the early eighties are precisely dated, and it seems likely that Cézanne returned to them again and again, compulsively fiddling with their visual dynamics. By the middle of the decade he was, in every way, a good deal more secure. In 1886, his father died, leaving Cézanne (albeit described in the will as 'without profession') an inheritance that included the house of Jas de Bouffan. More important, Cézanne had finally arrived at a visionary understanding of his painterly goals. Though the great series of paintings of the Mont Sainte-Victoire and the fruit still lifes are the most complete manifestations of this mature vision, the Philadelphia show is rich in lesser-known works, many of them from private collections, that perform the same miracles of counterpointing movement and stillness. The grey slate mansard roof and dormer windows in *The Allée at Chantilly*, framed by an arching tunnel of foliage, actually seem to be levitating upward at the end of a steeply dropping road; and straddling the road that marks the line of perspective is a wooden barrier – virtually a statement of Cézanne's determination to tease us with games of visual access and resistance.

In painting after painting in the eighteen-eighties and nineties, Cézanne manages to generate visual relationships that work independently of their ostensible subject matter yet are never wholly detached from it. To insist on these works as exercises in latent abstraction in order to admit him as a charter member of the Club of the Twentieth Century is to get Cézanne badly wrong. For his consuming idea – virtually a religious passion as he got older – was to invent a visual language that could

somehow be truer to the essential nature of things than either a literal description or an optical impression could be on its own. Notwithstanding the platitude reported by Emile Bernard (and virtually fetishized by his Cubist devotees), which held that one should 'treat nature by means of the cylinder, the sphere, the cone', it evidently mattered supremely to Cézanne that such shapes be seen as apples or nudes. 'Art is a harmony *parallel* to nature,' he wrote to Gasquet in 1897. (The italics are mine.) So that when Cézanne depicts his wife's face as a stylized ovoid (egglike rather than oval), it's because he looks not through her to some sort of pure geometry but *at* her, investing the soft features of eyes and mouth with broody passivity. Or when his son, Paul, posed as a bather treading a careful line between water and shore, is invested with the heroic poise of a Greek statue, it's because Cézanne sees a classical balance of energy and stillness take visible form in his boy's sinewy body.

The one-man show organized by Ambroise Vollard in 1895 – the artist's first – provoked both a round of derision from Cézanne's critics and equally passionate admiration from fellow-artists like Renoir, Monet, Degas and especially Paul Gauguin, who understood perfectly Cézanne's union of exacting erudition and intensely felt sensation. Gauguin wrote, 'His colour is grave like the character of Orientals; a man of the Midi, he spends entire days on mountaintops reading Virgil and looking at the sky...His horizons are high, his blues very intense, and the red he uses has an astonishing vibration.' Despite this recognition, Cézanne's most unrelenting critic was himself; he was always agonized at the idea that he was falling short of the perfect *réalisation*. Yet in the wonderful room in Philadelphia displaying the great still-life series of 1898–99 it's impossible to believe that these amazing paintings did not, at last, meet even his perfectionism. From the most ostensibly modest elements Cézanne builds compositions that are as heroic and dynamic as any grand history painting. The fruit is now both passive and active: contained by the rumpled cliff face of the linen but simultaneously invested with vital, brimming energy that seems to shift them against each other and over the tilting, uncertainly poised surface.

Cézanne was not content to spend his last years merely refining what

was already an extraordinary achievement. Instead, he returned with a vengeance to old obsessions. Where the eighteen-eighties series of the Mont Sainte-Victoire landscapes had skewed the angle of vision to vary the prominence given to the mountain, or had experimented with diagonal tracking lines by featuring or suppressing viaducts and roads, Cézanne's return to the subject in his last years freed turbulent energies that had never really been sublimated in the first place. The careful layers of banded colour and the strong rhyming lines between pine branch and mountain contour which give the Courtauld painting its serene structure are replaced, in the Moscow *Mont Sainte-Victoire* of 1904–05, by a hyperactive mosaic of broken colour shards heaped about the vestigial remains of the familiar scene. The adamant mass of the mountain seems desperately caught between Cézanne's last, manic bombing run on his favourite target and the livid, racing sky.

More than once Cézanne referred to himself as a Moses figure, who was destined to point the way toward the Promised Land of a new kind of art but was not given the years to pitch his tent in its scenery. There's no doubt that the urgency that marks his late painting is coloured by the unsparing (and unnecessary) sense of incompleteness that beset him. Cézanne's late work, however, was intense, not unhinged – still concerned with harmonizing natural energy and disembodied grace. Gasquet had no inhibition about assuming that the *Portrait of the Gardener Vallier* was a surrogate of the artist himself – 'the ravaged and feverish face...the misery of an immense soul whose dreams, whose art have deceived him.' But Gasquet's assumption of tragic autobiography is belied by an exquisite watercolour of the subject, painted in the same year, which radiates the pantheist serenity of a sage bathed in the light of nature. We, too, should beware of reading backward from Matisse's and Picasso's subsequent revolutionary reinterpretations of the *Bathers* and assuming that Cézanne's nagging sense of incompleteness would have been assuaged if he had turned fully modernist. Instead of saddling him with the curse of the precursor, it might be better to regard his work as wholly resolved within the terms of the tasks that he set himself.

Nowhere is this resolution more spectacularly demonstrated than in the Philadelphia *Large Bathers*, which in the company of an earlier version from London and two oil sketches makes its climactic role in Cézanne's career incontrovertible. The stormier, more sensually fretful versions have been replaced by a modern pastoral that harmonizes not only flesh and water, figures and landscape, but tradition and modernity. For while the great vault of trees – itself peculiarly corporeal – that frames the scene might be thought of as the gateway to the future, it is at least as valid to think of it as an arch of triumph, honouring the museum masters whom all his life Cézanne revered, and in whose company he now irreversibly belonged.

EGON SCHIELE

Tunnel Vision

IN HIS CUSTOM-FURNISHED CELL IN HELL, Egon Schiele decides he is ready for a fresh torment. He tunes in to Sister Wendy, television's art nun. It does the trick. She pours on the agony: the insatiable *bocca dentata* from which issues the softly trilling voice; the reverentially upturned eyes; the rapturously fluttering hands; the genuflections before the shrine of God's niftiest creation, the body. Schiele gnashes and seethes. 'Pubic hair? *Lovely and fluffy*, is it? Listen, Sister, I *know* pubic hair. And let me tell you, it's no cotton candy. It's barbed bloody wire, it's thorn-bushes, for Christ's sake.' 'Oh, dear Egon', she smiles, sympathetically. 'Are you still unhappy? Poor lamb.'

Yes, Wendy, he still is. And if your own cup of pleasure ran over long ago, if the mere thought of another Monet or Picasso show makes you reach for the angostura, then the Egon Schiele exhibition at the Museum of Modern Art is just what the therapist ordered. And if after a few hours of peering at the genitalia of pubescent girls you begin to feel that a getaway weekend at Giverny may not be such a terrible idea after all, at

least you won't be able to fault the curator of the Schiele show for a timorous installation. The image that greets you at the entrance sets the tone. There is Schiele himself, overlit, naked, and spread-eagled flat against the picture plane like a climb-down-the-wall toy, but with pieces of him missing – a half-consumed praying mantis, with hairy segmented limbs. Much of what's left of the body is not green, however, but a decorator shade of hepatitis yellow, with the exception of a single eye, the nipples, the navel and the scrotum, which are all Pepto pink. And you don't need the Expressionist Handbook to Strong Emotions to tell you that Schiele is in the throes of a paroxysm of self-hatred, or that he wants, truly and deeply, for us to Share his Pain – which (this being Vienna) is also, of course, his pleasure.

Since that image is by no means the most unsettling painting in the show, it's hard not to admire the pluck of the Central Bank of Austria, and also the Austrian Mint, which helped fund the passage of the Leopold Collection of Schiele watercolours, oils and drawings from Vienna to New York. After all, it's not every bank (as the organizers of a similar show in London several years ago discovered, to their cost) that wants its corporate image attached to lovingly detailed images of pudenda and receptively proffered derrières. But then (as both the critics and some of the more apologetic defenders of the NEA [National Endowment for the Arts] find it difficult to acknowledge) painting is not obliged to be Prozac on walls. Long before Bruce Nauman and Louise Bourgeois plundered the stockyard, artists like Goya responded to the political and military nightmares of their own time by doing a number on the classical tradition of the body, turning the Farnese Hercules and his buns of steel into slaughterhouse cuts. Goya's notorious 1820 dining-room painting, *Saturn Devouring His Children*, with its obscene mutilation and dementedly splayed limbs, may well have supplied the template for Schiele's comparably tortured self-image.

A century after Goya, Schiele's generation of Austrians was formed less by the experience of war than by the expectation of it. (Ironically, many of the best and brightest of the fin-de-siècle rebels – including Gustav Klimt and Schiele himself – were wiped out in 1918, not by

mustard gas or mortars but by the influenza pandemic that took more lives than had been lost on all the battlefields of the First World War.) Long before the Austro-Hungarian monarchy's terminal Bosnian-Serbian crisis, however, it was apparent that the monarchy was already at war, principally with itself. The patchwork quilt of nationalities, religions and language groups which had been held together by loyalty to the Habsburgs was coming apart at the seams as the King-Emperor Franz Josef declined from venerable to gaga. The conflict of classes in major cities like Vienna was threatening to go revolutionary. But the most unsparing campaign of all was being waged within the minds of individuals: an exchange of fire between the shell-shocked trenches occupied by the ego and the id.

Born in 1890, Schiele was an early casualty of those end-of-century onslaughts. His childhood reads like an Arthur Schnitzler story, featuring all the standard ingredients of Mittel-Europa neurosis: betrayal, disease, dementia and attempted suicide. His father, Adolf, was a stationmaster in the small town of Tulln, eighteen miles up the Danube from Vienna. He had married Schiele's mother, Marie, when she was just seventeen, against the wishes of her Czech family, and had then thanked her for her loyalty by spending the wedding night in a Trieste brothel, promptly passing on to his bride the syphilis he contracted there. Marie subsequently delivered three stillborn boys and a girl who died in childhood before Egon and his two sisters arrived. Sickly himself, Egon grew up watching his father drop steeply into insanity. Adolf would don his stationmaster's uniform and greet imaginary guests while the trains, closely observed and sketched by the gifted boy, rattled past on their way to Linz or Vienna. In 1904, dismissed by the railroad company, Adolf tried to kill himself and botched the job, but he died anyway, later that year.

Not surprisingly, then, much of Schiele's short life was punctuated by recurring acts of Oedipal rebellion. When he was sixteen, he re-enacted (symbolically, one hopes) his parents' contaminated honeymoon by running off to Trieste with his twelve-year-old sister, Gerti, who

frequently posed naked for him. They spent the night together in a hotel room. Soon after this escapade, he defied the veto of his uncle by taking the entrance examination for the Vienna Academy of Fine Arts, and was enrolled as the youngest student in the entering class of 1906. Once there, he made no secret of his loathing for the obstinately conservative programme of instruction provided by Professor Christian Griepenkerl. The feelings were mutual. 'The devil has shat you into my classroom', Griepenkerl is alleged to have said, and three years later Schiele and his friends in the newly formed Neukunstgruppe sent the professor a letter of defiant protest and walked out of the academy. Schiele's mentor in this little insurrection was Klimt, whom Schiele had first encountered in 1907, and who had invited him to show four paintings in the Kunstschau of 1909. By this time, Klimt had become the patriarch of Viennese modernism. A decade earlier, together with like-minded colleagues, he had broken from the official art institutions of the court and the city, establishing the Secession, a home for independent-minded artists, designers, and architects. Its house style was predominantly (though not exclusively) an Austrian variant of the decorative naturalism of Art Nouveau; its mission was to purge Vienna of the disingenuously correct portraiture, laboriously historical tableaux, insipid landscapes, sentimental genre paintings, and *Sacher Torte* nudes that had previously passed for polite taste.

The Secession succeeded so well that by 1905 it had become subject to the usual laws of modernist fission, splitting those like Klimt and Otto Wagner, who saw their future as an alliance of painting, architecture and design from those of the Nur-Maler group who wanted painting to be entirely free of the decorative arts. When Schiele became Klimt's protégé, Klimt was totally absorbed in his profusely ornamental, heavily symbolic, sexually charged paintings, in which vampirish succubi and their rapturously dream-clogged partners dissolved together in orgasmic baths of gold.

The powerful impression that Klimt's work made on Schiele is documented in some of the early paintings in the Leopold Collection, most obviously in the 1908 *Nude Boy*, languidly masturbating onto a

gold-and-bronze Jugendstil coverlet, his penis stirring through a mop of bright-green pubic hair. Even at this early stage, though, it's apparent that Schiele will himself secede from the great seceder, since the strongest element in his composition is not colour or texture but line. Instead of enclosing the body in multiple layers of decorative pattern, Schiele has rendered it as a flat, two-dimensional form, so that the sharply angular outlines of arms, trunk and knees create their own abstract, dancelike rhythm. In related drawings, all done in 1909 and 1910, he takes this anti-ornamentalism (somewhat akin to the architect Adolf Loos's crusade for the plain) much further, stripping away the last remnant of decorative or figurative background and tracing linear shapes against a featureless void, often on ordinary buff wrapping paper.

Albert Elsen has suggested that Schiele must have been influenced by Auguste Rodin, who had been conspicuously exhibited in the first Secession show, in 1898, and whose own erotic drawings had been shown in Vienna in 1908. Rodin had practised and promoted a style of continuous drawing in which the artist looked uninterruptedly at the model while his sketching hand wandered freely over the page in a single movement, sometimes travelling off the paper altogether, and creating incomplete or abitrarily truncated contours. He had made great claims for this new method, arguing that it liberated figure studies from the artificial tradition of mechanical drawing and allowed the body, as it were, to draw itself along the sinuously fluid line. It seems probable that Schiele, too, meant to recover an unmediated, spontaneous relationship between artist and model, including an overtly sexual connection, which had been expressly prohibited in academic art training.

Whatever Schiele's initial debts to Klimt or to Rodin, by the end of 1910 he had developed a manner that was unmistakably original. Its confrontational, occasionally sophomoric sexuality was of a piece with polemical writing then circulating in Vienna which attacked the hypocrisy of a culture that sent its bourgeois girls to convent schools and then displayed them for the marriage market in tight-laced corsets and bustles, all the while pretending that the female sex was by nature

passively receptive. Against this piety, a number of writers begged to differ. The pseudo-biologist Otto Weininger, for example, in 1903, had published his *Sex and Character*, in which he unblushingly asserted that 'the female principle is...nothing more than sexuality', and that 'the condition of sexual excitement is the supreme moment of a woman's life'. Weininger, who was Jewish himself, mysteriously equated this voracious fecundity with the 'Jewish principle' (thereby ensuring an appreciative audience in a city where the mayor, Karl Lueger, was a notorious anti-Semite). Female carnality was held responsible for the neurosis that Weininger saw dominating contemporary culture and that he believed could be held in check only by the weak barrier of male rationality. This was, in fact, simply the most modern version of ancient foolishness, reiterated at least since the Renaissance, when misogynist writers had solemnly proclaimed women to be governed by cool, wet humours that drove them to warm themselves over the fires of lust. But male insecurities in pre-war Vienna were acute enough to give theories like Weininger's temporary credibility, especially following his suicide in Beethoven's rooms – an act that guaranteed his instantaneous beatification as a cultural martyr.

The twenty-something Schiele could hardly have missed the mordant writing of Karl Kraus, either – the editor of the periodical *Die Fackel*, who likewise believed that women were defined by sexual passion but magnanimously argued that those 'tender fantasies' exercised a benign rather than a malign influence on social norms. Both Weininger and Kraus (and, for that matter, the good doctor-author Schnitzler) concluded that the institutionalized repression of bourgeois marriage was designed either to stifle female sexuality or to divert it into prostitution or adultery. Along with Oskar Kokoschka, Schiele was obviously eager to join the company of these self-consciously aggressive uncoverers, and some of his strongest works – like the paper-doll *Kneeling Girl in Orange-Red Dress*, with one eye collusively covered by a hand, the other staring provocatively at the beholder as if rehearsing a seduction – should be read as erotic attack pieces, meant to puncture the convenient delusions of bourgeois propriety.

Schiele also brought other pungent ingredients into his demonstrative sex art. His theatrical, often brutal vehemence, for example, owed something to much older Renaissance traditions of Austrian and German art, not least the tradition of compulsive self-examination and erotic morbidity. But the elaborately stylized contortions of Schiele's emaciated figures are apparently more directly modelled on archaic sculpture. It was this Dionysiac art that fascinated the immediately pre-war generation of artists and iconographers as a 'barbaric' corrective to what they saw as the suffocating rationality of the liberal élite. The celebration of primitivism made itself felt everywhere in Central and Eastern Europe's metropolitan culture: in the theatre, in the concert hall, and especially in performances of mime and modern dance, whose choreographers tried to represent the imagined body language of 'natural' men and women. One of Schiele's close friends, Erwin Osen, was a mime artist, and Schiele drew him going through contortions with a clownishly coloured face, pipe-cleaner arms, and colossally enlarged hands – a disconcerting cross between Nijinsky and ET.

Much of this seems uncomfortably hysterical, and was, of course, meant to be. Some of the most disconcerting gesticulation in Schiele's work, including his own grotesque grimaces, may have been translated from photographic studies of the mentally deranged. His colours turned similarly neurasthenic. He favoured raw, sharp tones, laid on in deliberately clumsy stains and dabs, the entire painterly performance becoming as aggressively combative as his subject matter: a pair of legs tinted deep blue and purple; a pregnant woman's belly rising greenishly above the dense black mat of her pubic hair; the labia of a twelve-year-old (or possibly younger) girl haloed by a wash of white gouache, her face tinted yellow.

Had enough? Well, Schiele, in fact, has barely got going. And as he hits his stride and the genitalia count starts to mount – as his angle of vision goes down and the distance between painter and model closes to a nose length – the language of MOMA's exhibition catalogue turns in desperation to the decorous conventions of artspeak, becoming ever more formalistic in the face of increasingly outrageous subject matter.

It's unrealistic, I guess, to expect the audio guide to murmur breathily, phone-sex style, and invite viewers to 'check out the especially well-defined, luxuriant pubic tuft – the dazzling painterly ingenuity with which Schiele has manipulated the fabric to suggest labial frill'. But it's odd to stare right into the flame-tinted vagina of *Red-Haired Girl with Spread Legs* and to be told by the catalogue: 'The colours in the work are especially delightful. Schiele juxtaposed the various shades from grey to black with those from orange to red – not to mention the touches of green in the skirt – and finally the white of the undergarments to the black and red...The foreshortening of the face, although only lightly drawn, is masterful.'

For once, 'masterful' is indeed the mot juste. And while Magdalena Dabrowski, the author of the catalogue, concedes that 'Schiele shows himself to be obsessed with sex' (the understatement of the season), she tiptoes around the serious implications of the extraordinary images on the walls, carefully avoiding having to address the violence done to the autonomy and integrity of women's bodies, or whether those images are in fact pornographic. Of course, merely to whisper the 'p' word in the company of the artocracy is to risk accusations of betraying Culture to the congressional ayatollahs who are bent on annihilating the NEA. So Schiele's black-stockinged working-class girls (15), one of whose skirt is pulled up to display her 'sex, peeking out from her white underclothes', need to be carefully classified by Dabrowski as 'erotic depictions without any of the trappings of pornography', only because they have been officially sanctified as Museum Objects rather than as mechanical aids to sexual arousal. Even to insist on the distinction, however, is to impose on Schiele precisely the aesthetic high-mindedness he obviously ached to violate. It's the virtue, not the vice, of his work that it is engaged directly with the relationship between art and sexual excitement, and much of his strongest work does exploit the standard tactics of voyeuristic pornography. It keeps its models half dressed so that the voyeur gets to experience, in visually surrogate form, their enforced dishevelment. Poses are struck which signal the availability of the body to the penetrating gaze. The budding sexuality of immature girls and the embraces of lesbians are

made objects of specialized but compulsive interest. And the faces of the visually colonized are almost always sketchily summarized, while their genitalia are minutely observed, often with attention-grabbing colour tints and accents. Like Rodin, Schiele was a lot less disingenuous than his connoisseurs were about whether the production of these images was indistinguishable from sexual acts, so that it became not simply permissible but actually essential to his campaign of demystification to represent himself as sexually aroused. I don't mean to suggest that MOMA should replace its mid-exhibit study tables with Eighth Avenue-style darkened private booths (if any have survived the Disney midtown jihad against lust). But to deny the lewdness of Schiele's art is to do him no favours, for that is precisely where he concentrated its potency.

In 1911, already something of a celebrity in a Vienna hungry for enfants terribles, Schiele decided that he wanted 'to be alone...to taste dark water, and see crackling trees and wild winds', and removed himself and his mistress, Valerie Neuzil, to Krumau, in Bohemia, his mother's native town. For a while, he did manage to change his tune somewhat, painting dense, slablike Expressionist canvases of the town (variations on a late-Gothic altarpiece in the Schottenkirche in Vienna), with its streets full of piled-up houses. Krumau was also the place where Schiele's father had attempted to commit suicide, and during Schiele's stay there images of mortality start to visit his work with ominous regularity. In one particularly disturbing oil painting, Schiele is embraced from behind by an incarnation of Death, modelled as a paler likeness of himself – or, conceivably, as his father.

Inevitably, though, Eros caught up with Thanatos, and the local burghers caught up with Schiele. Run out of Krumau for hiring adolescent and pre-pubescent girls to pose in the usual generous manner, Schiele and his mistress moved to the town of Neulengbach, twenty miles west of Vienna. There, in response to a complaint lodged by the father of one of his underage models, he was arrested and tried on charges of seducing a minor. That charge was proved groundless, and although it was clear that Schiele had never laid a hand on any of his

young models, he was convicted on a secondary charge of 'distributing obscene drawings', based on his having exposed children to the 'indecent images' in his studio. Though the judge solemnly burned one of the offending drawings at the trial, he commuted the maximum penalty of six months' hard labour to just three days in prison (on top of the three weeks that Schiele had already spent in custody awaiting trial). The art-historical literature has treated Schiele as a classic modernist martyr to stuffy provincial philistinism, echoing his own verdict: 'To restrict the artist is a crime. It is to murder germinating life.' But it's hard to commiserate uncritically with his bewildered outrage that anyone could possibly take offence at his asking thirteen-year-olds to spread their legs for his graphic benefit.

That Schiele was traumatized by the incarceration is evident from self-portraits done in 1912 – in particular, the savagely chiselled *Self-portrait with Hunched and Bared Shoulder*, and huge wet eyes, twists violently over a shoulder, as if in parody of a coquette's pose. There is more than a trace of self-pity in many of these images, and it nudged Schiele toward a slightly laborious symbolism in which he reappears in proxy forms: as an autumnal tree, for example, stripped of its leaves by a howling gale. (Two pictures in this vein were based on a famous Segantini painting, shown in the Secession and called *The Evil Mothers*, which Schiele made over into a self-portrait as bent twig.) Schiele also figures as, inter alia, a randy cardinal kneeling against the body of an unnerved nun; a half-naked 'preacher', his head bent to observe, with strange dispassion, his own arm extended phallically from his groin; and a medieval saint, draped in purple and crowned with a nimbus of shrieking lemon yellow. But, notwithstanding this burst of eroto-clericalism, Schiele's brush with the law decisively altered his art. Much of the excessive posturing and sophomoric reaching for shock disappeared, to be replaced by a tougher, spikier drawing style and a much stronger sense of modelled forms. Instead of slavishly fetishizing the vulva of a fourteen-year-old, Schiele turns the bodies of recognizably mature women into strong, self-contained images, often indirectly viewed (from behind or above), the models either oblivious of the artist or actively returning and

challenging his gaze. The extremely beautiful *Nude with Blue Stockings Bending Forward*, with its shock of golden hair atop a classically arched back, could almost be a study for one of Kiki Smith's powerful sculptures.

Had Schiele grown up and calmed down? Not quite. By 1915, he had dumped his mistress and married Edith Harms, the daughter of a machinist. Dabrowski, in describing his *Nude with Raised Right Leg* (clad in scarlet stockings) – an image in which the head is again stylized but with summary, caricatural lines and button-hole eyes, as if he were sketching for Brancusi – reports, with apparent relief, that 'even her labia have been toned down, an unusual touch for Schiele'. He may not have been ordinary enough for the Austro-Hungarian draft board, which initially deemed him unfit for military service, but by 1915 the Imperial Army was inclined to take anyone who could stand up, and reversed its judgement. Schiele was allowed to serve, albeit a long way from the hell of the Russian or the Italian front – either in Vienna, where a major retrospective of his work had opened, or at a camp for captured Russian officers. Doing his bit for the Fatherland did not, of course, preclude his producing the usual quotient of gaping vaginas, lesbian couplings and even (at last) a heterosexual copulation in which Schiele, his face glazed and dumb, leans over a red-haired lover like an oversize rag doll dropped between her thighs. A few of these late watercolours and drawings are powerful; many are nondescript; almost all seem to have been affected by a belated classicism, as if the Good Soldier Schiele felt at last that he had to stand to attention when the past-masters spoke. Especially depressing are large oil paintings in which Schiele has clearly attempted to give his nudes a statuesque, iconic monumentality. So we have Schiele, stranded somewhere between Cézanne and Picasso, doing his Expressionist makeover of the Three Graces or the Rokeby Venus.

In February of 1918, Gustav Klimt died, and Schiele, forsaken by his last and perhaps most burdensome father figure, made three very beautiful drawings of the dead artist and soon afterward published a memorial tribute to him. Later that year, no fewer than two hundred works on paper by Schiele and his New Art Group were shown in Prague and

Dresden. And it was at just that point, when he was becoming the principal eminence of Austrian painting, that he died of influenza, only three days after his wife.

He was twenty-eight years old. Inevitably, the temptation in reviewing a career so drastically abbreviated is to speculate on how he might have continued – whether, for example, he would have become a mentor for the New Objectivity, whose uncompromising rawness he seems to have anticipated. But as you go around the final galleries of the Leopold Collection show you don't get the impression of a talent that, despite a looser, stringier line, was restlessly searching for a radical new vision. It's possible, in fact, that if Schiele had lived his most original work would have been behind him. For the really awkward fact about Egon Schiele is that he was at his best when he was also at his most uninhibitedly and self-indulgently puerile. One of the most memorable items in the Leopold Collection is a self-portrait drawn at the age of twenty but depicted with the high-coloured cheek and rosy ear of an adolescent at least five years younger. Still more extraordinary, and more uncompromisingly elemental than any of the pudenda parade that would follow, are Schiele's two drawings of a newborn baby boy. In one of them, the infant, with swollen eyelids, gropes blindly forward on his knees. In the other, he lies on his back like a pink bug, belly distended, one leg waving helplessly over the alarmingly outsize scrotum, which, for once (as parents know), the artist has no need to exaggerate. Nothing Schiele ever did summarized more exactly his painful vision of the human condition: from the cradle to the grave, an infantile, myopic and helpless imprisonment by the tyrant libido.

CHAIM SOUTINE

Gut Feeling

AND THE PRIZE for the least well-advised museum publicity stunt goes to the Jewish Museum, whose press kit for its current show brightly announces, 'Café Weissman introduces new menu inspired by great French painter Chaim Soutine.' The mind reels. The palate gags. The scene unfolds: 'Waiter, give me a pair of those three-day-old herring, and for an entrée I guess I'll take the flyblown mini-carcass of prime – and make it bloody. And the lady will be having...Sharon? The pan-seared skate with hanging entrails?'

In fact, the café's idea of Soutine-inspired fare is (surprise) salmon en croute on a bed of couscous. But no one who walks past the livid, screaming paintings that fill the museum's show will suppose that this painter was in the business of cooking up comfort food for the eye.

Chaim Soutine was the last and most ferocious of the great European Expressionists. He arrived in Paris in 1913, from Jewish Lithuania, when Expressionism was beginning to run out of steam, and when Fauvist artists like Derain and Dunoyer de Segonzac were turning away from the

painting of inner turmoil and toward a more decorative aesthetic. Soutine, on the other hand, made van Gogh (whose obvious influence he nonetheless denied) look tame by comparison. At a time when modernism, led by the Cubists, was becoming ever more cerebral, Soutine's painting, with its extreme distortions of form and its howling colour, was shockingly visceral.

Soutine was the gutsiest of all the Expressionists – if not necessarily the most courageous, certainly the most intestinally fixated. This is not simply a matter of his subjects, although they included slaughtered animals in varying degrees of putrefaction or preservation and shifty-eyed cooks with meat-cleaver hands. For the background of his 1918 self-portrait – all jug ears, blubbery lips and brutally cropped hair – Soutine chose an acid-green colour that can only be described as bilious. The 1922 *Group of Trees* resembles nothing so much as a lower digestive tract extracted from its cavity and re-spooled, vertically, around a collapsing house. Soutine, who was afflicted with chronic stomach troubles, brought his alimentary turmoil right into his brushwork, whose peristaltically pulsing, wavelike rhythms make him the inventor (and sole practitioner) of gastric Expressionism. All Expressionism, of course, attempts to signify in paint the inner condition of the artist's mind and passions. But Soutine went further, translating the turbulence of his *body* into painterly upheaval. So, naturally, his palette is by 'ER' (haemorrhage red, venous blue and lipid yellow), while the poses of his figures and his stabbing impasto are drawn straight from the psychiatric-ward handbook on painting as therapy.

Gastric Expressionism can be either anorexic or bulimic. Soutine's friend and patron Madeleine Castaing claimed that he worked best when he was ravenous, and refrained from consuming precisely the meat, fish, or fowl that he was painting. But what he denied his gullet, either from prudence or from paranoia, Soutine freely disgorged onto the canvas in a copious explosion of pigment – high-velocity projectile painting. Notoriously defensive and solitary, Soutine practised the antacid principle of friendship, allowing people to come close to him only as pacifiers. His dealer, the saintly Léopold Zborowski, accompanied him to mineral

spas at Vittel and Châtelguyon, where he drank sulphurously thera-
peutic fluids. His mistress in the late thirties, Gerda Groth, spent her
first night with him warming his Vichy water after he had suffered a
violent attack of ulcers; and Elie Faure, the Bordeaux critic who wrote
with vivid sympathy about Soutine's painting, was also a physician, and
treated the painter for his perpetually raging gut. Though Soutine died
wearing the yellow star, on the run from the Nazis in Occupied France,
it was a perforated ulcer that killed him.

The Jewish Museum is the right place for a major Soutine show, and not
just because of the truism that for many of us Judaism is, first of all, a way
of diet. Much of the recent literature on Soutine – well represented in
the show's illuminating catalogue, by Norman Kleeblatt and Kenneth
Silver – assumes that religious and ethnic agonizing were the primary
source of the tortured quality of much of his painting, and of his com-
pulsive morbidity as well. Inevitably, not all the contributors manage to
avoid the woeful clichés of Judenschmerz: Donald Kuspit claims that
'Soutine's shudder is a sublimation of the trauma of being born a lowly
shtetl Jew and becoming an absurd Jew – not a real Jew – by becoming
a painter.' To which the only possible response is 'Oy!' More reasonably,
Kleeblatt and Silver ask us to think about Soutine in terms of three dis-
tinct critical responses to his throbbing brushwork and lurid colour: he is
the Necessary Wild Man, gratefully exploited by French critics as an
antidote to the creeping classicism that they believed had congealed
around modernist painting in the nineteen-twenties; he is the reinter-
preter of the most painterly masters, particularly Rembrandt, Chardin
and Courbet; and, finally, he is the retrospectively adopted prophet of
American gestural abstraction. The catalogue makes this triple case
persuasively, but what reads well on the page misfires badly as an organi-
zational principle for installation. Distributing paintings in the various
galleries not chronologically but theoretically, so that each gallery can
make a point, turns the exhibition into an obtrusively academic sympo-
sium, and precludes the innocent possibility of following the roller-
coaster progress of Soutine's development. It may be that mere

chronology seemed too paltry a concept around which to structure the show, but in Soutine's case chronology counts. It's of paramount importance, for example, to notice that he reversed the expected trajectory of a modernist painter, moving from explosive, almost Abstract Expressionism at the beginning of his career to a more resolved and tightly ordered figuration in the nineteen-thirties.

Beginning at the beginning would also have offered the Jewish Museum an opportunity for a critical re-examination of some of the more simplistic myths that have gathered around Soutine's relationship with his Jewish background. Legend has him jumping straight out of a Belorussian mud puddle – the village of Smilovitchi – into Parisian bohemia, with his demons clinging to him like body lice. It's true that Smilovitchi was not exactly hospitable to a boy with artistic leanings, and that his father, a clothes-mender, would have preferred him to be tailor. But when Soutine got locked in the basement it was not for buying watercolours (as the story goes); it was for stealing the money to obtain them. And, if he was energetically roughed up by the indignant sons of an old man he had drawn, Soutine's mother turned the pain to profit by taking the assailants to court – thus extracting the fifteen rubles that got the young painter out of Smilovitchi and into the city of Minsk.

Despite the apparently unequivocal prohibitions of the Second Commandment, the world of the Jewish Pale was not monolithically inimical to art. Rather, it was culturally divided between the parochial milieu of the shtetls, where the impoverished population was fearful (with good reason) of the attentions of the outside world, and the much more heterogeneous culture of the great urban centres, like Minsk, Vilna and Kovno. These cities had their own staunchly Orthodox citadels but were also alive with all manner of political and artistic experiment. The same world that produced Soutine, after all, nurtured an entire generation of Jewish modernists, including El Lissitzky, Jacques Lipchitz and Marc Chagall, some of whom were to become his friends and champions. Far from being a complete loner, left to fend for himself in a hostile world, Soutine was succoured by a long chain of mentors, companions, nurses, and selfless schleppers. In Minsk, as-a-sixteen-year-old, he lived

with his sister, and developed a friendship with Michel Kikoïne, another aspiring artist. In 1910, the two of them moved to Vilna and enrolled in the Academy of Fine Arts, and there, with the addition of another Lithuanian Jewish painter, Pinchus Krémègne, they became a trio. Kikoïne, who migrated to Paris ahead of Soutine, was on the platform at the Gare de l'Est when Soutine arrived, with money provided by his first benefactor, the Vilna physician Dr. Rafelkess.

If Soutine was not as solitary as has been supposed, he was certainly hard up, and when Dr. Rafelkess died, soon after Soutine's arrival in France, he was deprived of any kind of continuing financial support. But at La Ruche, a beehive of studios in the Fifteenth Arrondissement where artists from Russia and Eastern Europe lived on camp beds and kept the bugs at bay with dousings of kerosene, Soutine had a group of friends who did what they could to get his paintings shown and sold. His guardian angel was the Italian-Jewish artist Amedeo Modigliani, who introduced him to his dealer, Zborowski, and took him to dinner at the Zborowskis', much to the horror of Anna Zborowski, who complained bitterly of Modigliani's reeking companion. Modigliani also did the most affecting portraits of his unlikely comrade, including one that was painted on a door of the Zborowskis' apartment. Thirty-five years ago, the Arts Council of Great Britain had the inspired idea of mounting simultaneous shows of the two artists in the Tate Gallery, where the hysterical distortions of one painter and the graceful sensualism of the other seemed providentially complementary. In fact, Modigliani's chiselled angularity and silky flatness did find their way into some of Soutine's more sympathetic portraits, like that of the elegant Madeleine Castaing. But that happened long after Modigliani's death, in 1920, of tubercular meningitis, which had been badly aggravated by his addiction to drink and drugs.

Modigliani's tragic end can only have intensified Soutine's aversion to the dangerous pleasures of Montparnasse, which alternately attracted and repelled him. So he painted the personifications of those pleasures – cooks, bellhops, gaudily dressed women and ordinary bourgeois – as members of a fairground freak show, their faces mangled and pulpy, as if

seen in a distorting mirror. This love-hate relationship with Paris endured for most of Soutine's life, and he obliged the cliché-mongers by developing a serious case of the Wandering Jew, moving restlessly from one rural retreat to another. In the spring of 1918, he had gone south for the first time with Modigliani, to Nice and Cagnes, to get out of the way of the German shells that were falling on Paris. When the Armistice came, Soutine moved again, this time to the Pyrenean village of Céret.

Céret was known as a painters' retreat, frequented by the likes of Braque and Picasso, but Soutine's experience of the place over the next few years was a long way from being a romp at summer camp for Cubists. He was too poor to live in the village, and his pictures were too scary, or too incomprehensible, to be bartered for food at the local cafés, like the works of other resident painters; he was taken in as a lodger by two old ladies who lived on the outskirts. And although much in Soutine's career ought to caution us against seeing him purely as the loner, the *basfonds* poverty and misanthropy of his time at Céret did draw from him Expressionist landscapes of dumbfoundingly original power.

In some of the pictures, the vestige of a landscape subject – a roofline of houses, an avenue of plane trees – is retained, albeit wrenched out of line. In others, the ground buckles, heaves and writhes; solid forms balloon and blister, or implode back in on themselves, like matter sucked into the core of a twister. In the most radical pictures, like the Tate Gallery's *Landscape at Céret* (*The Storm*), observed phenomena dissolve completely into a pottage of pigment – the paint flung on with abandon, wet into wet, forming ropes, snakes, or flat ribbons of sharp colour, while the whole surging surface is sometimes slashed over with welt-raising strokes of black. At this point, the paint itself has become Soutine's subject matter, and he has become the virtuoso handler of its protean personality – from free-running fluidity and brightly spattered speckles to glistening rivers of turbid glop.

Who would have thought that this sort of thing would appeal to Dr. Albert Barnes, the omnivorous collector of Renoir, Cézanne, and Matisse? But it did. In December of 1922, Dr. Barnes, a tycoon from

Philadelphia, who had made his fortune from a cure for conjunctivitis, was introduced to Soutine's paintings by the Paris dealer Paul Guillaume. Instantly smitten, Barnes bought cartloads of them, at rock-bottom prices; the following year, he exhibited some of them in both Paris and Philadelphia, and in 1925 he devoted a chapter to Soutine in his book. *The Art in Painting*. Soutine now found his life and his place in Paris culture abruptly transformed: he went from scrofulous pariah to primitivist poster boy. His works were selling for thousands of francs, and he was repeatedly 'discovered' by Paris critics in the tones of lordly wonder usually heard from colonial anthropologists encountering an especially charming but infantile species of savage.

Soutine, however, was not the kind of painter who relaxed into success. By the mid-twenties, he was regularly mutilating works that he regretted, and even some that he liked, on one occasion taking a pair of scissors to a painting right in front of the understandably dismayed buyer, who had just paid twelve thousand francs for it. He had an anal reluctance to let his work go which was of a piece with his feeling that the paintings were never quite finished – that they were part of an endless process of creation, destruction and rebirth. And it was this sense of painting as a continuous process, rather than any sort of reverence for tradition, that, especially in the middle and late twenties, drew him to the art of the past – or, rather, to those masters he believed had treated painting as a perpetually incomplete creation. This impulse also led him to use already painted seventeenth-century canvases, so that his work would be deposited as the most recent layer of a dense palimpsest of artists' marks. And, although he produced extraordinary variations on works by the artists whom he judged to be the least academic and the most painterly in the canon, like Chardin and Courbet, it was with Rembrandt that he sustained his most abiding communion.

In Rembrandt, he correctly saw an artist passionately and materially involved with the texture of paint, one for whom, toward the end of his career, the experimental manipulation of pigment virtually became an end in itself. Soutine pored over the literature in an attempt to discover how Rembrandt mixed his paints; like Rembrandt, he used the stub end

of his brush to scrape paint away; and he took four trips to Amsterdam to sit in front of *The Jewish Bride* and to buy pigment, as if Dutch paint (probably chemically identical to the paint he could obtain in Paris) would somehow bring him closer to the proto-patriarch of Expressionism. He became transfixed by Rembrandt's paintings of dead birds and butchered oxen, profound meditations on the relationship between sacrifice and redemption, on the vitality of paint and the mortality of bodies. In Amsterdam, Soutine must have seen the magnificent *Girl with Dead Peacocks*; this peculiar painting, which shows blood oozing from the strung game, was surely the source of the sequence of slaughtered animals and birds – rabbits, turkeys, and chickens – which Soutine painted in the middle and late twenties, and which make up the most stunning sequence in the Jewish Museum's exhibition.

In the Louvre, Soutine became obsessed by Rembrandt's great *Slaughtered Ox*, of 1655, and he painted a number of versions of the eviscerated carcass, including the monumental crimson-and-purple painting from the Stedelijk Museum (16) and the more outlandishly coloured picture from Minneapolis. In order to help replicate the working conditions of the original, Zborowski spent thirty-five hundred francs on a whole beef carcass from a butcher and hung it from a hook in Soutine's studio, in the Rue du Saint-Gothard, where it promptly turned into a convention centre for swarms of enormous, hairy flies. The stench from the rotting beef also brought a visit from the health inspectors, who were greeted by Soutine's famous lofty epigram 'Art is more important than sanitation.' This being Paris, however, the considerate inspectors showed the painter how to preserve the cadaver by injecting it with formaldehyde. The only problem now was that the chemical dried the beef out. To get that just-butchered look he was after, Soutine went with Paulette Jourdain – a girl to whom Zborowski had assigned the unenviable job of taking care of him – to slaughterhouses to procure buckets of blood, so that he could drench the hanging carcass with it.

Soutine's need for sanguine brightness suggests that he may have known about another important Baroque work of art, by the three Carraccis – Annibale, Agostino and Ludovico – in which the painters

stand at a butcher's stall proudly displaying the *carne viva*, and which proclaimed, symbolically, their collective hostility to the 'dry goods' of the academic tradition. Perhaps, too, there was an element of ghoulish aestheticism in Soutine's loving exploration of sinews and innards, not unlike the creepy pleasure taken by Proust when he bullied butchers' boys into initiating him at first hand into the mysteries of the slaughterhouse.

Ultimately, though, it was the sacred, not the profane, that drew Soutine, as it had Rembrandt, to butchery. He would have been alert to the allusions to martyrdom, and even to the Passion, embodied in the *Slaughtered Ox*, but at the same time his Orthodox upbringing must have brought home to him the crucial distinctions between Jewish and Christian traditions of sacrificial atonement. Jewish oblations in the period of the Temple were rituals of propitiation, in which the guilt for transgression was displaced onto the slaughtered animal, and these rituals gradually evolved into such symbolic expressions as the shank bone on the Seder plate, or into simple acts of atoning prayer. So the fundamental Christian drama of incarnation and crucifixion – restoring the burden of sacrificial atonement to the body of the man-God – was bound to be repugnant to the Jewish tradition, which also equated exposure to the dead with uncleanness.

Soutine's series of hanging birds and butchered beasts is the painter at his most adamantly unkosher. The laws of kashruth prescribe the complete purging of blood from the body of the slaughtered animal, but Soutine's sides of beef and skinned horses are laved in it, and his birds are suspended the wrong way for draining – bills upward, feet down. The animals are, if anything, more heavily laden with sacrificial meaning than Rembrandt's martyred meat. It's also clear that Soutine understood, and doubtless identified with, the element of self-portraiture in Rembrandt's paintings, in which the plumage of birds or the interiors of oxen are treated to the most spectacular brushwork. Soutine, though, does something devilishly pathetic with the hanging carcasses, by giving them the unmistakable twitch of life: the turkey bills appear to have been choked in mid-gobble; the skate loses its innards through a gutter's gash even as

it appears to glide over a teakettle; the defunct hare appears to sprint endlessly over the green shutters.

Inevitably, of course, these images, relentlessly repeated, have been associated with the massacres to come, as if Soutine were a prophet of Aktionskommandos as well as of Action painting. But there is no reason to suppose that he meant his 'game pieces', painted in the twenties, to be a commentary on the fatefulness of any Jewish history except his own. During the thirties, as he was becoming a fixture on the art scene in both Europe and America, Soutine was ever more restless in his movements. Even before Zborowski's death, in 1932, he was adopted by Marcellin and Madeleine Castaing as their pet project. They set him up in a studio in their country house, near Chartres, from which he (or, rather, an assistant) scoured the local villages looking for picturesque poultry or peasants to pose for his increasingly dissonant variations on favourite museum pieces. Not one of these was more wilfully perverse than his picture of a dumpy barnyard matron up to her knees in muddy water – his rendition of Rembrandt's exquisitely beautiful *Woman Bathing*.

Rembrandt's painting is all sensual liquidity and delicate reflection; Soutine's *Woman Entering the Water* is solid, earthy and impacted. And in Soutine's last years, although he was only in his forties, much of his whirling-dervish energy ebbed away; his paintings became more laboriously attentive to their museum prototypes, the brushwork less manic, the forms more legibly described.

Perhaps he was, at last, becoming accustomed to being taken care of. In 1937, he met the twenty-three-year-old German-Jewish refugee Gerda Groth, whom he nicknamed Mademoiselle Garde in recognition of her custodial devotion. Under her watchful ministrations, Soutine even began to eat previously forbidden foods, like eggs, fish, and meat. Live animals replaced dead ones in his pictures; portraits became more sculpturally modelled and less grotesquely rubbery; mothers and children were tenderly depicted. The claustrophobic intensity of the Céret landscapes now opened up to scenes of light and space; his *Windy Day, Auxerre*, with its smoke-wisp clouds, actually looks back, without hostility, to the Impressionists!

As the war approached, one might have expected his anxiety level to rise. But the reverse seems to have been true. Garde, from whom he was separated in 1940 by her internment, reports an odd fatalism in his predictions for their future. Even odder was Soutine's pleasure in reading the work of the fiercely reactionary, anti-Semitic Charles Maurras, and the fact that some of his warmest admirers – like Waldemar George, who boasted of his interview with Mussolini, and Pierre Drieu La Rochelle – were enthusiasts of Fascism.

In November of 1940, Soutine took up with Marie-Berthe Aurenche, the divorced wife of Max Ernst, who was a devout Catholic, and whose mother claimed to trace her lineage to Louis XVIII; she looked forward to her daughter's becoming Queen of France, once the detested Third Republic had been done away with. Aurenche was with Soutine in the château town of Chinon when his ulcer perforated, and after he died she made sure that a cross was put on his tomb in the cemetery of Montparnasse.

Soutine had apparently declined an invitation to seek asylum in America, but his troubled ghost certainly made the crossing over the Atlantic. He had already been noticed in the thirties by the likes of Mark Rothko and Adolph Gottlieb; it was not until 1950, however, that an exhibition at the Museum of Modern Art (MoMA) officially canonized him as the patriarch of gestural abstraction – the inspiration for the vehemence of both Jackson Pollock and Willem de Kooning. Only Clement Greenberg, while admiring Soutine's painterly bravura, confessed himself uneasy with the uncontrolled onrush of his emotions. Soutine was not, as Norman Kleeblatt astutely observes, 'Greenberg's kind of Jew'. In fact, Greenberg singled out paintings at the furthest remove from Soutine's feverishness, like the densely picturesque *House at Oisème*, as his most completely realized works of art.

But to see, even in the later Soutine, a painter on the road to controlled self-mastery is wishful thinking. The Soutine who fully deserves his place among the masters of modern painting is the Soutine for whom painting was an ecstatic frenzy, a kind of trance in which unthought-of prodigies of brushed colour might be liberated. As his pictures leap off

the walls and set about attacking visitors to the show, it's plainer than ever that the painter whose first name means 'life' and whose career was spent peering at death still refuses to settle down and behave himself.

PIET MONDRIAN

True Grid

IN THE FOREGROUND of a crowded Pieter Bruegel masterpiece, the opposed forces of Carnival and Lent battle for the souls of believers. Carnival, the fat sausage warrior, sits astride a wine cask, brandishing a skewered pig. His foe, mirthless Lent, erect in a straight-backed chair, carries in one hand birch twigs to scourge earthly pleasure and in the other a paddle-load of fish. To the Dutch, he was, and is, *Pekelharing* (pickled herring), sharp and puritanical. His spare face and frame give him a startling resemblance to Piet Mondrian.

In 1893, the twenty-one-year-old Mondrian exhibited a still-life of herring and cut lemons. Its monochrome grays and browns bear the imprint of the Dutch academic tradition in which he had been trained. One of his first paintings had been a *vanitas*, a visual sermon; done to order for his Calvinist schoolteacher father, it depicted the stock emblems of mortality – scythe, hourglass, crown – and was inscribed *Thy Word Is Truth*. Much of Mondrian's subsequent career was devoted to a dialogue between the earthly and the spiritual. But the artistic record of that investigation is

anything but sombre. After the stunning show at the Museum of Modern Art (MOMA), Mondrian should no longer be thought of as the ascetic *Pekelharing* of modernism, dogmatic in conception and formulaic in execution. The story this exhibition tells is one not of captivity to dogma but of liberation from it; not of the 'ruled precision of the geometer' that was Clement Greenberg's term for Mondrian's art but of restless experiment.

For those who might be anticipating three hours with Mondrian as the museum equivalent of the grapefruit diet, the news from West Fifty-third Street is shockingly good. *Piet Mondrian: 1872–1944* is an illumination, and it offers an experience as exhilarating as and more profoundly moving than many of MOMA's line-around-the-block spectaculars. In Washington, the public, sensing an enigma, was wary. The reception at MOMA should be different, if New Yorkers have eyes to see. It was here, after all, that Alfred Barr first celebrated Mondrian's rightful place in the history of modernism by including nine Mondrian paintings in his great 1936 survey, *Cubism and Abstract Art*. And it was here that Mondrian spent the last years of his resolute life, producing work that flashed with colour and rhythm – the final refutation of critics who had pronounced him trapped within an aesthetic cell.

The view that Mondrian was abstraction's seminarian, all headwork and no handwork, has been convenient for the kind of high-minded criticism that writes off talk of 'art objects' as so much museum preciosity. The two-dimensional compositions of primary-colour planes and black lines for which Mondrian is best remembered have seemed ready-made for knockoffs, and the reproduction of a generic 'Mondrian effect' has been as widespread in industrial design and architecture as it has been in art. (His red rectangles and black grids became Hollywood shorthand for the computer age in the opening shot of the 1957 Tracy-Hepburn comedy *Desk Set*.) But this show reveals Mondrian as, at the core, one of the least mechanical of the heroic modernists. Despite his reputation, he believed that painting was the supreme visual art, free of any obligation to function.

Paint mattered to Mondrian. To go through this exhibition is to keep company with an artist who was almost exclusively paint-happy. He was

obsessed with paint's untranslatable pecularity – its viscosity or liquidity, its opaqueness or transparency – and, above all, with the radiance of its pigment. Like many other Dutch painters, he became restive with the grim palette that even the self-consciously modern painters of the eighteen-eighties and nineties confused with tonal integrity. But Mondrian was no precocious rebel. His first years as an artist in Amsterdam were spent making copies in the Rijksmuseum; studiously painting conventional portraits, still-lifes, and landscapes; and failing (twice) to win the Prix de Rome. The verdict, according to his examiners, was 'Application: good – Talent: fair'. In his late twenties, still very much the earnest and respectable novice, he began to do odd, crepuscular, off-centre landscapes, many of them near the river Gein, where churches and trees dissolve into cloudy backlight or watery reflection.

In his mid-thirties, having laboured through a programme of cautious Impressionism, Mondrian suddenly began plastering his depictions of Zeeland dunes and Holland riverbanks with colour combinations of aggressive unsuitability. Many of these concoctions, which he began turning out around 1908, are melodramatically beautiful. An engulfing dune, pulled up against the picture plane, is flecked with cobalt and turquoise. Its base and crest, though, are picked out in brutal tangerine. An avenue of riverside trees near Oele traps a creamy, high-fat-content moon within smeared and dripped bands of green and crimson. A stolid windmill is set alight in screaming scarlet and gold. Obviously, Mondrian had seen van Gogh. But, just as obviously, he was no Expressionist. Keying raw colour to psychic states was less compelling to him than experimenting with the sensory effects produced by this or that improbable chromatic juxtaposition. Nor was he interested for any length of time in breaking colour down to the basic optical constituents decreed by Pointillist theory. For Mondrian, even in these first forays, colour was not a scientific tool but a meditative pathway, whether it was laid on thickly, in custardy tints, or carefully modulated, in pink and grey halftones.

Almost nothing of this subtle play of colour can be discerned in printed reproductions, as even the best efforts of the exhibition catalogue make painfully clear. Something else that becomes evident at first

hand is Mondrian's compulsive labour with the brush, and his need to expose the process of his painting. Erasures, pentimenti and all the sudden tugs of intuition and regret are allowed full visibility, enlisting the beholder in the arduous work of completion. At no stage of his career was Mondrian complacently glossy in his finish. In *The Sea* (1912), a tour de force of self-conscious painterly display, the rhythm of the waves is partly abstracted into overlapping fish-scale forms, which are defined with dashing black curves and are folded into the marine grey-green of the scowling North Sea. As if he were moving with the tide, Mondrian mimetically performed the motion of the waves by applying the colour, wet in wet, in little undulations that snake over the entire surface of the painting.

The curators responsible for the exhibition – Angelica Zander Rudenstine, Joop Joosten, Hans Janssen, Yve-Alain Bois and MOMA's John Elderfield – would probably not be happy if visitors were to while away the hours in the galleries devoted to Mondrian's early work, which include both the chromatic explorations of the years after 1908 and the virtuoso Cubist compositions of his first stay in Paris, from 1912 to 1914. Bois, in particular, urges a brisk march toward the heart of the matter – the arrangements of colour planes and lines that Mondrian called his Neo-Plastic abstractions.

He began to paint them in Paris in 1919, not long after leaving the Netherlands permanently. For the curators, this is the only Mondrian that really counts – the Mondrian who decisively altered modern art, wiping it clean of the vestigial remains of representation that lingered on in Cubism and Surrealism. The artist's aim was to 'interiorize' external appearances, to extract the essence of things from the husk of appearance. Such essence, by definition, would have no resemblance whatever to the material casing of our external world. It could appear only after our vain craving for verisimilitude was suppressed. Once freed from the obligations of representation, 'abstract reality' could make itself felt and seen, could be revealed in the dynamic oppositions between plane and line, primary colour and white or black, horizontal and vertical.

Mondrian came to see himself as the liberator of paint from its servitude to the concrete world. In his hands, painting became prophetic and universal. It is this Mondrian who, in the view of Rudenstine and her colleagues, demands our utmost attention, not the loud pseudo-Fauve or the Cézanne-worshipping Cubist. And, they argue, it is this Mondrian who, if he is given proper breadth of display, can be freed from the clichés about the one-note virtuoso, boxed into angular obsessions.

It would be churlish to find fault with this approach. From the outset of his career, Mondrian habitually worked in series, and the curators present coherent groups of the abstract paintings with unprecedented completeness. Comparisons within a series and between separate series indeed reveal dramatic changes that result from what seem superficially like slight recalibrations of basic design. Inside Mondrian's Neo-Plastic world, though, a decision to halt a vertical black line a matter of millimetres above a bottom edge, or to transect a blue colour plane with a horizontal line, or to banish a primary colour to the outer limit becomes the painterly equivalent of earthquake. Moving from open-pane works, in which white or faintly grey planes dominate, with red or blue lying potently at the perimeter, to more monumental arrangements of large, counterbalanced planes of saturated colour is like travelling from one climate zone to another. The dramatic shifts of tone and balance attest to Mondrian's achievement in creating an infinitely variable universe of values from the most economical ingredients. There are almost a hundred of these compositions, and not a redundant work among them.

The overwhelming abundance of Neo-Plastic abstractions works brilliantly in the galleries. In the catalogue, however, the curators adopt a sternly tutorial mode. They lament that Mondrian scholars have emphasized the early biography at the expense of concentrating on the masterpieces of the nineteen-twenties and thirties. All we really need to know about the sources and intentions of his best work, they maintain, can be read from the compositions in front of us. (No headsets required.) According to this view, Mondrian's vocation was a prolonged exercise in redefining the nature of painting. It's as if Mondrian were the

product of some particularly strenuous seminar on modernism and had been assigned the task of inventing an alternative to the illusionistic visual language that had dominated painting since the Renaissance.

Given this approach, Mondrian's prolonged involvement with Theosophy, the Western Buddhism that sought to access divinity within humanity, may be safely relegated to a biographical footnote. Ignore those haunting photographs of the Dutchman as yogi. Skip his screeds, volumes of them, and be satisfied instead with the self-contained eloquence of the paintings. And stop hunting for lines of continuity that track through the isms. Once we're in the miracle years after the First World War, just forget about trees and stars. Abstraction is abstraction is abstraction.

In this jump-cut version, Mondrian becomes the merciless smasher of his own assumptions. After a late start, with the first true Neo-Plastic work begun when he was forty-seven, Mondrian's career hurtles forward in a series of self-obliterations, and each phase wholly supersedes its predecessor. It is less a journey than a sequence of unanticipated arrivals, and for that reason Yve-Alain Bois calls his dazzling catalogue essay on Mondrian *The Iconoclast*. To a certain extent, it's easy to sympathize with the impatience that an acutely focused critic like Bois feels on being confronted with the clunking historicism that plods through contemporary sociology and ideology, bent on 'unpacking' hidden subtexts from the art. Bois doesn't want to unpack. He travels light, with his eyes and his intellect neatly meshed in high gear, and unencumbered by historical baggage.

What a pity, then, that it isn't true, this nimble formalism – or, rather, isn't true enough. Take a powerful early work like *Red Mill at Domburg* (1911). At MOMA, the work is innocently displayed alongside Mondrian's colour rhapsodies of sea and shore. But in an interesting survey last year of twentieth-century Dutch art, at the Musée de l'Art Moderne de la Ville de Paris, the *Red Mill* was shown together with a symbol-laden Mondrian triptych, also from 1911, that the artist, in keeping with his Theosophical convictions, called *Evolution*. The triptych is an allegory of the progress of humanity from the corporeal to the

spiritual state, and it is perhaps not fortuitous that the stylized frontal figures on the side panels of the allegorical work are identical in composition to the vermillion mill that seems to throb from the blue ground of the other painting – for they were all meant to signify the incomplete process of transmutation, to show earthly objects in mid-metamorphosis, with the cladding of their worldly shape not yet sloughed off.

Heavy-duty metaphysics may slow down the sprint to pure abstraction, but respecting the seriousness of Mondrian's commitment to Theosophy is important to understanding just what he supposed the point of his abstract art to be. As Carel Blotkamp points out in an excellent new monograph, *Mondrian: The Art of Destruction*, the painter would have been dismayed to have his paintings read as exercises in pure aesthetics or as exempla of contemporary art-play. His enormous output of explanatory writings leaves not the slightest doubt that for him Neo-Plastic abstraction was the transformation of observation into inner vision. If only a few initiates could see with that inner eye, Mondrian argued, the world might yet be converted to a new, spiritually driven sensibility. The goal was transcendental knowledge, and abstraction was its visual mantra.

Mondrian's passion for metaphysics, then, was not the spare-time crankiness of a full-time artist. It made him the painter he was. He first saw the light of Mme. Helene Blavatsky's Theosophy when he was beginning his experiments with colour saturation. Mondrian became a formal adherent, and, although he was never slavishly captive to the doctrines of Theosophy, its core belief in the attainment of wisdom through disembodiment remained important to him for the rest of his life. Still, there's a lugubrious earnestness about Mondrian's quest for the grail of pure abstraction which doesn't sit very comfortably in a MOMA blockbuster. What is more, anyone familiar with the Dutch heritage will immediately recognize, and be moved by, its paradoxes: the struggle between matter and spirit (Carnival and Lent); between the local and the universal; between the parochial flatlands of the Low Countries and the cultural imperialism of Paris; between the humanism of Erasmus and the mortifications of Calvin. Yet it takes nothing away from the courage of

Mondrian's inventiveness to see that there are, in fact, clearly marked lines of development that are sustained throughout his career. There is actually nothing wrong with following Mondrian's odyssey from the physical and local to the disembodied and universal. It's just because that journey corresponds so closely to our own instinctively anxious progression from the known to the unknown, from the concrete to the abstract, that Mondrian establishes such a strong bond of sympathy with his beholders.

Notwithstanding the curatorial assertion that nothing in the early work prefigures the later abstractions, no one need be ashamed to notice that the spidery branches screening off the church at Winterswijk reflect Mondrian's early pleasure in Oriental calligraphy, and his decided preference for form over object. And in the paintings from around 1905 to 1910 it's hard to miss Mondrian's truncated and distorted perspective. Even while Mondrian was busy rejecting the dank mournfulness of Dutch Impressionism, he was connected to a much older, native fascination with two-dimensional landscapes, to the ambiguities of the edge, and to a classically Netherlandish obsession with delineation.

Mondrian may indeed have hungered to escape the narrow limits of Dutch art and culture, but when he went to Paris, in 1912, he was by no means a naïve apprentice of the Cubists. He did, it's true, worship at the shrine of Cézanne and paint two still-lifes with celadon pots at their centres. In telling ways, however, Mondrian's Cubism moved in the opposite direction from that of Picasso and Braque. The Cubist painters dismantled coherent forms – buildings, household objects, people – and reduced them to the sculptural blocks that they believed existed independently of mere appearance. But Mondrian was still more radical in his decompositions, deflating the volume and mass of his blossom-loaded apple trees and squashing them up against the picture plane as though they were pressed on a wind-shield. The flattened shapes were then further broken into abrupt arrangements of lines and curves, and were no longer legible as any kind of solid objects.

Can it really be mere happenstance that the moment when

Mondrian crossed irreversibly from representation to abstraction — the moment when he had his vision on the road to Damascus — occurred not in Paris but on the shorelines of Zeeland? As anyone who has stood on the mudflats of Walcheren knows, the horizon swims in a briny mist; solids and liquids seem to shift about with disconcerting instability. In the summer of 1914, Mondrian came home for a visit, and then, after the war began, found it impossible to return to Paris. Obliged by history to stay among the native emblems that had preoccupied him before he moved to France — the sea and the church — he now transformed them utterly in the light of his urgent new understanding. It's impossible to imagine a more powerful document of this conversion from perception to vision than the *Pier and Ocean* series of 1914–15, beautifully installed in its own room at MOMA (17). Within the oval format he had acquired from the Cubists, Mondrian executed a sense impression of a rolling sea glimpsed through half-closed eyes, the wave-glitter marked in short, stabbing black horizontals that are penetrated by the vertical axis of a pier or breakwater. In some versions, free areas of chalky-white gouache imply a smear of stars on a fine night. But Mondrian was at pains to disabuse anyone who might think these were landscapes in any traditional sense. Starting out with the memory of a sensory record, they evolve rapidly into independent organizations of lines against a neutral ground: a visualization of what could *not* be seen. It's one of the critical moments of altered sensibility in the history of painting: an optical impression lingering in phantom retinal space even while it loses ground to an alternative, cerebrally constituted vision.

These five years in Holland were a time of extraordinary development. Dutch bourgeois culture, so often misrepresented as staid and parochial, was humming with innovation. The perception that the Netherlands was weighed down with stolid materialism and conventional piety was what fired the founders of the De Stijl movement — Theo van Doesburg, Bart van der Leck and the architect J.J.P. Oud — to offer a new blueprint for communal life, based on the pure forms of geometry. The movements, utilizing mathematical definitions of beauty, sought to create an entirely fresh social habitat from which the clutter of

the past had been expunged. It offered a hospitable climate for Mondrian's ideas, and he wrote a lengthy manifesto on Neo-Plasticism that appeared in the magazine *De Stijl*, in 1917 and 1918. For a time, Mondrian's ideas seemed to outreach his practice, and his painting was hobbled by overtones of intellectual illustration. In the first, tentative experiments with colour planes, weak little blocks of pink, red and blue nuzzle up against one another, nervously overlap, or glide away in indeterminate space. Eventually, however, Mondrian began to create modular grids of small rectangles, with each unit repeating the format of the whole painting. In other works, he used patterns of diamonds within which interior patterns emerge and recede. For the only time in his career, the work becomes self-conscious and mechanical; some of the hesitant products of this interval suggest the tile floors and stained-glass windows that occupied a number of his colleagues in De Stijl.

Once again, a move made a difference. Upon returning to Paris, Mondrian rented a studio and immediately began to turn it into a Neo-Plastic habitat, gluing pieces of painted cardboard to the walls. And suddenly the painful conflict between the machine-stamped determinism of the De Stijl checkerboards and his own freer intuitions spontaneously resolved itself. The rectangles expanded in size and contracted in number. Everything becomes simpler, cleaner, and much more potent. The colour planes are now limited to primary colours: red, yellow and blue are used in virtually every painting. The planes are never contiguous. The armature of the compositions – the dark borders around colour and white planes – hardens from grey to heavily painted black. Soon the lines themselves evolve from passive devices of containment and proportion into dynamic carriers of rhythm.

Yve-Alain Bois insists that these are never adamantine structures, and he is right. Within the strong scaffolding of the abstractions, there is vital, unstable energy. Mondrian was always suspicious of balance, even as he sought to attain it, and throughout the nineteen-twenties he was willing to try anything to avoid the ossification of his habitual forms. Lines thicken, becoming virtual planes. Colour planes shrink to the breadth of line. Manipulating the variables, Mondrian arrived, in the late

nineteen-twenties, at something very like abstract monumentalism. In the immaculately organized *Composition No. III* (1929), for example, the unenclosed edges of the big upright red rectangle are balanced in the opposite quarter of the painting by a frame of hard black lines and fat strips of solid colour. Even the white strip is densely overpainted to avoid any impression of vacancy. But just at the height of this achievement Mondrian became wary of creative seizure. Fear of immobility pushed him in new directions. The aim, unflaggingly pursued, was never pure harmony but, rather, the perpetual motion of opposing forces.

If Mondrian was sustained by his resolve during his Paris years, it was just as well, for, aside from the occasional show at the gallery of Léonce Rosenberg, he soldiered on without recognition or money. Paying the rent for his Neo-Plastic studio meant having to turn out insipid water-colour flower paintings on the side. Though he remained single-minded, he was not solitary. Impressions of a Dutch hermit in Montparnasse are quite misleading. Theo Van Doesburg's wife, Nelly, remembered him as a shy man who was hungry for company, both intellectual and social. He was a member of the Circle and Square group that included Léger and Kandinsky, and he would sometimes invite a fellow-artist, like László Moholy-Nagy, to collaborate with him on a work. Once he got the paint off his fingers, Mondrian would spend evenings at the Italian circus in Montmartre, or linger over drinks at a café. Having taken the trouble to learn the tango and the foxtrot, he would try out the steps at a dance hall, his long, straight legs moving precisely over the parquet; he some-times launched into invented moves without bothering to notice the effect on his partner. Where women were concerned, Mondrian was generally hopeless. After a failed engagement, he became convinced that art was incompatible with conjugality, and in his case he was probably right.

It took Mondrian much of the nineteen-thirties to get Neo-Plasticism to trip the light fantastic. The decade has often been passed over in previous shows of his work, but MOMA's display highlights every one of the moves. Mondrian began in a gingerly fashion, loosening the

stays of his linear construction by doubling and tripling the lines. Narrow spaces open up, exposing delicate planes, which then appear to shake loose from the surface and travel up and down over the composition, creating a trellis that presupposes just the effects of superimposition that Mondrian had spent the better part of the nineteen-twenties eliminating. Yellow begins to dominate the other colours, weakening the rigidity of the black girders, and even, in one extraordinary composition, replacing them altogether. In *Composition No. III Blanc-Jaune*, an amazing painting, which took Mondrian from 1935 to 1942 to complete to his satisfaction, the narrow space between lines that is characteristic of many of the nineteen-thirties experiments has broadened to a vertical corridor. At right, a broadly spaced black-and-white plane is surmounted by a brilliant cadmium-yellow plane pouring out to the upper edge; to the left, a blue area seems to be contained by the old, hard black line until one notices that the line itself has grown into a little black rectangular patch – the kin of other red and black ribbons that lie at the perimeter like flying buttresses.

None of these moves, studied or agile, should be thought of as mere aesthetic adjustments. Admirers like Clement Greenberg have judged the most profound consequence of his work to be the reduction of painting to its intrinsic elements, but for Mondrian such considerations still came second to his quest for spiritual self-knowledge. In a 1919 essay, Mondrian had written that 'the deepest purpose of painting has always been to give concrete existence, through colour and line, to the universe that reveals itself in contemplation'. Twenty years later he was still trying to produce an art that was, in effect, 'a permanent contemplation'.

Conversion to the creed wasn't a condition of admiration. In the late twenties and thirties, Mondrian's work was shown more widely, in Zurich, Stockholm and Brussels. The great Kröller-Müller collection of modern art in the Netherlands prominently displayed his Neo-Plastic compositions, and his work was sufficiently well known to have made an impact on the young New York artist Harry Holtzman. In 1934, Holtzman visited Mondrian in Paris and became a devoted disciple; after Munich, he grew concerned for his hero's safety. In the fall of 1938,

Mondrian moved to London, but two years later, after the start of the Blitz, Holtzman arranged for him to make the move to America.

In late September of 1940, Mondrian boarded the SS *Samaria* in Liverpool and sailed to New York. His reputation had preceded him across the Atlantic. In the twenties, the collector Katherine Dreier, who had been alerted by Duchamp to Mondrian's work, sought out his paintings for an exhibition organized by her Société Anonyme at the Brooklyn Museum. By the early thirties, New York dealers like Sidney Janis were buying his work in Paris and singing his praises at home. Alfred Barr's 1936 MOMA show was the ultimate endorsement. When he arrived in America, he was a celebrated refugee.

Unlike the melancholy exiles streaming into Manhattan, Mondrian revelled in the New World. New York must have seemed the Neo-Plastic city of his dreams and visions: wonderfully uncentred and anonymous, brilliantly lit against the deathly European blackout, and magically free from the chafing sores of ancient history. His studio, on Fifty-sixth Street near First Avenue, rapidly filled with arrangements of painted matte boards – 'as gay as a child's wall', one visitor thought. He painted, as he had done for many years, flat on a table, while using his easel to prop up paintings that completed the interior design. He smoked seriously; listened to Pinetop Smith and Cow Cow Davenport, eight to the bar on his Victrola; kicked up his heels with Lee Krasner; and, in the back of a Checker cab, smooched with Peggy Guggenheim, who was then married to Max Ernst.

The paintings themselves became emancipated from their metaphysical vows. The great centres of the Neo-Plastic masterworks of the twenties and early thirties crumbled into hectic particoloured mosaics, ribbons of motion shot through with spangled, flickering energy. The rigid black lines that held the classic distributions of planes in order now surrendered their monopoly to bands of yellow, red, and even white. For the first time since the checkerboard modular grids of 1917 and 1918, Mondrian was satisfied with creating atmospherics, letting his brush shimmy over the surface of modern life. Though his execution was as

painstaking as ever, ideas came to him in sudden Manhattan visions. One morning in 1942, he told a friend that he had 'dreamed a lovely composition'; the dream was *Victory Boogie Woogie*, which, along with *Broadway Boogie Woogie*, was one of the last paintings he made before his death, at seventy-one, in 1944. Yet neither work should be thought of as remotely valedictory. As packed with action as the city itself, they constitute one of the great closing acts of modern art.

Suppose that Mondrian had survived the war? Would he have, like so many others in the *Artists-in-Exile Show* of 1942, returned to Europe? Perhaps it's my own immigrant fancy, but I like to imagine him staying in Manhattan in his old age, living off the high voltage of the place and generously encouraging the young New York painters who invoked him as they, too, toiled in the flat fields of colour. (Before his death, Mondrian shocked his disciples by approving of the drips of the young Jackson Pollock.) In any event, it's impossible to stand in his studio, lovingly reconstructed at MOMA, and not feel touched by his serene playfulness. Of course, in the presence of so many scrupulously fashioned paintings, the pains of Mondrian's Lenten labours are always evident, but one is continually warmed by the carnival fire that played behind the serious spectacles and dark suits. We may be no nearer to Mondrian's redeeming vision of an immaterial culture – not in midtown Manhattan, at any rate – but no one can go through this stirring exhibition and fail to be touched by the artist's exhilaration, independence and clear-sightedness. His majestic abstractions may not bring us any closer to Theosophical Heaven, but at least they put some distance between us and the prospects of Hell that, in these millennial days, take up more than their fair share of exhibition space.

4
FRESH MARKS

DAVID HOCKNEY

California Dreamer

THE LITTLE GIRL stood in front of *Fuck (Cunt)*, evidently impressed. 'Mummy, Mummy, he did this when he was only *eleven*!'

'No dear,' said the mummy, tugging her away from the David Hockney drawing of 1961. 'It's No. 11 in the exhibition. Now come and see the nice swimming pool.' It was, after all, the nice pool, not to mention the nice asparagus, the nice doggies, the nice mum and dad and the nice friends that were pleasing the crowds at London's Royal Academy this winter. What made the retrospective exhibition of Hockney's drawings a family outing was Hockney's reputation as a user-friendly modernist, an unthreatening prince of visual charm. For all its shortcomings as a serious review of his work, and despite (or possibly because of) the critics' habit of writing off Hockney's formal virtuosity as a sure sign of stunted conceptual growth, the retrospective is proving to be at least as popular at the Los Angeles County Museum of Art.

Hockney has had to live for a long time now with the accusation that he's a splashy lightweight. In 1948, when he *was* only eleven, he attracted

his first notice, as a member of the Bradford Grammar School Art Society. 'Hockney D. provided light relief' was the verdict of the school magazine. A precocious student of the arts, he assumed that this was a reference to the sculptural quality of his work. And those who believe that his work is fatally limited by its cheery celebration of life's sensuous pleasures (what, no *viscera*?) will not have their minds much changed by discovering that Hockney admires not only Picasso and Matisse but also Dufy and Fragonard. Of the last, he once said, doubtless feelingly, 'He is an artist who has been thought sometimes to be much too pleasurable, much too playful, much too sweet to be serious.' As Hockney went on to point out, though, 'People tend to forget that play is serious.'

It would be good to report that this show of drawings does full justice to Hockney's unflagging powers of creative mischief. But, after the scrappy naughtiness of the sixties, niceness ensues with a vengeance, swaddling everyone and everything – veggies, lovers, pals, scenery – with a cuddly blanket of affability. The fault may lie with the curatorial conception, for, although Hockney's indisputable brilliance as a draughts-man deserves celebrating, many of his most powerful drawings need to be seen alongside the radiant, enigmatic paintings into which they evolved if their conceptual subtlety and formal authority are to be prop-erly appreciated. One of Hockney's weirdly conjured suburban appari-tions – the *Lawn Sprinkler*, of 1966, with its helically turning spray flattened against the California sky – looks tentative and washed out in the absence of the great painting it became. Likewise, the studies made for the opera drop curtains of the seventies and eighties, deprived of the sound and spectacle of performance, have the subdued quality of working documents rather than the bravura triumph of the finished sets.

While this show includes a great many of the artist's favourite things, it isn't all comfy couches and pretty boys. Hockney's featured role among the London culture pin-ups of the sixties – the peroxide bangs, the Panzer cap, the fish-and-chips Yorkshire vowels – ought not to blind us to his gritty integrity. Though Hockney was not exactly a fugitive from the publicity hounds, his pose as working-class glamour-puss was mostly a creation of his handlers – especially the dealer John Kasmin, who

shrewdly marketed him as the Beatle of the brushes. (Oddly, Hockney's early cartoonish line drawings actually do resemble John Lennon's better efforts at visual jokes, as well as Thurber's whimsical fantasies.) A more reliable guide to the authentic Hockney was the unsixties sign he posted next to the bed in his London terrace flat: 'Get Up and Work Immediately.' Briefly the cynosure of fashion, for much longer he has been impervious to gallery cults, and much more likely to search for inspiration among the Renaissance and Baroque masters than among the contemporary avant-garde. Hockney himself is fond of pointing out that, for all his reputation as a gregarious pleasure lover, he is in fact something of a loner: happiest in a small group of old friends, romantically wistful for the perfect lover, and now, increasingly, stricken by deafness and locked up in his own company. 'If the crowd goes one way, I think my natural instinct says: "Go the other way, David,"' he remarked in 1976.

When Hockney, a twenty-two-year-old art-school graduate, arrived at the Royal College of Art, in 1959, the crowd was going seriously Abstract Expressionist, excited by the news from New York. Though by no means immune to the crowd's spell, Hockney, encouraged by his close friend R. B. Kitaj, was from the outset determined to work in a figurative language, however playfully chewed up. Some of the most impressive products of this early gutsiness are the wiry, droll drawings that he scratched and scribbled on dingy paper and that recorded the exuberantly randy pleasures of gay life in the London of the early sixties. To call these meaty little sketches 'homoerotic' is to give them the air of a visual manifesto when in fact they are unapologetically scruffy pleasure marks, full of holes and hickeys, as happy-go-lucky as the lavatory graffiti scribbled through them, and giving off a distinct whiff of tube-station piss. But the cartoonish rough-trade scrawler was also a softie. The *Study for Doll Boy* (it was worked up into a funny, sharp painting) was actually a backhanded love letter to the androgynous idol of English pop, Cliff Richard, on whose floppy pompadour Hockney desperately doted. The title of *We Two Boys Together Clinging* (17) was both an allusion to his literary hero Walt Whitman and a giggly reference to a newspaper headline

about stranded hikers that proclaimed, 'TWO BOYS CLING TO CLIFF ALL NIGHT.'

Like other gay English expatriates in California – his friend Isherwood, for example – Hockney has had a long love-hate relationship with his Englishness. (He has made the Golden State his permanent home since 1978.) The artist has always detested the sour insularity and mean-spiritedness that he thinks characterize Britain's critical establishment. But Britain – even if as satirical target – has provoked some of his most colourfully affectionate work. The two *Colonial Governor* drawings of 1962, with their beetroot-nosed, plumed-and-helmeted, barking proconsular panjandrums, are wickedly funny animations. When the editor of the London *Sunday Times Magazine*, Mark Boxer (himself a wonderfully spiky cartoonist), sent him to Egypt, in 1963, Hockney produced a scintillating post-Suez album of drawings that gleefully jumbled every kind of impression of Egypt as 'abroad'. Hockney had already developed an interest in the stylized processional figures of Egyptian reliefs and wall paintings, and he applied the same flat formalism to giant poster images, in coloured crayon, of the British Empire's bogeyman, Gamal Abdel Nasser, depicting him complete with anti-imperialist dental work and grinning unrepentantly beside garage lockups or posing ingratiatingly in doorways as pedestrians pass imperturbably by. And it was in Egypt that Hockney's lifelong obsession with the ambiguities of framing devices seems to have begun – from the glass vitrines of the Cairo Museum to the rugs and curtains spread out brilliantly in interiors.

Paradoxically, then, it was Hockney's Orientalism that prepared him for his greater infatuation with Occidentalism: Southern California as an idyll of dazzling light gleaming off well-oiled pecs. What he in fact found was something both less and more than the soft-core fantasies he had browsed through in the pages of *Physique Pictorial*, the photographic source for his early male nudes reaching eagerly for the shower nozzles. But the perfectly delineated West Coast rumps, registered as swiftly and economically as if Hockney had run his fingers lightly over their contours, are almost a pretext for making stunning neo-neoclassical compositions, like *Clean Boy* – a drawing full of air and space and dry light, in

which the coy aestheticism of the eighteenth-century passion for Hellenic beauty has been made candidly physical. In fact, it was not so much the human as the architectural expressions of California life – hard-edged, clean-cut, glaringly white or intensely coloured – that supplied Hockney with his boldest formal experiments: his answer, in effect, to the dominance of pure abstraction. For, while mature abstraction, in the work of colour-field and stain painters such as Morris Louis and Kenneth Noland, sought to obliterate even a residual distinction between figure and ground, leaving the field monopolized by the constituents of painting itself, Hockney moved in precisely the opposite direction. Intuitively excited by the tonal relationships that could be produced by strong bands and strips of black and white set against a ground of cerulean blue, he resolved them back into their figural source as a bank façade shimmering in the Los Angeles heat haze. It was as though he had seen through colour-field abstraction and dismissed it as somehow inadequate to the task of representing the essence of the modern condition – human behaviour caught in fleeting time. Minimalism, with its preference for the universal over the particular, for monumental statements rather than local anecdotes, was, he believed, ultimately barren in its conceited grandeur. Hockney would therefore devote himself to inventing forms that would seize the most slippery and momentary episodes of contemporary experience and trap them in his icons: the forever-running shower; the fleeting smile; the permanently suspended splash.

This has been an ambitious project, wonderfully realized, for the most part. Had Hockney done nothing except the works in this mode, his reputation as a genuinely original and powerful artist would have been secure. But his creative restlessness in an intellectual marketplace accustomed to single-idea signatures has been equated by some critics with dilettantism. And there are other unforgivable sins: the seductiveness of his colour; the sheer facility of his drawing; the gallery of friends paraded in brilliant crayon portraits, with their incongruous closeness of exhibitionism and intimacy (masturbating Mo, pink-eyed Ossie and Hockney's mother encased in black polka dots); his uncanny ability to

breathe new life into forms that adamant modernists would rather see defunct – the conversation piece, the domestic-pair portrait, the quotations from Domenichino, Lorenzetti, Hogarth, Gainsborough and Seurat. Most reprehensible of all, perhaps, is his excessive friendliness with the sister arts poetry and literature, opera and theatre – flirtations that subvert modern art's repeated proclamations of its own formal uniqueness.

Or is the problem Hockney's candour in conducting his continuing education in public, as his friend Henry Geldzahler once put it? Not all the adventures in self-instruction, it's true, have worked out equally well. For example, the passion for Picasso, whom Hockney especially admires for his refusal to be satisfied with a single graphic style, has produced neo-Cubist portraits that seem doggedly devoted rather than creatively inspired. Still, despite the uneven output, especially in the past ten years, we should be grateful that Hockney refuses to leave well enough alone. For his compulsive fidgetiness has also produced unanticipated departures like the canyon paintings and drawings, those drive-through compositions that bring together multiple-view impressions of a journey – road signs, street maps, geological slices, aerial views – not as in a collage but as experienced serially through the window of a moving car.

In telling ways, these latest works are both the logical outcome and the direct opposite of the poolside compositions that made Hockney famous: they replace freeze-frame with speed-up, and push the eye through areas of solid paint which have been quickened into the flashing curves of his abstract roadscapes. At the same time, his portrait drawings, touched by the shadow of mortality thrown over parents and friends, have turned elegiac. But, even if Hockney may not know what visions lie around the next unpredictable bend in the road, it seems unlikely that he's in the mood to take his foot off the gas.

CHUCK CLOSE

Head Honcho

THE ROMANTICS GOT IT WRONG. Calamity is seldom the friend of creativity. When Goya went stone deaf, in 1792, his painting, for a time, became stunned and muffled, and his mind teemed with phantasmagoria. As Willem de Kooning slipped gradually into the memory void of Alzheimer's disease, his spiky aggression surrendered to thin, flailing ribbons of bright colour, spooled through giant canvases, as though the artist were cheerily hailing a dimly recognized friend. No one knows better than Chuck Close the frosty indifference of disaster to the work of making good art. He has always insisted that the startling change of course in his painting, documented in the exhilarating and dazzling exhibition at the Museum of Modern Art, was not forced on him by the blood clot in the artery to the spine which left him nearly quadriplegic. Rather, it had begun years before the bad day in December, 1988, when he left an awards evening at the Mayor of New York's residence (having presented an award to a Brooklyn teacher) and walked into Doctors' Hospital. It may well be that the alteration in the temper of his work

from cool to warm, from cerebral to celebratory, was accelerated by his feisty response to debilitating sickness. But there is no reason to give an episode of arbitrary physiological evil the credit for Close's inventiveness. Perhaps the question ought to be upended, and we should ask not how disaster changed Chuck Close's work but how that work, and in particular its formidable discipline, gave the disaster its comeuppance.

The triumph over paralysis is all the more impressive because Close's work from the outset has been characterized by a fanatical devotion to manual craft, even when the finished product, like the enormously magnified pseudo-photographic black-and-white 'heads' with which the show begins, goes to extreme lengths to erase any evidence of craftiness. Like many members of his generation, Close marked his artistic independence in the late nineteen-sixties by repudiating the Abstract Expressionism at which he had dutifully toiled. Instead, he heeded Ad Reinhardt's dictum to adopt the kind of brushwork that covers all traces of the brush, completely dissolving the mark of the painter within the work. Conceptually, then, and despite being misleadingly pigeonholed as a photo-realist, Close has always felt an affinity with and an admiration for austere minimalists, like Robert Ryman and Brice Marden. But there is something monumentally maximal trying to get out of Chuck Close. Of his contemporaries, many of whom were at Yale with him, he has said, 'We all wanted to de-artify our work, to make something that didn't look like art.' And abstraction, however fiercely it tried to purify itself of the apparent mark of the painter, would always 'look like art'. Paradoxically, in a downtown New York culture where Clement Greenberg was king of the critics, and authentic painting was invariably equated with abstraction, figurative art lent itself more readily to being adopted as the 'anti-art' that Close was looking for as his point of painterly departure.

The type of figuration, though, had to be as content-free as possible, to avoid any impression that what was being painted was 'reality'. In Close's case, what was being painted was photography. And not the painterly photography that slavishly emulated Old Master portraiture, with its expressive modulations of light and shade and dramatic poses, but the most aesthetically dumb and socially utilitarian imagery –

passport photos, drivers' licences and mug shots – which seemed con-
fined to the literal record of identity through facial inspection. On the
other hand, Close has admitted that from the beginning he was counter-
suggestibly drawn to portraiture, precisely because it seemed the most
nearly extinct genre of all. He remembers reading that Clement
Greenberg proclaimed to de Kooning, 'The one thing you can't do in
art any more is make a portrait,' and that de Kooning, quick as a whip,
responded, 'Yeah, and you can't help but not make one.' Close's own
reaction was, 'Fuck 'em, I'm going to find a way to do it.'

'It' had to be something that couldn't be done: portraits that were
somehow also anti-portraits. Which is precisely what Close proceeded to
accomplish, in the black-and-white pseudo-photographs of friends. To
emphasize that these were paintings of photographs, mere distribution
of paint on a flat surface, and not in any sense conventional portraits,
Close made a point of calling them heads. Precluding any possibility of
their being read as figures, he squeezed them tightly against the edges of
the picture space, disconnecting the heads from the bodies, so they
looked like enormous Mardi Gras faces bobbing along the gallery wall.
To make these unsettling pictures, Close shot photographs of his sub-
jects, divided each image into a fine grid, and then painstakingly tran-
scribed the content of each square onto a gessoed, gridded canvas, in
some of the paintings leaving the lines faintly visible. The head was
worked up, square by square, with thin black paint airbrushed on the
canvas; highlights were created by the scraping back of paint with a razor
blade, and reflections, like the photo floods caught in the spectacles, were
rubbed in with an eraser.

Being both photographer and painter in this process entitled Close
to make pictures that attacked the conventions of both photography and
painting. Portraiture was deliberately robbed of what Close (in common
with most modern artists) assumed to be its traditional aim of capturing
some defining characteristic of the sitter through painterly means, such
as the expressiveness of brushstrokes, the fall of light, the selection of
pose. At the same time, Close's mega-faces made an end run around
photography's claim of mechanical duplication, delivering painted

images aiming to be more coolly objective than any photograph: dispassionate inventories of physiognomic data, recorded follicle by follicle, pore by pore, freckle by freckle. He succeeded in this detached and exhaustive scrutiny so well that many of his subjects, on seeing the result, instantly resolved to change their appearance.

The mega-mugs are still psychologically compelling. But they owe much of their power to the degree to which Close was forced to depart from, rather than observe, his self-imposed detachment. If he had really wanted to make images of randomly observed faces, he might have chosen complete strangers for his shots, or worked, like Malcolm Morley, from 'ready-made' photographs. But all his subjects were recruited from among his friends, many of them downtown artists, and the indulgent camaraderie of friendship got in the way of the attempt to create impassive colossi. Close (in keeping with the modernist doctrine of all-overness) was at pains to avoid emphasizing any area of the surface at the expense of any other, but the photographs turned out to have a life of their own, some areas being in tight, others in rather fuzzy, focus. And the lighting of the faces is not at all neutral but plays dramatically over wisps of cigarette smoke, bristling whiskers, sprouting nostrils, and, in the alarming case of Nancy Graves, snaggleteeth and staring eyes. Besides, since Close had chosen to paint himself as a don't-give-a-damn punk he could hardly deny the same sort of acting opportunities to his friends. Richard Serra's chosen persona is a stubble-cheeked tough guy, mean and murderous; Joe Zucker actually went to the length of assuming the guise of a low-rent salesman, getting himself up in a white polyester shirt and a car-dealer tie, slicking down his normally blond and curly hair with a dollop of Vaseline. These are not, after all, magnifications of arbitrarily captured IDs but calculated artifices, as artfully posed as any Renaissance image of a courtier or a condottiere.

The stylized poses brought the heads into closer company with the portrait tradition than Close might have imagined, since, much as modernism liked to deny it, portraiture has always been concerned as much with the reproduction of a social mask as with the visual fixing of the persona. Some of the most obviously successful portraits by Ingres or

Holbein, for example, have been remarkable for the calculated *avoidance* of anything remotely like self-revelation. Portrait painters, as Richard Brilliant's wise book on *Portraiture* argues, have always understood that the flattery of the sitter's sense of himself is only one of three coordinates in play in producing a face, the others being the imperatives of the artist's inner vision and, not least, the social expectations of the picture's likely audience.

Given, then, that photography was always more painterly and portrait painting more impersonally photographic than the modernist repudiation of both presupposed, it's no surprise to discover portraiture breaking through in Chuck Close's work, whether he wanted it there or not. During the nineteen-seventies, he decided to reproduce not merely the effect but the *process* of colour Polaroids by painting heads in three one-colour layers – red, yellow and blue – each corresponding to the separations of the print process. The finished result, far from being impersonally mechanical, has an eerily expressive effect; the portrait of *Linda*, for example, swims in a bloodshot red mist, where every bluish vein and waxy lipstick crease is mercilessly visible beneath a garish corona of hot-copper hair.

At some point, it must have become apparent to Close (as it had to Rembrandt three centuries before) that, paradoxically, the force of the sitter's presence was registered in *inverse* relation to the surface legibility of the image. Had he really wanted to keep his work clean of such impressions, he would have persevered with ever more crisply delineated contours. But warmth began to get the upper hand over cool, and the sharp lines crumbled sympathetically into emotive and suggestive techniques, used, very often, on subjects within his immediate family circle. His daughter Georgia is represented in a wonderfully free pulp-paper medium that forced him to execute the work gridless and at what for him was reckless speed. One of the most affecting of all the images in the show, a portrait of Close's grandmother-in-law, Fanny, was painted with just the tips of his index finger and his thumb, the minutely printed patterns of the artist's epidermis resolving into a miraculously sympathetic representation of the lines, cracks, crevices and erosions of her

face. It is as if the painter had closed his eyes and explored the old woman's features with his own delicate touch. The fingerprint, the favoured identification device of legal and criminal investigation, thus became in Close's hands something like its polar opposite: the tenderly applied mark of family affection.

By the late eighties, the match between subject and style had become overt. The explosively hot-tempered Lucas Samaras, for example, was painted by Close in 1987 (*Lucas II*) like a Byzantine mystic: a burst of brilliant concentric circles of colour radiate out from a hub of concentration situated right between the subject's wild eyes. For Samaras, the frontal hieratic pose that Close had generally adopted still seemed right. But Cindy Sherman, got up in a disguise of nerdy glasses and ponytail, is turned to three-quarters profile, her chin tilted down over the neck, eyes half-closed, drolly challenging the viewer to make something of it. Close was now painting in oils, glossy blues, purples, greens and pinks shimmering through the tight netting into which the painting remained divided. Yet the range of colour was still relatively limited and the patterning a dense harlequinade, the better to preserve the feeling of an all-over atmospheric.

Then came the catastrophe. Close spent seven months in agonizing rehabilitation at the Rusk Institute, where he remembers the 'art centre' as one of the most depressing places he had seen in his life. His first thought, when he could bear to consider what lay ahead, was that he would have to become a conceptual artist, with other hands executing his ideas. But this flew in the face of everything he had ever tried to accomplish as a painter. Supported in his resolve by his wife, Leslie, a landscape historian and a heroine herself in this story, Close battled to the point at which he was able to paint once more, using a brush-holding contraption attached to his right wrist and forearm, and directing it by means of the muscular strength left in the upper arm and shoulder. A mechanical easel raised or lowered his canvases through a slot in the floor to the height required for any particular passage in the painting.

In defiance of these formidable difficulties, Close determined to turn his loss of fine motor control into an asset, rather than let it be a

liability. The grid became bigger, the painting looser and more assertive. The tiles of bright, glowing paint now enclosed multicoloured ovals that bulged against their retaining walls or flowed generously over the borders (19). At some point, Close must have seen that the *irresolution* of the lozenges of colour could be exploited to wonderful effect, to lend the face a sense of perpetually composing itself, the fixed quality of a photograph shaken loose into human tentativeness. April Gornik's mouth of crushed strawberries looks as though it were on the point of making a speech or expecting a kiss; Kiki Smith's green eyes are suspiciously watchful.

As the individual units of the grid, having been filled to overspill with radiant puddles of colour, began to assume more importance relative to the over-all composition, Close began to treat them as miniature abstractions in their own right. They remained the building blocks for a complicated, interlocking optical structure. But the tremble on the surface – the *resistance* of the face to coherence – now became part of its power.

It's a commonplace these days to refer to the confectionery-coloured units from which Close's recent portraits are built as doughnuts. For that matter, the elongated rings and ovals, with four or five different dabs of colour overlapping each other, wet into wet, could as easily be described as jellybeans, bagels, or hot dogs, any of which might fairly convey the ballpark high spirits of the painting. But there's a lot more going on in the recent work than fast food for the eye. The webbing of colour that turns Roy Lichtenstein and Robert Rauschenberg into tattooed Marquesans, illustrated men, has been brought so overpoweringly close to the viewer that the effect is literally mesmerizing, like so many in-your-face drill sergeants turned hypnotists. Seen close up, the slippery glowing shapes seem charged with organic energy, jostling against their containing grid; they appear less like doughnuts than like cellular organisms in microscopic magnification, swimming in their nourishing culture and adhering to one another to generate new strings of life. Thanks to molecular biology, we now understand that within the most elementary strands of cells lies the genetic information needed to construct an entire

personality. Intentionally or not, Chuck Close's molecular faces seem also to encode both specific and general, microscopic and macroscopic, information. Thirty years ago, he subscribed to the modernist creed that an all-over democracy of detail was the American way of painting. Now he seems to have discovered that the motto for his indefatigably original work ought, after all, to be 'E Pluribus Unum'.

ELLSWORTH KELLY

Dangerous Curves

> WALL: Thus, have I, Wall, my part discharged so;
> And being done, thus Wall away doth go.
> (*A Midsummer Night's Dream*, Act V, Scene I)

NOT SINCE SHAKESPEARE has anyone had so much fun with the dumbness of walls as Ellsworth Kelly. Restive at the way museum and living-room walls bridle the freedom of modern art, Kelly has devoted his career to busting loose from their confinement. 'To hell with pictures,' he has said. 'They should *be* the wall.' And at their strongest his paintings and reliefs eat up the wall's space, or else co-opt it as a bit player in his loud theatre of colour and shape. Paradoxically, though, Kelly needs walls – straight old two-dimensional walls – in order to make us aware of their cloddish redundancy. The emphatically curvy Guggenheim is thus a potentially tricky site for an Ellsworth Kelly retrospective; Diane Waldman, who has installed his bulging, self-levitating forms around the spiral terraces of the Big Escargot, seems to have risked a curatorial

nightmare. And there are, in fact, places where the rolling ramps discon-
certingly jiggle the stillness against which Kelly's work needs to dance,
float, or stand pat. All the waviness makes for spatial tautology, rather as
if a Calder mobile were suspended from the undercarriage of a jet plane.
For the most part, though, the architectural peculiarities of the
Guggenheim collude, rather than collide, with the multidimensionality
of Kelly's work, not least because the museum has straightened out the
bay walls for this show. To catch sight of the big, crescent-shaped *Red
Curve* beside the circle-segment *Blue Curve*, framed by a half-moon open-
ing high on the gallery wall, is to participate, with sudden directness, in
Kelly's dialogue between objects and their surrounding space. If you look
over the circular well at *Black Ripe*, on the opposite wall, the biomorphic
blob seems to burgeon before your eyes, swelling and pressing against its
narrow white containing skin. At the Guggenheim, you can sense what
Kelly means when he characterizes his work as constantly emerging –
like the plants and flowers he likes to draw, unfolding at time-lapse
speed.

Not that Kelly's best work – opulently coloured and gracefully
formed – needs much help from artfully contrived angles of vision. Its
strength has always been its winning combination of perceptual subtlety
and sensuous immediacy: a philosophical delicacy of vision pumped up
into raw chromatic heft. It's this odd alliance of sweetness and might
which has made Kelly such an awkward fit in the canon of American
modernism, where, too often, the elemental purity of his work has been
mistaken for jejune intuition. At one end of the opinion spectrum,
critics nervous of pure shape, laconic theory and untextured brushwork
have tried to square his singular manner with the standard categories of
art-crit convenience – the Mondrian succession; proto-minimalism;
high formalism; 'hard-edge' – none of which suit the case. At the other
end are those who peer at the big, flat, bright shapes attached to the wall
and, like one woman at the Guggenheim the other day, see nothing but
big, flat, bright shapes attached to the wall, and exit swiftly, declaring,
'Fuggeddahboutit!'

If anything can persuade the public not to forget about it but,

instead, to give Kelly the rapt attention his art deserves, this retrospective will. One of its many pleasures is its revelation of the play of Kelly's thoughtfulness – especially visible in the rich and essential exhibition of his works on paper. Though the progress from his early Paris years to his most recent sculptures and reliefs may seem a road full of sharp bends and swerves, his career has in fact followed remarkably consistent principles. All his work begins with a moment of perceptual serendipity – a shadow, a reflection, a partly obscured object or shape – from which he then shears away a visual fragment. That fragment, exposed to his creative imagination, becomes simultaneously fixed and transformed, and arrives at an entirely separate life, one that may distill, summarize, or imply its source but never actually describe it.

This opportunism of the broken glimpse first worked its sorcery on Kelly in Paris, in the late forties. He arrived there in 1948, after a stint at the Boston Museum of Fine Arts school, with a passionate interest in Romanesque architecture and Byzantine icons, both of which have remained with him most of his life. Walking an exhibition in the Musée d'Art Moderne in 1949, he noticed that the windows between the paintings were more arresting than the works themselves, in that they suggested conjunctions of lines and planes that could be detached from the material object and transposed, virtually intact, into an independent art form. The result, *Window, Museum of Modern Art, Paris*, retains the dimensions of its source, as well as the division between the lit upper, and shaded lower, halves, yet by its opaqueness cuts itself off from its functional history. As an epitaph for conventional painting, the work is inadvertently eloquent, since the equation of the picture plane with a window, behind which the illusion of depth is perspectively ordered, has been the defining principle of representational art since the Renaissance. So there is something both mysteriously archaic and supremely modern about Kelly's work, with its hostility to the figure-ground distinction and its emulation of the flattening wall of fresco and icon painters.

Not that Kelly has been immune to the impulses of the contemporary. Many of his seen-between-the-lines pieces from the French period

sparkle with an impoverished jazziness that is pure American-in-Paris –
though distinctively Ellsworth, rather than Gene, Kelly. Broke and lonely,
he took a night-time job as a janitor at the Marshall Plan offices, but
managed, through his friend Jack Youngerman, to come to the attention
of some of the eminences of post-war Paris modernism. Mondrian's lit-
erary collaborator, Michel Seuphor, introduced Kelly to Hans Arp, whose
own poetic elementalism (along with that of Brancusi and Malevich) has
clearly had a formative impact on him. Arp had experimented with
chance composition (or rather, with anti-composition), and Kelly
applied some of its practices to his own way of seeing through half-closed
eyes. Reflected city lights glinting on the river were sketched, broken
into fragments, and reassembled, partly intuitively, to make the staccato
black-and-white *Seine*. *November Painting* consists merely of shreds of torn
paper laid randomly on a gessoed panel, but somehow evokes both the
present and the past – the scuttering motion of fallen leaves driven by
the wind and also fossilized forms embedded in chalk. The exceptionally
beautiful *Cité*, with its swimming, irregular bands of black and white,
originated in a dream that came to Kelly when he was staying overnight
at the Cité Universitaire, in which his students at the American School
were perched on scaffolding like roosting jackdaws. The child's vision, at
once ingenuous and wickedly shrewd, has never left Kelly, and is one of
his most appealing traits: the faith in the mesmerizing power of intense
colour; the mischief of shapes that can be made to jump out of their skins
and perform in unexpected ways. With the freestanding sculpture, *Pony*,
the artist transformed the shape of a bent can lid into a suggestion of the
rockers on a child's wooden horse, painting the aluminium primary
yellow above and red below, and slicing the metal with clean simplicity,
as if it were a kindergarten wall-hanging, cut from brightly coloured
paper. *Pony* also suggests the Manhattanization of Matisse. By 1954, Kelly
had sold just two works, and when he read an article on Ad Reinhardt in
ARTnews he wondered if New York might not be more receptive than
Paris to his flat planes of colour. It was and it wasn't. The intense gestural
drama of Pollock's and Kline's Abstract Expressionism was about as far
from Kelly's self-effacing purism as one could get, but, if the art world of

Greenwich Village was unwelcoming, the fellow-artists in Coenties Slip, like Rauschenberg and Agnes Martin, were at that time coming to be interested in a manner of painting which proclaimed the absence rather than the presence of the painterly hand. And while Kelly remained far from the Abstract Expressionists, he responded to their energy by combining colours and angles for dynamic, rather than static, effect.

Though his work was shown in 1965 by Sidney Janis, who had also championed Mondrian, Kelly's panels of single colours, either separate or set in horizontal or vertical combinations, presupposed freedom, not order. Where the Dutch master's colour planes all need to be seen at once for their meditative harmony to register with full force, Kelly's bands of what by Mondrian's standards are shockingly adulterated tints need to be read sequentially – like the planes of red, gold and orange in *Gaza*, which gather speed and heat and head out of the top of the frame. While Mondrian's work seems to sit lotuslike in the harmonious austerity of his apartment, Kelly's is very much Out on the Town. Mondrian's art is meant to transcend the material world, Kelly's to celebrate his satisfaction with its surfaces and signs. Even Kelly's *Broadway*, the monolithic block of scarlet that at first sight seems to be occupying virtually the entire canvas, proves on closer inspection to be notionally 'hinged' against a white ground, the red bled off only at the top edge, so that the painting appears to be opening itself into an imagined lit yonder. *Rebound*, which looks spectacular seen from the distance of an opposite Guggenheim terrace, can be read either horizontally, as two voluptuously fleshy white forms pleasurably brushing against each other, or vertically, as two opposing, sharpened black cusps. But these alternative visions can never be simultaneously available: they leave the hypnotized gaze to bounce glassily between the one and the other.

Kelly's work in the early sixties is full of such wisecracks and counter-punches. At a time of cultural fast-forward, his outward, roving eye was gobbling up all kinds of schematized visual information (road maps, traffic signs, nautical flags, architectural and archaeological plans), emptying them of their signifying meanings; he then looked, out of the corner of his inner eye, at what remained. Some of the most spirited paintings

in this period are Kelly's version of on-the-road works – abstract suburban pastorals, with all middle-distance effects obliterated, as in the speedy green-and-white *Jersey*, or in *Block Island II*, where an aerial view has been scrambled together with a side-on image, and both are punched flat like the shapes on a banner or pennant.

In the late sixties and early seventies, Kelly intensified the process by which his sources were rendered down into elemental forms. Sometimes the tense relationship between two strong colours constitute the drama of the pieces, and sometimes it is the relationship between a single colour and the wall, so that a trapezoidally distorted rectangle is uncannily made to appear flying away from the spectator, through the wall barrier, and off into indeterminate space. It may be here, confronted with opaquely laid, simple colour shapes, that the fuggeddahboutit lobby signs off, and, indeed, there are one or two moments in this exploratory period where the obsession with dead-flat comes perilously close to inert. More surprising is the degree to which an apparently elementary juxtaposition of colour shapes can open up an entire shifting universe of tension, relaxation, conflict and serenity, so that the economy of the means is out of all proportion to the magnitude of the effect. Anyone still in doubt should go stand in front of *Blue Curve III* and sense the circle segment slowly rising against its surmounting white triangle, the lower edge of which has been curved so that it seems to be both restraining and yielding to the inexorable ascent. Or the even simpler 1970 *White Black*, in which the upper panel, though actually painted as flatly as the lower, contrives the effect of infinity against which the white panel stands as a denying barrier. This is pure magic – the kind of wordless revelation that only the most confident abstraction can deliver, and it's light-years away from the design-driven formalism of which Kelly has been unobservantly accused.

Though Kelly is a skilled manipulator of optical values, there is no cheap deceit about his practice. The ingenuity with which colour shapes are brought together to give the impression of delicate movement – a slide or a shift – belongs to his ambition (shared philosophically, but not practically, with more austere minimalists, like Donald Judd, Richard

Serra and Tony Smith) to collapse the distinction between sculpture and painting, figure and ground. Kelly's flattened menhirlike columns, especially as they are sited in the Guggenheim's galleries, look ethereally two-dimensional, while some of the most ambitious recent paintings are true reliefs, mounted several inches from the wall, so that the play of shadow gives them lift and motion (20). The nineties work, carefully lit by the artist himself together with Diane Waldman, represents a consummation of his desire to distill a universal language from elemental forms. There is not a trace of monotony here. The closely adhering shapes of *Orange and Gray*, for example, one curved and the other triangular, are put in perfect equipoise with each other, so that they share a single contour, whereas in *Orange Red Relief (For Delphine Seyrig)* the dominant orange square appears to be arrested in its heavy fall away from the inadequately supporting red.

Many of these unresolved tensions and motions have a directly sensual impact, which corresponds to the primordial coupling of yoni and lingam that Kelly, as a young man in France, had suggested with his phallic *Kilometer Marker* and softly folded *Mandorla*. But the effect, I think, is less psychological than anthropological: the artist reaching for forms, akin to those revered by ancient religions, that are simultaneously spiritual and earthly – both rooted in the ground and heading, like the birds that the child Kelly copied from Audubon, for the heavens. This, at least, seems apparent in the marvellous room, in the high gallery, where Kelly's most recent *Curves* are shown, in calculated relationships with each other: the sharp yellow triangle, its left-hand edge eaten away so that the wall itself seems to be pressing it outward, facing a serenely stationed green; the opulent belly of the red curve arching away from the trapezoidal black. Together, they appear about ready to loose their moorings from the Guggenheim walls and drift off out of the museum and over Central Park – great weightless monuments turning, rotating, and shifting like the dimly seen planetary bodies whose celestial music they seem, mysteriously, to echo.

ALEX KATZ

Alex Katz's Landscapes

HERE ARE THE TERMS conventionally used to characterize Alex Katz's paintings: cool, flat, aggressively flat; enigmatic; laconic; sardonic; urbane. Now look at his big, recent landscapes. Now throw away the vocabulary you started with and think again. For it's evident that none of these standard-issue observations suffice to describe paintings that are vital, animated, charged with light (even when they seem to be draining it away) – compositions in which the paint seems to dart about the canvas, as sharply and intelligently as the artist's conversation. And in at least one respect, these paintings are as conversational as anything he has done, in that they require active, attentive and thoughtful engagement on the part of the beholder to fulfil their deliberately suggestive potential.

None of this means that Alex Katz has abruptly turned himself into an Abstract Expressionist. As rich with implication as these paintings are, their organizations of colour and form are emphatically not determined by emotional temper or psychic mood. Katz's eye is still the cat's eye: acute, watchful, opportunistic; most creatively playful when the light

fades from the day. And his dappled, freckled, etiolated work has as little to do with the revival of the landscape genre in contemporary art, as his portraits owed their power and authority to the drolleries of Pop Art. Once again he has managed to do something as astonishingly singular: a nature painting so peculiar and so unapologetically mysterious that not only could it not have been fashioned out of the stock of current painterly responses to nature, but it could hardly have been conceived by anyone with less than Katz's inexhaustible reserves of creative chutzpah.

Much contemporary landscape art has been a response to the long tradition of nature painting in the West, a tradition in which Katz is as deeply informed as he is about every other aspect of his painterly pedigree. (No contemporary artist, with the possible exception of Hockney, seems so passionately learned, yet wears his learning so lightly.) The characteristic responses of modern landscape artists since Joseph Beuys (a Green candidate for the European parliament) have been either prophetic, penitential, or recuperative modes. In all cases, the thrust has been emphatically anti-pastoral: a rebuke to the captivity of nature by the requirements of either narrative or picturesque taste. Deploying the materials of natural fabric – dirt, straw, ash – Anselm Kiefer attempted, with varying degrees of success, to document an anti-pastoral: an account of the explosive catastrophe visited on nature by history. More radically, artists like Richard Long, David Nash and Andy Goldsworthy have all attempted to liberate nature from its captivity within the framing taste of landscape, reducing the painterly presence to the most economic marks upon the land, allowing those marks to efface themselves through natural processes or allowing the independent and changing properties of wood, stone, ice, or water to generate their own artistic forms. Their work is rightly called land, rather than landscape, art, for (notwithstanding the crucially mediating presence of their camera lenses) it endeavours to reverse the traditional priorities of artist and subject.

Alex Katz's nature art is at the very opposite pole to those self-conscious efforts to obliterate the dominant painterly presence. So far from being in any sense ashamed of the organizing eye, he is one of its most jubilant celebrants, and a startling, impish optical intelligence is the

distinctive hallmark of his imagery. Yet he is not an anti-landscapist, nor is he really a neo-landscapist either, for he makes no bones about being averse to any kind of scenery-making. Even his very earliest work, like *Trees*, or the linocut *Maine Landscape*, both of 1951, while ostensibly a vision of slender tree trunks (in the latter case, screening figures in a rowboat) was much more devoted to formal patterning rhythms of colour and line than to any authentic representation of figure or field. Likewise, the most powerful and atmospherically haunting of his collages – like *Twilight* (1960), with its literally paper-thin horizon line separating a pure sheet of flat, tinted, dun surface, or the milky *Provincetown* (1971), where diminutive triangles of paper offer an allusion to sails, rather than their representation, improbably becalmed on a purely vertical skin of water – all begin with sensory impression and studious observation but are then worked up into something frankly and magically unnatural: a realm existing within the artist's inner eye and directed back steadily toward our own.

This is not to say that the big paintings of marshes, trees and ponds are gestural simulacra of their original objects, stylized phantoms confined entirely to painterly space. For despite the in-your-face colour; the shaking, rippling patterns; the artful manipulation of planes; the immediate and often overwhelming impression, on being confronted by Katz's 'Honey-I-Blew-Up-the-Greenhouse' phenomenon, is of being engulfed by physical sensation. What Katz has aimed at (and to an amazing extent succeeded in) is the grandest, most spectacular exhilaration – decidely uncool, in fact – prompted by natural observation: the sensory surge that nineteenth-century luminists like Frederick Edwin Church triggered through the contrived stupendousness of their panoramas. But Katz has ever been the enemy of visual bombast. His little collages managed to evoke an entire world of expanding and swimming light and space through the most minimalist means. The big paintings do something like the opposite, taking an ostensibly modest section of a natural vision – a stand of lazy susans, a light-licked corner of a linden tree, a trembling pond reflection at dusk – and expanding them into an immense, musically orchestrated display, right to the outer limit of the

picture space. The drastic suppression of any spatial distance between observer and object has the deliberate effect of dislocating the conventional measuring and bordering devices by which natural phenomena are culturally reframed as landscapes. At first sight, his abruptly cropped tree trunks and branches and the flickering masses of foliage suggest an interior space into which the eye might be welcomed. But, typically, the Katzian welcome is decidedly mixed, since the space itself is so immune to depth-penetration that it screens off as much as it records.

Much of this amazing formal organization happens in the original conception of the work, between the observation and its translation into paint. Katz remains famous for both the intensely painstaking quality of his preparation, and the dazzling, almost impulsive quality of the painting itself, which he himself compares to musical performance: concentrated virtuosity after lengthy and unsparing rehearsal. And if there is something reminiscent of Chinese and Japanese landscape masters in this ability to appropriate the suggestiveness of natural forms and transform them into independently complicated and aesthetically potent compositions, the resemblance is not purely fortuitous. Like the most stylized of the Sung masters, Katz is interested in a 'calligraphic' inscription of his vision: the deployment of rhythmically repeated marks, dashingly laid down, with deliberate distortions and interruptions of spatial conventions, the better to generate responses from within the painting itself (as distinct from any of its ostensible referents). Like the oriental artists, he depends on an intuitive understanding of surface, left implied rather than explicitly articulated, and the willingness of the beholder to engage with the ambiguities of infinite space suggested by his delicate modulations – the celadon-tinted wavelets of *10 am* (1994), for example.

Does all this add up to an essentially urbane, elegantly attired nature painting, a hip incarnation of the Mandarin of Maine? Not exactly. For while there is extraordinary formal beauty in works like *Lake Light* (1992) (21) – as there already was in *Luna Park* (1960), with its creamy lunar-light poured directly down the surface of the picture – the new work would be much more precious did it not in fact coincide with visions triggered by sense-impressions that swim beneath our half-closed eyes as

we lie beneath a tree or stare into a trembling marine twilight. The quiet universe of Katz's art has sometimes been described as a 'parallel world' existing in darkly reflected twinship with our material and social realm. And though it's tempting to extend the analogy to his landscapes, it would, I think, be misleading. For if one imagines, say, his portrait groups as perpetual cut-outs, unreadable at any angle other than parallel to our gaze, then the natural images can operate (at their most powerful) at ninety degrees to the picture plane as much as in alignment with it. *Mirabile dictu,* these are supremely contemporary paintings that have the challenge of depth.

Is it entirely fortuitous that it's the Maine coastal countryside that provides the setting for these works? For in his ability to dwell within and without nature, to begin with organic forms and end with potent, near-abstract, enveloping sequences of light and shape, disrupted spaces and intricately contrived formal relationships, Alex Katz, the philosopher in the woods, sailing along the pond, reminds me of another unpredictable Maine painter: Winslow Homer. And that's a compliment.

CY TWOMBLY

Works on Paper

I HAVE ALWAYS THOUGHT 'Twombly' ought to be (if it isn't already) a verb, as in, '*twombly (vt): to hover thoughtfully over a surface, tracing glyphs and graphs of mischievous suggestiveness, periodically touching down amidst discharges of passionate intensity.*' Or, then again, perhaps a noun, as in '*twombly (n): A line with a mind of its own.*'

Cy Twombly has always walked his own fine (but seldom straight) line, between impulse and calculation. Marked by the Abstract Expressionism that ruled his coming-of-age, he has never been content with its sovereignty of pure instinct. But nor has he ever had much time for the ontologies that insisted on the containment of art within the boundaries of its own material construction. Conceptualist solemnities have been, for Twombly, mere balls of wool to unravel with a wicked flick of his catspaw. So any attempt to bundle him into the 'ism' of the day is generally confounded by the restive fecundity of his reinventions. Ostensibly flirting with minimalism, he appropriated its rectangularities, not to make them coterminous with the work, but to tweak and

ultimately engulf them with the light movement of his errant marks. Even more malapropos is the attempt to turn him into some sort of neo-classicist on the grounds that Poussin and Jacques-Louis David also made the journey to Rome. Piranesi might perhaps be more like it, since not only does Twombly seem to follow the 'serpentine line of beauty', but his Rome consists of the pleasure of ruins; the attack of weedy nature on the defaced wreckage of the classical tradition. In so far as he limns antiquity, it is not the hard-edged discipline of celestial geometry; but the deeper, darker, Dionysiac archaisms of an Arcadia where Eros and Thanatos are the closest of chums and where the spilling of blood and semen blossom into Bacchic horticulture.

He is, I suppose some sort of impenitent Abstract Expressionist – and the debt to Pollock has at various times been both clear and readily acknowledged; not least in Twombly's sense that the essence of the work is the traced process of its own making. And yet no one could be less of a pure Ab-Ex practitioner – in the sense of the overriding need to nail down, visually, a surge of temper – than Cy Twombly who has always been after matter less evanescent and, for all its admission of personal preoccupation, less emotionally self-absorbed. That matter, famously, has been the history (even the pre-history) of human marks: from the most archaeologically primordial of scratches and incisions to the development of the rhythmic dexterities that would generate calligraphy, and then before they could be attached to meaning, would break up into the disrupted and disrupting raw matter of scribble, doodle and scrawl. Before ever there was Palm Pilot and pen Twombly was palm-piloting his cursive inscriptions in the loopy freehand he celebrates as a kind of proto-calligraphy; drawing blind, as he did as an army cryptologist, the hand moving with the lights out, a wily owl of Minerva.

Don't be deceived by the courtly gracefulness of the Virginian translated to Italy; the lightly worn erudition; the genteel touch of his botanizing. The truth is that Twombly, at various times in his long, prolific and protean career, has often been something of a scrapper, not in the sense in which his persona has ever exuded the kind of tearaway grab-baggy ebullience of his old comrade, Rauschenberg, much less the

hard-ass daemon-father, Pollock. Rather, Twombly has always enjoyed tearing a strip off the tendency of abstract painting towards its own monumentalism (enshrined, for instance, in the temple-like vacancies of colour-field stains). His was the trash-rooting, bricolage-rummaging, cut-and-paste, slash and smear moment; a dumpster-full of wiry, rusty ganglia; a wall, raucous with hoodlum graffiti. Twombly's resistance to 'finish'; even to the all-over, fused and thickly melded texture of Pollock's abstractions; his courage in performing looser, more disarrayed traces, is especially apparent in the works on paper, where the dog-eared, the torn-away; the dimpled, crumpled chewed-up and grubby are all enthusiastically welcomed into the creative process. The working materials, too, are a Falstaff's army of the art-maker, at the farthest possible remove from anything conspiring to aesthetic mystique: 4H dime-store pencils, ball-point pens, oil crayons, house paint.

The happy-scrappy quality was there from the beginning, but it was overlaid for a while by what would turn out to be an uncharacteristic straining for runic gravity; so that the earliest monotypes give the effect of being etched or densely worked like petroglyphs, and end up by being strangely sluggish, in their motion, even when they do their best to sprout, playfully. Paul Klee, often taken to be an inspiration for these early paper games was, in fact, not quite the right mentor. When Twombly reversed the effect (pencil drawing on light paper), some of this self-conscious prehistoricity disappears, only to be replaced, sometimes, with a different kind of oddity – and one that would return often in Twombly's repertoire – arrangements of biomorphic protuberances, shot through with allusions to zoological illustration, which sometimes suggest an entomological cemetery of defunct nematodes.

It is with the colour pencil drawings of 1954 that Twombly hits his stride, and it is already a limber gait; the line off on a fantastic dance, whirling and looping, pulling the artist's hand behind it; the colours ravelling through each other, still playfully eroticized, the darker greens writhing at the centre like so many snakes on the head of Medusa, while paler reds shade blissfully away into the indeterminate edge. Bolts of energy shoot through the scribbly mass which are already not like

anything else in Abstract Expressionism, a comer's reproach to the stately formalism of Kline or Tanguy. But even these exercises look prosaic beside the speedy whirl of pencil of 1956 when Twombly created a filigree of lines racing across the page, dissolving subject and ground, creating subtle scrims, which manage to be, somehow, both veil and disclosure.

In 1957 Twombly moved to Italy and, for a moment, some of this hectic energy takes a siesta. On paper, at any rate, the artist seems to be breathing more deeply, the vessel of his creativity a little becalmed. His marks turn discreet, drifting weightlessly over creamily coagulate surfaces, punctuated with the occasional sexy smear. But they seem – for Twombly – a little too laid back, too fluidly legato for an artist whose strongest motion is punchy staccato.

In the early sixties, however, and through the decade, Twombly's creative energy erupts, turning out an extended series of untitled compositions in which pictograms and ideograms – many, but not exclusively, sexual – swim and seethe in a broth of jittery action. It's all rather Pre-Cambrian submarine: fidgety with semi-evolved polyps, tentacular or tubal, ovoid and spermy, jiggly with fleshy playfulness. (One imagines companionate deep divers like Joán Miró and Pieter Bruegel off doing their own thing amongst the waving anemones.) The Flemish called such paintings *wimmebeelden*, or swarming pictures, in which caricatural details and half-obscured figures bounce and bob in carnavalesque commotion, with only the barest concession to classical pictorial hierarchy. The twomblies muck around doing their own thing (since they are, it must be said, very often tits and dicks) but do so in the patrolling presence of forbiddingly rectangular emblems of the Artistic Verities (from Albertian windows to minimalist boxes), which hang around like embarrassed schoolteachers in a chaotically raunchy playground. The year 1968 was, of course, the moment when, all across Europe, in the slogan of the anti-Gaullist students 'Imagination came to Power'. A cooler reality set in shortly thereafter, but Twombly's graffiti walls, though they sometimes wear a more formal regard – the monitoring frames and boxes recurring in greater strength still jabber on with

good dirty fun, capturing something of the moment's up-yours atmospherics, bubbles of raw energy popping against conceptualist asperities. The effect is to puncture the universalizing pretensions of hard-edge minimalism, for Twombly's energies are all about local animation; the unpredictability of the wayward line.

Through the paper works of the late nineteen-sixties and early seventies – while Twombly was redesigning the landscape around his house at Bassano, near the Renaissance 'Park of Monsters' at Bomarzo in northern Lazio – the tension between linearity and ebullient organicism stays unresolved. His creativity feeding off the dialogue, Twombly occasionally moves into more genuinely minimalist mode: laying down collages of irregular Schwitterian bands of paper, or blocky boxes of filled graphite. But even these more austere, diagrammatic compositions ultimately get attacked by looser lines. For at the same time as he seems to be making a more serious engagement with minimalism, Twombly is also experimenting with free-flowing pages of auto- or proto-calligraphy: loops, coils and spirals falling rhythmically over the surface, reminiscent of cursive exercises prescribed in Renaissance manuals of handwriting. The atmospheric effect – for which the dread word beautiful seems not completely inappropriate – is essentially musical, reductively simple yet cumulatively mysterious, suggestive both of childhood and eternity.

Then, in the mid-seventies, there is another caesura; certainly not a trailing off of Twombly's prodigious output, but rather what seems to be like a moment of earned reflectiveness. The collages lose their hectic chatter and are replaced again with creamy surfaces, nicked, slit, scabby with half-applied paper fragments, or patterned with yoni-like emblems that glide repetitively over the page.

But this proves to be a pause before another immense leap: into the expressive pantheism that has never left him. A 1975 collage can be thought of as something of a statement of intent, in which an aptly scrawled 'PAN' is crowned by two tenderly caressing leaves of chard (one crimson, one gold) as if laid gently over the brow of the goat-lord. Beneath, in a quasi-faecal smear, is the visceral reality of his rule: 'Pan-Ic'. Welcome, in other words, to the mixed blessings of Twombly's

Orphic Arcadia. He is, evidently now responding to a different kind of graffiti: inscriptions laid and overlaid on the ruins of antiquity, so the shorthand script used to summon up the demi-urges of Apollo, Venus and the rest, must necessarily be impolite: the rough hand of Dionysian energy. Twombly's Apollo is not the fine-limbed hunk of the Belvedere, but the pitiless flayer of Marsyas. But what Twombly draws from archaic mythology is its poetic emphasis on the consolations of metamorphosis: cruelty, rape and death (your usual day at the office in Olympus) transformed into the irrepressible burgeoning of nature. So Twombly lines up – literally – some of the victims along with their alter-egos in flora and fauna.

His art then undergoes transmutation, along with the bodies of the sacrificed heroes and heroines, and blossoms into fantastic blooms of heady, intense colour, applied (like the paintings of the eighties) in mimicry of mythic energy; delivered, either in raw gouts and squirts of pigment, flattened and smashed on the paper, or in a dervish-like whirl of brilliant oil stick, vortices turning in space, coming hard at the beholder. Exactly at the moment when Abstract Expressionism was decreed to have been played out, Twombly's gorgeous, florid bolts of colour, flaring and imploding over the surface invested the genre with new life – as if Soutine's ghost had traded the butcher's apron for the florist's. There are, to be sure, the much noted nods in the direction of Monet's *Nymphaea* – and in a more general sense, both Impressionism and even perhaps the Symbolism of Odilon Redon are recognized, but Twombly's bouquet is anything but decorative or mechanically emblematic. It is instead an almost anachronistic jolt of the Turnerian sublime; a theatre of natural passions played out with snaking darts of cobalt; dropped gobs of chrome yellow; thinned-out sunset smears of coraline and salmon; bunched-up corners of angry cobalt and black, like an Ab-Ex Hades giving Persephone her 'time's up' warning; about as 'ideal' a marriage as Twombly can drolly concede. The work is as Olympian as a Flemish world-landscape; as shot through with mortal introspection as a Giorgione picnic in a tenebrous storm; as organically congested as a bug's eye view of the herbaceous border; micro and macro; lyric and pastoral.

They are never sentimental, these colour-implosions, but lest they risk ingratiation, Twombly, in the late eighties and early nineties, slaps them around a bit, his strokes coarsening, reaching for the wide-eyes and fearless fists of childhood, the farther he gets from it; occasionally adding mournful, oracular jottings. In one particular rendering, a gloomy memo to self ('this is no time for poetry') accompanies a mere slug-trail slather as though, on a bad morning, the unlikely crosspatch has finally stuck his boot through the cucumber frame.

And like his alter-ego, Proteus, through whom he signs off on a regular basis, Twombly remains capable of infinite self-alteration. Of late, he has turned from natural history to epic, recovering themes of ominous voyages and heroic collisions, first essayed in *Fifty Years of Ilium*. His masterpiece in the genre has been *Lepanto*: twelve painted panels, as big as the great Breda battle series of prints produced by Jacques Callot three hundred and seventy years ago. As usual, Twombly's maximalist-historicist instincts have been engaged by a profound problem of translation; and one, moreover, which shows no sign of going away: how do we visually euphemize war? Against banal 'rectifications' of Goya, we might want to set instead Twombly's take on the ancient ideograms of battle, where the plans of men find themselves, literally as well as metaphorically, at sea. The renderings of warships are childlike, but no more so than where they first appear in the inscriptions of the warrior imagination: in the fleet of William the Conqueror making, cartoonishly, for the white cliffs across the unfurled film-strip space of the Bayeux Tapestry Channel; in friezes of Roman triremes paddling to hubris, officered by captains who ought to have known their Thucydides. These are games, Twombly hints, as he offers us a lethally empurpled *Naumachia* – the mock naval battles enacted in flooded arenas for the amusement of Roman crowds. But they are games of death.

The panels of *Lepanto* sail along the wall in the shouting brilliance of high Renaissance heraldry, all vainglorious scarlets, crimsons and gold, until, that is, they implode in flame. The works on paper achieved around the same time are, in both senses, more impacted, claustrophobic nightmares of exitless confusion (22). Some of the same hot hues that

flowered in the pantheist songs of nature now, as Ruskin wrote of his own *Turner, Slave Ship: Typhoon Coming On*, 'encarnadine' (i.e. redden) the sea. Local shots of colour leak and spurt as from the site of a deep laceration. The endorfin-pump of carnage haemorrhages life-blood, while the eye-scalding brilliance of spectacle continues to swim in the trans-fixed gaze. It is as terrible and as beautiful an obiter dicta as you could ask from art. Yet the good ship Twombly sails redoubtably on.

ANNA RUTH HENRIQUES

Illumination

A FORMER MISS JAMAICA (half Chinese, half Afro-Caribbean) lies dying of breast cancer. Outside her hospital room, her three daughters stare in through the aluminium louvred door. Their mother's face is a mask of gold, her head crowned by a nimbus of light. The same face, eyes turned down, appears at the base of a wild-ginger blossom or within the furled scarlet petals of a hibiscus. Elsewhere, the woman's hands grip the sides of a Braille alarm clock while her unseeing eyes stare out from the golden mask. And in the image at the right, also from Anna Ruth Henriques's poignant and beautiful *Book of Mechtílde*, a shofar sounds behind a great teardrop holding within it the green sprigs of the tree of life.

Multiculturalism is not invariably a platitude or a shibboleth, and in Henriques's gifted hands it becomes an illumination. *The Book of Mechtílde*, composed at her grandparents' house, is far removed from defensive brandishings of ethnic identity. It is, rather, a celebration of the many converging lines of blood, culture and confession that flow through her mother's and her own history: a Chinese grandmother; a Franciscan

convent school; the Jamaican Sephardic Jews of her father's family, the remnant of a community dating back to the seventeenth century; the Obeah animism of the island. All these traditions are poured into a work that has been conceived as a true illuminated manuscript, a reworking of the Book of Job with Sheila Mechtilde Henriques, née Chong, as the sufferer transfigured by affliction. Henriques relates the sad story like a bard, interleafing the images with her own poems and prose.

As anyone who goes to see Anna Ruth Henriques's original art work, on show at the Jewish Museum, will immediately recognize, it is the illuminations, tightly packed into circular or rectangular box frames, and painted in saturated acrylic and watercolour hues, that communicate the elegy with maximum intensity (26). Around them are broad wheels of gold lettering, passages from the Book of Job that act as a setting for the gemlike images. At the outer edges of the page are loosely sketched fields of fish, flowers and foliage: nature defiant and luxuriant in the face of death. The effect of each subtly constructed page is powerfully musical: medieval plainsong, Jamaican reggae, Sephardic chant and the shuffling of feet on the sanded wooden floors of the old synagogue echo through the imagery.

Early in the book, the fate of Jamaica (called the Land of Jah) becomes personified in Sheila Mechtilde Henriques's stricken and belea-guered body. Anna Ruth was only eleven when her mother died, and she has subsequently lived in northern France, western Massachusetts, southern California and Japan. Self-evidently, the stylized iconic manner of Gothic and Byzantine illumination made a profound impression on her. Yet her art is flooded with Caribbean light and dyed with the strong, sensuous colours of its earth and vegetation. (For the drawing section of her high-school art exam, she chose: fish head, and when it began crawling with flies they, too, became part of the composition.

Much of her work pulses with the vitality of the island cults: crabs, bones and snakes; eggs and mangoes. But as befits an artist who has managed single-handed, to revitalize an ancient sacred art form, one that beautified both Christian and Jewish texts, she is at her most majestic in images of meditation.

Many of these still moments – Mechtilde climbing the stairs of the family house past photographs of her daughters, as if entering another work or off in a fishing boat on the horizon – are rooted in the commonplace of a childhood vision. But their familiarity only reinforces their mysterious power of transcendence, making *The Book of Mechtilde* a more consoling experience than its Biblical model: the soughing in the mangrove rather than the wrathful void from the whirlwind.

FREDERIC BRENNER

Looking Jewish

IT'S THE FUTURE. There are no names; just social security numbers. Two men scan each other at a cocktail party:

Hi, good to meet you. I'm 5487120.
Hi yourself, 34100987. The pleasure's mine.
Funny, you don't look Jewish.

So who does look Jewish, Frédéric Brenner wants to know. His entire career has been spent resisting visual stereotype; denying the possibility of self-evidently Jewish appearance and manner. Yet the premise of his work is that there is indeed a distinctive Jewish culture that can be caught in his photographs. Distinctiveness, though, he also wants to say, may not be equated with exclusiveness, with cultural separation. It's the impurity of Jewish life, the ragged edge that frays into the surrounding culture, that engages his acutely intelligent attention. And from the ambiguous, shifting border between the Jewish and the Gentile world Brenner makes his visual reports in startling, beautiful images.

Brenner's chosen work site – on the nervous frontier of identity – is especially courageous, given the booby-traps awaiting any self-appointed codifier of Jewish types. The perilous nature of the enterprise is exemplified by the cautionary case of Rembrandt's Jews. All that is actually known of Rembrandt's relationship with Amsterdam's Jewish community is that for some years he lived on the Jodenbreestraat and was a neighbour of the great scholar and translator Menasseh ben Israel, for whom he made four etchings for the rabbi's Kabbalist treatise, the *Piedra Gloriosa*. But while attempts have been made to identify various sitters as the true Menasseh, none of those identifications rest on securely documented ground. Of all his purportedly Jewish sitters, only the identity of the physician Ephraim Bonus, painted and etched by Rembrandt, is indisputable. For many generations, though, a sentimental tradition of Rembrandtian philo-semitism assumed any figures with swarthy complexions, prominent noses, patriarchal whiskers or skullcaps to be the painter's favourite Hebrews. But Christians wore skullcaps, old men of every confession sported beards, and olive-skinned orientals could as easily have been Dalmatians, Iberians, Italians, or even Turks, as Jews. The face that makers of the 'Jewish Rembrandt' legend searched for was the one that had already been sketched by the Romantic imagination: brows creased by spiritual interrogation; deep-set eyes lit by redemptive devotion; a puff-ball corona of holy hair.

None of this, though, was the Jews' doing. The stereotyped physiognomy of the Good Jew, a Prophet shuffling through the streets of Rhineland Gomorrahs, was more welcome, but no less falsified, than the obscenely fabricated phiz of the *Ewige Jude* (archetypal Jew) with his hooked proboscis and blubbery lips. Ironically, the Jewish aversion to portraiture (in excessive deference to the Biblical prohibition on 'idolatry' or 'graven images') and the equally powerful truism that Judaism was, above all, a religion of the Word, not just distinct from, but actively opposed to, cults of the Image, meant that depictions of the Jews were, for centuries, the creation of their often paranoid Gentile observers. A stock feature of anti-Semitic neurosis has been the fear of Jewish pseudo-normality, cynically adopted to disarm hostility and for

smoother insinuation into the body of the host-culture, even, heaven forbid, into its bloodstream. To prevent this contamination, vigilant Gentiles were issued instructions on type-recognition, the better to spot the alien presence through the disguise of apparent ordinariness. And on a less sinister level, the wary Gentile fascination with the Hebrew beneath the frock-coat and spats has meant that we have many more portraits of half-Jews, quasi-Jews and ex-Jews – the Derondas, the Disraelis and the Dreyfuses – than of Jews. We are familiar with the look of Felix, not Moses, Mendelssohn. Conversely, it was only with the conscious creation of an ethnic counter-type – the Zionist hero – that an inspirational iconography could be fashioned from the stormy brows of Theodor Herzl, the philosophical cranium of Chaim Weizmann, the leonine tufts of David Ben Gurion, and the armour-plated, nicotine-scented bosom of Golda Meir. Doubtless there are images of the makers of modern Hebrew culture – of Bialik and Ben Yehuda – but their essential features are transmitted in texts, not countenances.

Not surprisingly, then, it was the contrast between the Old Jew and the New, the *shtetl* and the kibbutz, the *yeshiva bokher* (yeshiva boy) and the *halutz* (Zionist pioneer) that framed the photo-iconography of the Jewish world between the two World Wars. Of course we can hardly help projecting on to the documentary work of Roman Vishniac and other photographers of the Polish and Russian Diaspora, elegiac qualities of which they could never have been fully prescient. But even if these photographs are not self-consciously prophetic, they were certainly conceived to emphasize the differences between the *shtetl* (the world of the past) and the city (the hope of the future); between the goat-carts, the rutted tracks and timber shuls of the beleaguered village, and the unapologetic robustness of the Yiddish theatre, the Zionist newspaper and the sturdy orange-groves of the guarded settlement. Try as we may to look at the images of the *shtetl,* or the great seminar-worlds of Vilna and Kovno, without an anachronistic sense of tragic destiny, the enormity of their fate overwhelms the requirements of historical objectivity, so that it becomes impossible to look at those pictures as anything but photographs that helplessly understand their own conversion into

documents of absence. It's as if the process of chemical development were constantly in danger of going into reverse: images emerging from the developing bath refusing to fix themselves on the coated paper, losing their distinctness and substance beneath the red-glare of the darkroom lights.

Into this anguished realm of identity-trauma bounds Frédéric Brenner, sweetly unburdened by its desperation and rage. Not that the Holocaust is altogether missing from his work. But he refuses to allow perpetual mourning to shadow his lens. His subject is the Jewish sensibility of our own time, so that when, in one of the most shocking images of the book, Brenner invokes the genocide, he addresses himself directly to the *impossibility* of adequate recollection. In the Simon Wiesenthal Center's simulacrum of a gas chamber, a survivor stands, naked, impersonating the fate he avoided. Were this image to have been contrived purely for the purpose of photographic art, it would be an unspeakable obscenity. But precisely because the video-monitors and the other apparatus of the museum proclaim the inadequacy of communication, the photograph, I believe, turns into an authentically poignant statement about the guilt of survival, the grief of those who have nothing to atone for.

For the most part, though, Brenner's group portraits are free of lamentation. They are not entirely free, though, of the anxiety of integration which may, as Bernard Wasserstein has recently emphasized, may yet pose a more complete threat to the perpetuity of the Jews, than anti-Semitic massacre. But neither is Brenner's work captive to that anxiety. On the contrary, a striking number of images celebrate the cultural promiscuousness that characterizes much of Jewish-American life. Brenner does his best to make *The December Dilemma* (Chanukah Menorah or Christmas Tree?) seem troubling, but his shot looks more like a suburban choice of flavours, and the alternative versions of Solstice candles more like relatives than adversaries. Even what appears to be the chilling exception to this soft-focus definition of Jewishness – the startling image of teenage *Kahane Chai* (militant fundamentalist Zionist) militia cadets – subverts its own hostility by being indistinguishable from any other teenage forest-bonding ritual. The targets, guns and

macho-fist tee-shirts never quite dispel the distinct atmosphere of Camp Matzoball; the optimistically terrorist headgear obstinately remains *shmattes* (carefully laundered by the terrorists' mothers, I bet). In the same way, the Harley-Davidson Bikers gunning their two-strokes outside a Florida temple include too many Sharons, glossy and tan – Hell's Yentas in the making – to convey an air of convincing menace.

Frédéric Brenner comes to these brilliant studies of American Jewry after producing similar 'representations' of Russian and Italian Jews. But he readily confesses to being infected by a peculiarly American condition: enthusiasm. Unlike his photography in Russia, for example, where Brenner had to struggle to unearth a vestigial remnant, or a stunted bud of Jewishness from the monolith of Soviet culture, in America he has to adjust for the opposite condition: the exuberant parade of ethnicity. Typically, then, it's in the places where that ethnicity is most glaringly coloured by the red-white-and-blue – in Las Vegas, Florida, Manhattan – that Frédéric most often plants his tripod, and with results that are, by turn joyous, hilarious, absurd, vexing, poignant and often, as in the case of the Bedford Hills Maximum Security Female Correction Facility Seder, loaded with mordant irony.

Perhaps it's misleading to classify these compositions as photographs at all, if by photography is meant the freeze-framing of a fugitive moment. Brenner has always been more of a candid dramaturge; a baroque impresario of cultural encounters. Repudiating the 'accidental' nature of photography as disingenuous, Brenner makes no pretense to spontaneity. There are no pseudo-moments of happenstance here; no bogus kisses *à la Doisneau*. To present his Bokhara and Tashkent Jewish cab-drivers on Coney Island as figures from a trans-Caucasus caravan, landed on Brighton Beach, Brenner had first to cover the shooting area with wooden board to prevent the taxis from sinking and then replace the surface sand. Likewise, no one, except Brenner, would have thought of constructing a *sukkah* (tabernacle) on a skyscraper roof, directly facing the Empire State building, and his efforts to obtain the necessary building permit turned into a tortured education about the constraints on improvisation in contemporary America. Once in place, though, the

chorus line of glamorously dressed, heavily hairsprayed Broadway stars, smelling of Patou and Partagas, posed between the traditional straw-roof of the *sukkah* and the theatrical gesticulation of the Empire State Building, articulates an entire after-dinner *spiel*, about penthouses and tenthouses, oldhouses and Newhouses; wilderness austerity and metropolitan extravagance.

If the intellectually and technically elaborate construction of Brenner's photo-dramas is obviously marked by a French pleasure in the play of ideas; their in-your-face theatricality is well suited to American grandstanding. Evidently Brenner is moved by the national culture of transparency, its liberation from the inhibitions of European polite taste, and he flaunts New World exuberance with a swagger, which, by comparison, makes Max Bialystok look like a shrinking violet. The insatiable American appetite for demonstrative display, the obligation to public utterance, the shameless impulse for turning entire social groups into human bumper-stickers: all this is meat and drink to Brenner's own considerable showmanship. But more often than not, it is showmanship of an instructive kind. Take, for example, Brenner's astonishing re-enactment of a demonstration of solidarity by the sheriff and citizens of Billings, Montana, with a Jewish family whose house had been attacked by anti-Semitic vandals for having the temerity to display a menorah in their window during Chanukah. Brenner shoots the scene from behind the shattered window, recapitulating both the crime and the penitential gesture. But by immobilizing the extraordinary crowd, framed against the half-raised arms of a railway crossing, he manages to suggest the competing sensations of exhilaration and disquiet. What we see is a reverse pogrom: men on horses, robed priests, waitresses and cops, gathered in friendly resolution. Yet even the ostentatiously multicultural nature of the assembly – African Americans, whites, Indians and Latinos – with their implied embrace of the perennial stranger in their midst, does not quite dispel the air of uncertainty suspended over main street. In no other image, not even the *Nice Jewish Boy Removal Company*, where the moving men are almost exclusively black, is the Jewish presence registered more completely in the response of the Gentiles.

Brenner's Gallic alertness to the eloquence of symbols encourages him to scatter them around in his photographs, usually to fruitful effect. The menorah has a particular resonance in the context of the Billings vandalism, because the Chanukah story turns on a narrative of desecration and miraculous purification. Brenner's characteristically generous and expansive variation on the ancient narrative is to emphasize the ethnic heterogeneity of the Montana Maccabees, as if a coalition of Samaritans, Hittites and Jebusites had been mysteriously summoned to the defence of Jerusalem. Likewise, the eerily disturbing group portrait of the Bedford Hills Jail Seder, depends for its power on the relationship between the narrative of the exodus – the heart of the Passover service, with its emphasis on freedom from bondage, and the brutal denial of Exit, signposted at the back of the prison room. The jarring impression that the inmates, with their careful coiffures might easily be our own sister Rivka or Aunt Esther only maximizes the shock of the paradox. Their next year will certainly *not* be in Jerusalem.

Brenner is best, I think, when observing serendipitous mirror images between Jews and non-Jews. One such image – of Navajo Indians – is literally caught in the wing mirror of a car driving through Monument Valley, Arizona. Constructing a complicated pattern of interrelated, yet discontinuous visual fields and groups worthy of Velázquez at his most demanding, Brenner counterpoints the Indians with a group of Jewish pilgrims, come to the sacred place to read the opening chapters of Genesis on *Shabbat Bereshit*. There is no facile claim to the interchangeability of faiths here; and the car-mirror that performs the pairing is a deliberate reminder of its contrivance. Yet for all the unbridgeable differences, the primordially ancient desert wilderness (Brenner being as interesting a photographer of landscape as he is of townscape) does somehow manage to wrap the creation cosmologies of the two tribes together; never slighting *either* their alterity or their common humanity. Elsewhere in the book there is a sweet memento of the generations of Levi Strauss, the epitomizing union of the Jewish dry-goods peddler with the cowhand. But it's the other Lévi-Strauss who has really set his mark on Brenner's dramatization of the Structuralist Shabbat in Monument Valley.

There are places where Brenner lets his innocent pleasure in what might be called occident-orientalism prompt his comic muse. The carpet that flies mysteriously along a New Jersey suburban street, carrying its load of Iranian-Jewish rug traders is the kind of surreal disruption of expectations he enjoys indulging; so is the painstakingly assembled pyramid of Hebrew Academy Students (not all of them Jews) posed alongside the pseudo-Egyptian splendours of the Luxor Hotel, Las Vegas.

Equally there are places where Frédéric Brenner takes immense, even foolhardy risks of tone and sensibility, and his most self-consciously startling groups will certainly be found distressing by those who fail to credit the integrity and conviction of his conceptions. It could be objected, for example, that his hauntingly beautiful circle of women, shot in darkness, the daughters' heads resting on the shoulders of their mothers as they seem to perform a danced dirge in space, was already sufficiently emotionally charged given that the older women are all Holocaust survivors (24). *Dayenu*, as the Seder song goes, enough already. Why add the gratuitous element that the daughters also happen to be lesbian, as if *their* burden could ever be remotely equivalent to the suffering of their mothers? But Brenner, I think, does not pose a callow equivalence. What moves him here is the mutuality of love, of *bodily* support, given the one to the other. And he has found a genuinely poetic form in which to make it eloquent: the circularity of the group proclaiming their perpetuation against the odds. It's difficult, in fact, to think of many other contemporary photographers, especially males, who are prepared to treat female experience with such compassionate intensity. It's this corporeal sympathy that permits Brenner to go to places from which most male photographers have forbidden themselves. To describe, verbally, the extraordinary picture of half-naked mastectomy patients is to provoke understandable suspicions of sensationalism. To see it, though, is to have those suspicions immediately confounded in the presence of heroic dignity; the absolute denial of sentimentality; the equally absolute perception of unforced and uncompromised vitality. It is a picture which actually glows with rude health.

Though Brenner's great *tableaux* of Jewish American life make up the heart of this *Representation*, they do not constitute all of it. At the back is a marvellously rich inventory of objects, signs, inscriptions, gathered from the immense diversity of quotidian Jewish life in America (though, at times the images give the impression that Jewish America stops at the Hudson River). The very randomness of the selection makes a welcome counterpoint to the studied orchestration of places and faces that dominate the rest of the book. But often enough they carry the same wry, quizzical look that Brenner brings to all his subjects, his generous merriment at the cultural oxymorons of Jewish America: the kosher cappucino, the talk-show Talmud broadcast, Fiorello La Guardia who could be claimed simultaneously as a son of the Italians and the Jews, the Jericho Dairy Bar and 'Howard Stern for Governor' posters.

Between the portrait groups and the inventory, Brenner has assembled what he calls his 'Jewish Icons', and I wish he hadn't. Few of the chosen subjects will come as a surprise, and it's hard to believe that our sense of Jewish America is much enriched by yet another portrait of Itzhak Perlman or Lauren Bacall, lovely people and great talents though I'm sure they are. And some of the inclusions – Dr Ruth Westheimer, the diminutive, squeaky sexologist, for example – are simply ridiculous. In fairness, of course, these are not just celebrity portraits of *gantze machers* (tribal Big Shots). Brenner's framing device is evidently meant to parody the conventional publicity portrait and to ironize both the sitters' sense of themselves and the projection of those images. Thus Saul Bellow's three-quarter profile exaggerates the dandyism of his own self-consciousness and Avedon's frame within a frame makes a similarly unsubtle point. (Let's hope he never gets to return the compliment by photographing Frédéric.) Occasionally, the selective exploitation of framed space works brilliantly to emblematize both the working identity of the sitters and the public persona. Stephen Spielberg, for example, is posed with his elbow projecting through the bottom edge of the frame, the black space above him becoming, in effect, an unlit frame of film awaiting his creative attention. Ed Koch, the ex-Mayor of new York, bursts irrepressibly through his frame with a snap of his braces, his

thumbs hoisted into the air, filling it completely as if to ensure there was no space left for anything but the public man.

There is unquestionably much to enjoy in this portrait gallery, not least Brenner's expressive way of posing hands. Often enough it's the hands that do the talking more eloquently than the faces: Ralph Lauren's stylish knuckles; Mailer's palms laid flat on the outside of the frame, ready for...something; the Hollywood agent Michael Ovitz's right folded into his left waiting for someone to make his day. And there are, of course, important precedents for attempting to embody the essence of a culture through a portrait gallery of its Talents: the Kit-Kat Club of the late Stuart and Hanoverian Whigs; Félix Nadar's engraved procession of literary lights in mid-nineteenth-century Paris, for example. But Brenner's clear intention to undercut the working assumptions of celebrity photography, is itself undercut by the predictability of his choices, very much a selection made from a trans-Atlantic distance. Lacking real sharpness, the satire begins to stick and cloy and develop a bad case of ingratiation.

Amazingly, though, the clichés fall away when Brenner relocates all these portraits to Ellis Island in one of the great *coups de théâtre* of the book. Crowded on to a scaffolding against the backdrop of the Manhattan skyline, the celebrities are wonderfully transformed into a jumbled line of immigrants, dressed up for admission, or even more astonishingly like so much *baggage,* jumbled together, the piles of faces and hands and torsos rhyming with the blocks and towers projecting into the sky behind them. And we cease to care (or be embarrassed) that Philip Roth has been turned horizontal (in a feeble play on his favourite acrobatics) or that Dustin Hoffmann appears to be pointing towards Ireland or that the art historian Meyer Schapiro for some reason has been turned into a half-submerged pixie. We don't even care that Henry Kissinger appears to be weighing heavily above the folded knees of his nemesis Allen Ginsberg. None of these assorted gestures matter at all beside the crumpling of celebrity into the clamorous array of people who seem to be our relatives, brought together for some mysterious *simcha* (a celebration) on an island at the threshold of Liberty. Crowded together,

you don't see FAME; you think instead, oy, watch out for Cousin Barbara's nails; and be polite when Uncle Miltie tells you that joke *again*; and did you hear about poor Milkie; and that Isaac with his fiddle, he hasn't aged a day and Ralphie, you just take a look at his shiksas if you should forgive the expression and so, *nu*, what can I say?

Wondrous though this conceit is, it's for his depiction of the unknown, not the known, that Frédéric Brenner deserves to be thought of as one of the great visual chroniclers of Jewish life. For myself (I should be so lucky), I'd gladly trade in the whole Ellis Island gang for the stunningly beautiful and deeply affecting group of the family of Marvin Josephson and Tina Chen in their Upper East Side apartment. Josephson, with his flat, square face, itself oddly reminiscent of the figurines from the ancient Chinese-Jewish community of Kai-Feng, is seated at the foot of a staircase on which his wife and daughter stand, while the other daughter, Rebekah Chen-Josephson, is present both directly and in a mirror image, half-turned toward a Sung porcelain horse. In its movement back and forth through sectioned space, its deli-cate sense of travel through Eastern and Western worlds, the photograph is fusion music of the most exquisite and spellbinding kind.

And yes, I know, the Josephsons are not exactly your typical Jews. But then again, nor are the Lubavichers. Nor are any of us, as Frédéric Brenner, thank God, well knows.

ANSELM KIEFER

Lecture at the Metropolitan Museum of Art,
New York, March 1999

ALMOST EXACTLY A YEAR AGO I went to an Anselm Kiefer opening at the Gagosian Gallery. Downtown, of course, for the paintings, massive even by Kiefer's standards, would hardly have made it into those upstairs rooms on Madison Avenue. So there they were filling all the available wall space in the Soho gallery, colossal, mute, archaic, unpeopled structures, glaring down at the usual gathering of Persons in Black, who were chatting, checking each other out, sipping the libations (have you noticed how minimalism extends to the cocktails), while conscientiously avoiding looking at the work. Hey, it was Saturday night in Soho. Apocalypse *not now.* Occasionally, though, the word 'awesome' could be heard; if used literally, then, for once, not inappropriately. To be fair, it was all but impossible to see the paintings anyway, and would have been without emptying the gallery entirely since they demanded to be contemplated, as if in an encounter with Ozymandias, across a vast desert-like space, the forms swimming in the light of a dusty mirage, half-emerged from the camel-coloured sand covering their surfaces. Instead, the images on

the wall were broken up by areas of fashionable blackness, not unlike the fall of snowy or sooty flakes that speckle the surface of one of Kiefer's studies in *horror vacui* (a good name for a modern art gallery I've always thought).

I suppose the disconnect between the occasion and its objects was no more glaring than usual. But it felt like it, because what we might have been looking at stood, archaically, in the starkest possible opposition to the fashionable, which is to say something that taps into and feeds off the electricity of the moment. There is, of course, an important sense in which Kiefer's art has never been and never will be truly contemporary – the same sense that makes it irresistible for people like me, professionally captive to, and pretty much unbothered by, the obstinate drag of history (about which more later). But the works on show at the Gagosian last year, stood, I thought, as reproof to the shifting idea of the contemporary itself; made the obsession with what's hot seem itself picayune and ridiculous. Kiefer's shaky architectural monsters – half-ruined piles, crumbling hecatombs, rather than finished buildings, spoke of some place beyond the tracks of the Western, linear view of time, and certainly about as far away as you could possibly get from the occidental obsession with history as an epic of progress. Kiefer's lines, as we shall see a bit later, do not travel in the direction required by teleological optimism. In his world there is no west for young men to go to, only an east where the end of the journey really *IS the end of* the road. While you could hardly ask for work more deeply shadowed by presentiments of the millennium, it's not going to be much good asking him, I think, to help build a 'bridge to the twenty-first century'. Instead, at least in this last cycle of works, we are put in mind of cosmic cycles of creation and destruction: the pyramids, ziggurats and walls, seeming to gather shape from the broken, rubble-strewn wilderness of stone and dust in which they are set, and at the same time to be doomed to disintegrate back towards it. Over his photographs of Indian brickyards or his painted monuments, Kiefer has applied a blown storm of sand, clay and paint, so that they seem beached, stranded, in a post-apocalyptic uninhabited dustbowl. These are compositions and they are decompositions.

Of all the things that *might* be said (and to my amazement very little *was* said last year), the most improbable I think was one critic's remark that he thought these works exhibited once more Kiefer's healthy sense of humour. I don't deny that sometimes Kiefer thinks he's being funny – though try as I might I don't exactly see him as the stand-up comedian of late twentieth-century art, a Teutonic Seinfeld. For his shows are certainly *not* about 'nothing'. And while there is plenty of irony in Kiefer's work, I seriously doubt that these images represent Kiefer at his comedic best. The other typical comment made about the sand pictures – that they marked Kiefer's 'return to form' and a return to the forms of painting – seemed to me to miss the point even more completely. Kiefer has always been a stalking horse, I think, for those who are eager to give *painting* a new lease of life. In fairness it should be said that the techniques deployed in these compositions are in fact prodigiously inventive: surfaces are baked, caked, crackled, parched, scarified – treated, in other words, not like the ferocious fire-storm burnings of, say, the *Cauterization of the District of Buchen*, and thus not, as if on the receiving end of some sudden catastrophe, but rather as though worn down, eroded and gradually decomposed over a literally immeasurable period of time – creating something that might be the process of instants or aeons.

Given their immediate visual richness and accessibility, it's understandable that the formal power of these pieces should be registered, if not actually celebrated, five years after a quite different appearance: that of the notorious installation, *Twenty Years of Solitude,* in the Marian Goodman Gallery in 1993. That was, of course, the famously shocking stack of Kiefer's own art works, put together at the time of the break-up of his marriage to his wife, Julia (who appears crucially in a number of the works on paper in the Met show, not least orgasmically in *Winter Landscape,* and the least likely impersonation of Virginia Woolf you'll ever see), and his removal from the Odenwald, where he's lived since the beginning of his career in the early seventies, to Barjac in France. The stack of work gave a new meaning to the term 'retrospective', since it consisted of a randomly jumbled pile of canvases and other pieces made invisible and deliberately befouled with grime, and, as it turned out,

Kiefer's own semen ejaculated on paper, the rather gloomy 'twenty years of solitary onanism'. Not the kind of 'Works on Paper' you're invited to see, I hasten to say, in the show here at the Met.

All the same I can't help thinking that it's a mistake to rejoice in the brick-and-dust pictures as some sort of 'recovery' from depression as if we were peering nervously at a patient emerging from a mental institution, who had been hospitalized to prevent him doing harm to himself, or in this case to his work. In fact I actually think that, while it makes for a less upbeat conclusion, there is, in fact, an important continuity between the masochistic exhibitionism of *Twenty Years of Solitude*, and what I would call the more measured pessimism of the desert paintings. Memory, of course, has always been Kiefer's great subject: the fixation which both set him sharply aside from the self-conscious a-historical obliviousness of avant-garde modernism of the nineteen-fifties and sixties, and which made him so suspicious a provocateur for so long in his own homeland of Germany. And what he remembers is not just the calamities of the century about to disappear, but (perhaps subliminally) the archive of art and, in particular, those works which themselves, oxymoronically, have pointed us towards, not the redemptive character of art (another mistake made about Kiefer I think), but something like its opposite: its helplessness in the face of the irredeemable. Kiefer's work is an utterance (unlike Beuys's shamanistic pretensions): not an act of healing. If it is a recovery, it is a recovery of things we should most likely want to go away. The works of art it put me in mind of come from the archive of hubris and plantasmagorical ruin: Bruegel's *Tower of Babel*; Piranesi's *Veduti* and *Carceri* (which may also have provided a source for some of Kiefer's most forbidding brick-and-masonry); and above all (and here I admit I'm winging a speculation) Hubert Robert's paintings from the seventeen-seventies through the French Revolution (which took him prisoner): paintings that described, on the verge of a new messianism, both construction and demolition, renovation and ruin.

Kiefer, though, has taken some of that subject matter and thematized it as the tragic quandary of art itself, wanting somehow to make art that is not self-vindicatory, but self-incriminating, even self-destructive.

Hence the empty and shattered frames of one of his most powerful relatively recent works, *Fall of Pictures* (1986). Works of art are in a fallen or falling state in Kiefer's dark imagination. All those feeble facetious jokes cracked in the eighties – about museum guards needing dustpans and brooms to clean up the dropped pieces of straw and dirt – are inadvertent endorsements of Kiefer's own tragic pessimism about the one quality that museums, including this one, assume about their holdings, namely their permanence, or at least their long-term survival. Kiefer's apparently wilful engagement in auto-critical, if not auto-destructive art, is Dada without the jokes. And it is also at the opposite pole to a Duchampian idea of ecumenical inclusiveness. What makes Kiefer so damned hard to live with (and I always wonder where collectors of Kiefer end up putting his work) is the paradoxical fact that he is creatively at his strongest when he is wanting to proclaim the moral inadequacy of art in the face of shattering calamity: whether historical, ecological or personal.

The most conspicuous of the recent paintings, *Dein und Mein Alter und Das Alter Der Welt* (*Your and My Age and the Age of the World*), is based on a poem by the Austrian feminist poet Ingeborg Bachmann (who is also, by the way, the author of a play called *The Good God of Manhattan*). It was under the auspices of Bachmann and her Gruppe 47 that the poetry of Paul Celan (without whom no discussion of Kiefer would be complete or, for that matter, even possible) became first noticed in the German-speaking world in the nineteen-fifties. Celan's life ended in suicide by drowning in Paris in 1970, an event that unquestionably deeply affected Kiefer, who, like countless Germans growing up in the nineteen-fifties, had been taught Celan's *Todesfugue* as the dirge of the death camps. It was precisely in the early seventies that Kiefer seemed to take on Celan's most desperately felt themes: the possibility or impossibility of art, more specifically *German* art in the world after Auschwitz. What's less well known is that Ingeborg Bachmann's life also ended tragically a few years later in 1973 when her nightgown caught fire in bed. Whether this was an accidental event or not, it was certainly not treated as such, not least because for years Bachmann had been in a suicidal state of drug

dependency and depression. What Kiefer also certainly knew was that en route to this terrible self-cremation Bachmann had made a journey to Egypt and had written a poem called *Das Spiel ist Aus (The Game's Up)*. Kiefer, of course, did work in the nineteen-eighties on the *Isis and Osiris* myths with their themes of self-immolation and tragic surrender to fate; and it seems extremely likely that Bachmann's own tragedy is being invoked in *Dein und Mein Alter und Das Alter Der Welt* as a metonym for the larger tragedy of artistic ambition. It is almost as if he had transferred the suicidal impulse, the impulse of auto-destruct, not to himself, but to the matter of art.

Paul Celan and Ingeborg Bachmann have never ceased their haunting of Kiefer's work. The *Todesfugue* was, of course, most poignantly worked in Kiefer's series invoking the golden-haired Margarethe, the concentration camp commandant, the voice of the poem (and Faust's heroine, of course), in opposition to the black-haired, ashen Jewish Shulamit, her victim. In the late nineteen-nineties, Kiefer left the golden straw images of Margarethe behind, but kept finding ways to register the presence of Shulamit's hair, embedded in lead, in strands or hanks, as if it were woollen yarn, evoking the horrifying translation by the Third Reich of human remains into workable textiles: the perversion of craft. And in the latest cycle, too, the best of the new cycle, *The Sand from the Urns* takes its title directly from another of Celan's earliest poems, which is, of course, about memory.

> Green as mould is the house of oblivion
> Before each of the blowing gates your beheaded minstrel turns blue
> For you he beats his drum made of moss and of harsh pubic hair
> With a festering toe in the sand he traces your eyebrow.
> Longer he draws it than ever it was, and the red of your lip.
> You fill up the urns here and nourish your heart
> (from Michael Hamburger's beautiful translation of *The Sand from the Urns*)

This is a poem about atrophy, the malevolent trickery of the anti-minstrel, working not with memory and endurance, but corrosion and

oblivion, the elements of mould and sand. Celan suggests ('with a festering toe in the sand he traces your eyebrow') the infected promise of the making of the very first images, images in rock and sand, icons fated to surrender to their own obliteration. Not an especially upbeat motif for the artist, and one reiterated twenty years later in 1969 when Celan was himself in Israel amidst the blowing sands of the khamsin (and like Kiefer passionately interested in, but mournfully overcast by, archaeology):

No more sand art, no sand book, no masters
Nothing on the dice.

In the end Paul Celan, like Primo Levi, who admired him, was tragically incapable of exorcizing his demons: of resolving the contradictions of art and history; of continuing to profess a poetry, which itself attacked the moral status of poetry, indeed of all art, which respected Adorno's famous dictum, 'After Auschwitz, no poetry', and yet which resisted the opiate of silence. And while, one deeply wants Kiefer to avoid the same nightmarish cul de sac, it has to be said that his own work, in this latest mood, represents yet another round of struggling with his own demons to make an art that at the same time bears the scars of its desperation.

Now rejecting anything remotely like art's claim for transcendence, and insisting on its impotence as an instrument of catharsis, may not make us feel tremendously bright and shiny about the future, but it is the mark of Kiefer's own unsparing integrity. He would, I think, entirely endorse Leo Bersani's denial that 'the catastrophes of history matter much less if they are somehow compensated for in art, and art itself gets reduced to a kind of superior patching function and is enslaved to those very materials to which it presumably imparts life; the redemptive aesthetic asks us to consider art as a correction of life'. For this is exactly the kind of feel-good claim that Kiefer's most uncompromising work asks us to *reject*. Even his archaeology has an element of despair in it (as indeed it did for Celan looking at the stones of Jerusalem): the sedimentary layers

of the past picked over and dug through, only for the results to await another shrouding by disaster.

As I've already implied, this insistent fatalism puts Kiefer's truth at odds with just about every account of the evolution of art, especially Western art, most especially *American* modernist art, with its euphoric belief in the perpetual self-invigoration that we can bring to the table (or to the lecture room). It's often pointed out, and not incorrectly, that Kiefer ought to be read as a German edition of the break-out from the narcissistic self-referentiality of abstract colour-field painting of the nineteen-sixties, the ultimate result of art's self-scrutiny. But what strikingly separates the break-out in forms taken by American artists like Jasper Johns and Robert Rauschenberg from their German counterparts was the euphoric openness, on this side of the Atlantic, to a universe of popular signs and icons, a sort of big-chested embrace of the American vernacular.

That, to put it mildly, is not what happened with Kiefer. He is often at pains to insist that his engagement with the icons of German culture was not at the level of esoteric erudition, but rather at the level at which they had become truisms and clichés, like the expression 'Heaven on Earth', invoked not as a description of transcendentalist rapture but, say, of the enjoyment of ice-cream or good sex. But though it's often struck me that Marlene might have made just as good an ironic icon as Marilyn, we could hardly look to Kiefer for it. He was interested in the ways in which the canon of high culture – the standard repertoire of *bildung* – entered the impure bloodstream of the vernacular world. For Kiefer this vulgarization was not especially benign. Arguably it was in their popular form that the icons of *Deutschtum* became *more* potent and sinister precisely for being un-thought. The show of his works on paper at the Met (*Anselm Kiefer: Works on Paper 1969–1998*) surely documents this conflicted relationship that Kiefer has with both learned and popular German iconography.

Now I'm well aware that I'm setting off alarm bells here, in that some of Kiefer's appeal has, in the past (especially in 1987, when a major exhibition of his work in Chicago and New York met with something like a triumphal reception), come from a misplaced devotion to what were

thought to be its runic and oracular eloquence. To be fair to some of the more uninhibited enthusiasts, they were following on from the cue of similar devotees in the Netherlands (where I first saw Kiefer's work at the Stedelijk Museum in Amsterdam), and which triggered ecstatic outpourings, like the following breathy offering, best classified as soft-porn metaphysics:

> Admiration begins at the source, where the fount rises and
> seethes speeding in blissful freedom, longing for what is to come,
> in its impetuousness, already headed for the still unknown goal...

It was precisely the attribution to Kiefer of seer-like moral authority that, of course, drew the ire of sceptics, both here and to a much greater extent in Germany itself, where the Stefan Georg tripwire alert against Romantic obscurantism went off loud and alarmed. Equally, German opinion, both inside the art world and beyond, poured scorn on the naïvety of foreign enthusiasts, for drinking in the heady elixir of Kieferian visual rhetoric. I don't want to rehash this dispute. Andreas Huyssen has written eloquently on it in his book *Twilight Memories*. But — while I share Huyssen's hostility to an a-historical enthusiasm awarded to what seems suspiciously like New Age shamanism, and while I endorse Huyssen's insistence on restoring the proper cultural context of German post-war debates about history, memory and national identity — for even an elementary understanding of Kiefer's purposes, I also want to say that such an understanding does not preclude, in fact, it necessarily leads to, a wider encounter with the more universalizing implications of what Kiefer has to say about the power of images themselves. To put it another way, we must start with Germany, but we can't possibly end with Germany. I don't want to violate the spirit of the passages I've just read by Celan and Leo Bersani by implying that Kiefer's ongoing scrutiny of the load-carrying weight of images is, in some sense, more *significant* than his lamentation of calamity. I want to say instead that looking at such signs and symbols, and having them look back at us, is his *way* of confronting calamity, of facing down the seductions of evil.

This happens in the show here at the Met right from the get-go, with the *Heroische Sinnbilder* (*Heroic Symbols*), itself an extension of Kiefer's photographic montage, *Besetzungen* (*Occupations*). Writing about Kiefer's record of himself strutting around, parodying the Sieg Heil salute, 'occupying' Europe on what we might call his vocational vacations (occupation/occupations), I described the gesture as 'sophomoric', thinking of the behaviourist politics of 1968–69, familiar to all of us who lived through them in the university and the street. But, of course, it's possible, as it were, to be *seriously* childish, with the intention of exposing the infantile-regressive quality of the gesture, and also, ironizing it by stripping away the herd- or crowd collectivity from which its dangerous magic flowed. An occupation of one is, by definition, self-disarming. But, as almost all of those writing about Kiefer have also noticed, there's another frame of reference summoned up in Kiefer's posturing impersonation, an image this time not from the newsreel but from the museum, in particular, as it were, from the Deutsche Nationalmuseum, namely Caspar David Friedrich. And this was not the only occasion when Kiefer had recourse to quote, in subtly altered but telling form, from Friedrich's Romantic painting, as in the extraordinary *Varus* of 1976. Once again, we are warned, and with good reason, that it would be banal to imagine Kiefer as recycling Friedrich for contemporary use. Indeed it would, for Kiefer's purpose is not at all to revert, but to invert the sense of these compositions. Friedrich, of course, especially in the *Chasseur in the Snow*, was concerned to glorify and sacralize the memory of those German, principally Prussian, soldiers and partisans who fell in the *Freiheitskrieg* (*War of Liberation*) against Napoleon for which he had designed a memorial monument. Kiefer's concern is with de-legitimizing the war that overshadowed his entire childhood and youth. Friedrich's concern is with tombs as sacred places, places from which resurrections could take place; the ashes all give birth to phoenixes; stone sprouts greenery, the colour of Christian hope. The organic, *natural* life of the reborn nation impends. For Kiefer, ashes are, of course, just death; not the medium from which new growth springs, but the matrix of annihilation. A pantheon of the German past was for Friedrich the condition of German

nationality; for Kiefer, the pantheon turns into the crematorium. For Friedrich, the *Holzweg*, the path in the forest represented the victory of German nature, a kind-of ur-habitat, over classical culture (the French imperium). For Kiefer, the *Holzweg* is, as it is often understood in vernacular German, a *dead-end*, and instead of the slaughter being aesthetically euphemized in truncated trees and the inevitable raven, the dead-end is defiled by drops of blood dripped on to the begrimed snow.

This is quite evidently not any kind of infatuated reworking of the canon, much less a mystification of it, as Kiefer's most ferocious critics believed when this work got its first international showing in the late seventies and early eighties. The allusions to all kinds of motifs in the canon of German literature – Hölderlin, Hoffmansthal von Fallersleben, Stefan Georg, Wagner and the *Nibelungenlied* – are all robbed of any possibility of cultural innocence, much less Romantic mystique. If Kiefer's aim here is to try, simultaneously to project the emotive power of these works at the same time that he frames them ironically, it has to be said that the negative overwhelms the positive charge in their cultural electricity. Whether Kiefer is pointing to it, or resisting the determinism, they become signposts along the road to catastrophe. Arguably, in fact Kiefer's trail of heroes – with its fluvial line incorporating the names of teleologists like Hegel and Marx – is an attack on the idea of teleology itself: the inexorable unfolding of an historical will or *Schicksal* (destiny).

Kiefer goes still further, making the basic working machinery of figurative art an accomplice, so that the line of perspective, the line that creates illusionistic space, itself becomes implicated in this historical process, turning inevitably into a railway line, with its very particular historical vanishing point, the vanishing point of an entire race. 'We see railway tracks anywhere,' said Kiefer, 'and think about Auschwitz. In the long run this is the way it will always be.' The pointer to infinity becomes for Kiefer a wound, a gash or tear in the body of Western culture, a scar that goes necrotic, refuses to heal.

In *Märkische Sand*, Kiefer revisits (in the manner of a bitter graveside pilgrimage), one of the acts that German Romantic culture had ordained as a spiritual experience. I'm referring, of course, to walking. The

Brandenburg Mark, ostensibly depicted here, was the native landscape that Theodor Fontane's *Walking Tours through Brandenburg* had consecrated as the site of a communion: between walker and nature and between walker and walker – in effect a double-solution for the woes of Romantic alienation. By the end of the nineteenth century, a generation later, the patriotic hike, with its overnight bonfires and above all its hiking songs, became *the* activity that kindled the fires of patriotic ardour and brotherhood in the breasts of German boys – and occasionally girls – the *Wandervogelen*. But Kiefer does not altogether 'love to go a wandering', since he knows that the hiking song became the marching song, the *Märkische Sand*, literally one of the favourite marching songs of the Reichswehr as it revisited the east: a route, of course, that had already been intensively marched over between 1914 and 1917. The route marked by Kiefer's way through the landscape changes, tragically from walking to marching and also from seeing to burning (23). And when Kiefer makes the desperate admission that to paint is to burn; that the palette itself has brushes licked by fire, he cannot possibly be claiming that in art lies salvation, reparation, consolation, transcendence. On the contrary, art is the accomplice, the pathetic fellow-traveller along the road of fire and tears.

Kiefer, then, was someone who was going places that German culture in the nineteen-seventies really would rather not go. He was re-opening both old wounds and deep pictorial space, thus managing to cause offence to just about everyone: the conservative right in Germany much preferring the dense obliviousness of the *Wirtschaftswunder* (the 'economic miracle'); the avant-garde left aghast both at what it wrongly took to be Kiefer's sympathetic revisiting of abhorrent nationalist iconography and, even worse, his rescue of discredited figurative techniques. Painting, especially landscape painting, it had been agreed, was dead along with the old Germany. If one objected, by way of defending the choice of Kiefer to represent German art at the Venice Biennale in 1980, that this was not exactly Painting as Usual, the critical response was, indeed, it was worse, since Kiefer had evidently flagrantly violated the modernist doctrine that painting's legitimacy lay in its acknowledgement of its

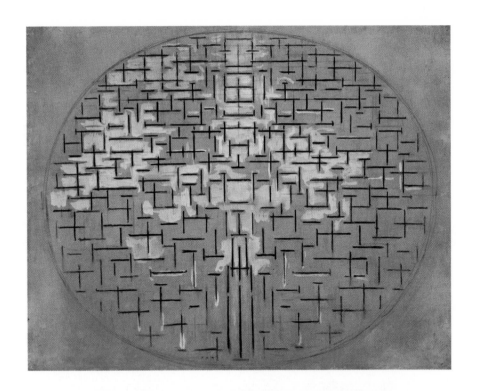

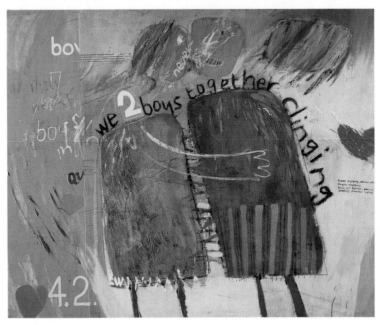

TOP 17 Piet Mondrian, *Pier and Ocean 5*, 1915, charcoal and gouache on paper, 87.9 x 111.7mm, (Museum of Modern Art, New York, USA). © 2004 Mondrian/Holtzman Trust, c/o hcr@hcrinternational.com

ABOVE 18 David Hockney, *We Two Boys Together Clinging*, 1961, oil on board (Arts Council Collection, Hayward Gallery, London, UK). © David Hockney.

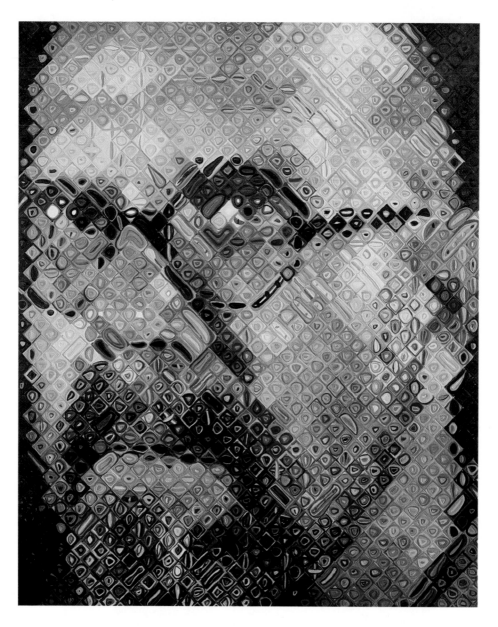

ABOVE 19 Chuck Close, *Self-portrait*, 1997, scribble etching (Museum of Modern Art, New York, USA). © Chuck Close 2004.

OPPOSITE, TOP 20 Ellsworth Kelly, *Orange Relief with Green*, 1991, oil on canvas, two joined panels (Tate Gallery, London, UK). © Ellsworth Kelly. Photo © Tate London 2004.

OPPOSITE, BELOW 21 Alex Katz, *Lake Light*, 1992, oil on canvas. Photo Courtesy the Saatchi Gallery, London, UK. © Alex Katz/VAGA, New York/DACS, London, 2004.

TOP 22 Cy Twombly, *Petals of Fire*, 1989, acrylic paint, oil stick, pencil, colour pencil on paper (Private Collection). Photo Courtesy the Gagosian Gallery, London, UK. © Cy Twombly 2004.

ABOVE 23 Anselm Kiefer, *Märkische Heide (Heath of the Brandenburg March)*, 1974, oil, acrylic and shellac on burlap (Collection Van Abbemuseum, Eindhoven, The Netherlands). © Anselm Kiefer 2004.

TOP LEFT 24 Frédéric Brenner, *Jewish Lesbian Daughters of Holocaust Survivors, with Their Mothers, New York City*, 1994, print. Photo Courtesy the Howard Greenberg Gallery, New York City, USA. © Frédéric Brenner 2004.

TOP RIGHT 25 Charles Breijer, *The Kuyt Brothers Listening to the Radio in Their Hiding Place, Amsterdam, 1945*, print (The Nederlands fotomuseum, Amsterdam, The Netherlands).

ABOVE 26 Anna Ruth Henriques, illumination from *The Book of Mechtilde*, 1997, mixed media on paper (Collection of the Jewish Museum, New York, USA). © Anna Ruth Henriques, 2004.

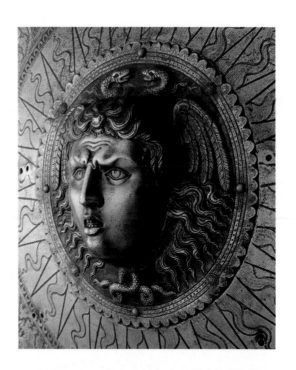

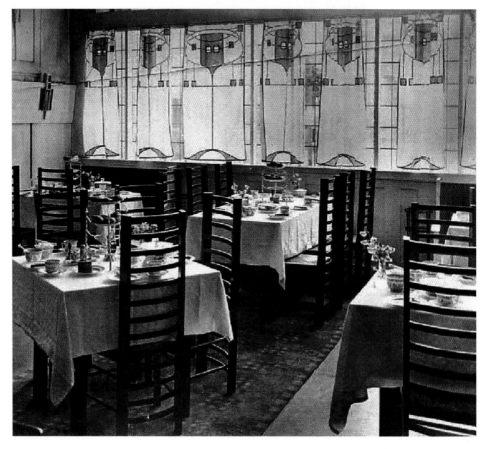

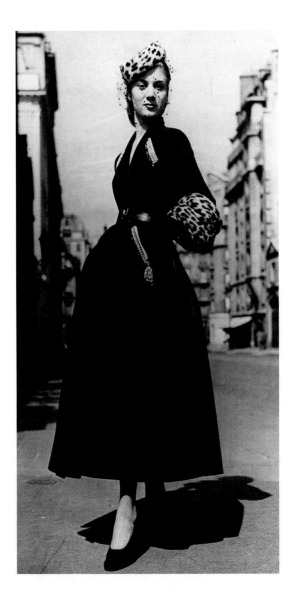

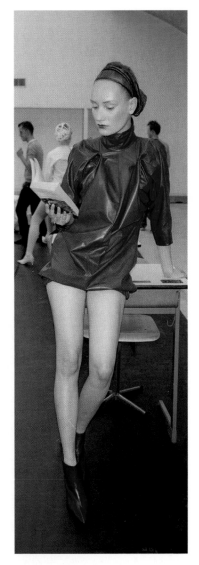

OPPOSITE, TOP 27 Milanese workshop, Medusa shield, *c.* 1570–80, steel, gold, silver and brass (Musée de l'Armée, Hôtel National des Invalides, Paris, France).

OPPOSITE, BELOW 28 Charles Rennie Mackintosh, The Willow Tea Rooms, ground-floor interior, *c.* 1904 (Annan Collection, Scotland, UK).

ABOVE LEFT 29 Christian Dior, 'Prince Igor' design of full-skirted green velvet coat, embroidered in gold and silver, with slant pockets, deep leopard skin cuffs and pillbox hat (*Picture Post*, 1947, Paris, France).

ABOVE RIGHT 30 Niels Klavers, leather design for the autumn-winter season, Paris, 2003. Photo © Marleen Daniels/Hollandse Hoogte (HH), Amsterdam, The Netherlands.

ABOVE 31 *Andy Goldsworthy and Ed Monti, Stony Creek, Connecticut, August 5, 2003*, photograph by Richard Avedon. © 2003 Richard Avedon (Courtesy *The New Yorker*).

autonomy, a distribution of pigment laid on a two-dimensional surface. According to his fiercest critics, Kiefer had not only reverted to the most retrograde forms of bourgeois figuration, he had committed further sins against flatness by piling texture upon texture on the surface of his pictures, creating a kind of corrupt tapestry of materials, a sort of kitsch weaving. But this was to confuse Kiefer's exhibition, his exposure of those things, with a celebration, or a renovation, of them. His aim was in fact precisely the opposite: to subject all those things (history painting, heroic narrative, the Idealist atmospherics of Romanticism) to the end-point at which they had arrived – in catastrophe – to face them with their own exhaustion. And his calculated agglomeration of heteroge-neous materials – earth, sand, dirt, ash – was in the service of literally soiling, rather than refining the aesthetics of landscape. His emblematic signature, the palette, is everywhere in the pictures of the nineteen-seventies, but it is emphatically not a triumphalist or even hopeful icon. 'The palette represents the art of painting,' he has said, 'everything else, which can be seen in the painting, for example the landscape, is, like the beauty of nature, annihilated by the palette.' In other words, art, the destroyer, the best thing about which we can say is that it usually fails in its destruction.

When I argued that tragic irony makes any kind of historically innocent revisitation of these icons virtually impossible, I don't want to imply that Kiefer was entirely and unconditionally immu-nized from the sorcery of this mythology, while reworking it. He was on record as saying, while making the *Besetzungen* (*Occupations*), that, in order to understand the fatal spell cast by fascist myth, he needed to enter their charmed but poisoned atmosphere. He was not the first to suffer from this kind of risky enterprise. Not only Nietzsche himself and Carl Jung – both evidently serious influences on Kiefer – suffered from this per-ilous emphathy, but also Aby Warburg, who as a defecting law student (like Kiefer) had the opportunity to listen to both Jakob Burkhardt *and* Nietzsche lecture on art at Basle University in the eighteen-eighties. For the rest of his life Warburg saw Western culture as a kind of gladiatorial struggle between the rational and the demonic, personified by those two

figures, with the result, as the century wore on, looking increasingly omi-
nous. It was a struggle that Warburg internalised so intensively that it
literally cost him his sanity.

It would have been inconceivable if Paul Celan, a survivor of the
Holocaust, from Bukovina, had been diabolically enchanted in the same
way as Warburg. And, of course, he was not. But for a while, at least,
Celan tried to comprehend how a figure he respected as a philosopher,
namely Martin Heidegger, could also have been an enthusiast of
National Socialism, occupying the Rectorship of Freiburg University
from 1932–34, signing his letters Heil Hitler, wearing the swastika pin
and paying Nazi Party dues all the way until 1945. In fact the interest was,
for a while two-way, Heidegger at one point requesting from both Celan
and Ingeborg Bachmann copies of their poems and being turned down.
But in July 1967, Celan actually made the journey to see Heidegger in the
fastness of his *Hütte* at Todtnauberg in the Black Forest, where he
affected the dress of the local woodland villagers, as if returned to some
primal *Heimat,* and had recently proclaimed that 'Being speaks German'.
Celan and Heidegger, the *Dichter* and the *Denker* (the poet and the
thinker) went walking in the rain, Heidegger conceding afterwards that
the Jew had known far more about the flora and fauna of the Black Forest
than himself.

There was, of course, a kind of wilful obtuseness in Heidegger's
response; patronizing the Jew for understanding the botany while the
poet was contemplating the *bankruptcy* of the German Idealist landscape
tradition, and for that matter of the entire culture of *Bildung* or moral
formation in which it had played such a crucial part. Within the termi-
nology of the old vocabulary of *Bildung* you might say that, when Celan
drank from the well on Heidegger's property, with its famous star-
shaped wooden head, he was going back to the *source*, the fons et origo, of
enlightenment. But history, not least Heidegger's personal history, had
made this kind of Idealist association between landscape and transcen-
dence ridiculous, if not obscene. In Heidegger's visitor's book, Celan was
brave enough to write: 'Into the hut-book, looking at the well-star, with
a hope for a coming word in the heart.' But, needless to say, that word

never came. Heidegger's landscape was a lived lie. Celan, on the other hand, was coming to dwell in the poetic anticipation of Kiefer's landscape, its transcendentalist pieties scarred and incinerated by the fires of history. In this world, fire was not the purifying flame of Romantic Idealism, or the white heat that could forge the sword Nothung; it was the creator of dead ash. Celan's poem, *Entwurf Einer Landschaft* (*Sketch of a Landscape*), almost exactly anticipated Kiefer's brutal elementalism, his insistence on describing land and soil (especially in the most recent works) in geological, rather than aesthetic, language:

> ...Circular graves below. In
> four beat time the year's pace on
> the steep steps around them
>
> ...lava, basalt, glowing stone from the world's heart-
> wellspring tuff...
> Where light grew for us before
> Our breath...

Celan's *Todtnauberg*, the poem written about his visit to Heidegger, still managed to reiterate 'a hope today of a thinking man's coming,/word in the heart'. But by the end of the poem, his expectations of any kind of redemptive moment collapse: his walk, 'the half-trodden fascine, walks over the high moors', encapsulated in the deadly phrase, 'Feuchtes. Viel – Dampness. Much,' followed by: 'now that the hassocks are burning I eat the book with all its insignia'.

Burials, entombments, bodies pinned to, or pressed into, the ground recur, both in Celan's poetry and Kiefer's paintings, as if in a kind of terrestrial entrapment. Idealist and transcendentalist philosophy of the kind dear to the *Bildungsroman* naturally opposed to that imprisoning earth the celestial vault: *Luft und Licht* (air and light). It was proclaimed in the works of the more metaphysically minded writers of the Romantic period (the Schlegels, for example) that intense contemplation of nature had the capacity to transport and transform earth-bound experience into

a kind of celestial communion. And the vehicle of that transport (when it was not direct contemplation) was, of course, art – in the broadest sense: literature and music as well as painting. This is precisely the meaning of the radiance that illuminates Friedrich's most intensely felt landscapes, for example. Once again, of course, that kind of neo-Platonist vision, the assumption that a close encounter with nature could lead directly to a spiritual ascent to the divine, had been horribly contradicted by the supine helplessness of nature in the face of twentieth-century brutalization. Now Heidegger and others had a kind of philosophical solution to the apparent contradiction between earthly disfigurement and spiritual purity. Following Aristotle (rather than Plato) and in particular the medieval interpreters of Aristotle like the Arab Avicenna and the Catholic Aquinas, the universe was divided into 'Essence' – representing the spiritual creative force – and Existence – representing the inscription, or visible approximation of the divine in the concrete material world. A landscape, then, was part of Existence, both in reality and in representation. The Existence of a disfigured landscape would not, then, contaminate the autonomy and purity of the Essence.

Kiefer ostensibly re-makes this division of realms while, I think, at the same time, exposing its absurdity. Virtually the very first images that greet you in this show are those of the heavens: the comically discrete privatized 'dome of heaven' available to each believer after his own fashion and on his own patch; then the heavens mottled with blood-stains; the winter sky supporting a severed head; 'sick art' affected by suppurating sores. And so on for thirty years: the utter inability of the heavens to remain unpolluted by the experience of the lower world, and for that matter the utter breakdown of that spiritual transport system, which is supposed to be supplied by the vehicle of art. Kiefer likes on occasion to disclaim all access to or interest in the archive of signs in the history of image-making (rather in the manner of the rock-star song writer – take your pick, Lennon, Bob Dylan – who, when confronted with the fiendish cleverness and complexity of his lyrics, replies, 'Oh I dunno, it's just words isn't it?'). But this profession of iconographic innocence comes across as a little disingenuous from someone who has twice

represented the Byzantine Iconoclasm controversy as the subject of ambitious compositions.

So it's not too much to assume, I think, that Kiefer is familiar with the most commonplace of all the emblems of artistic invention: the winged foot, sometimes just wings, which since the Renaissance have been taken as the symbol of *invenio* or *ingenio*: the touch of the divinely creative spark, the source of invention. That's why Mercury was one of the two patron deities of painters (along with Minerva for wisdom): the winged heels indicating art's capacity for levitation, for transporting the beholder from the mundane to the sublime.

But, of course, Kiefer's winged palettes are made of lead, as are his aeroplanes and, as such, they stall, crash and burn. They make up a whole fleet of planes flying for *Air Icarus* – the airline that's really *hot*. Ingeborg Bachmann, too, was obsessed with the fantasy of doomed flight, as a metaphor for the failure of love, and the failure of civilization.

Instead of light, then, lead. But lead with a difference. Lead that Kiefer, when he wants to, can make *airy*, vaporous, light as feathers. Once again, of course, Kiefer disclaims anything close to intellectual artfulness in his choice of the medium in the nineteen-eighties, saying that he just stumbled over the plasticity of the metal in its molten or fluid form while fixing a broken washing-machine. But the serendipitous discovery of painterly effect is itself an extremely ancient trope going back to Pliny's description of the Greek painter Protogenes's frustration – at not being able to get the flecked muzzle of a dog right – becoming so extreme that he ended throwing the sponge at the painting and, of course, *eureka*. So, too, I think with Kiefer's inspired happenstance on lead. Lead was always there in the actual chemical substance of every tube of oil paint that he would have used, especially in the whites; and the paradoxical union of qualities that Kiefer was searching for, also, was always there: namely, the combination of toxicity and purity (in lead white); the union of heaviness and lightness, of weight and levity, solidity and fluidity; lead as the material of entombment and lead as the material of protection.

For Kiefer, the choice of a working material has never been an abstract or formal decision, rather a rhetorical and polemical one, so that

the material of figuration becomes the substance of the argument or the narrative. Thus there is dirt soiling the landscape of the Brandenburg Mark, defaced by war and annihilation; straw in the golden hair of Margarethe; black ash representing the pubic hair of Margarethe's counter-type, the doomed Jewess Shulamit, headed for the ovens; wood-work, of course, for allegories, which are about the forest battle of the Teutoburgwald, where the primitive German tribes annihilated the legions of Rome; and so lead for pictures, which argue for the crushing of levity.

Once he had seen how lead perfectly answered his needs to express the self-negating qualities of art, Kiefer was, as it were, off and running with its use, and produced some of the strongest works in his entire output. My only complaint with the Met show – and it's a mild one – would be the sparseness of the lead painting/photograph combinations.

Kiefer's lead works on paper are, even by his standards, amazing in their expressive intensity. He can make the forms billow and erupt, seem both to ascend and descend, issue from things, or spill over them. He can give lead the sense of an electrical charge, a numinous cloud or a sucking vortex. By working with its natural sallow or rusty bleed he can give the material a diseased pallor like an infection. But though there have been strenuous attempts to interpret the leaden-ness of these passages as a kind of positive and even alchemical transmutation, in all cases lead remains the negation of light, and thus the negation, too, of enlighten-ment or, to put it another way, the suicide of art.

It is the destruction of *logos*, the word, as well as of *icon*, the image, or rather the demise of the long-standing relationship between word and image, which begins, at least in the West, with Aristotle's *Poetics*, rein-forced by the famous Horatian dictum, *ut pictura poesis*, implying paint-ing's striving after the condition and eloquence of poetry. Word and image, of course, were inseparable in Kiefer's work from the beginning: the words deliberately scrawled, rather than elegantly inscribed on the images, again, as if in aggressive, graffiti-like repudiation of the classical coupling of the two forms of rhetoric. But in *Zweiströmland (The Land of the Twin Rivers)*, namely Mesopotamia, Kiefer invokes – how presciently! –

both the birth and death of writing and also, perhaps, Paul Celan's famous speech in Bremen in 1958, where he confronted his audience with the fate of his own native world in Bukovina. 'It was,' he said, 'a region in which human beings and books used to live.' Kiefer had explored this theme of the incineration of the word with his carbonized books harking back to the book burnings of the Third Reich, even though the contemporary pretext and occasion in this case was an explosion at an oil storage depot near his home at Buchen. But his lead books, tottering from their glass case seemed to summon up whole epochs of destruction. They are the frozen relics of a culture overtaken by cataclysm (rather like Pompeii caught in lava); things whose chastening eloquence comes precisely from their dumbness, mute mutations.

Which brings us back in a circular fashion wholly apt for Kiefer to the scene at which we entered: one where remote beginnings and ominous endings cross each others' path, as if in an Einsteinian world of temporal relativity. And it may leave you, on the verge of spring as well as on the brink of the millennium, wondering if you really truly need this?

Well, there's no hope of turning Anselm Kiefer into visual Prozac. The definition of a futile exhortation would be: 'Hey, Anselm, you're in France now, have a glass of wine, lighten *up*.' But without offering much in the way of expectation that he will, I might all the same point you towards *pleasures*, yes *pleasures* that can be had from his work without ever turning Kiefer into, shall we say, entertainment. For even though I've argued that, during the Reaganite eighties, Kiefer seemed to feel the heaviness of the air with a desperate kind of ominousness, there were moments when visions in the sky were capable of turning pink and, *mirabile dictu*, voluptuous. The wonderful watercolour book, *Erotik im Fernen Osten* was painted as a record, in the first instance, of a voyage he took to Norway, travelling north in an Argonaut-like vessel (again reminiscent of Friedrich's mysterious ships). In the bled-through watercolours Kiefer dissolves the fjords into an aqueous murk while the sunset-red sky shapes itself, liquidly in the form of a billowing giantess of sex, straight from the feverish dreams of that austerely Nordic character, Federico Fellini. The subtitle (in English) of Kiefer's book is *Transition*

from Cool to Warm, implying an equivalence between the modulation in colours and tones and those of his own psychic temperature, which by the end reaches a state of enveloped, pneumatically consummated bliss, as if Kiefer had finally found a place in which he might be swallowed up by pleasure.

Not entirely happy, though, not even here amidst these pink blobs of rapture, since Kiefer evidently felt the need to register pain amidst pleasure, dropping cigar ash on the pictures so that holes are burnt into the *zaftig* thighs of the foam-flecked Aphrodite.

At least, in his chosen exile in the warmth of southern France, Kiefer is not, I think, any longer a nihilist. He is in his own fashion a survivalist. But instead of stocking up with cans of corn and packs of Jello against the coming of the millenial apocalypse, Kiefer has taken to suggesting, with exquisite delicacy – and in surprising violation of his sombre rule that neither nature nor art carries with it any hope of salvation – what in fact might endure amidst the sand and blowing dirt: namely, the frail tendrils and petals of an autumn crocus, the flower that protests the advent of the winter; and still more perfectly, I think, in his great work of abstractly figured lead, called (again pessimistically) *Saturn Time*, a fern. Now, Saturn is, of course, the god of melancholy, and the Saturnine disposition has, since the Renaissance, been taken as the characteristic melancholia affecting the great artist. Kiefer's image of the fern is, literally, a double-edged sword, alluding to yet another sorrowful poem of Paul Celan, *Das Geheimnis der Farne (The Secret of the Ferns)*, the secret being that their perfect forms are constructed in the shape of sheathed swords: blades of greenery. Even so, laid out on its leaden bier, the fern, like the blasted ziggurats, suggests both the last and the very first forms on earth (at least the lichens and mosses): both a fossil and an augury, a reminder that in our end is our beginning.

ANDY GOLDSWORTHY

ON A SULTRY MORNING IN EARLY AUGUST, the sculptor Andy Goldsworthy is standing in a Connecticut quarry watching the heart being burned out of a ten-ton granite boulder. Eighteen of these tawny-grey brutes, varying between three and fifteen tons, are to be scattered through a space of about a hundred feet by twenty-eight on the roof of the Museum of Jewish Heritage's new extension in Battery Park City. The hollowed rocks will then be filled with soil and on August 16, in each of them, a Holocaust survivor will plant a dwarf oak sapling, creating a memorial garden of stones.

Ten feet away from Goldsworthy the stone cutter, the aptly named Ed di Monte (son of an Italian immigrant quarryman) and known to all as 'Monte', draped in a yellow safety coat, stands on an upended milk crate, his head masked by a black welder's helmet, pointing a six-foot shoulder-mounted lance at the half-eaten core of the lichen-webbed rock (31). From the nozzle of the lance a propane-ignited mix of kerosene and oxygen hits the stone at around four thousand degrees

Fahrenheit, generating a jet-engine roar of painful sound. Sprays of sparks erupt about Monte's cowled head as the granite slowly yields to his gouging flame. For the largest, fifteen-ton rocks, it can take twenty-two hours of this relentless attack to turn the boulder into a scooped egg.

Amidst the din, Goldsworthy, a wiry Englishman in his forties, his expression habitually frank and friendly, watches the burning intently. The rock surrenders to the fire, he says, because fire created it in the first place. But he is also aware that fire cleans as well as sculpts. Shooting flames at granite is not only to re-enact primordial geology but to convert the incinerations of genocide into the flames of sanctification.

Monte, a short stocky man in his seventies, with a creased, nutbrown face, has no time for these grand meditations. After about half an hour of concentrated fire he descends from the milk crate and emerges from the helmet, haloed by clouds of steam produced by the cooling spray he runs at the same time as the fire-lance. He is more at home fashioning big, high-polished neo-classical fountains, one of which stands at the back of Goldsworthy's boulders like a duchess stranded in low company. Driving to the quarry every day from Quincy, north of Boston, Monte makes no secret of the fact that the job is more perseverance than pleasure since kerosene fumes get inside his mask and wayward sparks sometimes scorch unprotected patches of flesh. Goldsworthy, too, who has been often scarred, frozen and lacerated while making his strenuously wrought pieces, shows off fresh burn marks acquired on the job. 'Dangerous work, can get nahsty,' Monte says in his flattened Massachussetts accent, cracking a rueful grin. He is not invariably uncomplaining. Jacob Ehrenberg, Goldsworthy's imperturbable young project manager, has had to deal with operatic Monte specials: tantrums over pay, impromptu walk-outs. But on this summer morning, Monte goes at it with a will, looking, with his helm and spear, decidedly archaic, like a warrior from an Attic vase, as distant thunder growls over New Haven.

During a break from the burning, Goldsworthy, Ehrenberg and I peer into the opened belly of the rock. The interior is speckled grey with shreds of stone flaking away from the walls, or pulverized into a granular silica, like sand on a beach, some of its tiny grains glassily fused. John

Ruskin's feverishly beautiful passages on 'Compact Crystalline' in *Modern Painters* come to mind where he describes the glitter of smashed granite as looking 'somewhat like that of a coarse piece of freshly broken loaf sugar'.

The shape of the cavity is conical, a form that much preoccupies Goldsworthy, who often declares a debt to Brancusi. Monte is working from the opened base down to the narrowing funnel. Once hollowed, the rocks are inverted so that the saplings can sit at the neck of the boulder, atop their bed of earth. The disproportion between the hefty stones and the tiny six-inch plants risks looking absurd, but it will at least preclude any possibility of the stones resembling the oversized plant-holders commonplace in corporate atriums. Instead a mysterious hatching will be inaugurated: the sprig from the rock.

The growth process of the sprouting menhirs, standing between the Hudson and Ground Zero will, however, not be risk-free. Tom Whitlow, the Cornell botanist whom Goldsworthy has consulted, has warned that, should the growing oak press against its unyielding stone girdle, it risks crushing the living cambium immediately beneath the bark. In that case the root system will inevitably atrophy and die. But unlike contemporary artists fretful about their posterity, Goldsworthy incorporates the indeterminate outcomes of natural process into most of his work. His collaborations with the found materials of ice and thorns, driftwood and even bleached kangaroo bones have all presupposed artistic design yielding to the cycles of time and climate, whether over an hour or a decade. Often misread as a placid pastoralist, Goldsworthy is in fact a dramaturge of nature's temper, often fickle, often foul. A recent, very beautiful film of his work, *Rivers and Tides: Andy Goldsworthy Working with Time,* must be one of the few documentaries in which an artist is seen enduring, repeatedly, the collapse of his own creation, as he attempts to build a cone of black seashore stones. The idea, a dream of every seven-year-old sandcastle engineer, was that the cone should stand sentinel, almost wholly submerged in the high tide, yet survive intact to reappear as it receded. (After multiple failures he finally pulls it off.) So, too, Goldsworthy relishes the embattled growth of his dwarf oaks, contending as they must

with the jack-hammer shaking of downtown construction, the judder of helicopter rotaries on the riverbank, sudden gusts of estuarine winds and the murky air of lower Manhattan. Their struggle for survival against the odds is meant as an emblem of the Jewish experience they memorialize. 'The trees I wanted,' he said, 'couldn't be decorative. They needed to be tough little SOBs.' He has told the Holocaust survivors that the trees are for their children and grandchildren and 'now I think [pause] they understand'.

On August 22, three weeks before the inauguration of the *Garden of Stones*, the last boulders are being hoisted into their positions on the roof and it is already apparent that Goldsworthy's sculpture will be one of the most powerfully affecting monuments in a city still struggling to find visual expressions for the tug between the perishable and the imperishable. With this most testing commission behind him it may well be that Andy Goldsworthy will end up being more honoured in the United States than in Britain. At least one of his American works – the *Wall That Went for a Walk*, at Storm King Sculpture Park in Mountainville, New York – comes close to being a masterpiece of land art.

Prompted by his discovery of the derelict remains of old drystone farm walls similar to those he encounters in Dumfriesshire, Goldsworthy's two thousand, eight hundred and seventy feet long limestone line tracks dizzyingly amidst stands of maple, hickory and oak, spooling and snaking at increasingly sharp hairpin curves, brushing and pushing the vegetation as it travels through the woods. Typically learned in its associations, the form brings together art-historical memory and the experience of both English and American farming. Mimicking Hogarth's 'serpentine line of beauty', such walls are called 'crinkle-crankles' in Goldsworthy's native northern England, but pay homage to Jefferson's design for a wavy wall of brick. The Storm King Wall is yet another of Goldsworthy's dialogues between the two natures of plant and stone, only with expectations reversed, the trees standing still, and the stone line descending giddily into a pond, appearing to resurface before climbing the far bank, and getting itself straightened out, American fashion, as it heads directly for the speeding perimeter highway.

The Wall has been one of Storm King's crowd-pleasers and through-out his career Goldsworthy has found it easier to find favour with the public and devoted patrons than with critics and curators. A series of large-format volumes published by Abrams (*Stone, Wood* and *Wall*) are packed with dazzling photographic documents of his ephemeral works: pools dyed blood red with pigment rubbed from on-site iron oxide rocks; dazzlingly translucent arches of ice destined to self-destruct in the winter sun; rocks smeared with peat to coal-black; thrown clouds of sand or snow, photographed at the sprayed arc of their ascent; coronas of bracken twigs tied with thorns and hung from trees; delicate strings of pale green rush threaded about a mossy trunk. Much of the work dismissed by one hostile British critic, as 'fiddling around with nature' is in fact densely and poetically emblematic, returning insistently to the themes of vitality and mortality, which have long preoccupied Goldsworthy. A drape of autumnal elm leaves about a rock documents, through the belying brilliance of its yellow, the doom of the diseased species of tree; a line of fleece laid atop a Dumfriesshire drystone wall invoked a sorry history when entire rural populations were cleared to make way for sheep.

None of these complicated layers of meaning register on Goldsworthy's inattentive critics for whom the glossy volumes betray the productions of a sentimental glamorist of nature. The result has been that, while Goldsworthy has been widely exhibited and praised on three continents, the highest benediction of contemporary art – inclusion in the collections of the Tate – has been glaringly denied him. The omis-sion is indefensible though depressingly predictable. For the peculiar virtues of Goldsworthy's work – its moral intensity; its Ruskinian devo-tion to work and craft; its scientific curiosity; its intelligent engagement with the long history of land use; its marvellous instinct for the baroque hyperbole of the natural world – all those mottlings and juttings and peelings and stainings – are all precisely the things that have locked it out from the contemporary pantheon. It is as though Goldsworthy was written off for being not much more than a placid ornamentalist: a practitioner of heavy-duty ikebana.

But any serious engagement with the work (rather than the books) reveals Goldsworthy's constructions, both evanescent and permanent, as at least as conceptually complex and richly site-specific as Robert Smithson's exhaustively over-examined *Spiral Jetty*; his metaphysically suggestive openings and his compressions of space as Platonically probing as Anish Kapoor's; his versatile use of found materials, to invoke both their past life and a reworked future, as ingenious as those of his friend, the fine wood sculptor David Nash; and his commentaries on decay, mutation and rebirth eloquently registered long before the first blue-bottle ever buzzed about the head of Damian Hirst's putrefying cow.

But the connoisseurs of decomposition are overwhelmingly urban, and walls capture their interest only when they come amusingly inscribed with palimpsests of graffiti. Goldsworthy, too, plays in the junkyards of the world, but his are strewn with the rubble of the aeons, not last night's Chinese takeaway. And then there is the artist's provincial indifference to cool; his dug-in resistance to the laconic game-playing required for certification in conceptual subtlety. Goldsworthy – a fatal move for a comer's reputation in Britain – has always refused to apologize for preferring clarity over irony, and northern ruggedness over metropolitan chic. When his dealer, Fabian Carlsson, in the early eighties offered Goldsworthy a long-term contract on condition he moved to the capital, the price was too high.

From the beginning Goldsworthy worried about the disingenuousness of a 'land art' fashioned in an urban studio and modelled for galleries and apartment living rooms. The genre had begun in the nineteen-sixties as a break-out from exactly those confinements. Land art was to be the comeuppance for landscape, the aesthetic framing of nature. The fancy was that a true land art would reverse the customary relationship between artist and subject. For once, the scenery, whether the western wilderness or the grungy streetscape recorded in Robert Smithson's *Walk in Passaic County* would, at least photographically, call the shots. Paradoxically, the measure of success would be in the impermanence of the mark, the artist leaving nothing behind other than second-hand traces of the encounter in photographic or cartographic

information: gallery walls dutifully filled with austere lists, journal pages and studiously amateurish photographs. The unreproducibility of the original epiphany was precisely the point: the action of the site-specific walk (or the dig or the trench) being the authentic art work, leaving behind for the delectation of the galleries only the phantom record. Thrilled with the implied slight, museums of modern art promptly lined up to acquire typed lists of map coordinates and rambling manifestos on entropy. In 1967, Richard Long exhibited his *A Line Left by Walking*: a photograph of the trail left by his boots marching up and down over the grass. Never mind, of course, that nature could not, in fact, take its own even lightly bruised likeness, and was as usual the object of much staging, the image and others like it rapidly acquired canonical status as austerely inaugural documents of a British land art. Unlike the 'Big Sky, Bad Boy', American approach to the wilderness, chunks of which might be privately acquired on which to exercise back-hoe heroics, British land art would be carried on as though Wordsworth were still with us, respectful of ancient rights of way and reverently self-effacing.

Long's persona in the nineteen-seventies, as taciturn pilgrim, extended to his occasional public appearances. While a student at Bradford College of Art (the same school that produced David Hockney), Goldsworthy went to hear a Long 'lecture', which turned out to be a slide show punctuated by country and western music. Resolutely mute when asked if he would mind answering questions, Long replied that, yes, he would. But Goldsworthy, who had worked off and on as a farm labourer just outside Leeds since he was thirteen, had been introduced by his teachers to the work of Smithson, Christo and Denis Oppenheim and had already deserted the study cubicle to work outdoors with the found materials of the land. On the other side of the Pennine Mountains at Morecambe Bay, he made his first temporary constructions of stone against the sweeping arc of the Lancashire coast.

Pretty soon Goldsworthy would come up against the inescapable dilemma common to all land artists. While insisting on the site-specific authenticity of their work, 'non site' works (as Smithson called them) needed something more than the arid records of their making if they

were to register with the art public at all. Even the Zen-puritan, Long, played with material analogues of his original experience to lay on the gallery floor: circles of slate; lines representing a paced walk; mud taken from the site and hand-palmed to the wall; anything that might protest its confinement even as it was exhibiting it. Acknowledging the problem, Goldsworthy has tried to make a virtue of the dilemma, actively co-opting museum space as a collaborator in natural process, covering the gallery floor with clay taken from a construction site on the gallery and letting it dry and split into craquelure; or bringing a giant snowball stained with the natural dirt of its place of origin and making an image of its melt on large sheets of Japanese paper.

These elegant auto-performances of natural materials, the latest of which will be the slow burgeoning of the oaks within his granite rocks, make an end run round the insuperable problem of translation by making the urban site itself a stage of natural drama. Far from feeling defensive about importing his natural monoliths into a crowded urban setting, Goldsworthy sees it as just another move along the continuum of the social landscapes to which he has long been drawn. Not for him has been what he calls the 'pioneer spirit' epic approach of Michael Heizer's deep cuts and trenches in the Nevada Desert, nor the solitary, imperially guilt-burdened peregrinations of Richard Long in the Andes or Himalayas. For Goldsworthy, working rather than walking is the heart of his matter, so he welcomes collaborative labour, getting down and dirty with wallers and shepherds; and pulling into his art the densely packed memories of human and animal occupation, limned through old hedges and cart-tracks, sheepfolds and wells.

Not surprisingly, then, he retains the white scuffmarks and scratches of the long transportation history of his boulders: taken first from the field near Barrie, Vermont, where Goldsworthy and Ehrenberg discovered them, to the Connecticut quarry where they were hollowed, thence to a Brooklyn holding yard, from which, finally, they were moved, one at a time to Battery Park City and finally crane-lifted, gingerly, on to the roof of the Museum of Jewish Heritage. The fact that the stones had already long been cleared from their original geological site by farmers

needing agricultural land was a plus for Goldsworthy though he had to persuade incensed members of a local commune that he was not, in fact, uprooting the rocks from an ancestral resting place. But wandering stones seem right for a Jewish memorial garden, especially one that faces outward across the broad swathe of the slate-green river to merciful stopping places: Ellis Island and the Statue of Liberty. Goldsworthy and Ehrenberg, who themselves have travelled a good deal in the making of their work, feel the weight of impending repose as the last boulders are hoisted on to the roof. There is still much more to be done. The concrete plinths on which they have been settled need to be covered – along with the rest of the garden bed – with the gold-brown gravel that the sculptor has chosen to set off his grey monoliths. A watering system for the dwarf oaks has to be installed and tested. Goldsworthy worries, with good reason, that the broad planter – running along the length of the stone walls of the garden behind its stone wall but visible from the summit of the stepped entrance and the Museum's upper levels – will be filled by Battery Park City landscapists with flowers and shrubs, prettying up the meditative austerity of the site. Worse still, as rock number fifteen swings over the roof, Goldsworthy learns that a corner jutting over the garden and unavoidable for anyone looking towards the harbour is to be covered by a trellis. The coming of creepers does not make the sculptor happy. But for the moment, the work seems wonderfully well-done: a poignant metaphysical conceit strongly realised; the crush and mass of history penetrated by the germination of hope.

The derrick men, led by their athletic crew boss J. B. Jones, from Augusta, Georgia, sporting a nifty headscarf and with more graceful moves than Alvin Ailey, have got into the spirit of the thing. As one of the last of the boulders drifts down seemingly weightlessly on to its receiving plinth, J. B. sweet-talks the rock down, shouting, 'Whoah, treat the LADY nice and easy,' and yells to Goldsworthy as the titan settles, 'You like? You LIKE?' He does. We all do.

Pangs

THE IRISH HUNGER MEMORIAL

WHAT DOES A NEW YORK LAMENT LOOK LIKE? Green – at any rate, if you're Irish. Down by the unhealed scar of lower Manhattan, at the northern tip of Battery Park City, a brilliant, heavily irrigated field of clover, bog grass, rushes and heather, strewn with rocks, mourns the one million dead, and the one and a half million uprooted, of the Irish potato famine of 1845–52. Despite the fact that the Hunger Memorial, at North End Avenue, tilts up sharply over the Hudson, no one seems to be able to find it. Nancy, an Irish New Yorker, had heard about it from Joan, who had heard about it at home in County Mayo, but both women had a devil of a time tracking it down last week, and complained that there were no signs anywhere indicating its whereabouts, and no one, least of all a cop, who had a clue about what or where it was.

We seem wired to grieve with greenery. Allowing the dead to dissolve into the earth, to become part of the cycle of the seasons, has, for millennia, held the promise of cheating mortality. Come spring, memory buds. Funeral barrows and mounds were among the first marks made by

man on the northern European landscape, and Brian Tolle, the designer of the memorial, had the inspired idea of creating an urban tumulus – in this case, a cantilevered platform of verdure supported by a concrete base. Into this micro-landscape, planted with species native to Mayo (one of the hardest hit of the western counties) and strewn with field-stones engraved with the names of all the counties of Ireland, is packed the memory of the calamity.

A walk up the hill becomes a journey from Old World ruin to New World redemption. At the bottom stands a ruined stone cottage, dismantled in Mayo and reassembled here, its end gables and hearthstone intact. It is roofless, a reminder of the evictions that followed the famine. At the brow of the hill is a rough-hewn standing stone, a cross cut into its face. From the retaining wall at the top, the view opens to the glittering river, the Statue of Liberty, Ellis Island – and the cranes and towers of American commerce on the New Jersey bank. The experience of the place suddenly doubles in significance: both trauma and hope, departure and arrival, exile and rescue. Walking the memorial's perimeter, one becomes aware that what appears from the front to be a meadow turns out, when seen from the side, to be ship-shaped, the prow pointing toward the Hudson.

By having the landscape virtually enact the story, Tolle neatly side-stepped the figurative-abstract dilemma facing designers of historical memorials. Figurative monuments are habitually presented as the populist choice: statuary or groups that freeze an emblematic moment. For historians committed to the absolute inimitability of the past, these totems come painfully close to kitsch, three-dimensional boosters of the movie event. In Stirling, Scotland, no one paid much attention to the statue of a whiskered William Wallace until the making of *Braveheart*, at which point a second statue, at its base, of Mel Gibson dressed as the Hero, was celebrated by flocks of pilgrims as 'more real'. Abstract monuments, on the other hand, run the risk of philosophical remoteness from lived experience; their symbolic forms are too rarefied to trigger memories of dates, places and people. Only occasionally, as with Ossip Zadkine's *Destroyed City*, in Rotterdam, which commemorates the

Luftwaffe bombing with a stylized figure whose upraised arms suggest both defenceless entreaty and ferocious defiance, can the two genres successfully marry.

The Hunger Memorial makes these alternatives moot. Its tiny scale – a fragment of Ireland torn from the blighted whole – reminds the visitor of the unviable minuteness of the lots that, when the potatoes rotted, left millions destitute. But the grassy hill, a piece of the auld sod stripped of sentimentality but not of emotion, is also meant as a space for meditation: how could the greatest famine in nineteenth-century Europe have persisted in the back yard of the wealthiest empire in the world?

Anything resembling a linear narrative of the famine has been studiously avoided to allow for a display of quotations, homilies and data recitations, deliberately jumbled, so that George Pataki shares wall space with Tocqueville (nice for the Governor). Genuinely heartbreaking moments of witness are crowded out by social-studies pieties relating the number of Americans who are obese. Such pedagogy could not have been more wrongheaded, reducing history to screen-crawl captioning.

The most telling quotation is from Charles Trevelyan, the British Treasury official in charge of famine relief, who, as people ate wild cabbage and buried their babies, opined that the best thing for Ireland would be for the misfortune to teach the Irish 'to depend upon themselves for developing the resources of their country, instead of having recourse to the assistance of government on every occasion'. Government, in other words, was the problem, not the solution. One can emerge from this tunnel of obtuseness, gaze north and south at the canyons of capitalism, and marvel at the certainties of the rich.

5

FIXTURES AND FITTINGS

Heavy Metal

RENAISSANCE ARMOUR

JUST HOW BIG WAS J. P. MORGAN'S HEAD? Could it, for example, have fitted into the fantastically embossed Renaissance helmet that he once owned, and which is one of the showstoppers in the Met's current exhibition of sixteenth-century Italian armour? It's nice to imagine the banker, his head as yet unswollen by his fortune, sneaking to his display cabinet in the dead of night, extracting the steel-and-gold headgear – grasping it by the siren who is thrown backward over its coxcomb, her upper torso wrapped in a skintight antique bodysuit – and trying it on for size. If he had inspected himself in the mirror, he would have been confronted by the petrifying glare of the Medusa punched into the front of the helmet, complete with writhing serpent coiffure. But then, like others among New York's antique-helmet-owning plutocracy (the Harknesses, Stuyvesants and the like who were members of the Armour and Arms Club), Morgan might have fancied himself a modern Perseus: Morgan the Gorgon-slayer.

To walk through the Met show is to enter a dark glade of metallic

male fantasy, in a Renaissance version that is at once archaically remote and instantly familiar: the overwrought dreams of impenetrability, the tight-contoured steel cladding of fabulous personae. *Heroic Armour of the Italian Renaissance: Filippo Negroli and His Contemporaries* might just as well have been called 'The Origins of Spiderman': the godlike thorax, the grotesque animal-human mutations, the bat-wing mask and the Apollonian kiss-curls are all present in force. So, although an exhibition of Renaissance armour may sound like an event exclusively for chain-mail mavens – people who like to trade banter about pauldrons, greaves and sabatons – the Met show is actually a popular spectacle, which ought to draw the same kind of crowds that flocked to the Versace show at the Costume Institute last winter, and for some of the same reasons. For this is a show about the forging (in both senses of the word) of secondary personae – the creation of surrogate body casings. What it's not about is the practical clankety-clunk and whackety-whack of battle. Of course, you'll learn a lot about rivets, if that's your sort of thing. But the grim visage of war is not much in evidence in a show that is altogether more Schwarzenegger than Schwarzkopf.

Few of the jaw-dropping ensembles gathered here, from museum collections in Russia, Spain, Austria and Italy, ever encountered a cross-bow fired in anger, or were meant to equip knights and princes in the field. For centuries, the job of the master armourer had simply been to provide maximum protection against the various unpleasantnesses that would come the way of cavalry: arrows from above, sword and lance thrusts from dead on, and spear-stabbing from below. The properly attired knight thus cantered into action encased from head to toe, with no orifice left unguarded. He had his choice of what the historians call 'pig-faced', 'dog-faced' or 'frog-mouthed' visors, all of which offered only the tiniest slits for sight and breath. By the fifteenth century, though, battles were being decided by more than just the headlong charge of hardware on horseback. The need for manoeuvrability among the different units of an army – infantry, bowmen and cavalry – encouraged the development of flexibly articulated plates and open-faced helmets, so that commanders could get more than a letterbox glimpse of

the action around them. And for the first time armour was assigned a psychological purpose, on the principle that maximum awe-inspiring display might actually impress a potential enemy enough for him to desist from risking combat altogether.

So, paradoxically, armour was at its most extravagantly decorative in the middle of the Renaissance, precisely when mounted horsemen were becoming vulnerable to companies of tightly massed pikemen (hence the emphasis on the protection of the lower limbs and extremities), and were increasingly exposed to the firepower of harquebuses and muskets. By the end of the sixteenth century, armourers were being required to put their metals through 'trials', by having pistols fired point-blank at the plates. In 1580, Sir Henry Lee, Master of the Armoury to Queen Elizabeth, sadly reported that the plate 'made in the Offyce and of the metall of Houngere [Hungary] helde out and more than alittel dent of the pellet nothing perced', while 'the other clene shotte thereowe…Thus much for the Ynglishe metall.'

The dreams and the gorgeous get-up of chivalry lived on long after its military importance had withered away. The lustre of polished armour caught the sun in jousts and tournaments, parades and processions, which in the world of the high Renaissance were far more than idle entertainments for the horsy classes. Tournaments were the indices of magnificence – ostentatiously ritualized displays that purchased loyalty, intimidated the envious, and gave the disaffected serious pause. But, even as the great absolutist princes of Europe pursued their Machiavellian politics, they still, at some level, conceived of themselves as the authentic flower of chivalry. Henry VIII of England took swaggering pride in his prowess in the joust, and the Habsburg Holy Roman Emperor Charles V regarded the cult of Christian knighthood with the utmost seriousness. Charles, who had been reared amid Burgundian heraldry and pageantry, remained all his long life a Boy Scout who never quite grew up. His Captain Marvel comics were *Amadis of Gaul* and Ariosto's *Orlando Furioso* with its ripping yarns of Carolingian knights going up against sorcerers, Saracens and many-headed monsters. At some point, Charles set eyes on the extraordinary steel helmet made for

Francesco della Rovere, the Duke of Urbino, which is on display here: it took the form of an entire heroic head, with tightly wound curls and nobly protruding ears, pierced to carry pendant earrings. Such things had apparently been made for the Romans when they acted out the jousts of the Trojans recorded in Virgil's *Aeneid*. But nothing like the curly-haired helm had ever been seen in modern armour, whether functional or fanciful. Needless to say, the Emperor had to have one, and in short order Filippo Negroli, of Milan, was commissioned to make one like Urbino's. In fact, Negroli shrewdly went one better by supplying Charles with an idealized version of the imperial face, sporting a full set of gilded moustaches and a forked beard. Negroli even understood how to make the Emperor's thwarted dreams come true, if only in silver and gold: a turbaned Turk whom Charles had conspicuously failed to vanquish appears on the comb of another spectacular helmet, in the guise of a helpless prisoner, with his hands tied behind his back and his long moustaches painfully gripped by the deities of Victory and Fame.

It's not fortuitous that Negroli was a Milanese. Then, as now, Milan, perched at the Alpine crossroads between the worlds of metal and the worlds of silk, was the most inventive fashion centre in Europe. Its craftsmen, or milaners (as we would say, milliners), were in demand in all the courts of Europe. And their ingenuity with metals was such that they could make of steel or gold something infinitely mutable – something beaten out of its solid state into lacy fronds and webs, or made to mimic the natural drape of cloth or the swelling of human muscle.

The Negroli family had begun its career in the fifteenth century, working for the Sforza dukes of Milan. By the time the third generation came along, in the early sixteenth century, a business decision had to be made. Were the Negrolis to gear up as suppliers to the international trade, producing large batches of relatively affordable suits for men-at-arms and knights in the saddle? Or were they to go strictly upmarket, concentrating on the metallic equivalent of haute couture? Filippo Negroli and his extended family opted to be artists, not industrialists (and probably made a lot less money as a result). Their forte was fantasy – erudite fantasy that catered to the omnivorous hunger for the classical

world, which was then being dug up, catalogued and displayed more than at any time since the fall of Rome. Prompted by pattern books and transcriptions of Hellenic and Roman sarcophagi, archaeological finds of Corinthian and Phrygian helmets and antique busts and shields, Negroli and his sons created headgear or breastplates that could transform the wearer into a new Alexander, Hannibal, or Scipio (27). They obliged their customers' demands for showy references to humanist learning; hence the dense allusions to classical mythology and military history which crowded the decoration of the armour. But they were also shrewd enough to grasp the unspoken need for a kind of anti-armour – something that pretended to expose the body while actually covering it, in a brazen show of heroic invulnerability. Thus, undressed to kill, the run-of-the-mill condottiere stuck in a mudhole principality would turn into a St. George with a trophy dragon's head at his feet, or a Hercules who wore on his own head the pelt of the Nemean lion he had strangled in Labour No. 1.

While lion armour is everywhere in the exhibit, there were also pieces demonstrating that when the Negroli group got serious they could produce astounding phantasmagoria to sit on their customers' heads: killer dolphins, unclassifiable spiny-snouted reptiles direct from the bestiary of Bosch and Brueghel, or, in one astonishing instance, a tiny crocodile head erupting from the end of a human tongue.

But is it Art? Giorgio Vasari, the biographer of Renaissance painters and sculptors, evidently thought so, for he included Filippo Negroli in his pantheon. And there were plenty of bona-fide painters – Giulio Romano, Leonardo, Pollaiuoulo – who produced armour designs for fabrication. In fact the transformations wrought by Negroli and his peers – the treatment of metal as if it were fabric, the abstract exuberance of their patterning (etching was an armour decorator's technique long before it was a medium of printing), the Rabelaisian exoticism of their imagination – make the anachronistically modern distinction between art and craft moot. What the word 'art' meant to the generation of the Negrolis was an almost alchemical craft: the mastery of a mystery. And the great armourers of Italy were famous for their jealous guardianship

of metallurgical secrets: they were rumoured to dip their metals in miraculous waters or to hammer them with inconceivably subtle tools. Above all, they were deemed artists because they could harmonize qualities that would normally be at war with one another. They could forge suits of armour hard enough to withstand the glancing blows of the lance and sword but so flexibly articulated that their wearers were as light and limber as if they fought naked – and, above all, had a sporting chance to get back on a horse if unseated.

No wonder, then, that seventeenth-century connoisseurs of the marvellous like Rubens and Rembrandt were avid collectors of armour and found a place for helmets, shields, swords and cuirasses amid their arrays of precious shells, ancient cameos, and stuffed birds. Rubens was even fooled by the Negrolis' classicizing skill into supposing that one of his own helmets was a Roman original. But, for every precious piece of armour that survived (its constituent pieces often split up among different royal and aristocratic collections), countless suits of armour of the more workaday kind rusted peacefully somewhere at the back of a barn, or were cannibalized into lowly ironmongery like steelyard weights or lock casings. It was only in the early nineteenth century that the paladins of the Gothic revival – antiquarian enthusiasts of everything medieval – began to publish comprehensive, illustrated histories of armour and encouraged patrons, from kings downward, to rescue, restore, and exhibit the hollow warriors in vaulted galleries or in grand halls.

This Gothic passion did not work its way into the taste of the American plutocracy for another century. Its great champion in New York was a Columbia University ichthyologist glorying in the name of Bashford Dean, who must surely be the only scholar to have been simultaneously curator of the American Museum of Natural History and of the Metropolitan Museum of Art. It was Dean who, in 1917, acquired the Negroli helmet from J. P. Morgan, albeit under the mistaken impression that it had been made for King Francis I. But anything can be forgiven someone who must have walked from his installation of fishes and reptiles in one museum to a gallery dimly glittering with medieval hardware in the other – indeed, who saw a happy evolutionary connection between

the segmented arthropods of the ocean floor and the metal-plated heroes of the age of chivalry. One likes to think that, were he around today, he would sit looking through the tall windows of the Met toward Central Park, survey the procession of Rollerblade helmets, Harley-Davidson jackets emblazoned with studs, and the occasional ice-hockey-goalie mask and nod in a gesture of appreciative recognition.

Narrow Spaces

IN THE SALONS OF THE COURT JEWS
AND THE CELLARS OF RESISTANCE HOLLAND

THE CLOSEST I EVER GOT to the world of the Court Jew was when I worked, some twenty years ago, for a Rothschild — an experience that was not all Bordeaux and banking. At a testy moment in our self-evidently unequal relationship, the Rothschild in question informed me that the family motto was 'Service', adding (lest I be in any doubt), 'And by God we get it!'

A single image in the Jewish Museum's learned and evocative exhibition, *From Court Jews to the Rothschilds: Art, Patronage and Power, 1600–1800*, reminded me of the ambiguities of such service. In an eighteenth-century Moravian Passover Haggadah, sweetly illuminated by the scribe Moses Leib, a family sits at Seder. Dinner has been eaten, and it is time to open the door to receive the prophet Elijah, for whom a cup of wine is being filled by a liveried servant, dressed in blue tunic, tricorne hat and breeches. The Seder, then, is in proper accordance with tradition. But given the sumptuous attire of the heads of the house (white silk gown for father, embroidered crimson jacket for mother), given the dolphin-tail

chairs, the fountain playing in the garden court, and the glass decanter from which the wine is being poured, you can bet it's not Moravian Manischewitz that's being offered as the prophet's tipple. Even the Paschal foods – bitter herbs, boiled egg and roasted shank bone – repose not on a conventional Seder dish but on a crimson cushion, as if they were the crown jewels. Welcome to the kosher Baroque, made up in equal parts of piety and pomposity and, for a century or two, permitted a little room to air its pretensions and its cultivation.

The curators of the show, Richard I. Cohen and Vivian B. Mann, have done the memory of the *hoyfyuden* proud. Their thoughtfully conceived exhibition is less an array of masterpieces than an evocation of a particular cultural world through its treasures and self-representations. Amazingly, they have managed to avoid both sentimentality and the claustrophobia that one might expect from an exhibition dominated by the German princely courts. A gallery devoted to the rise and fall of Joseph Oppenheimer, known as Jud Süss, who in 1738 ended his spectacular career as financial counsellor to the Duke of Württemberg by being hanged inside an iron cage, is reminder enough that the power and prosperity of the Court Jews were always precarious. But even amid the graphic evidence of schadenfreude in the thirty prints that gloat and cackle over the fate of the presumptuous Jew, with his fancy carriages and Christian mistresses, the victim's features are relatively free from the poisonous demonology that both preceded and followed this historical moment. The Devil's horns and tail that featured in sixteenth-century Lutheran anti-Semitism have gone, and the hook noses and blubbery lips of modern anti-Semitic stereotypes have not yet arrived. This is a celebration, then, of a cultural intermission, profuse and colourful within its narrow space, and sometimes displaying surprising exchanges between Jewish and Gentile cultures. A *mahzor*, a festival prayer book, made for Alexander David of Braunschweig, for example, borrows the calendrical conventions of Books of Hours, so that Kislev, the month of Chanukah, is represented by a hunter handling a pair of hounds. A coffee service in impeccable Nymphenburg porcelain bears Hebrew inscriptions; and a silver-gilt ship centrepiece, which was presented by Veitel David to the

Landgrave of Hesse, is crewed by a host of miniature sailors and pike-men, but has at its commanding centre an Oriental, turbaned figure – the very incarnation of the merchant captain.

The curators want to suggest that the hybrids were the result of a genuine two-way cultural traffic – that the Star of David and the menorah that appear on the gem-studded agate amulet given to the Habsburg Emperor Rudolf II by the Prague community are symptoms of active interest among the German princes in the religion they had routinely brutalized. But Rudolf – a neo-Platonist mystic drawn to the Cabala, among other occult treatises – was the least typical of the Habsburgs, and he was followed by a series of fanatical Counter-Reformation martinets for whom the only good Jew was an apostate. The electors and landgraves and margraves whose patronage dominates the centre of the show were less interested in Cabala than in cash. Their Court Jews were no more than the latest version of the minters, treasurers and gem merchants who for centuries had been either privileged or punished (and often both, in swift succession) as the services to the princely coffers merited. It was the collapse of the revenue base of the German princes in the wake of the Thirty Years' War (1618–1648), when the populations and territories were devastated by plague, famine and indiscriminate slaughter, that gave the likes of the Oppenheimers, Wertheimers and Gomperzes their main chance. Puny or powerful, the German princes needed the wherewithal to furnish the palaces and parks that secured their status within the complicated pecking order of the Holy Roman Empire. In the state of military anarchy that prevailed in Baroque Central Europe, offices and tax exemptions were made available to Jews, who could guarantee all the military supplies from oats to groats – a necessity, if the prince was to emerge victor rather than victim of that merciless plunder-world.

Of course, functioning as moneybags to these peruked gangsters entailed risks as well as opportunities. What made the Court Jews so convenient was their defencelessness against default. And, should new taxes become unavoidable, the ruler was the first to pin responsibility for his own prodigality on the Jewish treasurer.

Given the hazardousness of their position, it was all the more remarkable that a number of the Court Jews not only survived but went on, in rococo Germany, to establish prospering dynasties, whose solidity was reinforced by judicious marriage alliances. In Berlin and Vienna, Mannheim and Frankfurt, they moved from timbered residences to grandiose, masonry-fronted town houses, some of which, like the Ephraim mansion, in Berlin (represented in the exhibition by a stunning modern model), were of truly palatial proportions. Yet this transformation into an urban patriciate happened, at least initially, without much loss of traditional faith and customs. Some of the handsomest items in the exhibition speak to this unforced marriage of modes. A prettily embroidered Torah-scroll binder, for example, features a wedding canopy – the chupah – with the bride and groom dressed in high-rococo fashion, in gold-green silk hooped dress and black silver-trimmed tunic and cloak. But since the chupah was meant to be open to the stars, it is accompanied in the decorative pattern by images of the zodiac – bulls, goats and archers – vaulting, Chagall-like, through the heavens.

When the Court Jews felt secure enough, they began to sit for their portraits. Visibility, once shunned as the mark of the pariah, now became desirable, and the scriptural equation of man-made likenesses with idolatry surrendered to the desire for conspicuous self-commemoration. Few of the portraits in the show rise above mediocrity, but the awkwardness with which the Jewish sitters are fitted into an aristocratic genre precisely mirrors early conflicts between assimilation and orthodoxy. As some of these anxieties recede, so does facial hair, retreating from the full and shaggy beard in the portraits of early-eighteenth-century rabbis and patriarchs to the mercantile goatee of the mid-century and then disappearing altogether, leaving the clean-shaven gentlemen-scholars of the Berlin salons. The most engaging of the show's paintings are of Jewish women – less surprising when one knows that some of them were active, indeed senior, partners in the family business. The formidable Chaila Kaulla, of Stuttgart, for example, who stares back at us framed by cake-rack bonnet and industrial-strength earrings, became contractor to the Duke of Württemberg.

Ultimately, though, Court Jew society reveals itself more eloquently through its objects – things that were palmed or sipped from or worn – than in its stiff and stilted paintings. It is most palpable in the elegance of a lovingly fashioned travelling case of weights, measures and a hand-held balance; in the brilliant floral decoration of a prayer shawl; or in the delicate butterfly sketched in Brunette Oppenheim's 1790 *Liber Amicorum*, an apt symbol for a culture whose splendour was matched by its fragility.

Visibility and invisibility are the subject of a second, powerfully affecting show at the Jewish Museum – *The Illegal Camera: Photography in the Netherlands During the German Occupation 1940–1945*. While German Jewry had long been anxious about conspicuousness, the relatively smooth integration of Jews into Dutch culture made them significantly less prone to 'peculiarity anxiety'. Louis de Jong, the eminent historian on the wartime Netherlands, has commented on the bitter irony by which the experience of Jews in his country left them *less* well prepared for the betrayals and cruelties that would mark the road to Westerbork and Auschwitz. One of the most poignant images in the exhibition is of a Jewish girl waving cheerfully from the courtyard of the Hollandsche Theatre in Amsterdam, where arrested Jews were rounded up, as she spies her friend, the photographer.

The Jewish catastrophe, however, is not the central subject of these photographs, nor (though the helmets and boots of German soldiers and police appear in the shots) is the behaviour of occupiers. Instead, what emerges with force and clarity – even when the images themselves are out of focus or partly obscured by lace curtains and cellar doors – is a collective portrait of the wartime Dutch themselves. In 1944, Queen Wilhelmina, still in London exile, called her compatriots 'a nation of heroes', an honour that most of its resistance leaders immediately repudiated as being sharply at odds with the anti-epic nature of their sabotage. They understood only too well that the geo-political circumstances of their occupation had dictated a strategy of urban subterfuge, perfectly captured in photographs shot from cameras mounted in bicycle

baskets or roof gutters. For the classic landscape of partisan resistance was utterly missing in the Low Countries. There were no mountains or dense forests offering shelter for armed bands, but rather nakedly open countryside, tightly packed towns, and a closely connected system of road, rail and canals, which made the Netherlands an occupier's playground. Those who chose to resist, then, had no alternative but to take the struggle in the territory they knew best, their streets and alleys, and deeper, into the very innards of their houses – into cellars, attics, crawl spaces and cisterns. So the photographs of the resistance at work are as much scenes of domestic business as those in a seventeenth-century genre painting. Indeed, some of the pictures of food containers being studiously filled with explosives or of radio sets being tuned by clandestine 'marconists' adopt the same poses of intense absorption that feature in Golden Age paintings of lacemakers (25).

The Germans made things worse themselves by violating so many of the sacred cows of Dutch patriotism – including, of course, cows, requisitioned along with bicycles, church bells (to be melted down), and horses, as the grip of the Reich on northern Europe became steadily less secure. Forced labour was another assault on the settled freedoms of Dutch civic life. About two hundred thousand of the conscripts went underground; many of these *onderduikers*, or 'divers', were sheltered in the homes of resisters and subsequently became active themselves. Some of the most startling images in the show are cases of guns and grenades intruding into the smoky coziness of the Dutch parlour.

Courage is seldom rewarded as it deserves, and the sufferings inflicted on the Dutch – Jews and non-Jews – seem in inverse proportion to their sacrifices. In no other occupied country were there so many public strikes against the occupiers, yet the Dutch economy was effectively exploited for the German war effort. Initial attempts to round up Jews in Amsterdam were met with the protests of February, 1941, yet the Holocaust consumed all but a remnant of that community. To make matters worse, news of the Allied liberation of the southern town of Breda, in September, 1944, proved tragically premature, provoking only the unseemly scramble of Dolle Dinsdag (Crazy Tuesday), when hidden

cameras gleefully recorded the sight of German troops and Dutch collaborators attempting to exit by the quickest possible route, seated ingloriously atop coal tenders. And when 'Operation Market-Garden' at Arnhem turned into a débâcle, the occupation tightened throughout the northern section of the country, which was forced to endure the nightmarish Hunger Winter of 1944–45: it is movingly recorded in the sunken eye sockets and gaunt cheeks of some of the famished victims.

There are big and little ways to resist wickedness. Along with strikes and sabotage and illegal news bulletins, the Dutch specialized in countless small acts that defied the German presumption of incorporating them into some greater Germanic Reich. Postage stamps were stuck on the left-hand corner of envelopes, leaving the right-hand corner free for the Queen in exile; noisy 'HALLOS', meaning *'hang alle landverraders op'* ('hang all traitors'), were exchanged. So, if we are becoming overfamiliar with images recording the banality of evil, these few photographs remind us of the redeeming goodness of the prosaic.

CHARLES RENNIE MACKINTOSH

The Trellis and the Rose

AT ONE POINT in the Met's handsome Charles Rennie Mackintosh exhibition, the Aesthetic Movement meets up with the kipper. The setting is Kate Cranston's Ingram Street Ladies' Luncheon Room, carefully reassembled for this show, where customers wolfed down fried whiting and Dundee cake beneath murals of haloed, blossom-bedecked maidens. Glasgow grime was screened out by panelling painted silvery white and inset with peridot-green glass panes, which were decorated with stylized patterns of trees and plants. Tucked beneath the mezzanine stairs was a cashier's booth, delicately arched – a fairy grotto in the tea room. And if the full improbability of the scene fails to strike home, it's only because this creamy space has been made over as a decorous museum installation, complete with excessively Manhattan designer touches, like white roses for each table. White roses? Glasgow? A halfpenny a cup? I don't think so. What's missing here is the kind of audio-olfactory enhancement undreamed of even by the Met: the hum and burr of sardonic Glasgow chatter; the smells of industrial-strength tea and fried everything; the

grease and the gossip. A hint of this would have made the case for Mackintosh magic still more compelling, because his designs always sought to marry the domestic and the fantastic, the homely and the exotic. A born showman, Mackintosh would have been happy, one suspects, with Lutyens' recollection of a tea room that Mackintosh decorated as 'gorgeous...a wee bit vulgar...all just a little *outré*'.

The flamboyantly ornamental aspects of Mackintosh's personality have not much embarrassed those who have adopted him as a misunderstood patriarch of modernism. As early as 1924, Charles Marriott, in *Modern English Architecture*, set the tone by claiming that since European modernists had been influenced by Mackintosh's displays (all carefully labelled *Scottish*, not English) at the Vienna Secession, in 1900, and at the Turin Exhibition, in 1902, 'it is hardly too much to say that the whole modernist movement in European architecture derives from him'. Nikolaus Pevsner, in *Pioneers of the Modern Movement* (1936), celebrated the grids and lattices of Mackintosh's furniture and the strong angularity of his architecture as authentically proto-modernist, while dismissing as an irrelevant remnant of his immaturity the symbolist decoration and undulating details with which they continued to be embellished. An alternative school of thought argues that Mackinstosh is more properly understood as a late Romantic — a true disciple of Ruskin — committed to inscribing the forms of nature on the handiwork of man. His watercolours and those of his wife and collaborator, Margaret Macdonald, in which cabbages are rendered as faintly tinted globules and trees as slender green columns (rather like Theosophically overgrown leeks), do indeed suggest a couple dreamily entwined in the tendrils of the botanical life force. But this battle between the champions of the right angle and the advocates of the bounding curve remains strictly a contest of interpreters. For Mackintosh and Macdonald themselves, it was axiomatic that the trellis and the rose needed each other. Strength without beauty, they might have said, was brute structure, and beauty without strength idle whimsy. How to marry the two without lapsing into either sentimentality or crude functionalism was the task they set themselves for most of their lives.

Part of Mackintosh's enduring appeal is precisely his refusal to be enlisted in any particular camp in the modernist wars. 'I care not the least for theories, for this or that dogma,' he wrote in a lecture entitled 'Seemliness', and stated, 'Go alone: crawl-stumble-stagger – but go alone.' While Mackintosh worked together with his wife, her sister Frances, and Frances's husband, Herbert McNair, he showed no interest at all in establishing anything like the 'schools' that attracted a student following in Continental Europe. Though he was influenced by the English Arts and Crafts movement, and as a student probably heard William Morris and Walter Crane lecture at the Glasgow School of Art, he was too much of a true Glaswegian to share their aversion to industrial society, not to mention their goal of reinstating cottage handicrafts. It's impossible to imagine Morris, for example, recognizing plastic as a rich material for decorative inlay, as Mackintosh did. The closest Mackintosh ever came to a true Arts and Crafts piece of furniture was an ostensibly simple and sturdy chair made around 1900 for William Davidson's house, Windyhill. But if its rush seat is meant to announce rustic unostentatiousness, the effect is completely undone by a solid, tapered back that projects more than four feet from the base – a rude sit-you-down grandly elongated into something fit for a thane.

Mackintosh's origins were distinctly unthanelike. Born in 1868, the son of a clerk in the Glasgow police force, he showed enough early talent to be enrolled at the age of fifteen in the Glasgow School of Art, where the headmaster, Francis Newbery, was on a mission to expose his students to the most progressive trends in European art and architecture. But Honeyman & Keppie, the architectural firm that Mackintosh joined when he was twenty, was, like much of Victorian Scotland, caught between the competing demands of history and technology. The firm was required to service the grandiose needs of an imperial metropolis, which was the densest, grittiest concentration of industrial power in Britain. So, despite Newbery's enthusiasm for the simple honesties of Arts and Crafts, his pupil's early designs veer between Beaux-Arts bombast and Italian-Gothic exhibitionism.

In 1893, Mackintosh and his friend Herbert McNair fell in with

Margaret and Frances Macdonald, and all their lives changed dramatically, and for good. Henceforth they were known as 'the Four' (or, to unreceptive critics, as 'the Spook School'), and turned out posters, magazine illustrations and furniture, all of which attempted to bring the new 'Glasgow Style' before a suspicious public. The manner was Caledonian nouveau, in which the slogans of purity and truth were supported by pairs of willow-women arching toward each other with swan necks and cushion lips, or else posed frontally, with their enlarged doe eyes issuing sensual challenges to the porridge-clogged bourgeoisie. Frances Macdonald's stunningly beautiful mirror, where Glasgow metal (in this case, beaten tin) has been worked into an undulating liquid form, is a perfect example of the Four's audacity. Conceived as a paradoxical anti-vanity, the mirror is called *Honesty* – the familiar name for the plant *lunaria*, whose ovary-like seed pods supply the decorative motif at its top, and for the anti-cosmetic Glaswegian candour that was supposed to flow into the faces framed by its art.

It must have been this reputation for artfully contrived artlessness that won Mackintosh and his friends the commissions to decorate Kate Cranston's tea rooms. Their owner, who was the sister of a tea retailer, aimed to provide middle-class Glaswegians with a therapeutic alternative to the rows of pubs and bars from which hordes of reeking drunks issued day and night. The look was meant to differ from that of the London tea rooms, where Joe Lyons had supplied Frenchified marble-top tables and ooh-la-la waitresses, as well as from Glasgow's own dark-panelled, exclusively masculine dining clubs, with their brownish aroma of pipe tobacco and decomposing grouse.

Much has been made of the whiteness and brightness of Mackintosh's tea rooms – the antidote to Glasgow's soot and smoke (28). But his real genius lay in the canny subdivision of their interiors into discrete chambers, each with its own cultural and visual atmosphere. At the Willow Tea Rooms, on Sauchiehall Street, a brilliantly light front room, meant primarily for ladies, was divided from a darker, tweedier dining room at the rear, by the extraordinary chair – virtually a shogun's throne – that

has become the best known of all Mackintosh's furniture pieces. A boundary between female and male zones, it was a typical product of the Four's inventive androgyny: the strong, fretted lines that make up its back converge into a great fountain spray that could be read as the trunk and overhang of a willow (an allusion to Sauchiehall's Celtic etymology as 'a boggy place full of willows'). Upstairs, the double doors to the Salon de Luxe offer a similar marriage between the prose of structure and the poetry of decorated surface. The handles of both doors are set in panels of beaten steel that taper upward to rectangles of purple ceramic, and below the handles the panels are stamped with an early version of Mackintosh's portcullis-like grid, from which two single drops of glass are suspended. Each door features a stylized giant rose above a cascade of vertical leaded lines, and when both doors are closed these intricately webbed patterns seem to resolve themselves into forms that are at once botanical, zoological and mythical: a lepidopterous angel, wings extended, beckons customers into a celestial realm of bloater paste and scones.

By the time Mackintosh had completed the Sauchiehall Street rooms, in 1903, he had become well known (if not exactly universally acclaimed) both in Scotland and in Europe. In 1902, Hermann Muthesius had published an article in *Dekorative Kunst* that sang Mackintosh's praises as the exemplar of a radically new art – one that treated the design of interiors as a total tactile and visual experience, a *Gesamtkunstwerk*. But where Mackintosh differs from his counterparts – designers like Morris, whose firm integrated textile, furniture and architecture by using motifs from nature, and early moderns like Josef Hoffmann, who did the same with stripped-down geometric designs – is in his resistance to the doctrine of unity. He didn't assume that the exterior of a house must articulate its interior, or even that the several sub-interiors must all be imprinted with an identical concept and style. While many of his signature motifs – the rose petals and the portcullises – are repeated throughout a house, they appear in subtly altered combinations, colours and materials, which differentiate darker, ostensibly more masculine rooms from softer, more inviting places. Though they are superficially a gender theorist's dream,

Mackintosh was actually at pains to complicate and mingle these separate zones. For example, the gridded doors to the panelled library of the Hill House, built for the publisher Walter Blackie, are decorated with delicate damson-coloured glass insets. Similarly, a set of tall ladder-back chairs, placed at strategic points in a dazzling white bedroom, supply punctuation and anchorage, so that its occupants would not altogether drift away in what John McKean, in an entertaining catalogue essay on the Hill House, calls the 'ivory mist' of the room's atmosphere.

Visitors to the Met who want to experience these subtle effects will have to content themselves with the videos that walk (a little too hastily) through that stunning house, and through other interiors, like the Glasgow School of Art and the Scotland Street School. When individual items of furniture are isolated from their minutely thought-out settings, they sometimes seem more like prodigies of craft than like interdependent works of art. Occasionally, though, they are so jaw-droppingly beautiful that they transcend their function altogether. Nothing symbolizes Mackintosh's genius for marrying strength to grace better than his clocks – the embodiment of the Scottish Presbyterian passion for strict timeliness. But at the Willow Tea Rooms, in contravention of the discipline, time was meant to be idled. So Mackintosh built a grandfather clock with a polished steel face and a gridded oak case – pure Glasgow engineering – and then attached two wing panels filled with glass the hue of Highland heather.

Time, however, turned out not to be on Mackintosh's side. Caught on the cultural cusp between Art Nouveau and geometric modernism, his exteriors often seemed too traditional for the avant-garde and his interiors too radically startling for the sweetness-and-light crowd. Mournful legends have attached themselves to the long years of his decline, during which he was ignored in Britain and acclaimed, at a distance, in Central Europe. The truth, however, as many of the catalogue authors point out, is more complicated and, if anything, sadder. Mackintosh continued to have some enthusiasts in Glasgow but certainly provoked as much criticism as praise in Vienna. While he was still in his mid-forties, Blackie

reported him to be downcast because 'only a very few saw merit in his work and the many passed him by'. Inevitably, Mackintosh's well of inspiration, along with his bank account, diminished with every slight, imagined or real. And his sense of increasing isolation was given farcical immediacy during the First World War, after he and Margaret Macdonald had moved to the Suffolk fishing village of Walberswick. There the couple contented themselves with sketching plants and flowers, the more anthropomorphic the better. In 1915, at the height of the anti-German hysteria in Britain, rumours circulated that the artsy Scottish gentleman had had extensive dealings with the Hun. Letters were discovered in his house which indeed seemed to originate in the empires of the two Kaisers – evidence enough for the village Kitcheners and Haigs that they had an enemy agent in their midst. Ordered to leave the East Anglian counties forthwith, Mackintosh and Macdonald ended up in the more bohemian milieu of Chelsea, where they scraped along by creating brilliantly coloured abstract textile designs. Occasional commissions still came Mackintosh's way, and his sketches for a group of studios in Chelsea, with steeply pitched gables and gridded windows, make it clear that his old sharpness had not altogether disappeared. But this, like many other projects, never was built.

Mackintosh's last years were spent in southern France, mostly in the coastal town of Port-Vendres. Even in this remote retreat, his inspired peculiarity did not quite desert him. The watercolour landscapes of his last years are fantastic manipulations of scale and perspective: cliffs and hills abruptly tilted as if in geological upheaval; cubist houses scrambled together in a manner owning less to Cézanne than to memories of fivestones thrown over a Glasgow playground. Their air of expressive agitation, like everything Mackintosh did, renders moot all easy distinctions between ancient and modern, Old Guard and vanguard.

'In our country, he would have been Frank Lloyd Wright,' the design historian Alan Crawford once overheard a well-meaning American enthusiast exclaim. And it is tempting to see Mackintosh's vertically driven architecture and furniture as Wright horizontals turned on end: the lofty Scot peering down at the short Welsh-American. Both men

were committed to synthesizing the natural and the built environments, but Wright's creative imagination was fed by the expansive American landscape, while Mackintosh's was a response to the narrower gauge of industrial, urban Scotland. And, though Mackintosh began his career in an explosion of inventiveness, he ultimately exhausted the ebullient self-confidence that Wright had in boundless reserve. In his strongest buildings Mackintosh did succeed in creating works for the ages. But it is sometimes his simplest pieces that bear the clearest mark of his phenomenal originality. Look in the vitrine uninvitingly captioned 'Cutlery', for example, and you will find a fish knife whose body is formed, like those of the nymphs in the tea room murals, as a slender, elongated cylinder, tapering to a blade shaped like a tulip. However posterity may judge its creator, it's safe to say that no one ever designed a more perfect place of repose for a flake of haddock.

Modes of Seduction

HAUTE COUTURE

AMID THE TIERED RANKS of tulle and lace and taffeta and feathers crowding the Metropolitan Museum Costume Institute's smart little *Haute Couture* show, Yves Saint Laurent's so-called Mondrian dress, in primary-colour panels of wool jersey, shouts for attention. 'Look at me,' it says. 'I'm Art.' A quick reality check down at MOMA will confirm that it isn't, but instead the dress is artful, in concealing a minimal three-dimensional structure within the black grid. And this calculated craftiness, which allows for a third dimension, unavailable to painting – body movement – is what makes the homage to Mondrian's flat abstractions superfluous. Fashion, as this show unquestionably demonstrates, is indeed a legitimate art form, with its own distinctive language of representation and its own spectacular history. While it has had important connections with the visual arts, not least its dependence on illustrated reproductions to make it commercially desirable, fashion doesn't need to slipstream behind high art to claim its space in the museum. Above all, it doesn't need to apologize for its creative embrace of the pleasure principle.

So Richard Martin and Harold Koda, who between them have made the Costume Institute one of the most interesting places in the city's art world, didn't really have to invoke a list of heroic modernists – from Manet and Degas to Seurat and the Cubists – to clear themselves of suspicion that an exhibition like this one is a gala-driven exercise to gratify well-heeled donors. Still, the spirited note of defensiveness struck in the catalogue ('Today, the haute couture is neither haughty nor superannuated') is understandable. The preceding haute-couture show at the Costume Institute, in 1983, was a classic Diana Vreeland extravaganza that eulogized Yves Saint Laurent as a tormented genius. Three years later, Debora Silverman's book *Selling Culture* attacked the Vreeland epoch at the Costume Institute as a thinly disguised public-relations campaign for department-store retailing. *The Man and the Horse*, for example, in 1984, billed by the museum as a celebration of 'the splendour of equestrian attire' and 'man's desire to emulate the nobility of the horse', was not unhelpful to the Polo line of the major sponsor of the exhibition, Ralph Lauren. Silverman argued that Vreeland had annexed 'museum culture for marketing' and had turned the Costume Institute's programme into a playground for Reagan-era adulation of wealth and glamour.

Fair or unfair, Silverman's critique echoed puritanical attacks on fashionable excesses which have been voiced since the reign of the gaudy third-century tyrant Diocletian. The timing of the present *Haute Couture* show, which opens just as Congress is arguing over whose backs are to bear the burden of deficit reduction, may have made its curators a little edgy about, say, those patches of white mink clinging to the bust of an opulently embroidered Jacques Fath ball gown of 1951. In any case, the curators have been careful to eschew the kind of ritzy-glitzy touches that were Mrs. Vreeland's trademark. No bright-red walls, no orchidaceous settings – just a freely painted evocation of a fifties fashion show at the entrance, and displays conceived with exceptional intelligence and integrity. The pure showiness of exhibits devoted to the pieces that define changing style, from Charles Frederick Worth's crinolines of the eighteen-nineties to Christian Dior's post-Second World War New Look (29), is complemented by coats and dresses exemplifying the

artisanal techniques involved in the creation of the most ambitious products of couture. The show includes displays that deal with embroidery, appliqué work and lace, and the *flou*, or the relationship of cut and fabric to body movement. Cumulatively, these elements go a long way toward vindicating the curators' argument that haute couture must be seen as the product not merely of designing geniuses but of the entire community of specialized work that constitutes the métier.

Serious as the exhibition is about work, it is also a tour de force of playfulness. And, much as Martin and Koda want to show couture as a collective enterprise, they don't mind (nor should they) advertising the claims of its most inspired creators to be serious artists in their own right. Charles Frederick Worth, the English drygoods salesman generally credited with inventing haute couture, in Second Empire Paris, sometimes got himself up in a Rembrandt costume, complete with beret, fur-lined cape, and floppy tie, to designate his place among the immortals. But his creative genius – which was real, to judge by the astonishing pink, ivory and ice-blue silk ball gowns at the Met – was based at least as much on commercial and cultural acumen as on design. Worth came from a Victorian society in which landed wealth (and its horsy aversion to metropolitan glamour) still dictated the norms of social display, and nubile young women were trotted around the paddocks of the country balls like good breeding fillies. In the London millinery establishment, salesmen were required to grovel before their lordly customers like countryhouse servants. Gilded, plutocratic Paris was altogether different. Like Karl Marx, Worth grasped the fact that Louis Napoleon's gangster-ish empire was based on the ruthless manipulation of raw wealth, and he didn't need Thorstein Veblen to tell him that conspicuous consumption was the cloak necessary for disguising this political vulgarity. After 1858, when he opened his own shop, Worth made himself useful both to plutocrats hoping to find a market for their daughters among the aristocracy and to aristocrats mortgaging the château to dress their daughters as millionaire bait. A major part of his clientele, however, consisted of the *grandes horizontales* – the courtesans who were at the centre of the gossipy, libidinous demimonde. This was the world that Hugo, Flaubert and Zola

detested and the world in which Worth flourished as the man who could make female display function as investment capital.

Worth also understood that what should have been interpreted as a scandalous exhibition of owned women actually worked to reinforce status in the gaze-besotted world of metropolitan Paris. Baron Haussmann's architectural reordering of the city provided exactly the theatres of spectacle – the Opéra, Longchamp, the *grands boulevards* – in which the parade of expensively dressed women could serve as an advertisement of moneyed power. And the specific forms of dress that Worth specialized in catered precisely to this display of women as enviable – indeed, negotiable – sexual property. The Worth ball gowns on show at the Met divided women's bodies into opposing zones of display and concealment, each with its own potent allure. (Anne Hollander makes just this point in her recent, brilliantly observant book *Sex and Suits*.) Above the corset-pinched waist and rib cage, a semi-exposed bosom and a naked show of back and arms emerged like the petals of a pale hothouse bloom. And although the lower dress conformed to the full, robelike covering that had been largely unchanged since the Middle Ages, Worth found ways to invest the skirt with theatrical eloquence. Using trains and bustles, he could create a river of decorative material flowing from the waist; or he could use figured damask and satin to sing the joys of the erotic welcome concealed within the silken tent. One especially beautiful creation that the Met's show features is a sunburst exploding asymmetrically on its wearer's thighs and an arrow-dart stomacher pointing unambiguously south.

Worth was not the first dress designer to trade on his reputation of being a virtuoso of an arcane craft, or to establish a relationship with his clients which was more like the reciprocity of artist and patron than like the fawning dependence of tailor on aristocrat. Marie-Antoinette's dressmaker, Rose Bertin, who had created the loose muslin *à la Gaulle* outfits for the Queen, had been criticized by both the friends and the enemies of the monarchy for her presumption in talking to her sovereign like an equal. When the artist Elisabeth Vigée-Lebrun painted portraits both of

herself and of the Queen wearing the Bertin dresses, and exhibited them for public admiration in the biennial Salon, the golden triangle of couturier, patron and illustrator was formed. But, for all its notoriety, this was a women's circle. Eighty years later, Worth, by intruding on what had been the intimate preserve of seamstress and patroness, and by winding his tape measure around his customers' bodies, caused a scandal. But he knew that by turning the fitting room into a place of male power he could claim to be working as much for masters as for mistresses, and it was the *seigneurs* who settled his outrageous bills.

To be sure, there were women designers who were a match for the House of Worth, both in creativity and in profitability – in particular, Jeanne Paquin. But it was Paul Poiret, another male, and at least as shameless a self-promoter as Worth, who advertised himself as the liberator of couture from the tyranny of the corset. Though his claims were immodest, Poiret does deserve the credit for designing, in the decade before the First World War, unstructured cylindrical dresses in which women's bodies resumed something like their natural shape. Instead of being imposing vessels of fabric sailing over the dance floor, women who dressed in the looser, kimono-like Poiret dresses seemed more plausibly equal partners of men. Much taken with the sensuous forms of Oriental dress, Poiret used panels of brilliant solid-colour silks, often stitched to black grounds, to create the breathtakingly beautiful effect evident in the current exhibition's showstopper – the 'Sorbet' dress, of 1913. Before his career collapsed, in the twenties, Poiret had pioneered another decisive innovation: the American tour. Declaring himself delighted with the independence he discovered in American women, he played to their craving for a couture messiah. Accounts of ecstatic fashion shows describe him gazing, Svengali-like, into the eyes of female devotees and whispering the colour – jade or ivory or rose – that best matched the essence of their personalities.

Though Poiret had important female competitors, such as the Callot sisters, it was only in the inter-war period, when Gabrielle Chanel and Elsa Schiaparelli dominated couture, that Rose Bertin's promise of haute couture by women was finally fulfilled. Like Bertin, Chanel made the

supple articulation of the entire female body (and not the male fetishes of breasts and buttocks) the essential condition of finesse. And Chanel took the revolutionary step of raising hemlines all the way to the knee, exposing women's legs for literally the first time in the entire history of women's fashion. In an age when hemlines might reach for the crotch or drop to the side-walk, it is easy to take this for granted. But Chanel's Little Black Dress, with its inspired use of the theretofore commonplace material of jersey, and with its crêpe-de-chine hem holding a perfect waterfall of pleats in rhythmic order, ought to be seen for the act of great daring it was. At last, clothing was designed to flatter a woman's independent pleasure in her own body. With fabric functioning like a second skin, Chanel was confident that this act of self-possession, far from diminishing male desire, might actually enhance it.

Paradoxically, this long-term triumph of the natural line subverted the defining exclusiveness of haute couture more seriously than the women designers of the twenties and thirties could ever have intended. For although some of the most apparently simple designs of Jeanne Lanvin's tubelike gown and the liquidly Hellenic creations of Alix Grès and Madeleine Vionnet concealed sophisticated structural supports, they were easy to approximate in machine-made versions for the ready-to-wear trade.

It was the consciousness of the Pyrrhic nature of Chanel's victories that emboldened Christian Dior to present old male fantasies of pneumatic bliss as the supermodern New Look of 1947. Rigidly structured underwear was back, along with lethally cantilevered brassières and martial girdles, creating the arabesque silhouettes of the fifties, with petticoat-puffed skirts flouncing and bouncing their way to dreams of domestic bliss. Norms of male and female dress had not been so far apart since the days of Worth.

When the pendulum swung back once more, producing the sharply linear forms of the sixties, the initiative came not from within couture but from the street culture and off-the-rack fearlessness of London designers like Mary Quant. In France, Yves Saint Laurent, Paco Rabanne

and Courrèges were left merely to embellish and outrage, to exploit the expectations built into couture – its demand for the irrational and the extravagant. Instead of Worth's yard after yard of embroidered taffeta, they offered aggressively synthetic totems of modernity, like Cardin's peekaboo cut-out breast holes and his spaceman's helmet. The ultimate folly of couture's painful mismatch of popular and high culture is Versace's elaborate polyvinyl evening dress embroidered with denim stitching and jeans-style pockets – a jokey mixture of the transparent and the opaque perfectly suited to its client Madonna.

The survival of haute couture now turns more on perfume-marketing strategies and on the performance of ready-to-wear affiliates like Saint Laurent's Rive Gauche than on its classic role as producer of exclusive designs for individual customers. If couture still displays the vitality that is claimed for it in this show, it does so largely as a personal-service branch of the dream-and-fantasy empire we call contemporary Western culture. Its most conspicuous products are explorations of the improbable, like Oscar de la Renta's astounding apparition of layered pink feathers, designed to turn its wearer into a flamingo in mating season. Such confections are a reversion to the traditions of the princely masques of the Renaissance and Baroque courts, intended not just for a single client but for a single event, since shaved ostrich feathers are unlikely to stay unruffled after repeated use.

In fact, the conspicuousness of fowl, fur and even fish (as in Yves Saint Laurent's 'sardine' dress of 1983) gives the last section of this show a faintly taxidermic atmosphere, as if someone had strayed across the park from the American Museum of Natural History to create dioramas in which prime specimens of Couture Culture stalk their female prey across a landscape of gala events. Perhaps the Costume Institute should go all the way, and use animatronics – robot mannequins and the like – to liven things up a bit. When I made this helpful suggestion to the curators of the show, they demurred. 'Ah, yes,' one of them replied politely. 'Of course, the conservators would commit suicide.' Fatal Collection – there's a really interesting idea for a show.

The Dandy Dutch

DUTCH FASHION NOW AND THEN

HERE ARE THE WORDS that ought to come to mind when you think of the Dutch: flamboyant, theatrical, whimsical, visionary, self-mocking, eccentric. The ready-to-wear clichés are usually of the opposite, minimalist variety: inevitable references to rectilinear landscapes, cool utilitarianism and churchgoing. But the current generation of Dutch maximalist fashion designers – Oscar and Suleyman, Keupr and van Bentm, Jeroen Teunissen, Melanie Rozema and Niels Klavers – are producing clothes that declare the victory of the fantastic over the functional (30). The Dutch Baroque – not an oxymoron at all – lives on into the millennium.

Dutch taste has long been a negotiation between austerity and extravagance. Those men in black who people the group portraits of the late sixteenth and early seventeenth centuries were simply surrendering (unlike their armies) to the international Spanish style. But the instinct for peacock display was always lurking amid the gatherings of crows. When the young William of Orange accompanied the Habsburg Holy Roman Emperor Charles V to announce his abdication, in 1555, both the

old man and his heir (the future King Philip II of Spain) were sombrely kitted out in the black uniform of Catholic piety, while the young prince – rich, handsome, and dangerously intelligent – was a vision in a slashed doublet threaded with silver.

The devotion to exuberant display was imported in part from ducal Burgundy, which was the sovereign power in the Netherlands in the late Middle Ages, and was the last word in showy heraldry. In Catholic towns like Bruges and Ghent, this impulse found its way into the street, in parades and processions of the city guilds. In the great textile workshops of Flanders and Brabant, piety was no bar to sumptuousness: images and statues of the Virgin came swathed in yards of dazzling fabric. Antwerp, Europe's global mart in the early sixteenth century, began to import silks and rugs from Turkey, Persia, China and Mughal India. Some of the most brilliant passages in the Met's recent show on early Netherlandish painting – the treatment of intricate gold embroidery – celebrate this unapologetic alliance between the sacred and the spectacular.

Calvinism, it's true, frowned on gaudiness as a glint in the eye of Satan, but during the eighty years' war against Spain (1568–1648) orthodox Calvinists remained a minority in the Dutch Republic. While their preachers dressed like magpies and urged God-pleasing plainness on their flocks, they were powerless to prevent the extravagance that ran through city life in Holland like so much shimmering thread. The most fantastic furniture designs in Europe, for example, came from the buzzing brain of the Mannerist Hans Vredeman de Vries. His bedposts, mantels, and chests dripped with swags and scrolls, and sprouted broken pediments against which harpies and sphinxes stood guard. Similarly, above the brick façades of canal houses in the Amsterdam of the sixteen-thirties and forties, gables began to frolic with displays of leaping dolphins, Moorish heads and ships in full sail.

There was always an enthusiasm in the Netherlands for the exhila-rating irregularity of nature. We think of the tulip as exemplifying a Dutch preference for odourless simplicity (over, say, the sensual rose). But early Dutch horticulturists took a botanical virus as a providential blessing, and the unassuming Turkish flower soon broke out in frills,

multicoloured stripes and ragged cuts and tears – the same kind of happy pinking and shearing that appears in the dresses of the current Dutch designers. And if you look at the silver ewers and *tazze* that came out of the workshop of the van Vianen dynasty, in Utrecht, you encounter an art nouveau two and half centuries early: near-abstract forms that ripple and flow in mimicry of nature's secretions.

Of course, there were limits to the razzle-dazzle. The powerful were obliged to observe modesty and public decorum (much as the senators of Venice, the seat of another butterfly culture, made sure to appear in public in black). Some paintings of the rich and vain, shown disporting themselves in arbours and on terraces, can be read either as attacks on the extravagance of costume or – more likely, in my view – as celebrations of it. In one confection of this kind, painted by Willem Buytewech, a couple stands against a terrace wall, she in a dusty-rose-and-crimson number, with a high-standing collar edged in lace flowers and a false 'sleeve' hanging from her arm, in almost exactly the manner of Rozema and Teunissen's dresses, while her partner is dressed from head to foot in dove-grey silk, his super-baggy breeches secured with black ribbons, his glossily polished shoes sporting raised pump heels and pompoms on the toes.

In his slavish attention to every frill and pleat, Buytewech was showing his skill at *stofuitdrukking* – the faithful rendering of fabric, without which no painter could hope to be a success. Even an artist who was more interested in what lay behind and within, like Rembrandt, made himself an unparalleled master of this craft: able to suggest the darkness of velvet brushed against the nap, or the electric rise of hairs on a sable trim. Arguably, no other visual culture – not even that of the Venetians – was as involved with textiles as the Dutch; it was almost as if they were fabricating them with the paintbrush. Abraham van den Tempel, a painter from Rembrandt's home town of Leiden, actually remained a cloth manufacturer while practising as a painter, and produced three allegorical pictures glorifying the city's cloth trade. His women, who are clothed in iridescent satins and crushed velvets, or have great balloons of fabric wrapped about their bodies, in hues of hot peach and persimmon

and mallard green, are about as Calvinist as the Ziegfeld Follies. High-minded critics attacked van den Tempel as a *mode-schilder* – a fashion painter. But the burghers loved him.

So when the new Dutch designers distance themselves from the past, it's only one kind of past – the nineteenth-century stereotype of starched linen, box beds and silver skates – that they're running from. There has always been another Dutch past – one of gorgeous, unapologetic outrageousness – from which they have received an expansive inheritance.

1492

THE COLUMBUS SHOW (1991)

EXCUSE ME FOR NOTICING, but haven't we been commemorating Columbus's quincentennial in the wrong year? I know that dates and maths aren't America's strong suit right now, but it doesn't take advanced calculus to figure that 1492 plus 500 equals 1992.

What is it about Columbus that makes for botched commemoration? The Quatercentennial Columbian Exposition opened a year late, in 1893, delayed by the enormous scale of the show and by the protesting groups (yes, even then) who saw themselves more as victims than as beneficiaries of 1492. A century later, in a culture notorious for its brutally short attention span, the clock has been advanced a year. The predictable events – the PBS series, the special issue of *Newsweek*, an enormous autumnal harvest of biographies, the museum exhibitions – have all come and nearly gone, making it virtually impossible to avoid a feeling of anti-climax when October 12, 1992 finally rolls around.

There is the possibility, of course, that fooling around with the date may represent some learned allusion to the replacement of the Julian

calendar by the Gregorian calendar, but perhaps not. More likely, advancing the timetable of commemoration was the impulse of publishers, producers and curators who worried that they would be overtaken by a jaded public and a short shelf life for Columbiana. Then again, with the multicultural wind blowing strong offshore, there is certainly some nervousness about focusing too precisely on a particular date, a particular person, a particular historical moment; a nagging anxiety that bothersome ghosts might be disturbed. Better to take refuge in cosily inclusive generalizations.

For anniversaries can be risky business. In 1688 the centenary of the defeat of the Spanish Armada helped to crystallize hostility to the Catholic Stuart King James II, and legitimized an appeal to Dutch William in the name of imperilled English liberties. A century later the centennial of that Glorious Revolution in 1788 seemed to Friends of Liberty on both sides of the English Channel to herald a new crisis for absolutism. And in 1989, Chinese students erected a Goddess of Liberty in Tiananmen Square modelled on both French and American iconographic types.

There may indeed be Some Unpleasantness in the offing. On the first day of 1992, for example, a lineal descendent of the Admiral of the Ocean Seas is to act as marshal at the Rose Bowl parade in Pasadena; but angry Native American activists have already ensured that there are likely to be thorns among the petals. So was it a sense of pre-emptive prudence that moved the National Gallery to call its megashow *Circa 1492* and to exhibit it circa 1991? In any case, the notion of simultaneously specifying a date and generalizing it is self-defeating, rather as if one made an appointment for approximately 3:21 p.m.

What we have at the National Gallery, in fact, is the Blockbuster That Lost Its Nerve: an exhibition that manages to be both aggressively bold and depressingly pusillanimous, not least in its studied refusal to consider head-on the phenomenon of Columbus himself and the historical experience of his four voyages. Only one of the 569 objects in the exhibition relates directly to the Admiral. It is the woodcut-illustrated Basel edition of his famous letter written on the homeward journey and published just fifty-four days after his return, one of the most

astonishing moments in the history of Renaissance publishing and heroic self-promotion. Not that one would know this from the dry caption on the wall; but then Columbus appears only twice in the wall captions (once as Columbus, Ohio).

He does a little better in the extraordinary catalogue, which is a major contribution to the historical literature of the European encounter with other cultures, especially in the cartographic articles by David Woodward and Francis Maddison. But even in the book Columbus features more prominently as a counterfactual case. Thus, dense articles on Asian art and culture, in keeping with the considerable space given to them in the show, present what Columbus would have seen had he actually made landfall in Japan, or in Korea, or in China, or in India.

Not only has the Admiral gone missing, so has 1492. For it is precisely the Iberian cultures that had their most traumatic moments in that year – the cultures of Moorish Granada and Hispanic Judaism – that are most scantily represented. There are a score or more objects (all of stunning quality) from Ottoman Turkey, Mamluk Egypt and Iran, but only two items, including the so-called sword of Boabdil, the last ruler of the shrunken Moorish state, from Granada. Jewish Spain is also represented by just two objects, a Passover dish and the exquisitely illuminated Lisbon Bible from the British Library, inexplicably opened (in its reproduction in the catalogue, too) to a sampling of the laws of leprosy.

Still, if there are glaring absences in *Circa 1492*, there are also extraordinary presences. By globally contextualizing the Columbian moment, the show has succeeded in suggesting, through thoughtfully chosen and ravishingly beautiful examples, alternative cultural encounters to the one that actually took place on Guanahani on October 12. Chinese figures carrying Ming blue and white porcelain appear in an Iranian silk scroll. A spectacular Bini ivory salt-cellar carved in West Africa for the export trade to Europe features figures of the fearsomely whiskery Portuguese. Christopher Weiditz's sympathetic drawings of the Aztecs, brought back to Spain by Hernán Cortés, depict the natives playing their wonderful version of tlachtli, or buttockball, in which the solid rubber ball could only be struck with the elbow or the rump.

Frederick Mote's fine essay on Ming China, moreover, draws attention to the ambitious western voyages of the imperial eunuch-admiral (a wonderful concept, unlikely to win favour at Annapolis) Zheng-he. The comparison with European exploration is indeed instructive. For although the Chinese preferred a massive display of authority (hundreds of junks, and twenty thousand or more soldiers and sailors) to conversion by fire and sword, they were hardly models of multicultural pluralism. Their explorers assumed that barbarian cultures would be so awed by the omnipotence of the Middle Kingdom that they would gladly submit to a tributary relationship as the price of being admitted to its imperium.

Given this extraordinary cornucopia of gorgeous items brought together from four continents, it seems rather churlish to cavil at the revisionism of the exercise. But it is precisely the superabundance of the event, the feeling of massive cultural bloat with which one leaves the show, that is so troubling. However worthily uncolonial the goals of the exhibition may have been, it is hard to go into a gallery brimming with glittering golden objects without feeling a little like the Peruvian conquistadors, who demanded that chambers be filled to the ceiling with gold as the ransom for the doomed Inca Atahualpa. The insatiable omnivorousness of the exhibition puts one in mind of what Roland Barthes, in a famous essay about another consumer-crazed culture, the seventeenth-century Dutch, called 'the empire of things'.

It is a peculiar irony that an exhibition so single-minded in its avoidance of the celebratory pieties of Western colonialism, a show so politically correct and diplomatically correct (and so multicultural in its corporate sponsors), should finally exemplify one of the values that it ostensibly deplores: the cultural power of metropolitan institutions. In this case, the acquisitive conqueror is not the Spanish crown, it is the National Gallery. For what we have here is nothing less than an imperial enterprise, authentically American in scale, so heroic and stupendous as to stun the beholder into critical submission – the last museological hurrah (one hopes) of the excessively gilded nineteen-eighties, the curatorial equivalent of a Malcolm Forbes party.

And the curatorial equivalent, too, of one of those multidecker Stage Deli sandwiches stuffed with brilliant and alluring ingredients that prove, after a while, to be punitively indigestible. For this megashow is not really a single exhibition at all, but multiple exhibitions, more or less under one roof. Hispano-Lusitanian art, Ottoman art, African art, Asian art, Meso-American art all enfilade into one another, with contemporaneity as their justifying connection. One of the most spectacular of the shows within the show presents a display of Renaissance paintings, drawings and prints, ostensibly with the aim of demonstrating how scientific observation and the exploration of perspective were the necessary conditions of geographical exploration. And some of the items in these rooms, such as Leonardo's anatomical drawings, do indeed speak to the issue, though they have nothing to do with the visionary fabulism that lay at the heart of Columbus's own mission.

Still, even if the connection is taken, what is Cranach's painting of the *Nymph of the Sacred Well* doing here? And more to the point, what does Leonardo's *Lady with an Ermine* – the image used as the public relations emblem for the entire enterprise – have to do with 1492, or with science, or with the history of the colonial encounter in America? If there is a compelling intellectual reason, other then the precise naturalistic rendering of a stoat, for this precious panel to have been freighted from Krakow to Washington, it is certainly lost on me. And even if the delicate and sympathetic drawing by Dürer of Katherina, a black Moorish servant to a Portuguese merchant, speaks to the problem of cross-cultural images, it is impossible to make the same case for his painted portrait of a Venetian Lady (especially since she might have been German).

In his introduction to the catalogue, Jay Levenson, the curator of the exhibition, claims that 'difficult choices had to be made in each of the major sections of the show, and if a particular culture is not represented then it is likely to be because it is less central to the theme of the exhibition rather than because of any shortcoming in its artistic creations'. But the immense disparity between, say, the Hispanic-Judaic representation and the Italian Renaissance drawings hardly bears this out. In fact, the criteria for inclusion and exclusion seem to have simply collapsed into a

curatorial appetite beside which the procurement policy of the Pentagon looks positively cheese-paring. The guiding rule seems to have been, if it's out there and it's circa fifteenth century and it's beautiful and it's available, then go for it. It is a principle of incorporation that would have been familiar to the *wunderkammer* collectors of the time.

In all this transhipment there is at least some unwitting connection with Columbus, for in his *Book of Prophecies*, an anthology of sacred texts and fragments compiled in 1501, these verses, I Kings 10: 21–22, are prominently displayed:

> ...there was no silver nor was any account made of it in the days of Solomon. For the King's navy, once in three years went with the navy of Hiram by sea to Tarshish and brought from thence gold and silver, elephants' teeth and apes and peacocks.

In the end, however, the whole becomes less than the sum of its parts. The glutted density of the show subverts one of its implicit purposes: to give as much careful attention to the masterpieces of non-European culture as one would to a Dürer or a Leonardo. Visitors from out of town, however, must strictly ration their time, and those steered by the gallery's tapes will experience approximately half an hour of West Africa, fifteen minutes of India (the culture most brutally compressed), half an hour of Korea, and so on, until they arrive, their aesthetic machinery in serious overload, at the American realms of gold, by which point it becomes virtually impossible to do justice to the complicated splendour of Tupinamba feather capes, and the remarkable textiles of the Inca (peculiarly and pedantically spelled 'Inka'), and the strangely wonderful 'vomiting spatulas' of the Tainos – the people whom Columbus actually encountered on Guanahani and Hispaniola.

The effect is not unlike those multicultural textbooks designed around the principle of Least Offence. The claims of each ethnic and cultural constituency are judiciously weighed in so many pages and graphically represented in so many visuals, sidebars and charts. Exquisite care is taken not to commit any act of vulgar Eurocentricity, or to cast

aspersions on non-European cultures by suggesting that, like the Judaeo-Christian and Greco-Roman traditions, they, too, may have had their share of cruelty, narrow-mindedness and fanaticism. But to recast the pieties of a historiographical tradition dominated by sagas of Western saintliness and native savagery into its precise opposite is simply to replace one kind of reductionism with another.

Western culture has been culpable of demonizing and patronizing its victims as primitives; but redress through idealization commits only another form of condescension quite as egregious, by robbing such cultures of their human complexity, of a plausible complement of vices as well as virtues. Perhaps this is why I was relieved (if that is the word) to see the horrific obsidian sacrificial knives of the Aztecs given proper prominence in the exhibition. For what happened at Tenochtitlán, when Cortés's conquistadors burst into the Aztec empire, was that one cult of military fatalism and sacrificial ritual, in which blood was invested with the power of resurrection, was confronted with another. In 1487, for example, between twenty thousand and eighty thousand prisoners (the different sources, Nauhatl as well as Spanish, give different figures) were sacrificed at the dedication of the new Great Temple. According to the historian Friedrich Katz, they stood in four columns, stretching over two miles, before the Chief Speaker Ahuitzotl and his deputy collapsed in exhaustion from tearing out bleeding hearts, hour after hour.

It should have been possible to do justice in such an exhibition to all these terrible and fateful events without whitewashing either culture, and on a scale that would have given them more historical immediacy and vividness. A historically more rigorous design for a Mother of All Blockbusters would have sufficed with the exhibits of Portuguese, Spanish, Moorish and Jewish artefacts; the instruments and the documents of navigation (which include some of the most extraordinary items, such as the sole copy of the Martin Waldseemüller map of 1507, and the great Catalan Atlas of 1375); and the stunning art and artefacts of indigenous America. What would have been lost in encyclopaedic inclusiveness would have been gained in narrative coherence.

These problems of selection and scale, though, are only symptoms of

a deeper failure to understand what it means to historicize. Columbus's conspicuous banishment from the exhibition exemplifies the kind of approach that is willing to sacrifice the consideration of historical agency to a kind of milquetoast universalism. The mere presentation of contemporaneity, after all, explains nothing. Instead, the whole invidious, conflict-ridden mess of history disappears within the embrace of synchronicity. In the weightless historical space called *Circa 1492*, no particular persons or powers actually bring about events. Indeed, there are no events; there are only phenomena hazily defined, formed and reformed and deformed with the shifting winds and tides of the zeitgeist, now medieval, now Renaissance, now scientific-empirical-capitalist.

Presumably this exercise in cultural latitudinarianism is meant to pre-empt the anger and the agitation that would inevitably be directed at the commemoration of a particular historical event and its author – as if to remember is to endorse. But commemorations, when they are seriously conceived and broadly addressed, are not the same as celebrations. The original meaning of *historia*, of course, is 'inquiry'. If inquiry is confined, however, only to reiterating the piety of forefathers, if remembering is indeed to be equated with endorsement, then Hitler and Stalin may repose undisturbed.

Such a conveniently emasculated version of historical understanding would be especially inappropriate for the encounter between Catholic Europe and the Americas. For whatever the atrocities inflicted by the conquistadors (and their fellow travellers, the European microbes), the impressive fact remains that the historians of the Spanish empire never suppressed them. Indeed, the immense chronicle of Bartolomé de las Casas and his many successors recorded the horrors in the most unsparing detail. Conversely, it does no service to an understanding of native American cultures to cloak them in a mantle of innocence and virtue: to pretend, for example, that the hostile relationship between the Carib and the Arawak peoples was a European fantasy, or that cults of human sacrifice were strictly Aztec and didn't have a much older and widespread history throughout earlier Maya, Mixtec and Diquis cultures.

This is an acute problem, obviously, for histories that are consciously designed as reparation. Thus, in his introduction to *America in 1492*, a collection of essays on indigenous American cultures, Alvin M. Josephy Jr. professes to discard both the myth of savagery and the myth of Eden (the latter myth completely overwhelms Kirkpatrick Sale's *The Conquest of Paradise*). Yet from the start he indignantly rejects reports of cannibalism among the Caribs (and, by extension, other American societies) as a typically abusive Eurocentric fantasy, fed by medieval marvel literature like the *Voyages of Sir John Mandeville*. In an essay on South American cultures in the same book, however, Louis C. Faron writes that 'the Tupinamba and others like the Carib and Cubeo considered the eating of human flesh a ritual act, part of their belief in consubstantiation'. In what may rank as the most startling throwaway line of quincentennial literature, Faron remarks that 'a time for torturing and eating the captives was set but until then there was no harsh treatment of the prisoners'. And he switches to a Julia Child-like breeziness in describing the practices of the Mundurucu: 'Long before the men's return to the village the brains were removed and the teeth were taken out...the head was then parboiled and dried...'

Of course, one might produce, in a trice, countless instances from the European millennia of comparable horror. But the history of cultural encounters is not well served by grisliness contests, in which the most wretched atrocity is deemed the most representative social practice. In the same way, it makes no sense whatsoever for Sale to caricature European agronomy in the early modern period as based exclusively on the principle of 'warring against species', while non-Europeans idyllically harmonize with land and landscape. To clean up the history of the Americas is worse than to ignore it, or to subordinate it to Eurocentric notions of the 'primitive'; it is to subject it to a crippling form of moral depletion.

'Ah...Colón, they [meaning us]...live out our legacy, your destiny, more successfully and more grandly, if more terribly, than you ever could have dreamed.' Thus Kirkpatrick Sale, to the shade of the Admiral. Sale is ready to convict Columbus for pretty much everything that has been wrong with the planet from then until now, including the extinction of

the Great Auk and the Eskimo curlew, and for all I know Wonderbread and the hole in the ozone layer, too. There is a kind of puritan, brimstone astringency to Sale's book (along with some genuinely wonderful passages of narrative), though it helps at least to cut the treacle of the surviving eulogies.

Paolo Taviani, at the opposite extreme from Sale, seeks to reclaim Columbus from the biographical tradition of the waspified dauntless mariner invented by Washington Irving and William Prescott and perpetuated by Samuel Eliot Morison. But in so doing he characterizes Columbus not only as 'an extraordinary genius', but as an extraordinary Italian genius, one of 'a host of Italian geniuses', as a Renaissance prodigy, self-made and self-taught (the latter is certainly true), and worthy to lie in a pantheon with Leonardo and Dante. This may be an ominous sign of things to come: the breast-beating of American self-criticism in 1991 superceded by Hispano-Italian hagiography in 1992, a year already designated as opening a new epoch in European history.

Paradoxically, both the defenders and the prosecutors fight their battles on the same premise, namely that Columbus and 1492 represent, for good or ill, the advent of modernity. This assumption was emblematically expressed by the National Gallery, too, when it decided to conclude its show with a photograph of the Earth from space. And it is also the organizing concept of Barnett Litvinoff's rather plodding book, in which he 'seeks to reach down to the stirrings of modernism's miscalculations'.

For the eulogists, Columbus was the embodiment of Renaissance empiricism, a mixture of intrepid perseverance, maritime savvy, and colonial acquisitiveness. For the critics, he was an agent of cultural and demographic annihilation. For all of them, however, he was a paradigm of the modern, brutally smashing into fatalistic or innocently traditional worlds. That, everyone seems to agree, was his accomplishment or his offence. And that, to quote Ira Gershwin, is why 'they all laughed at Christopher Columbus when he said the world was round'.

Now we all know that there was no one of any account in 1492 who did not know that the world was round. But the reversal of the

commonplace can be taken much further. There are two documents in which Columbus reports that he was indeed laughed at, or at least smiled at. The first is an entry of his diary for December 26, as reproduced (and, as David Henige brilliantly argues, heavily edited) by Las Casas. In this text, the Admiral refers to his request to Ferdinand and Isabella: 'I declared to your Majesties that all the profits of my enterprise should be spent in the conquest of Jerusalem. Your Majesties laughed and said it pleased you and even without this you had that strong desire...'

The second is a letter from the autumn of 1501, between the third and the fourth voyage, written by Columbus from the Carthusian monastery of Nuestra Señora de las Cuevas, in which he bitterly complains that 'all who found out about my project denounced it with laughter and ridiculed me.' The textbook interpretation of this remark is that the visionary boldness of Columbus's original proposal had been greeted with derision by dug-in conservatives. But the knowledge that we have gained of Columbus's mentality, particularly from recent editions of less well-known documents such as his *Book of Prophecies*, which was written about the same time as his letter, forces us to stand the traditional interpretation on its head.

In fact, it was Columbus's sceptics and inquisitors – from the Portuguese monarch João II and his Jewish advisers to the Spanish Talavera Commission, which rejected his case in 1492 – who should be called the empiricists and the cost-conscious entrepreneurs of practical colonialism, mercantile or religious. After all, what confronted them in the person of Columbus was someone who had the relative magnitude of land masses and the oceans completely wrong; who preposterously abbreviated both the estimate of the globe's circumference and the breadth of the distance from the Canaries to 'Cipango' (Japan). For all his years of practical nautical experience, as far east as Chios and as far west into the Atlantic as Ireland and possibly Iceland, Columbus's insistence on going west to Cathay represented the subjection of the cumulative and detailed knowledge on portolan charts to the holistic spiritual vision embodied in the *Mappa Mundi* tradition and the ancient maps with Jerusalem at their centre. When he finally embarked in the *Santa María* at

Palos, Columbus was not holding course for modernity. He was sailing away into a fabulous neo-Ptolemaic wonder-world.

A number of the quincentennial biographies recognize the messianic and mythical role that Columbus invented for himself. John Noble Wilford, in a book otherwise oddly adrift between history and historiography, gives the *Book of Prophecies* the full importance it deserves (as does Sale, though for him it is yet more evidence of the apocalypse to be visited on the defenceless indigenes). Felipe Fernandez-Armesto, in much the sprightliest and the most acutely intelligent of all the biographies, is likewise most illuminating when he is dealing with the aspects of Columbus's story most amenable to traditional historical analysis. As one might expect from a scholar whose first research was on the colonization of the Canary Islands (a more crucial episode than one might imagine), Fernandez-Armesto is wonderfully informative on the sites of colonial preparation (Portuguese Madeira was Columbus's home for many years), and even better on the axis of the Genoese commerce and money without which Spanish imperialism would have foundered. Still, he is perhaps too Britishly inclined to make much of Columbus the social climber.

Columbus was indeed obsessed with turning himself and his family into lords, as his other eloquently strange project, *The Book of Privileges*, attests. From the beginning of the Atlantic project, however, there were other, even odder visions that swam in his brain. Going west to go east, Columbus imagined audiences with the 'Great Khan' and contacts with the mysterious Christian prince Prester John, which might open a second front against Ottoman Islam. The enterprise of the Indies was about far more than interloping in the Portuguese-dominated spice routes. Its objective was nothing less than the fulfilment of the crusading vocation: the liberation of the Holy Places and the rebuilding of the Holy Temple.

No wonder, then, that Columbus was for so long dismissed as a madman, since in some degree he was one. Indeed, it is his stubborn peculiarity, his remoteness from the self-evident nostrums of European imperialism that make Columbus so complicated and fascinating. So far from seeing his voyages as the inauguration of some expansive and illimitable age, he actually defined their success as hastening the Coming

of the Last Days, in an eschatology he took from the Calabrian abbot Joachim of Fiore. His desperate sense of urgency about his enterprise was largely determined by elaborate chronological calculations, based on scriptural reckonings and on the calendar proposed in Pierre d'Ailly's *Imago Mundi*, which told him that in 1492 there were just 155 days left to mankind before the Apocalypse.

'I was not aided by intelligence, by mathematics or by maps,' Columbus said in the letter of 1500 to Ferdinand and Isabella that prefaces the *Book of Prophecies*. 'It was simply the fulfilment of what Isaiah had prophesied.' So much for Columbus the proto-modern man, and so much for the kind of exploration that Ameritech declares, in its supporting publicity for the National Gallery show, 'was made possible by art and science'.

This does not mean that Columbus's mentality should be conventionally refiled under 'anachronisms, medieval', though that would be a less false description than the conventional one. For such a classification begs the large issue of what we imagine the track of modernity, of Western modernity in particular, to have been. If we assume the course of modernity to have consisted in a long march of Aristotelian objectification, accelerated now and then by Baconian induction, and continuing onward through the Enlightenment to a world governed by the insights of Adam Smith and Charles Darwin, then Columbus may indeed be written off as a cultural freak, and his place in the history books may be judged the result of the wildest contingency: south to the Canaries, turn right, and follow your dream directly to Cathay.

But to see Columbus as owing more to Roger Bacon than to the antecedents of Francis Bacon, as pursuing a mystically charged dream of the Ideal, hoping to bump into Japan and the Terrestrial Paradise on the way, is not at all to write him off. It is to put him, instead, in the company of other neo-Platonist souls whose work we conventionally assume to have modernized our universe, but for whom, by their own lights, astrology meant as much as astronomy. Kepler and Newton in particular would have their tents pitched in the same corner of the Elysian Fields as the star-gazy Admiral.

Thus, in keeping with the neo-Platonist cult of sublime disclosure and revelation, we should perhaps take more seriously Columbus's pre-occupation with his own name, and especially with the cryptic way that he encoded it in the mystic triangle that, from 1498 onward, he commanded would be the only way his heirs should sign themselves. Though the precise meaning of the symbol remains obscure, we do know that the Admiral meditated, before his third voyage, on the marvel by which his name appeared to prophecy his life: a perfect neo-Platonist conceit. It was preordained, he believed, that he should be Christoferens, or the Christ-bearer, the carrier of the evangel to the nations of the world. In Spanish, moreover, he was Colón, the populator, not merely with new men but also indigenes who would be made new by their conversion to the true faith. And the name Columbus, most miraculously of all, echoes the apparition of the Holy Spirit, who had appeared to him in the form of a Dove to announce his mission and to declare that his name – that is, interchangeably the dove of the Holy Ghost and the dove Columbus – would resound around the world.

Until quite recently, these mystical and messianic aspects of Columbus's career have been shunted to the margins of the story. From the conventional perspective of colonial history, Columbus's fixation on gold was seen as symptomatic of the conquistadors' self-evident lust for enrichment. What often went overlooked was that Columbus's quest was a product of his celestially revealed certainty that he would locate not just any lode, but the very Mines of King Solomon. Similarly, his hunt for the Terrestrial Paradise, and his conviction during the third voyage in 1498 that he would see it in the form of a nipple raised on the swelling breast of the imperfectly spherical world, has been an embarrassment to historians determined to represent him as the unstoppable force of colonial conquest and enslavement.

A common feature of many histories (including the PBS television series, *Columbus and the Age of Discovery*) is to present the development of the journeys from the first to the fourth as a voyage from clear-sighted, empirically informed navigation (even if sailing the wrong way) toward a dark delirium. Accordingly, with the exception of the Caribbean

historian Michael Paiewonsky's fascinating and beautifully produced *Conquest of Eden: 1493–1515*, less attention is paid to the third and fourth voyages, even though it was on the former that Columbus discovered the South American continent and on the latter that he accomplished his most amazing feats of endurance and navigation. In the conventional view, the measure of Columbus's tragedy is the degree to which he comes unhinged, that is, out of time with the lockstep of the proto-modern spirit of the age. It is safe to say that the Admiral did not see things this way. Summarily removed from the governorship of Hispaniola in 1500 by Francisco de Bobadilla, who had been sent from Spain at the behest of disaffected colonists, Columbus was manacled and sent home in disgrace. But when the captain of the returning ship offered to remove the chains, Columbus refused, glorying in the fetters that he took to be the attributes of his martyrdom. Brought low in the eyes of the world, he was closer than ever to the apostolic and evangelic consummation that he craved. (In their entertaining and imaginative novel *The Crown of Columbus*, Michael Dorris and Louise Erdrich are exactly on the mark when they turn that golden treasure into a crown of thorns.) For the most part, though, the *Libro de las Profecías (Book of Prophecies)* has until the past few years been dismissed as eccentric gibberish, as the disordered ravings of a defeated mind, as a document of Columbus's declining years. (Catholic propagandists, especially in France in the last century, were alone in finding comfort in its wild-eyed ecumenism.) Only the scholarly work of Pauline Moffatt Watts has taken the text and the other aspects of Columbus's religiosity as seriously as they deserve. Delno C. West and August Kling, the editors of the first English translation of the *Libro*, in an understandably missionary introduction to a superb text, recall that when they went to work on the Spanish version in Princeton, they found the pages of that copy still uncut. It is not too much to say, I think, that the publication of their devoted and impeccable research (not to mention the act of faith of the University of Florida Press in giving it such handsome form) is one of the major events of the quincentennial.

The other concentrated act of textual criticism and reconstruction appears in David Henige's *In Search of Columbus*, in which he subjects

assumptions about the 'Diary' of the first voyage to searching scrutiny. After Henige, that text can no longer be described with any accuracy as a 'log', and its authorship ought more properly be given to Las Casas. The original of the Diary is lost, and all we have had to go on is what Las Casas chose to transcribe. But the doubtful reliability of the Diary only serves to heighten the importance of the *Book of Prophecies* as a source for Columbus's convictions. Together with the *Book of Privileges*, the antiquarian and genealogical work by which he endeavoured to make good his claim to a succession of entailed titles and possessions for his heirs, the *Libro* may now be the best guide to Columbus's mental world that we have.

It, too, was largely transcribed, but by his thirteen-year-old elder son Diego, and then it was reviewed by the Carthusian Father Gorricio; and the prefatory letter containing so many powerful reflections of the Admiral's sense of spiritual invincibility was, Kling and West believe, written in his own hand. Moreover, the objection that the *Book of Prophecies* represents only the Columbus of 1501 may now be set aside, in light of the discovery that in 1481 he wrote four postilles or annotations on scriptural sources in blank pages at the end of his copy of Aeneas Silvius Piccolomini's *Historia Rerum Ubique Gestarum*, a work that, along with d'Ailly's *Imago Mundi*, meant at least as much to him as his famously marked-up copy of Marco Polo or his copy of the Toscanelli-Martins letter on the narrowness of the Atlantic passage. These postilles so exactly anticipate the themes of the *Book of Prophecies* that Kling and West seem quite justified in describing the two documents together as 'the bookends around his mind and his discovery'.

Nobody in search of Columbus the pioneer of the Renaissance and the vanguard imperialist need repair to this document of 1481, for what they will find there are scraps of biblical authorities from Isaiah and other prophets, the apocryphal Book of Esdras, passages of Flavius Josephus, and an intricate chronology of the Earth. Together, they reveal the true Columbian fixations: the location of a 'saving work' in 'the middle land of promise'; the mission to extend the evangel among all the peoples of the earth, thus accelerating the desired Last Days; the longing

for what Josephus described, in his account of the Solomonic voyages, as 'the place called Ophir which is now called Gold Country which is in India', where 'precious stones and timbers' could be found to build and to ornament the Temple.

In the *Libro*, as well as in his later correspondence, Columbus was evidently persuaded that Ferdinand was the new David, the Expected King under whose reign the prophecies would be fulfilled, with himself as the designated instrument of providential design. Did he not, after all, bear the crusading title of King of Jerusalem, acquired first through his Aragonese forebears, and later reinforced by acquisition of the Hohenstaufen Emperor Frederick II's Kingdom of Naples? And within such an eschatological mind, as Richard Kagan points out in his exemplary essay in the *Circa 1492* catalogue, the other major events of that year – the conquest of Granada and the expulsion of the Jews from Spain – were not simply accidents of chronology. They were linked strategic elements in the building of the new Zion, and therefore of a piece with Columbus's maritime enterprise.

The fall of Boabdil's Moorish citadel on the second day of 1492 was hailed as announcing an *annus mirabilis*. So it must have been of overwhelming significance to Columbus that he was received by the king and the queen at their encampment of Santa Fe, and probably rode into the liberated city in their retinue; and indeed that it was Luis de Santangel, the royal treasurer and convert from Judaism, who finally rescued him from yet another rejection. No wonder, too, that he included another *converso*, Luis de Torres, in his company: Torres was someone who could speak Hebrew and Arabic. He was not (as some have suggested) a poor substitute for someone fluent in Chinese or Japanese; he was an essential companion, because the Admiral may well have expected to end up in some part of the sacred 'Middle Land'.

In the 1930s Salvador de Madariaga, the Spanish writer and critic, notoriously misinterpreted all these messianic, millennial and Joachite impulses, these visions of Jerusalem the Golden, as a code for Columbus's own Jewish identity. And following his evidence, Simon Wiesenthal even imagined Columbus's journey to a New Land as a kind

328

of vanguard Zionism for the victims of the Inquisition. All this is pre-
posterous. Though he was unquestionably saturated in scriptural and
apocryphal lore, and though his own spiritual personality was built out of
the cultural criss-crossings between the Jewish and Christian traditions
that characterized much of the mystical and redemptive creeds of the late
Middle Ages, including the Observantine Franciscans with whom he was
closely associated, there is no doubt that Columbus's zeal was exclusively
Christian, and profoundly evangelical in nature.

Nor can there be any question that the literalism of this vision deeply
coloured both the deeds and the records of his voyages. The texts that
may best approximate his self-perception – the famous Barcelona letter
of 1493, speedily published as *De Insulis Inventis* just fifty-four days later;
passages from Ferdinand's biography (despite being published seventy
years after his death); and, for all the heavy freight of its editor's
Dominican passion, Las Casas's version of the Diary – all structure their
narratives as if they were reporting pilgrimages. The maritime peregri-
nation is punctuated by stations, illuminated by signs and apparitions,
animated by miracles, exalted by trials and ordeals. The vast ocean
becomes a wilderness; and the Admiral compares himself to Moses,
destined to lead a fractious and increasingly unbelieving tribe across its
face toward 'that land of middle promised for salvation'. When he
attempts to quiet the unbelievers in the near-mutinous second week of
October 1492, he scans the waters, like Noah, for signs of growing things,
and for birds, especially for his namesakes the doves; and he is rewarded
by the appearance of birds with sprigs in their beak – a sign, if ever there
was one, to persevere.

When land is finally sighted, Columbus pre-empts the sailor who
claimed the reward for it by insisting that he had first seen the mysteri-
ous blue light on the horizon that announced its presence. When the
Santa María is grounded off Hispaniola on Christmas Eve, he recovers
from the shock by determining that this, too, must be a divinely expe-
dited message that he should establish a settlement at the exact spot,
whence the ill-fated la Navidad, the nativity simultaneously of Christ
and of Spanish America. Naming, as Stephen Greenblatt points out in

his brilliant and riveting book, was of essential and formative significance for Columbus. San Salvador, the name that he gave to the Taino island of Guanahani on which he made first landfall, declared from the outset the redemptive purpose of the Enterprise of the Indies. And thereafter his names always performed a baptismal or conversionary rite, altering pagan space to sacred space. So the innumerable verdant islands of the western Antilles through which he threaded his way on the second voyage were named the Virgins, for the eleven thousand virgins who had been martyred with St. Ursula; and on the third voyage, dedicated to the Holy Trinity, Columbus had a vision of three hills on an island near the mouth of the Orinoco, which he promptly named Trinidad.

The turbulence of the elements was likewise seen as a trial or a punishment. During the fourth voyage, a hurricane from which Columbus's little flotilla narrowly escaped, proceeded to devour a great homeward fleet together with his old enemy Bobadilla, who had put him in chains. (The Admiral had advised not to set sail.) It is unlikely that the moral symmetry of the history would have been lost on him. On the violent home journey of the first voyage, Columbus was said (perhaps apocryphally) to have exorcised a waterspout that then passed harmlessly between the *Niña* and the *Pínta*. His response to the terrible storms of February 1493 was to have the crew of the *Niña*, three times on February 14 and once again three weeks later, draw lots of chickpeas, not to cast a propitiatory Jonah into the sea, but to have the fated person swear to perform a pilgrimage to an important shrine should the company survive the ordeal. A single chickpea had been marked with a cross, and three times out of four Columbus drew the pea: an eventuality that Henige has calculated (he is this kind of assiduous scholar, and no mean humourist) as carrying odds of eleven-thousand-to-one. Gadzooks, could this itself have been a prophecy of the isles of the eleven thousand virgins?

True or not, the drawing of the holy garbanzos became part of the Columbus lore, and it was used by the Admiral even further to reinforce his faith that he was the specially appointed agent of God's design for the world. In the Barcelona letter he asked, as the most appropriate form of celebration of the first discovery, that 'religious letters be solemnized,

sacred festivals be held, let churches be covered with festive garlands'. For 'the Eternal God our Lord gives to all those who walk in his way victory over things which appear impossible, and this was notably one', he wrote to Santangel; and later he characterized his whole career as guided directly by the dove-Spirit 'who encouraged me with a radiance of marvellous illumination from His Sacred Holy Scriptures'.

No wonder, then, that the officially stated object of the second voyage in 1493, equipped with six priests along with one thousand two hundred other men in seventeen vessels, was:

> to strive by all means to win over the inhabitants of the said islands and mainlands to our Holy Catholic Faith...to treat the said Indians very well and lovingly and abstain from doing them any injury...to arrange that both people have much conversation and intimacy each serving the others to the best of their ability...

Notoriously, of course, the 'conversation and intimacy' that the conquistador hidalgos had with the Tainos and the Caribs was loving only in the carnal sense, and the lofty spiritual charge of the enterprise dissolved into a horrific succession of slaughter, servitude, and the increasingly frantic search for the elusive gold mines of Hispaniola. Columbus should certainly not be exonerated for his contribution to this wretched fiasco. If he was a crusader, his crusading personality certainly conformed to its early medieval antecedents, by seeing personal ennoblement and enrichment as the proper reward for courage and risk.

The low point of Columbus's career was his willingness to sanction slavery in Hispaniola. If he attempted, at the beginning, to make a distinction between the bellicose and (as he thought) flesh-eating Caribs, whom he deemed fit for slavery, and the Tainos, whom he wished to make into peaceful converts, this distinction rapidly collapsed with the all-consuming need to have natives produce gold, food and sex on demand. And Columbus also has been held responsible for the introduction of the *encomienda*, or the tribute service by which drafts of native labour were allotted to the conquerors. But Fernandez-Armesto stresses

the radical novelty of the institution, unknown in both the Spanish Reconquista and the settlement of the Canaries, and argues that it was likely to have come, paradoxically, from the Spanish superimposing their own labour needs, however brutal and unrealistic, on tribute patterns already established in the islands. That there was no single colonial policy or practice that one could properly characterize as purely Spanish was eloquently demonstrated by the shocked Isabella immediately liberating all the slaves who were landed in Spain at the end of the second voyage.

By far the most intellectually gripping and penetrating discussion of the relationship between intruders and natives is provided by Stephen Greenblatt's *Marvelous Possessions*. Nothing else in the entire literature of the quincentennial remotely approaches his vivid engagement with the crucial issue of cross-cultural perceptions. Though Greenblatt addresses himself to works like Tzvetan Todorov's *The Conquest of America: The Question of the Other*, he is mercifully free of the kind of dogmatic critical theory that insists that the essential instrument of conquest was the European possession of written language – an ostensibly anti-colonial view that in fact 'privileges' European forms of communication over indigenous hieroglyphs and other systems of signs and utterances. Against this narrow view of the discrepancy between the two kinds of culture, Greenblatt wants to substitute the notion of 'marvel' or 'wonder' inherited from, but not identical with, the fabulous imaginings of medieval Mandevillean travel literature.

Greenblatt's title is well chosen, for he argues rather paradoxically that it was precisely the sense of wonder that is exemplified by Columbus's description of the first voyage that predisposed the Admiral and the conquistadors to possess these human and topographical treasures. In this respect, they are held to be different from Mandeville, who could produce a literature of gossipy astonishment at, or reluctant admiration of, the natives without any assumption that they were there to be taken. Thus, for Greenblatt, the elaborate rituals of possession – the unfurling of the flag, the reading of the absurd *requerimiento* by which uncomprehending natives were asked if they accepted the true faith –

are simply the formulas of covetousness. In one of two brilliant chapters on the Columbian encounter, he shrewdly proposes an ambiguity in the concept of convertibility: it may be applied both to souls and to gold, so that the one in effect could be traded into the other. This, for Greenblatt, was the perfect expression of the peculiar European Christian emphasis on monopolies of faith, land and belief. 'The whole achievement of the discourse of Christian imperialism,' he writes, 'is to represent desires as convertible and in a constant process of exchange.'

Greenblatt, of course, is a founding father of the New Historicism in literary studies, and it may be that this interesting notion of conversion and convertibility suits the New Historicist marriage between economic forms and moral forms a little too well. Still, it is very persuasive, especially when Greenblatt cuts loose of obligations to nod deferentially to colleagues and protagonists in his literary community, and relaxes his vigilance against the 'moves', 'tactics' and 'swerves' that are always said in this kind of work to be behind the construction of narratives. For someone so sensitive to the play of language, though, Greenblatt is occasionally not above playing around with it a little too adroitly himself. Thus, he quotes Columbus in the Diary describing the Tainos as 'good and intelligent servants for I see that they say everything that is said to them...', and later in the same passage remarking that 'no animals did I see on this island except parrots'. For Greenblatt, this is equivalent to Columbus equating natives with parrots, even though he nowhere says anything about the birds' capacity for mimicry.

Nine pages later we are told that it was a European characteristic to dismiss the natives as 'parrots', but we are then referred to a note featuring an account of a sympathetic advocate of the Indians who reports, no doubt angrily, the reaction of a cardinal who does indeed make the parrot comparison. Thus subtle differences and distinctions that point up the differences in European responses – there was not one European response, there were many – are slid together into one cunning but naughty generalization. Still, the need to keep one's wits sharpened when reading Greenblatt is a mark of the shrewdness, the intelligence and the energy of the arguments that fill every page.

And yet this marvellous book leaves me wondering about marvels. For where Greenblatt sees Columbus full of a kind of trembling stupefaction, 'wonder-thrilling, potentially dangerous, momentarily immobilizing, charged at once with desire, ignorance, fear', I read these same signals as expressions not of disorientation, but quite literally as signs of orientation, or Orientation: of the Admiral's unshakable conviction that he has arrived in the East. In the Barcelona letter to Santangel, for example, his description of the topography and the ethnography of the islands (as
J. H. Elliott, who contributes a characteristically elegant and powerful conclusion to the National Gallery catalogue, pointed out some years ago in *The Old World and the New*) invoked nothing so much as the terrestrial paradise. So the song of the nightingale, not a species native to America, could be heard 'singing in the month of November', and 'a great variety of trees stretch up to the stars, the leaves of which I believe are never shed for I saw them as green and flowering as they usually are in Spain in the month of May'.

This description is not just an intuitive report from a thunderstruck seaman. It is a text in sacred geography. For in such a paradise, October becomes May, and autumn becomes spring; and spring in Christian metaphor is Easter, the season of resurrection, and green is the colour of eternal Hope. And the seven or eight new species of palm tree that Columbus encountered also had numinous meaning: since at least the fifth century, the palm tree, as a tree that was believed to replenish its own leaves, had symbolized not just the Easter victory of Christ over his own death, but also the etymological and metaphorical equivalent of the phoenix.

If we accept a portrait of Columbus not as an embodiment of Renaissance man, but in most ways as the very opposite of Renaissance man, then his manifest incompetence as a colonialist, his arrogance and obtuseness in virtually all aspects of stewardship and government become not only less surprising, but wholly predictable. He could no more govern his staging post to Jerusalem in the Caribbean than the Frankish Kings could govern theirs in Antioch and Edessa. And in this

sense it would indeed be better, as the loyal citizens of Palos insist to this day, to acclaim or to execrate Martin Alonso Pinzón as the true inaugurator of the Spanish empire. Certainly Pinzón was the more representative type, as were many who followed in subsequent voyages, including men like Bobadilla, Fonseca and Roldan, who rapidly became exasperated and alienated by what they took to be the Admiral's disingenuous dithering – by his mercurial swings from sentimentality to brutal rage, his fantastic optimism about Solomon's gold and the tantalizing closeness of Ophir and Cipango, the arbitrary power he vested in his insufferable brothers, and above all by his willingness to inflict violent, even capital penalties on Spanish Christians.

Still, for all his editorial licence, it is supremely appropriate that it is Las Casas, the conquistador turned holy man and historian, the epitome of passionate indignation at the miseries committed by Europeans against Indians, who nonetheless had no doubt whatever of the significance of Columbus's life and career. For Las Casas, it was not the aggrandizement of the Spanish crown, still less the creation of the colonial class whom he detested, that was the hallmark of Columbus's work. It was rather the ecumenical effect, however tragic, of bringing diverse multitudes within the realm of Christian grace:

> Many times have I wished that God would inspire me again and that I had the eloquence of Cicero to extol the indescribable service to God and to the world which Christopher Columbus rendered at the cost of such pain and dangers when he so courageously discovered the New World with skill and expertise. Is there anything in the world comparable to the opening of the tightly shut doors of an ocean that no one dared enter before?... He showed the way to discoveries of immense territories...whose peoples form wealthy and illustrious nations of diverse peoples and languages...and of all the sons of Adam they are now prepared to be brought to the knowledge of their Creator and the faith.

Five hundred years later we may not wish to genuflect before this spiri-

tual hyperbole, though perhaps the cause of understanding Columbus is just as poorly served by turning a deaf ear to its plainsong, as if the conflicts and the passions that sound within it will conveniently go away and spare everyone further embarrassment.

Many of the contemporary anxieties about the Admiral and his accomplishments turn on the assumption that there was an impossibly incommensurable distance between the parties in this cultural encounter. When they faced each other, to be sure, they were as utterly different as any human societies could be, and their mutual incomprehension was indeed a crucial factor in the tragedy that unfolded. Yet the more we know about the wild and wonder-full Columbus, and also about Ponce de León and Balboa, the more hidden consonances there seem to be between European and American cosmologies. A truly open-minded cultural pluralism can hardly avoid these intriguing analogies. The Taino vomiting ritual, for example, was the kind of strict ritual practice that devotees of extreme Franciscan forms of mortification might have understood.

It goes against the grain of historical writing to linger unduly on these haunting peculiarities. Most historians of the Renaissance world are attuned more to discussions of cartography or Spanish imperial policy than to daydreams about the proximity of Ophir and the nightmares of Joachim of Fiore. And perhaps it is this quality of the fantastic that is missing from the pages of most of the books of the quincentennial. Even Greenblatt's book, so eloquently concerned with exactly this issue, delivers a discussion rather than an impression of its strange, grotesque quality. To dive into those realms of wonder, to see the parrots in great dazzling viridian flocks as Columbus did, the quincentennialist in search of the heroically crazed and relentless Admiral needs to see Herzog's *Aguirre, the Wrath of God* again; or better still, to pick up some of the superb novels about the time. Nothing captures the smoke and the horror of 1492, the year of the Jewish catastrophe as well as the Columbian epic, better than Homero Aridjis's overwhelmingly moving novel, *1492*. And for the experience of a Spaniard possessed by dreams but lost in the rainforest, nothing is more brilliantly textured than Antonio Benitez-Rojo's magnificent (and preposterously overlooked)

novel, *Sea of Lentils*:

> So there you are, Anton Babtista, feeling like a duke from the vantage of your lousy hammock, your feet moldering with sores and chiggers, your loins festooned with pustules that all the arboreal waters of the guayacan will never cure; there you are shooting mosquitoes and sweating out the midday fever, underneath the pallium of the branches that you've improvised to overhang your miserable pomp; there you are Anton Babtista, lord and master of unhappy Indians, lord of fear, lord of iron and bad dreams, master of death.

Though John Hemming has given us superb narratives of this experience, of the catastrophe that engulfed the Inca and other Amerindian societies, and though we have more subtle and more penetrating scholarship than ever before, the terrible story of Tenochtitlán in 1519 still awaits its new Prescott. In that terrible and magnificent place, one bellicose and sacrificial culture faced another, one despotism of tribute and service was annihilated by another. Aztec cosmology, trapped within its fifty-two year fatal cycle, assumed an impending apocalypse when the sun would cease to create new life unless nourished by blood. Christian eschatology, in its most radically millenarian form, assumed a linear destiny in which the whole world would be consumed by fire and sword before a celestial age could dawn.

It is a commonplace now that in Central and South America these cults – the primitive Christian and the Native American – have survived the very worst that microbes, social oppression, and economic brutality could have done. Though the cultures of the Tainos and the other Arawak are extinct, many other syncretic societies have somehow managed to mutate into forms that reflect the possibility of a shared historical evolution. The outcome of this development, of this mingling of destinies, certainly has many chapters of tragedy ahead of it, most obviously in the Andes, where among the ranks of the Sendero Luminoso a cult of renewal through blood has taken fresh and ominous life. Facing this disaster, however, is a Peruvian president who is an ethnic Japanese:

Cipango transported, after all to the south Atlantic. Columbus had hoped to find the fabled offshore island further to the north, so that in his reckoning America and Japan were the same place. No one, in 1992, is likely to suffer from the same confusion. But the mingling of the destinies continues, and the Admiral's mistaken calculations should not lessen our admiration for the rich bravery of his craziness.

INDEX

ACKNOWLEDGEMENTS

Though I am deeply grateful to John Gross and Leon Wieseltier for imagining I might have something printable to say about art in the pages, respectively, of *The Times Literary Supplement* and *The New Republic, Hang-Ups* is, more than anything else, a *New Yorker* book, the product of ten years of being let loose by the editors of the magazine on pretty much anything that took my fancy in the museums and galleries of Manhattan and sometimes places further-flung. My biggest debt of gratitude, then, is to Tina Brown who, in 1995, dared me to turn down the job of the magazine's art critic knowing (after the deepest of breaths) that I couldn't and wouldn't; and for being, over the years I wrote a regular column, the most perceptive, generous and eagle-eyed of editors. Deborah Garrison had the unenviable job of cleaning up after my adjectival excesses and was simultaneously the strongest and most sympathetic line editor I have ever had. When she left the magazine Sharon Delano and Ann Goldstein took over editing my *New Yorker* pieces and to them too I am grateful for making the finished product so much better than the original. David Remnick and Dorothy Wickenden continue to indulge me space in *The New Yorker* and act as the friendliest and most astute senior editors any writer could want.

There have been a multitude of friends and colleagues in the art world and the art historical academy on both sides of the Atlantic with whom, over the years, I have talked about all kinds of art and on whose wisdom and erudition I have shamelessly drawn: Matthew Slotover, the publisher of Frieze who persuaded me I might write provokingly on painting; the painters David Rankin, Alex Katz, John Virtue and Brenda Mayo from whom I've learned a great deal about both concept and technique; Robert Hughes for being simultaneously, the lodestar and an

impossible act to emulate; the late Kirk Varnedoe who was teacher as well as friend; Geraldine Johnson; Mary Sabatini at Galerie LeLong; Molly Dent-Brocklehurst at Gagosian; Walter Liedtke and Harold Holzer at the Metropolitan Museum of Art and to the museum for inviting me to give the Rubin Lecture and the lecture on Anselm Kiefer reproduced here, and not least to all of my colleagues and students in the Columbia University Department of Art History and Archaeology from whom I continue to learn.

At BBC Books I must thank Belinda Wilkinson for her editorial work once again on my text and for her immense help in tracking down and securing the illustrations; Sally Potter for continuing to be a sympathetic and constructive editor; and Linda Blakemore for her design.

As usual, my agents Michael Sissons and James Gill not only helped make this book happen but prevented its author from going off the rails every so often, as did Rosemary Scoular, Sophie Laurimore, Clare Beavan, Jill Slotover, Alicia Hall Moran, Lily Brett and Terry Piccucci. My two children and my wife Ginny continue to give me three more sets of eyes with which to see art afresh. To Chloe, my thanks for the idea that I should take American trompe-l'oeil painting as the subject of the Rubin Lecture and to Gabriel whose own paintings and enthusiasms in the gallery constantly make me rethink my own.

PICTURE CREDITS

TEXT CREDITS

1 DUTCH GAMES

Another Dimension (Michael Sweerts), *The New Yorker*, October 28, 2002.
Did He Do It? (Rembrandt), *The New Yorker*, November 13, 1996.
Hendrick Goltzius, *The New Yorker*, July 14–21, 2003.
Through a Glass Brightly (Johannes Vermeer), *The New Republic*, January 8–16, 1996.

2 BRITISH EYES

Flashes of the Peacock's Tail (Thomas Lawrence), *The Times Literary Supplement*, November 23, 1979.
Rowlandson in the Round (Thomas Rowlandson), *The Times Literary Supplement*, March 10, 1978.
Mad Cows and Englishmen (William Hogarth), *The New Yorker*, April 8, 1996.
The Church of Me (Stanley Spencer), *The New Yorker*, February 17, 1997.

3 MODERN MOVES

Homer's Odyssey (Winslow Homer), *The New Yorker, 1996.*.
American Illusions (Trompe l'Oeil Painting in the Gilded Age), The Rubin Lecture, the Metropolitan Museum of Art, New York, December 1998.
Up the Nile with a Camera (Nineteenth-century Photography), *The New Yorker*, October 8, 2001.
Cézanne's Mission (Paul Cézanne), *The New Yorker*, June 17, 1996.
Tunnel Vision (Egon Schiele), *The New Yorker*, November 10, 1997.
Gut Feeling (Chaim Soutine), *The New Yorker*, May 25, 1998.
True Grid (Piet Mondrian), *The New Yorker*, October 9, 1995.

4 FRESH MARKS

California Dreamer (David Hockney), *The New Yorker*, March 18, 1996.
Head Honcho (Chuck Close), *The New Yorker*, March 23, 1998.
Dangerous Curves (Ellsworth Kelly), *The New Yorker*, November 4, 1996.
Alex Katz's Landscapes, *Alex Katz: Twenty-five Years of Painting* (The Saatchi Gallery, 1997).
Cy Twombly (Works on Paper), *Cy Twombly: Fifty Years of Works on Paper: The Drawings at the Hermitage* (Schirmer-Mosel Verlag, 2003).
Illumination (Anna Ruth Henriques), *The New Yorker*, October 1997.
Looking Jewish (The Photographs of Frédéric Brenner), *Jews: America: A Representation* (Harry N. Abrams, Inc., 1996).
Anselm Kiefer, Lecture at the Metropolitan Museum of Art, New York, March 1999.
Andy Goldsworthy, *The New Yorker*, September 22, 2003.
Pangs (The Irish Hunger Memorial), originally published in *The New Yorker*, August 19–26, 2002. Copyright © 2002 Condé Nast Publications Inc. Reprinted by permission. All Rights Reserved.

5 FIXTURES AND FITTINGS

Heavy Metal (Renaissance Armour), *The New Yorker*, December 21, 1998.
Narrow Spaces (In the Salons of the Court Jews and the Cellars of Resistance Holland), *The New Yorker*, September 23, 1996.
The Trellis and the Rose (Charles Rennie Mackintosh), *The New Yorker*, December 16, 1996.
Modes of Seduction (Haute Couture), *The New Yorker*, December 18, 1995.
The Dandy Dutch (Dutch Fashion Now and Then), *The New Yorker*.
1492 (The Columbus Show 1991), *The New Republic*, January 6–13, 1992.